MUSEUM MEMORIES

History, Technology, Art

Cultural Memory
in
the
Present

Mieke Bal and Hent de Vries, Editors

MUSEUM MEMORIES

History, Technology, Art

Didier Maleuvre

STANFORD UNIVERSITY PRESS

STANFORD, CALIFORNIA

1999

Stanford University Press
Stanford, California
© 1999 by the Board of Trustees of the
Leland Stanford Junior University

Printed in the United States of America

CIP data appear at the end of the book

To Marie-Claire, and Faust

Acknowledgments

This book grew out of research done at Yale University for a doctoral dissertation on collecting and encyclopedias, a thesis to which the present work bears only nominal ties. I am indebted to Peter Brooks and Denis Hollier for their support, example, and teachings. The University of California has assisted me by way of grants, the University of California Faculty Career Development Award, the University of California Junior Faculty Regents' Honor Fellowship, and yearly research grants. These funds were instrumental in giving me the time and peace of mind to write. Equally beneficial was the support of a sabbatical leave during which I gave the finishing touches to this manuscript, and launched into the next project. I wish to express my appreciation to the Department of French and Italian at the University of California, Santa Barbara, for providing the collegial support that enabled this work to evolve. I owe a special acknowledgment to my friend Vijay Mascarenhas who, in addition to the unenviable task of rooting out the rogue gallicisms and tightening the prose, refined the text with canny, illuminating questions. The comments and suggestions of Stanford Press's anonymous readers were also invaluable in sharpening the book's analyses. I also wish to thank my editor, Helen Tartar, for turning stylistic infelicities into arguments. Her encouraging support throughout the publication of this project is greatly appreciated. Further thanks to Jeanine Ivy and Denise Baxter for tending to the business of illustration permissions.

D.M.

Contents

Figures

MUSEUM MEMORIES

History, Technology, Art

Introduction

From its official inception near the turn of the nineteenth century, the museum has been more than a mere historical object; it has manufactured an image of history. By collecting past artifacts, it gives shape and presence to history, inventing it, in effect, by defining the space of a ritual encounter with the past. Significantly, however, the museum was not initially perceived as a protector of the arts and history. When the first great art museums were created in the nineteenth century, they were greeted by complaints that they destroyed the life of history and culture instead of preserving it. The museum's reinvention of history was said to threaten historical meaning as such. Embroiled in the cultural battles of the French Revolution, the museum in France was attacked as a proof of the cultural falsehood of the new era, a modern age cut off from the ties that had bound a formerly integrated society to the lifeblood of its historical tradition. The criticism leveled at the museum centered on the question of authenticity: the museum endangers artistic and cultural authenticity by removing artworks and artifacts from their original locations and placing them in galleries where they can only be gawked at, and never, so to speak, lived with. Loss of context, loss of cultural meaning, destruction of a direct connection with life, promotion of an esthetically alienated mode of observation, instigation of a passive attitude toward the past and of a debilitating mood of nostalgia—the museum seemed to

embody all these ills of the modern age, an age that, by its own account, had forsaken the immanent ties with tradition that had blessed every previous era.

Rumors of the museum's inauthenticity have haunted museographic discourse to this day. The comparatively recent ecomuseums and community-aware, decentralized museums, which aim to find a mode of museum exhibition authentically tied to the life of the surrounding society, show that such concerns are still with us. It further demonstrates that charges of cultural denaturalization still hover over the existence of museums. This complex of inauthenticity pervades the esthetic discourse of the last two centuries. Accordingly, the museum looms large in the mood of historical decadence that pervades modern reflections on art and culture—it is implicated in the sentiment that art and culture have seen better days. In a line that runs from Antoine-Chrysostome Quatremère de Quincy (the cultural eminence who, in France, first theorized the antimuseum critique) through Hegel, Nietzsche, the first historical avant-garde, Dewey, Heidegger, and Merleau-Ponty, esthetic discourse has bemoaned the separation of art from existence, a separation for which the museum is held largely responsible. As Adorno writes, the German word *museal* bears an unpleasant affinity with necrology, with a culture of death, mausolea, and sepulchres.[1] The museification of art has been taken as a symptom that art in the modern period is no longer an integrated living praxis but an object fit only for historians, connoisseurs, curators, and cultural officials. At bottom the debate about museums involves an intellectual dilemma concerning the principle of culture itself. Is it to be viewed as production or as conservation? Inauguration or preservation? It would be wrong, however, to assume that in this debate the museum has been consistently aligned with the forces of conservation and retrogression, given that the earliest criticism of the museum denounced its hotheaded extremism and dangerous innovations. Thus initially the museum came under the attack, not of the leftist avant-garde, but of the reactionary. The museum is a shifting value in the discourse on culture: it confounds political affiliation. The reconciliation of art with existence (that is, the undoing of *museal* culture) is sought by Marinetti as well as Malevich, Valéry and the first avant-garde, Dewey and Heidegger, the

cultural politics of twentieth-century authoritarian regimes and left-leaning museum reformers alike.

The idea that art in the museum is no longer authentic implies that art outside the museum enjoyed a truer, more immanent connection with history and culture. This view ratifies an idealist notion of history whereby history is thought to be a substratum existing prior to the work of art, or a predetermined sphere wherein the work of art is placed at birth. Thus a given work of art is said to "fit" in its historical context as in a natural essence. For both sorts of museum detractors, this notion confirms the thesis that artworks must be reintegrated into a setting akin to their "original" circumstances; for the museum champions the presentation of artworks as primarily *historical* artifacts, presented according to chronological and national (rather than thematic or formal) categories. Among other things this book proposes to reconsider the idealist conception of history, which thus restricts art to being a mere inhabitant, rather than a shaper, of its historical circumstances. Art itself asks us to examine notions of culture, history, and authenticity in light of the work of art itself. What one says of museums of aeronautics, farming instruments, or folk dress cannot directly apply to the art museums. Art warrants a different historical thinking because the work of art *makes* history in an essentially different way than other artifacts do. Art constitutes a *caesura* of history, hence of experience and of the subject: it cuts into the very concept of the subject of culture in a way that calls into question ideas of immanence, naturalism, and authenticity.

The history of museums reveals changing practices in the ways of presenting and apprehending art. From the cabinet of curiosities to the modern art gallery, the culture of esthetic visuality undergirds an ideological production of the individual. The estheticization of the artwork in the museum parallels an estheticization—neutralization and autonomization—of the bourgeois subject in industrial society. The museum constitutes a formidable model of civic membership, a ritual of social identification, in short, a technology of the subject. What must be uncovered is the link between the ideology of art's presentation and the ideology of autonomized bourgeois existence. In pointing out the repressive dimension of the museum's model of identification, I thus hope to delin-

eate the possibility of a museum and of a museum subject that would be attuned to the emancipatory thrust of art itself. No longer would the museum be a lesson in compliance to authority and conformity; instead, undoing the process of identification, the museum could become cultural in the sense suggested by the work of art: a liberation from "culture."

Engaging a broad literary, artistic, and philosophic context, the second part of the book investigates how far the museum penetrated the cultural consciousness of the nineteenth century, right down to the bourgeois interior. The nineteenth-century mania for collecting was not merely a public concern: domestic collections flourished, and remodeled interior spaces into esthetic and historic museums of themselves. The critique of the traditional museum thus applies to the houses of the bourgeoisie, great and small. Rummaging through the attics of philosophy, literature, popular imagination, and art, this chapter looks for traces of the subject-object dialectic in the most mundane aspects of daily life, in the frills and trifles of the bygone past. "The trifles of an era, once ten centuries have elapsed, become the stuff of the most serious scholarship," Proust wrote.[2] What would our image of the Roman empire be without the fragments of kitchen utensils and broken domestic accouterments unearthed from volcanic ash? Wasn't the Rosetta stone after all a mere government edict? With time or critical distance, the decorative dross left by past historical eras becomes philosophic material. The domestic interior may now open up a new understanding of the *inhabitant* of history: what it meant to inhabit the nineteenth century. Observed through literature, the nineteenth-century domestic interior unfolds a document that illuminates the question of being and dwelling in history.

Constructed like a museographic or still-life display of itself, the bourgeois home in the nineteenth century is haunted by the inauthenticity ascribed to museums at the time. The domestic collection estheticizes private existence and instills an alienated form of objective experience at the heart of the subject's space. The decorative object, or bibelot, which is the essence and spirit of nineteenth-century decoration, crystallizes the imitative and spurious character of the bourgeois interior. Like the museum piece, the bibelot is an uprooted object, a replica or a substitute that poses as historical value but in fact dilutes, hybridizes, or denatures it.

Restitution of an immanent culture appears illusory in the age of industrialized production. The interior designs itself as a museum of preciousness in part as a reaction against the deauthentication of object production and objective experience in the nascent world of commodities and mass consumerism. Even objects are not what they used to be: they have lost the gold standard of concrete actuality on which philosophy once fastened the dialectic of subject and object. Realism, this chapter argues, is the esthetic reaction that concerns the loss of concreteness in objective experience. In this sense, realism is nostalgia for reality and thus inherently a principle of historical alienation. The descriptive eyes of Balzac, Goncourt, or Huysmans in their home inventories seek to stymie the liquidation of objective reality by isolating and preserving the minutiae of domestic existence, by elevating the detail as a fetish of realness. Unhoused from the dialectic that once bound it to object in a solid fashion, the subject experiences a decay in the principle of dwelling (in the real, in history, in being), a decay that plays a crucial part in the standing of the individual in the modern era. That the subject cannot be at home even in the domestic interior mirrors the inability of the bourgeois to dwell in the present, to be at home in the time and space of the nineteenth century.

The third section of the book juxtaposes a critical analysis of a passage in Balzac's *La Peau de chagrin* with a larger theoretical reflection on the concepts of history, instrumental reason, and the subject of technology in the modern period. The scene recounts the hero's visit to a gallery of antiquities. For Balzac the museum symbolizes a break in the traditional transmission of the past: in the museum, the past is not handed over to the new generation; rather, it is exhibited as an alienated and decontextualized object, at once estranged and strange. Balzac's depiction of the museum as a place of alienation and thwarted experience couches the dynamics of the dialectic of subject and object in the language of esthetics, as the confrontation between interpretation and art. This confrontation provides the blueprint for understanding the nineteenth-century reification, or estheticization, of experience in technological reason, artistic modernity, and the culture of objects. The deadly entanglement of subject and object in Balzac's story, rooted in the experience of art, sheds a new light on the domains of architecture, economics, and ethics. The

museum is no longer simply an esthetic experience: it is a model of subjectivity caught in history, in the industrialization of labor (that is, of subject), in finitude. Tipped to the side of the object, culture in Balzac emerges essentially as a culture of death. His writing places the experience of the museum at the crux of the dual preoccupation with history and subjectivity in the modern era.

1

Museum Times

History Lab

[handwritten annotation: Museums produce history]

One must look at museums historically not because method dictates it, but because they are *essentially* historical. By putting forward an image of the past and managing the handing on of tradition through artworks and artifacts, museums participate in a historical production of history. Historiographic through and through, museums thereby beg the question of their historical appearance, of the role they fulfill toward history, in history.

Broadly speaking, museums are institutions devoted to the protection, preservation, exhibition, and furtherance of what a community agrees to identify as works of artistic or historical value. In them, the artistic and the historical fuse into one seemingly immanent essence. To the museum, the beautiful is inherently historical: it emerges out of the past like a residue or a ruin. The work of art in the age of museums is thus a historical appearance, a principle to which we have grown so accustomed that it almost eludes attention. Hardly anything in the museum is not historical, that is, hallowed by official history and productive of a collective idea of what history is. Even the creation of museums is a historical coup staged on the idea of history itself. Museums in their present form came into being at the turn of the nineteenth century, during the cultural secularization of history. Art and historical artifacts were being deprivatized, removed from the princely houses in which they had hitherto rested. The nation became the legitimate vestal of memory and of the past's ruins. Art institutes began cropping up throughout Europe: in France, the Louvre opened in 1793; Spain followed suit in 1820, with the Prado Museum; Britain produced the National Gallery in 1824 and the British Museum in 1852; and in Berlin, the Altes Museum was founded in 1830. This bracketing of art into the autonomous sphere of museums complements the movement that hands art over to the expertise of historical science, to the investigations of historiographic study and the minutiae of scholarship. This process takes place concretely in the establishing of academies and institutes, in the museification of music via repertoires, in the annexation of literature by philological studies. Art in the nineteenth century becomes an object of historical expertise.

Curiously, whereas the museum in today's world is associated with

cultural preservation, it first appeared as a means of social renewal: as a way of breaking, rather than bonding, with the ways of the past. The museum was meant to further the momentum of a historical putsch, in reaction against history conceived as the politics of the status quo. The Louvre Museum, founded in 1793, illustrates the revolutionary thrust of the museum as institution: its initial purpose was to exhibit the spoils wrested from the aristocracy by the Revolution. Art, heretofore the plaything of noblemen, high clerics, and princes, suddenly became the official property of the nation. The opening of the king's palace to a crowd of visitors on August 10, 1793—the anniversary of the fall of the monarchy—demonstrates the political symbolism of the museum.[1] Conceived as a pedagogical tool for the people, the revolutionary museum was an instrument consolidating a newly revamped national character, promoting the myth of a nation's innate "genius" as well as the image of a grand historical destiny. In the museum, history assumes the paternalistic countenance of fate: it tells the awed visitor that all stages of the past belong to a necessary pattern of reason, triumph, and order; that all is as it should be on the stage of world history. It is all constructed as a pageant of high artistic and historical moments, and history is viewed as an uninterrupted series of climaxes. The museum makes history into its own reason and justification. Its ecumenical mission of encompassing history is political insofar as it fulfills the essence of politics, to wit, the fantasy projection of a reconciled polis (Baudelaire wryly said that "a national museum is a communion whose gentle influence softens people's hearts").[2] History becomes. myth: that is, an image that gathers people and summons an identity.

Initiated under these political auspices, the museum immediately had the effect of politicizing the contents of artworks. The Revolutionary Louvre Museum selected artworks partly on the basis of their potential for providing political instruction to the public. Civic, republican values were never far from mind when the Louvre's first curators decided which pictures to hang. The museum is often regarded as a symptom of art's autonomization in modern times. Yet such autonomization ironically began when art was assigned a political mission. However neutral the museum estheticization of art appears to be, it is nonetheless fraught with political overtones. Art is not the only thing that the museum neutralizes: as a powerful propaganda instrument, it also reifies collective identity by con-

fining it to a set of seemingly eternal traits, thus neutralizing conflicting or errant tendencies. It is little wonder the museum falls under the charge of complicity with bourgeois ideology: it enthrones the values of conformism, respectability, stability, rationalism, permanence, and therefore class resignation;[3] it confers onto the bourgeois order the halo of fate. These values bolster the ideology that conceives identity as invariant. Bourgeois history awards itself the prize for having "done" history: that is, for having gone through all the stages of development toward the present and for making the present into the summation and final stage of history. The paradox of museums lies in their representing the progress of history through diversity, yet doing it from the standpoint of a suprahistorical, transcendental notion of what this history is—from a principle of rigid identity above and beyond diversity.

Thus the museum takes part in the process of societal rationalization that controls beings by immobilizing their identity, or by simply postulating an identity—identity being already a precipitate of social immobility. Rightfully, it seems, the traditional museum has been compared with the disciplinary institutions of the bureaucratic nation state that enforce control over persons, spaces, and objects by pigeonholing them and curbing their nomadic tendency. Thus the museum is like the school in that it purports both to educate and to regiment; it is like the prison in that it isolates its inmates in categoric cells; and it is like the hospital insofar as artworks are sanitized and shielded from the nefarious influence of extra-esthetic abuses.[4] Thus confined to a specific place and reduced to a set of taxonomic segments, art is immobilized, stamped as an essence of eternal history. The museum is the temple of culture conceived as a fetish of identity: there culture is supposed to manifest itself concretely, magically. This fact may explain why, in keeping with this quasi-religious symbolism, the Revolution specified requisitioned churches and monasteries as the natural places in which to establish museums.

The ideological dimension of museum exhibition invalidates the idea that art can be neutrally exhibited. For all the museum's appearance of Olympian detachment, social forces actively shape the presentation of art. Indeed, the museum's primary function of preservation and exhibition involves a process of socialization that translates the primary language of art into the secondary language of culture. Art becomes a trophy

of culture and, as such, an instrument of collective identification. The intensely private language of the work of art collaborates, in the museum context, with what such art may once have stood against: the forces of historical preservation, that is, tradition and the political status quo. Yet the reinscription of art into a socially meaningful language must be more than good politics; people must also believe such reinscription to be in the best interest of art. Otherwise the museum would lose the reputation of protector of the arts, which makes good advertising for its sponsors, national and corporate. Apart from its political function, which was rarely avowed, the nineteenth-century museum assumed a disinterested artistic task: that of preserving, protecting, and restoring works of art and generally rescuing them from the abusive treatment of historical events, mercantile interests, infelicitous conditions, haphazard relocation, and so forth. Salvaging artifacts from history, however, is itself a historical gesture, on three counts: it takes place in history; it passes a judgment on history; it grants artworks a historical character. To decree that the museum piece is an object henceforth removed from historical becoming turns that object into a sacrament of history, a history so absolute as to be above historical being itself. The museum artifact is crowned with a historical aura of such sacredness that history itself, in its becoming, cannot touch it: art stops living the bad history of historical becoming and attains the transcendental history of a historical invariant. This sublimation of history affects the artistic material. The museum absorbs all particularities—works at every stage of their production, pieces of sculpture severed from larger ensembles, works that may have been disowned, or left unfinished—and makes them into precipitates of artistic essence. The museum conveys upon artifacts the sanctity of an eternal judgment: how they look here is how they always have looked and how they always should look. Objecthood is invested with the aura of fate. Thus the museum is historical and ahistorical: the former because it actively shapes the historical becoming of its collections; the latter because it seeks to raise them into a realm above the vagaries of history, where history itself has come to a stop or has not yet begun.

History, therefore, is not a stream in which museums are thrown, on a par with other cultural formations. Rather, museums *manufacture* history; they engage its image and concept. They claim as historical that

which survives history. History is what perdures above and beyond historical becoming, the museum seems to say. History is what escapes the material forces at work in history; what challenges history by means of history.

Pointing Fingers

Museum preservation and exhibition invite us to reflect on the concept of history. History in the museum is no longer the space where one dwells, the objects we touch and live with; it is a spectacle objectively removed. Museums thus lead us to ask: Is history to be conceived as historical living, that is, as immanence within a tradition? Or is history an objectified spectacle, a way of holding tradition as a *thing*? Does true historical being lie in embeddedness within the social, economic, and material forces of evolution? Or is historical being preservation against the tide of these very forces? In short, the debate boils down to whether history is concerned with life or the petrifaction of life. Here philosophy entered the debate concerning museums, identifying in the museum a new manner of dealing with history and, most of all, of being *in* history.

Contemporaries of the Louvre's creation were aware of this fact. Today their voices are heard most intelligibly through the writings of Quatremère de Quincy, a man who occupied for a few decades the center of official cultural discourse in France. Quatremère began his career as an artist, later became an art historian and reigned over the Académie des Beaux-Arts from 1816 until 1839, from whose pinnacle he exerted enormous influence over the current esthetic discourse.[5] A man of the Revolution who in time got in trouble with the Convention, Quatremère witnessed firsthand the cultural upheaval when the self-appointed French State requisitioned artistic and historical artifacts. To him, the foundation of the Louvre Museum did not look like a holy incarnation of manifest destiny, a canonical fixture. In the turbulent and precarious days of the Revolution, the museum seemed rather a cultural coup, a forceful instrument of social engineering. What the museum did to history by wresting artworks from the hands of the few was consonant with the Revolution's agenda of chopping off centuries of French history. It was a matter of liq-

uidation as much as preservation. Understanding the museum begins with the realization that, at least in France, it began as a revolutionary device. It intended not so much to maintain the past but to assert the rights of the present over the past; it was not a way of paying respect to tradition, but a way of settling accounts with French history.

Thus Quatremère saw history reappropriated as a regular spoil of war. He witnessed history being rationally managed by public policies intent on asserting themselves over the claims of tradition. Democratization of the access to art and high historical culture meant that the private citizen could become a *historiographic* subject—the rational observer of history rather than its passive subject. In the revolutionary museum, one was no longer subjected to history, as a serf was subjugated to the ancestral rights of the feudal lord; rather, one is *addressed* by history, as a citizen is invested with the responsibility of managing the past and the nation's destiny. The difference between subjugation to history and rational and esthetic contemplation of history lies in a degree of immanence. The serf had no choice but to bow to the authority of perennial modes of living; his very existence as serf was an admission of the power of tradition, that is, the replication of the status quo understood as a natural process. Insofar as the serf's life acted out history's self-replication, his existence was immanent to history. By contrast, the ideal citizen is theoretically defined by his potential for self-determination and invention. His rapport with history is no longer one of acceptance and inclusion, but rather of observation and criticism: it is a thoughtfully mediated rapport. History is no longer the ground, air, and substance of existence; it is an *object* of intellectual observation and social experiment. As an object, a piece of reification, it can be put away, stored, held in reserve, managed. In short, it can be placed in a museum.

The realization that history was being alienated first dawned on Quatremère as the revolutionary armies began raking up artworks and artifacts during victorious foreign campaigns. First came the Flemish pictures, requisitioned after the annexation of Belgium; then came the Italian art triumphantly sent home by Napoleon during the Italian campaign (1796), and finally the ancient art pillaged during the Egyptian wars (1798). Already in 1796, Quatremère published "Letters to Miranda on the Displacement of Italian Artistic Monuments," which drew alarmed

attention to the cultural damage of dislocating and transplanting art-
works from their places of origin. Having in his youth admired the works
of antiquity in their native settings, he found the sight of the Laocoon or
Belvedere Apollo standing in Les Invalides, in Paris, an artistic impiety, a
barbaric swindle that tainted the very meaning of culture. Quatremère
did not see the museum as preserving art or culture; rather, he saw it as
bracketing culture from its true context, in living history. Quatremère
collected his thoughts and read them publicly in 1806. With the Restora-
tion of 1815, when it was safe to do so, he published them under the title
Considérations morales sur la destination des ouvrages de l'art (Moral con-
siderations on the destination of works of art).

This work constitutes social criticism's first full-fledged attempt to
respond to the phenomenon of museums. It is a plea for a traditional cul-
ture which Quatremère saw badly compromised by the practice of pluck-
ing artifacts out of their settings. What underlies Quatremère's protest
against museums is the principle of cultural authenticity:

One destroys the vital example of art by taking it out of the public sphere and dis-
assembling the works as it has been done for the last twenty-five years, and then
reconstituting the debris in those warehouses called *Conservatories*. . . . To what
wretched destiny do you condemn Art if its products are no longer tied to the im-
mediate needs of society and if its religious and socializing uses are curtailed. . . .
You must stop pretending that artworks are preserved in those depositories. You
may have carried the material hull there; but it is doubtful you transferred the net-
work of ideas and relations that made the works alive with interest. . . . Their es-
sential merit depended on the beliefs that created them, on the ideas to which
they were tied, to the circumstances that explained, to the community of thoughts
which gave them their unity. But now who may tell us what those statues mean,
purposeless in their attitudes, their expressions turning to caricatures, their cir-
cumstances turning into enigmas? What do those effigies, which are now mere
matter, mean to me? What are those mausolea without a proper resting place,
these cenotaphs twice empty, these graves which even death has deserted?[6]

By wrenching artifacts out of their original contexts, the museum de-
prives them of their cultural lifeblood. Once removed from its environ-
ment in the church, the temple, or the agora, the statue is neutralized,
washed of its cultural, political, religious, spiritual functions. Chateau-
briand made the same point in *Le Génie du Christianisme*:

Each thing must be put in its proper place: this oft-repeated truth is almost trite, yet no perfection may exist without it. The Greeks would not have liked an Egyptian temple in Athens, nor would the Egyptians have liked a Greek temple in Memphis. Once removed, these two monuments would have lost their essential beauty, viz., their connections to the institutions and habits of a people.[7]

Beauty, the value of an artwork, is therefore contextual, dependent on affiliations with use and cultural provenance. This idea is by no means restricted to conservative cultural politics. Even a progressive thinker like Proudhon shares its basic assumption, namely, that culture is circumstantial: he argued that the Obelisk of Luxor lost its commemorative dimension by being transplanted to the Place de la Concorde, where it became just another blank-faced urban gimcrack.[8] In a similar vein, Quatremère writes that, outside of their proper settings, artworks on museum display revert to "mere matter." Thus despiritualized, the artifact hangs vacantly and meaninglessly ("turning into enigmas"). It is almost as though, in the museum piece, Quatremère feared the experience of the esthetic itself: form without a purposive content, a singular object and, as such, very much an enigma. The stone-faced objects reject all human resonance. Consequently, museified art invites a detached, passive attitude toward artworks. This contemplative attitude is responsible for the deadening reification of artifacts, their becoming fetishes of alienated consciousness:

> So many monuments are stripped of their worth just from being displaced! So many works have lost their real value in losing their usage! . . . They are currencies only exchanged among scholars. Thus, as one can see everyday, these scattered pieces are condemned to a sterile admiration, these mutilated remains of antiquity, . . . where the antiquary looks for scholarship but where vainly the soul would look for real emotions. They are too far removed from the original destination. (*Considérations morales* 52–55)

Deprived of experiential content, the museum objects are mere vessels of dead knowledge, of alienated contemplation. The museum thereby testifies to modernity's failure to preserve the past unmaimed. Abstracted from any context, stripped of living history and shrouded with scholarly history, artifacts lie in the museum as corpses in an ossuary. Culture becomes synonymous with preservation, not production. It sides with the

forces of death. Art, as the expression of vital culture, is only there to be contemplated as a hollow shell of its former life:

> Displacing all these monuments, collecting their broken fragments, classifying religiously their debris, and making this collection into a modern history course; all this is to constitute oneself into a dead nation; it is like attending one's burial; it is killing Art in the name of its historical investigation; it is not writing history, but an epitaph. (*Considérations morales* 48)

In sepulchral museum culture, history itself seems to bow to the verdict of its own obsolescence. It agrees with the touristic mindset which holds that culture does not really pertain to the present but to a glorious past— which is a feeble past because it cannot survive unaided in the present.

Authenticity

In Quatremère's critique, the museum is proof that the present has failed to devise an immanent rapport with the past. This alienation between a past embalmed as an image of itself and a present lost in contemplative ennui involves a problem of authenticity. Wrenching the past away from itself, dismembering and classifying it, the museum turns history into a fetish. Despite the respect and awe it commands in the art gallery, history is nevertheless emptied of experiential value. Thus the industrialist who declares all history to be "bunk" can, in the same breath, sign a fat check in support of the local art institute without in the least contradicting himself. For history in the museum is precisely what is kept dead, relevant so long as it safely pertains to what is no more. History in the museum is inauthentic: it has been stripped of its driving power, it convalesces eternally and powerlessly. Thus the problem of authenticity comes to the fore at the moment it suffers a decisive blow. Modern thought invents the principle of cultural authenticity as, actually, nostalgia for authenticity. Modern consciousness, it seems, begins to worry about authenticity only when the social, economic, and political upheavals of revolution, war, and, later, industrialization started liquidating the genuine and the perennial. Authenticity is therefore an embattled concept: it owes its momentum to its negation in the empirical sphere.

Perhaps, then, authenticity in cultural representation is a mirage in the epigone's mind, a nostalgic illusion of modern consciousness dreaming of a past ideal integration of life and culture, of art and history. Certainly in Quatremère, authenticity becomes a concern because it is endangered: endangerment of authenticity, it seems, is inherent to the concept of authenticity itself.

This perhaps justifies the relevance of Quatremère today: it is not just that his emphatic critique was a watershed in identifying the very notion of culture as an autonomous concept itself worthy of cultural criticism;[9] Quatremère is important because the demise of cultural authenticity he diagnosed became a leitmotiv of cultural criticism in the modern period. It is heard in the ever-repeated, ever-pressing realization that the modern era is ungrounded, cast adrift from the immanent life of tradition, that perennial ties have been broken. Indeed, reflection on the problem of inauthenticity is almost synonymous with modern philosophy of culture. The tenets of Quatremère's critique surface in Hegel (even if the latter nevertheless managed to turn the disenfranchisement of modern thought into its own panacea, the quantum leap of Spirit over the heads of all previous historical ages). Likewise Nietzsche is unknowingly Quatremèrian when, in his *Untimely Meditations*, he warns that our hypertrophied sense of historiography so impoverishes culture that it "is not a real culture at all but only a kind of knowledge of culture."[10] The legacy of Quatremère's critique is also discernible in Heidegger's call to rescue Being from inauthenticity by wresting the work of art from the metaphysical discourse of art history and from museums. Heidegger, however, is more of a pessimist than Nietzsche: he deems irreversible the damage done to culture and art by museification:

The Aegina sculptures in the Munich collection . . . are, as works, torn out of their native sphere. . . . Placing them in a collection has withdrawn them from their own world. . . . Their standing before us is still indeed a consequence of, but no longer the same as, their former self-subsistence. . . . This self-subsistence has fled from them. . . . The works themselves stand and hang in collections and exhibitions. But are they here in themselves as the works they themselves are, or are they not rather here as objects of the art industry? . . . Even when we make an effort to cancel or avoid such displacement of works—when, for instance, we visit the temple in Paestum at its own site or the Bamberg cathedral on its own

square—the world of the work that stands there has perished. World-withdrawal and world-decay can never be undone.[11]

The authentic experience of the Greek work of art as a reconciliation of life and art has given way to the irrevocable petrifaction of art and culture in modern times. This mood of ontological nostalgia is not restricted to that segment of philosophy concerned with overturning metaphysics. Even the Anglo-American pragmatism of John Dewey searches for a similar authentic experience of art:

When artistic objects are separated from both conditions of origin and operation in experience, a wall is built around them that renders almost opaque their general significance, with which aesthetic theory deals. Art is remitted to a separate realm, where it is cut off from that association with the materials and aims of every other form of human effect, undergoing and achievement. . . . Our present museums and galleries to which works of fine art are removed and stored illustrate some of the causes that have operated to segregate art instead of finding it an attendant of temple, forum, and other forms of associated life. . . . Their segregation from the common life reflects the fact that they are not a part of a native and spontaneous culture.[12]

The museum embodies the doldrums of modern culture. Even in those philosophies that most accommodate themselves to the instrumentalization of mind, consciousness hankers for "a native and spontaneous culture." It is as though, for Dewey, art was the last repository of primal being, which instrumental reason had otherwise discarded from practical existence. More recently, Merleau-Ponty registered philosophy's complaint against the museum's dressing of living history into pompous history:

The museum adds a false prestige to the true value of the works by detaching them from the chance circumstances they arose from and making us believe that the artist's hand was guided from the start by fate. . . . The museum kills the vehemence of painting as the library, Sartre said, changes writings which were originally a man's gestures into "messages." It is the historicity of death. And there is a historicity of life of which the museum provides no more than a fallen image.[13]

Western culture sings the blues of its own fatigue, seeing that it has replaced artists and makers with curators, fatalists and observers. Enlisting materialist philosophy in this chorus of woe, Adorno too puts the mu-

seum in the dock, charged with the crime of stultifying culture in the name of culture, presenting objects "to which the observer no longer has a vital relationship and which are in the process of dying. . . . Museums . . . testify to the neutralization of culture."[14]

The idea that museums kill culture thus forms a universal doxa of modern philosophy. In truth, regretting authenticity seems almost synonymous with esthetic modernity. It is as though the embattled modern mind saw in art the last chance of authentic experience. Because the most important voices of modern philosophy have taken up the problem of extricating culture from the inauthenticity of museums, they are somehow indebted to Quatremère. His influence consists in marking an intellectual moment to which subsequent discourses on culture have returned consistently, hence perhaps a moment that modern philosophy has never fully lived down. Nor is it clear that our contemporary debates on culture have outgrown the complex of inauthenticity detected by Quatremère. On the contrary, the question concerning an authentic rapport to culture is raised every time the museum is the object of serious analysis. Recent scholarship attests to this fact. The issues of multiculturalism encountered by today's curators and museologists rehearse the Quatremèrian issue of bridging the gap between the theoria of culture (historical preservation and exhibition) and the praxis of culture (the social, religious, and political life in which it flourishes).[15] The modern museum is self-conscious about its deauthentifying and uprooting effects. Thus its profession of cultural inclusiveness and relativism bespeak a guilty conscience concerning the museum's tendency to level off and subsume all native particularities in the neutral sphere of historical culture. Curators have taken in stride Quatremère's idea that preserving culture is inherently fraught with objectification, mistranslation, and conjectural admixtures;[16] and that cultures are subjected to essential damage in being transplanted to foreign climes, even under the best of circumstances and intentions.

The notion that art segregated from its original milieu is as good as dead echoes in today's debate about the "postmodern museum." The art critic Douglas Crimp welcomes the postmodern sensibilities of those artists who create artworks reflective and critical of the museum institution.[17] This strategy, Crimp argues, allows art to secure a critical hold over its institutional circumstances and, to some extent, reverse the pro-

cess of cultural and historical neutralization. Yet Crimp's postmodernism proves Quatremèrian, hence merely "modern," in his assertion that the task of cultural critique consists in returning art to its contextual life in history ("It is upon the wresting of art from its necessity in reality that idealist aesthetics and the [nineteenth-century] ideal museum are founded; and it is against the power of their legacy that we must still struggle for a materialist aesthetics and a materialist art").[18] The order of the day calls for recontextualization. In this, at least, the materialist criticism that demands the reinscription of culture in the praxis of society joins forces with the reactionary expostulations of Quatremère against the newfangledness of museums.

Thus the craving for cultural authenticity builds into a philosophic consensus about nostalgia and long-lost life. It is nostalgia for immediacy, truth, authenticity in an idea—culture—where perhaps, by definition, it is not to be found. The point is not to invalidate Quatremère's claims, nor to cure the West of its longing for immanent culture. However, so much talk about cultural authenticity (yearned for, defended, mourned, and sought anew) does require that the idea of culture be once again examined, if only to see how authenticity as a notion pertains to it. Indeed, the claim that museums wreck culture is only valid after it is proven that culture embodies in itself an immanence, that its much-touted connection to "life" is strong and actual. It is one thing for modern consciousness to yearn for a golden age of cultural immediacy, the happy union of art and history, of mind and context, that is, in the end, of subject and object; yet this yearning is only justified if the principle it seeks (contextual, live, rooted culture) is proven true. To investigate this question, we turn to Quatremère's contemporary, to Hegel's critique of culture.

Hegel's Guide to the Museum

> Hegel is the museum.
>
> M. Merleau-Ponty, "Indirect Language and the Voices of Silence"

> Culture is the child of each individual's self-knowledge and dissatisfaction with himself.
>
> Nietzsche, "Schopenhauer as Educator"

That museums elicited an immediate philosophical response shows that, from the start, philosophy recognized in them more than a phenomenon worthy of philosophical attention. They represented perhaps a full-fledged philosophical situation: that is, not a mere category of philosophical discourse but a mirror of philosophy. It is a fact that the uprootedness of culture in museums resembles philosophy's own feeling of having forsaken an immanent rapport with being. Loss of origin is an inherent motif of modern philosophy. Philosophy, as Novalis's influential definition goes, is essentially nostalgia, an aspiration to find a home.[19] Philosophy is the discourse concerned with ontological homelessness, with the lack of home at the basis of human existence. It is the discourse in search of its own origin and consequently, long before Rousseau, *the* discourse on origins, on the place it can call home.[20] Coincidentally, it is the problem of origins that we find also at the basis of philosophy's interest in the museum. Rushing to the site of the museum's beginning, philosophy was there to decry its perverted origin and denounce the injury committed on authenticity. No sooner had the museum settled in its new quarters and founded a new home for art than philosophy declared this home a terrible travesty of homeliness. It is as though, from the beginning, philosophy was saying to the museum: you too have no ground, you like me have forsaken your origin.

Museum culture is epigone culture—belatedness as Weltanschauung. This much is made clear by Quatremère, who equated the museum with an impoverishment of the creative drive of societies: "Just as collections of masterpieces only begin in the wake of the centuries that produced these works, so the spirit of criticism develops only after masterpieces are created. The abuse of museums and the abuse of criticism therefore occur at the same time and stem from impotence" (*Considérations* 42–43). From being an expression of praxis, of *vita activa*, art is demoted to the rank of embalmed life, of *vita contemplativa*. The museum embodies an age whose creative powers have atrophied and which invests instead in a critically detached and impervious stance toward art. The painter David made the same point in 1798 at the height of Napoleonic appropriation of foreign treasures: "Those pictures, in particular, will lose a great deal of their charm and their effect when they are no longer in the spot for which they were made. The study of these masterpieces (now in

the Louvre) will perhaps help to form scholars—Winckelmanns—but artists, no!"[21] The museum is the crepuscular time when the Owl of Minerva takes its flight: it is the time for the criticism of art—for a philosophy of esthetics; it is not, by contrast, a time for creating art, not the time *of* art.

Promoting contemplation over action, the museum exercises the very same debilitating influence of which philosophy has been accused since its earliest days: that of advocating criticism over action, judgment over participation, watching over doing. Through the denunciation of the museum, in the person of Quatremère, philosophy thus diagnoses its own illness. To cure it, a true synthesis of subject and object is necessary: a remedy that will reground the disembodied subject of philosophy into the material substratum of existence, a reconciliation of spirit with substance. This is how Hegel conceived the task of philosophy, a way of curing itself of his friend Novalis's nostalgia for an ontological home. The point is not to argue the development of Hegel's *Phenomenology of Spirit*, whereby he reunites subject and object and declares, in the end, that Substance is Thought and that the Real is rational. Of interest, however, is the way in which the *Phenomenology of Spirit* takes up Quatremère's argument against museification at the precise moment when self-consciousness is about to pass over into absolute knowing, that is, at the moment when philosophy is about to fulfill the subject's dialectical incorporation of object and become the absolute Spirit. This is not to suggest that Quatremère in any way influenced Hegel, since the former made public his *Considérations morales* in 1806 and the latter published the *Phenomenology* in 1807. Yet the coincidence does emphasize the point that museums were very much at the forefront of philosophy's concern at the time. Paragraph 753 of the *Phenomenology* begins by scoring the soon-to-become familiar critique of museification: <u>the museum artwork exists as a beautiful but petrified object emptied of the spirit of its age.</u> A fossil fit only for historiographic scholarship, the artwork is an object from which life itself has flown: "The statues are now only stones from which the living soul has flown, just as the hymns are words from which belief has gone. . . . The works of the Muse now lack the power of the Spirit, for the Spirit has gained its certainty of itself from the crushing of gods and men."[22] Consciousness is no longer content with representing itself in ex-

ternal objects, Hegel argues. Overcoming the need to project itself in concrete phenomena, consciousness swears off the medium of art. The death of the spiritual work of art (what Quatremère calls the "undeified statue") has to do with the self-possession of consciousness. No longer in need of representing itself, self-consciousness ascends to the realm of pure spirit. Spirit thereby deserts the work, and the gods no longer inhabit statues. The despiritualization of art in museums thus coincides with the age of philosophical maturity. What Quatremère bemoans as the despiritualizing of the work of art, Hegel celebrates as the sign that consciousness has discarded archaic forms of totemistic projection and evolved into a self-possessed, self-ruling spirit. Quatremère says that art is dead in museums; Hegel adds that that is as it should be. If the statue of the god standing in the gallery is devoid of its spiritual, necromantic, or religious force, it is because Spirit has surpassed the type of concrete embodiment proper to the age of the spiritual work of art. The spirit of philosophy, a free-floating abstraction, has taken in stride its separation from material life. That museums began to appear at the time when Spirit reconciled with its own uprootedness is thus no coincidence at all. If art is no longer *vital,* and is consequently entrusted to the care of curators rather than priests, it is because the philosophical subject has moved well beyond the need for objective embodiments. Thus freed of the need for immanence, the perfected philosophical subject feels quite at home with its own abstraction and art, stowed away in museums, slowly dies.

Of course, all this is not initially explained in Hegel. Yet, to be sure, seen through the mirror of philosophy, the uprooting and dereliction of art no longer look as tragic and senseless as Quatremère depicts it. Philosophically, Hegel paves the way for the museum's triumphant entrance onto the scene of history, a history that, as Hegel's demonstration goes, has reached its final stage. Just as history is in possession of its complete story, so the museum is capable of arranging synchronically artifacts from all historical strata. The museum mirrors the idealist totalization of world history by Spirit.[23] In fact, Hegel's lectures on fine arts directly influenced the architectural layout of the Altes Museum in Berlin during the 1820's.[24] The accession of the World Spirit to its zenith meant that earlier incarnations of mind had become mere curiosities and historical oddities fit for the detached gaze of esthetes.

Yet Hegel suddenly seems to come under the sway of cultural nostalgia: he too sees that museified art is but a pale image of real art, that is, the one living in its true historical setting:

They [the works of the Muse] now lack the power of the Spirit, for the Spirit has gained its certainty of itself. . . . They have become what they are for us now—beautiful fruit already picked from the tree, which a friendly Fate has offered us, as a girl might set the fruit before us. It cannot give us the actual life in which they existed, not the tree that bore them, not the earth and the elements which constituted their substance, not the climate which gave them their peculiar character, nor the cycle of the changing seasons that governed the process of their growth. So Fate does not restore their world to us along with the works of antique Art, it gives not the spring and the summer of the ethical life in which they blossomed and ripened, but only the veiled recollection of that actual world. Our active enjoyment of them is therefore not an act of divine worship through which our consciousness might come to its perfect truth and fulfillment; it is an external activity—the wiping-off of some drops of rain or specks of dust from these fruits, so to speak—one which erects an intricate scaffolding of the dead elements of their outward existence—the language, the historical circumstances, etc. in place of the inner elements of the ethical life which environed, created, and inspired them. (*Phenomenology of Spirit* 455–56)

Like tropical fruits plucked from their trees and transported to temperate zones, artworks can still be enjoyed, but they have lost the savor and freshness they had in their original habitat. All that remains is the work's unconnected form and the archival knowledge that seeks to imagine its former circumstances. The world that has been left behind can no longer be apprehended firsthand. The despiritualization of art means also that art has become the alienated object of historical science. Being an object of study, art is objectified out of the theater of praxis. Indeed the very study of art implies that art shares only mediated and historiographic connections with life. Art history supplants religion in the caretaking of art and seals the despiritualized status of the artwork. The world in which the work of art blossomed, Hegel claims, can be laboriously reconstructed through recollection, historical data, and imagination; but this world as it was lived, and as it was brought to life *inside* the work of art, is forever lost to us. We may picture the world *outside* of the work of art—Greek social and cultural customs around the statues, for instance—but not

that world as it was brought to fulfillment and breathed into those stat-
ues: this historical reconstruction will lead us not "into their very life" but
merely to the imagining of their circumstances. This, Hegel explains, is
the result of our objectifying mode of perceiving art. The statue in An-
cient Greece was an epiphany: in it human consciousness encountered
the object immanently. We, on the other hand, experience art from the
outside, as an esthetic object. Hence, in looking at the ancient statue we
try to perceive *outwardly* what took place *inwardly*—the commingling of
subject and object in an esthetic object.

Thus far, Hegel mostly offers a sophisticated version of Quatre-
mère's main idea: the opinion that the work of art seen in complete sep-
aration from its religious, social, and political background is as good as
dead. Suddenly, however, Hegel reverses the course:

> But, just as the girl who offers us the plucked fruits is more than the Nature
> which provides them— . . . the tree, air, light, and so on—because she sums all
> this up in a higher mode, in the gleam of her self-conscious eye and in the ges-
> ture with which she offers them, so, too, the Spirit of the Fate that presents us
> with those works of art is more than the ethical life and the actual world of that
> nation, for it is the *inwardizing* in us of the Spirit which in them was still [only]
> *outwardly* manifested; it is the Spirit of the tragic Fate which gathers all those in-
> dividual gods and attributes of the [divine] substance into one pantheon, into
> the Spirit that is itself conscious of itself as Spirit. (*Phenomenology of Spirit* 456)

In a bold about-face, Hegel reveals that what Quatremère holds to be the
very heart of the artwork, its original context, is actually merely inciden-
tal. Where the artwork once belonged is a comparatively superficial mat-
ter, Hegel claims. Historical scholarship can bring us closer to the inner
life of the artwork. The apparently alienating transmission of the artwork
from past to present actually allows the work to be more true to itself.
How does philosophy perform this reversal? For Hegel, the origin of the
work of art in its cultural and historical context is a matter of happen-
stance. Thrown at birth in its cultural milieu, the work of art is no more
fundamentally related to its context than a tree is genuinely—that is,
consciously—connected with the landscape around it. Because it is
bound to be, the contact between artwork and cultural milieu is as unre-
flective and meaningless as an act of nature. Art does not will to be sur-

rounded by its period: that is no more its own doing than the wind that has shaped the tree is the doing of that tree. An artwork may decide whether or not to exist, but cannot change the when and where of its existence once it comes to be. What Quatremère assumed to be an essential intimacy between artwork and history is thus perhaps a matter of bland, object-bound generality.

The merely outward rapport between the work and its cultural landscape can be turned inward when it is consciously recollected. In the same way that the maiden offering us the fruit gestures toward the fruit's connection to the tree on the one hand and to us on the other, the museum brings us the artworks from their natural surroundings and mediates the connection. By being taken up in consciousness, what was merely external—the contact between the statue and its surroundings—becomes a matter of conscious realization. What was outwardly manifested becomes inwardly comprehended. What was once a natural fact—the fruit hanging from the tree—is now enlightened by the gleam of recognition: fruit and tree are brought into a comprehended constellation. Thus, to Hegel, the mediation of historical consciousness has the opposite effect of the alienation commonly imputed to it: plucking the artwork out of its natural context does not sever it from its context but presents this context as what it in fact always is, a product of mind. At the extreme, there is no context outside of the subject who thinks it: hence there is no context outside of the reflective separation of subject from the immediacy of its surroundings. All this simply to say that object is a mediated category of mind, not an absolute. Hegel would say that the relation of the Elgin marbles to antiquity (whose transplantation Quatremère bemoaned)[25] is more reflective once this connection is actually taken out of its immediate circumstance. The relation of the statue to its cultural origin stands out more clearly as a *reflective* connection, rather than a *natural* one, when it is actually taken up in discourse (the only place where, in fact, relations exist). Insofar as their relation was always one of extreme self-conscious mediation, the statue stands truer to the culture of antiquity when it is not ensconced in it. Only in cultural separation does the true significance of culture emerge for Hegel. In that sense, our recollection of antiquity is truer to the spirit of antiquity than antiquity was in

itself. Or again, antiquity is more genuinely itself in the British Museum than in the temple at Paestum.

How can this be? Is this not subjectivistic idealism, that is, Hegelianism, at its worst? Yet Hegel is correct in the argument that culture is, after all, a product of subject. Culture is not the air we breathe; it is rather the atmosphere that we must *produce* in order to make the natural air breathable, that is, to dispel the terror of nature. Hegel is loath to give immediacy any lasting place in his system. Yet in resisting the allure of immediacy, Hegel has at least reminded us that culture, as a product of subject, is anything but immanent or natural. This reflection is striking. It means that the historian who looks upon antiquity at a remove of two millennia has a better grasp of the real spirit of antiquity than the ancients themselves. Yet this suggestion merely stresses the fact that there is no antiquity, that is, no *culture of antiquity*, without the reflective distance mediating and removing antiquity from itself. Indeed, to Hegel, a historical period is more than the sum of events in a given temporal sequence. Thus, for instance, the spirit of antiquity (what made antiquity a cultural entity) cannot be confined to the particular time of its occurrence. Time conceived as a mere temporal index, homogeneously identical throughout the whole of world history, is meaningless. A true historical period is more than a lapse of time. It is the self-consciousness of time: it is consciousness abstracting itself from mere immersion in time, and recollecting itself through the dialectic of presence and absence inherent to self-consciousness. In order to found a culture, a historical period must abstract itself from its immediate situation and consider itself for what it is not, what it is no longer, what differentiates it from other periods. In this manner, a historical period is a suspension of time, a way of resisting time. And this resistance is culture.

Ortega y Gasset gave vivid expression to this idea: "Life is, in itself and forever, shipwreck. . . . The poor human being, feeling himself sinking into the abyss, moves his arms to keep afloat. This movement of the arms which is a reaction against his own destruction, is culture—a swimming stroke."[26] Surely this comes from a cultural standpoint that has already made nature synonymous with primitive terror, dissolution, and tragic engulfment. Yet it also registers the basic realization that culture does not rest in the immediate. By its very existence, culture negates im-

mediacy, the primal unity of subject and object, of mind and being. Even when it flirts with the reinstatement of this unity, philosophy does so from the standpoint of the philosophic subject.[27] Culture is that by which consciousness hands itself over to itself: in doing so it steps out of mere embeddedness in being.

Hegel creates the philosophical language that allows us to understand culture as always already a *theoria* of culture. He thus dispenses with the Quatremèrian dichotomy that, pitting theory against praxis, proves as deadly to culture as the museums against which it is supposed to protect culture. It is by wrenching *theoria* out of praxis, and knowing culture out of living culture, that one weakens culture in the first place. Quatremère's love of immanence is actually a complacency with the status quo, one that paves the way for blood-and-soil ideologies redolent of twentieth-century totalitarianism. Such ideologies too spoke for the reconciliation between art and existence, the sacred return of culture to the life of the people— all things which in the end proved repressive of culture. Although his argument is in good faith, Quatremère actually endangers culture by confusing it with identity, that is, the repressive drive to mete out identification at any cost. This drive for identity stands behind nationalism—to mention only the most rampant form of difference-denying formations. Culture as identification crushes otherness instead of submitting to the dialectical production of self-difference, as Hegel saw it. It is siding too much with reaction to assume that culture is self-preservation only, clinging to the rock of its foundation as though such basis were a natural substratum rather than a point of self-departure.

Even at the time of its occurrence, antiquity, as *culture*, was a self-conscious detachment from its own historical embeddedness. There is no culture conceivable outside of this dissension from the blind sway of time. Because it has to leave its native ground in order to become what it is, culture, according to Hegel, is essentially an uprooting, and philosophy—so Novalis's motto implies—is its homeless conscience. In offering an image of uprooted culture, the museum preserves the self-estranging drive of culture. In this sense, the museum stands true to antiquity by doing to it what antiquity, *as culture*, did to itself.

Thus, to Hegel, culture is a culture of freedom insofar as it rejects immediacy. At the end of the *Phenomenology of Spirit*, the absolute spirit

reviews the stages of its historical development and discovers that a dialectic of self-liberation from the immediacy of circumstances, physical laws, and fate has guided its steps. The history of spirit is a series of steps liberating spirit from necessity; the history of culture is correspondingly the progression of difference and not mere adaptation to the historical circumstances. To be sure, this history of difference is eventually subsumed by Spirit's triumphant mediation of all dialectical tensions at the end of the *Phenomenology*. In the same way, the museum neutralizes all works of art—which were, in their times, gestures of difference—and converts them into images of identity with Spirit. There is no denying that, in the end, Hegel's idealism corners culture into its pantheon. The ideally panoramic and synthesizing arrangement of the Altes Museum, inspired by Hegel's lectures, is an indication of the neutralizing effect of Spirit's victory over difference. Nevertheless Hegel offers us a lesson. No longer is it possible to hear Quatremèrian objections to the museum without pointing out the essentialism of this critique. Dewey writes, for instance, that the artworks' "segregation reflects the fact they are not part of a native and spontaneous culture."[28] The philosophy of culture emerging out of Hegel uncovers the idealist underpinnings of historical pragmatism: what is a "spontaneous" culture? Can culture simply be? Does that not naturalize culture, that is, idealize it or negate it? Is not culture rather a way of stepping out of the mere happening of history? Art will not let us settle these questions to the advantage of essentialism.

The comparison, historical and timely, between Quatremère and Hegel demonstrates that a philosophical debate about culture inhered in the museum from its beginnings. As a cultural object and an object in which the very idea of culture is at stake, the museum encapsulates modernity, that is, a certain distress concerning tradition and a worse sense of rootlessness concerning inauguration; an unsettled balance between preservation and estrangement.

Art of Misplacement

If the museum conserves the idea of freedom for culture (and such *conservation* of freedom is no doubt an oxymoron), it is because the work

of art personifies freedom. As Hegel writes, art is ruled by "freedom of production."[29] Unlike science, which "is occupied with what is inherently necessary" (*Aesthetics* I, 6), art does not create itself in conformity with physical laws and the dictates of nature; rather, it pries open the clamp of necessity over human existence. For one thing, art does not *have* to be. It creates forms that need not obey either the forms of nature or those of tradition. Art, like culture, "fulfills itself independently and conformably with its own ends alone" (*Aesthetics* I, 7). Hegel assimilates Kant's lesson concerning the "purposiveness without purpose" of art and sees in it the evidence of a human activity not simply ruled by self-reproduction and survival, but also indulging in a free and apparently pointless production. To Hegel, this is almost enough to qualify art as *the* basic cultural gesture. That the work of art is not tied to the immediate—or to "desire," as Hegel says—confirms art's superiority. Desire, which enchains man to brutish physical existence, to survival, is overcome in art: "this relation of desire is not the one in which man stands to the work of art. He leaves it free as an object to exist on its own account" (*Aesthetics* I, 36).

No doubt there lies in all this the seed of estheticism, the belief in art's empyrean detachment from existence. Yet the assumption that art is not necessary, and is therefore an act of freedom, cannot be wished away. The work of art is not simply a curious witness sitting by the race track of history. The artwork is the very model of a free activity that propels history forward. Art acts on the peculiarly *human* stance that what is (nature), is insufficient: "just being *there* in the unconscious sensuousness of nature is not a mode of appearance appropriate to" spirit, that is, to the principle of cultural production (*Aesthetics* I, 30). It is a telling fact that Hegel grounds his history of art in architecture. For Hegel, architecture is first and foremost the negation of the cave, of the natural shelter. It embodies the human drive to escape from the womb of nature and to renounce being as it is. By making architecture, human existence shows itself as that which does not merely inhabit naturally but which has to leave its place of birth. As Hegel's idea of the very model for all artistic production, architecture exemplifies the step of culture away from mere immanence.

Retracing culture's surge toward self-expulsion, the work of art embodies the essential drive of culture: that of breaking free of natural cir-

cumstances and *representing* nature as something left behind. Being a deliberate presentation of antiquity, the statue is the self-conscious separation of antiquity from itself: it is the self-consciousness and self-distance implicit in representation. The work of art is not merely the fruit on the tree of life but rather the fruit *and* the maiden's "self-conscious gesture" that hands it over from the tree. The work of art carries within itself the awareness of its detachment from the cultural ground.

This all but reverses the ideology of art that underlies Quatremère's argument against museums. The cornerstone of that argument is that it is crucial for the artwork to rest in its context; it fits so snugly into its space and time that to remove it is to kill it. Quatremère's dramatic conclusion to his *Considérations morales* is instructive in this matter:

What emotions, what memories were attached to those very walls around this painting! Those walls have now all vanished and so did the enchanting spell of ideas and illusions that embellished the painted work. This discolored painting now exhibited in pompous galleries to the vain curiosity of cold criticism, seems but the shadow of itself. It is barely noticeable. . . . Nay . . . I saw it, this image now unfaithful to the beliefs that watched over its making, I saw this image, a perjure against itself, decorating the gilded walls of that palace [Versailles], the one place in the world that should never have received it . . . I saw it . . . and I averted my eyes." (*Considérations* 84–85)

An artwork without its original context vanishes; it is like a charm whose power vanishes at the magic kingdom's border. Hence art is contextual or it is not at all. Quatremère cannot bear to look at the displaced painting ("I averted my eyes"); it is an unseeable painting and therefore a painting no more. Quatremère's remonstration against the transplantation of ancient art stands on the belief that artworks are necessarily bound to their surroundings, as though, Hegel would sneer, they simply grew like vegetables in the garden patch. In arguing that it cannot be severed from itself, Quatremère assimilates culture to nature, plowing it back into the realm of necessity. Because it has no choice but that of belonging to what surrounds it, the Quatremèrian work of art likewise yields to the tyranny of social dictates. In the end, the work of art becomes a mere instrument in cultural reproduction. Thus Quatremère writes that the value of artworks "stems less from their formal perfection than from their ancient-

ness, from the authenticity of their use, from their public life" (*Considéra-tions* 47); "I need to find them useful," he says about artworks, "in order to find them altogether beautiful" (*Considérations* 45). The belief that art essentially belongs to its "publicité," its historical situation, leads to the repression of art, its submission to the status of mere mouthpiece. The argument against museums, when it is done in the name of art's "authenticity" to the established culture, leads to political authoritarianism.[30] Art is consensual: this stands out clearly in Quatremère, for whom the work of art is essentially an aid in stabilizing and enforcing the social consensus. Insistence on art's entrenchment in immanence (to life, history, society) neutralizes it far more than any museum display. For when art stops being an objection to what is, but instead becomes society's self-congratulating vote of confidence, then presumably it ceases to be art (this is not militantism, but the Kantian distinction between craft and art).

Hegel's notion that the work of art is the determinate negation of the established historical synthesis at least dispels the threat of social assimilationism hanging over art. As a genuine *cultural* gesture, the Hegelian work of art pulls away from all sources, from all immediacy and determination imposed by necessity. Whereas the Quatremèrian work of art bows to culture conceived as an overarching authority, the Hegelian work of art *interrupts* culture and thereby achieves inventive, emancipatory culture.

At the empirical level, however, Quatremère does seem to have a point: insofar as the work of art is made of matter it is bound to the material substratum of existence. Objectively the temple does cling to the mountain on which it is built; likewise the statue inhabits the agora or the Roman villa. In this respect, at least, art never occurs in an absolute contextual vacuum. But this argument is irrefutable only so long as the work of art is assumed to be primarily an *object*. It loses cogency if, as Hegel proposes, the essence of the work of art lies in its image-character, its appearance as *semblance*. Hegel develops his argument about the nonempirical nature of the art in the chapter entitled "Painting" in the *Aesthetics*: A work of art is primarily always an image; it makes something appear, it puts forward a fiction. As illusion, it maintains a reflective, and therefore mediated, rapport to empirical existence. Even as a concrete object, Hegel argues, a painting is foremost the presentation of an appear-

ance as appearance: "Its [painting's] content is the spiritual inner life which can come into appearance in the external only as retiring into it-self out of it . . . the object which it presents does not remain an actual total spatial natural existent but becomes a reflection of the spirit in which the spirit only reveals its spiritual quality" (*Aesthetics* II, 805). In other words, however external and concrete the visual appearance may be in painting, the image itself remains spiritual, not actual: "It is the inner life of the spirit which undertakes to express itself as inner in the mirror of externality" (*Aesthetics* II, 801–2). The actual painted object is precisely, for Hegel, just a mirror, an image itself of something inner that presents itself as inner, that is, as subjective, non-empirical, illusory. The nonactuality of the work of art eventually brings Hegel to question the place of art. Painting, for Hegel, is the consummately modern work of art: it is more illusory, more spiritual, than sculpture or architecture. Hence paint-ing somehow comes to encapsulate the problematic place of art in the age of museums. In Hegel's scenario, image-making first appeared as mosaic, an ornament to architecture. As such its place was definite and contextu-alized from the start. But the subsequent history of art made for an in-creased autonomization of the image:

Originally it [painting] has only the purpose of filling empty wall-surfaces. This function it fulfilled, especially in antiquity where the walls of the temples, and later of private houses, were decorated in this way . . . painting occurs only in earlier mosaics as a decoration of empty surfaces. The later architecture of the fourteenth century, on the contrary, fills its tremendous walls in a purely archi-tectural way. . . . On the whole, Christian religious painting is separated from ar-chitecture, and its works become independent . . . , its function is not merely fill-ing surfaces on a wall; on the contrary, it is there on its own account. (*Aesthetics* II, 807)

To understand why the modern, Christian painting does not merely fit in its architectural setting, one must take into account the appearance-as-appearance status of the modern work of art. What justifies art's de-tached, autonomous status ("there on its own account") is the nonactual, nonconcrete appearance of the image *as* image in painting. The end of the decorative, that is, integrated, artwork is the advent of the artistic im-age as an "object which does not remain an actual total spatial natural ex-

istent but [which] becomes a reflection of the spirit in which the spirit only its spiritual quality by canceling the real existent and transforming it into a pure appearance in the domain of spirit for apprehension by spirit" (*Aesthetics* II, 805). A painting, as image, is the negation of the materiality out of which it is made: for the image to appear as image, the mere concrete material of the image must recede and let the illusion appear (otherwise we would only be staring at paint and stone). This is the work of art in the age of spirit: the appearance of something that does not appear (spirit) through something which recedes in this presentation (the concrete material of the painting). Thus the "Christian" or "romantic" work of art not only negates the external context given by its architectural and social surroundings; it also erases the context given by its own material support. In arguing that art, as *image*, is nonactual, Hegel derives the principle that art cannot inhabit empirical space in an immediate, natural fashion. Quatremère could not look at the painting because it had been removed from its primitive context. For Hegel, on the contrary, the work of art only appears once it abstracts itself from the framework of empirical immediacy. If the work of art ends up in a museum it is perhaps because museums provide the least amount of context, and this suits the noncontextual nature of the artistic image *as* image. In this respect, the museum is merely part of modernity, that is what unveils the spiritual, nonactual, illusory nature of art as image, that is, as semblance and not object.

What, however, of the antique mosaic? Does its original place in the temple justify Quatremère's judgment that it depends immediately on its architectural framing? Would a detached fragment of a fresco be necessarily misplaced in the museum? To investigate this question is once again to raise the problem of the ontological status of an artwork. Hegel's *Aesthetics* uncovers a categorical trembling about the image which does not just concern painting (a modern invention) but also the antique work of art. A brief recapitulation of Hegel's historical position in the esthetic debate sheds light on his analysis. Quatremère's belief that art must remain embedded in life stems from a strong tradition of esthetic discourse set in the mid-eighteenth century by Baumgarten and later by Schiller. In fact, the idea that art is rooted in life stems from the concept of esthetics itself. *Aisthesis* designated the sensuous experience whereby the intellect

fused with things perceptible, with matter.[31] Art ought to reunite consciousness with being, with unmediated existence, with the sensate. Indeed Quatremère's theory is rooted in the belief that art has a special, almost direct, connection with concrete, material existence, a connection that is generally described as "feeling." Feeling is what connects the subject with the artwork and its context in one effusive and symbiotic partnership. Quatremère argues that relegating artworks to the abstract space of the gallery snuffs out art's vital connection with life and "feeling." Because of museums, "the Arts have lost the ability to move; worse still, we have lost the ability to be moved. . . . We have taken from art its former ability to make its works eloquent, when a harmonious agreement of feelings prevailed between them, the moral sphere of their placing and the affection of those to whom they were addressed" (*Considérations* 61). Herein starts the rumor that museified art only addresses the intellect and no longer the senses. This assessment rests on the idea that art's native milieu is the sensate, that is, "feeling," or unreflective experience. In feeling, the subject believes he strikes an authentic, emphatic, and immediate rapport with the object. Because it rouses feeling, Quatremère thinks, the work of art reunites subject and object, consciousness with its surrounding, mind and matter. It offers a total experience, that is, a contextual experience.

Despite Kant's admonition that no work of art should be confused with the emotions it arouses, the "ideology of feeling" dominates romanticism until Hegel's *Aesthetics*. It is Hegel who philosophically raised art to the dignity of a form of reflection, calling it more than a plaything of the senses. By emphasizing the reflective, self-knowing character of the artwork, Hegel rescued it from the ideology that restricted it to a instinctive form of consciousness immanent with the object, a primitivism of the soul:

What [the work of art] wants is sensuous presence which indeed should remain sensuous, but liberated from the scaffolding of its purely material nature. Thereby the sensuous aspect of a work of art, in comparison with the immediate existence of things in nature, is elevated to a pure appearance, and the work of art stands in the *middle* between immediate sensuousness and ideal thought. It is *not yet* pure thought, but, despite its sensuousness, it is *no longer* a purely material existent either, like stones, plants, and organic life. (*Aesthetics* I, 38)

That the work of art is an expression of the intellect seeking to be one with the sensuous does not mean that it achieves such a fusion. The work of art does not merely dwell in being, in the sensate, but raises it to a reflective level. The stone out of which the statue is made is no longer the stone in the quarry (for instance, Hugo's "let us just say it, once man has touched a piece of wood or stone, this wood and stone are no longer either wood or stone").[32] The statue is the self-consciousness of stone. Yet Hegel does not save art from the Scylla of materialism to throw it into the Charybdis of idealism. Leaving the material substratum of sensual existence behind, the work of art does not take refuge in the realm of transcendental thought. The work of art, Hegel argues, fills the fracture between a *no longer* and a *not yet*, where what has been extracted from a purely material basis does not yet participate in the pure abstraction. Stretching across the gap separating sensuous existence from abstract cognition, the work of art does not dwell in either side of the subject-object antinomy. The dialectical surpassing of sensuous nature does not mean that the just-negated nature settles into the pacified realm of pure culture. That would mean that art falls prey to a second-order immediacy. Art also turns down the synthesis offered by self-establishing spirit. Neither a repression of nature nor the latter's transposition into culture, art is nonidentity itself. In this Hegel is not the idealist zealot he is often mistaken for. Art is a trembling expression that forgoes both the immediacy of life *and* the immediacy of triumphant culture. The movement of difference between the sensuous and the conceptual, espousing neither life nor its cultural sublation by spirit: such is the restless experience sketched out in the work of art, one that does not rest in synthesis but shakes itself loose from synthesis and, in doing so, nudges culture into motion. For art's refusal of both immediacy *and* its sublimation by the subject rules out the principle of identity that Quatremère threatens to foist upon art and culture. Its unstable position between subject and object ensures that it avoids the pitfall of identification, that categorical compulsion by which culture petrifies itself and turns into second nature. In this respect, the work of art constitutes what is best in culture: the restless movement away from the barbarism of essentialist thinking; as well as away from established culture which, passing itself off as a natural ground, is barbarism to the second degree.

There is, one could conclude, consistency in Hegel's endorsement of the museum. This consistency is not in the service of idealism, that is, it does not secure the hold of the Hegelian Spirit over art, culture, and history. To his credit, Hegel does not speak in the interest of Spirit alone.[33] Nor is the museum justifiable for Hegel simply because it seems to replicate Spirit's triumphant summation of all preceding history. Hegel's defense of museum culture stems from the work of art itself, as it eludes the interests of both materialism and idealism, Quatremèrian contextualism and Hegelianism. The artwork's restless movement between the sensate and the conceptual means that it belongs neither to the ground of nature nor to the home of culture. By putting art in museums, culture perhaps acknowledges the rebellious, uncategorical nature of art, its *non-identity*.[34] Any protest against the museum's program of uprooting unknowingly amounts to an attack on art's non-identity. To complain, like Quatremère, that artworks lose all value upon being removed from their context is, in the end, to subordinate the restlessness of art to the identity principle (place, nation, people, and historical setting). One should not forget that the romantic museum once was deemed to stand against such subjugation. The real lesson of Quatremère is that he reminds us museums were once called anticultural for practicing a systematic uprooting of culture. This accusation underscores the revolutionary dimension of museums and their invitation to rethink culture apart from the pathos of roots, belonging, and identity.

In ungrounding art from the common run of existence, the museum officially makes room for the restless drive of culture. Museums are paradoxical: they shelter restlessness but, in doing so, they build a home around it. Curating the inventive drive of culture is a contradiction, for it destroys exactly what it means to preserve. In so doing, the museum embodies the antagonistic nature of culture, at once striving for self-invention and pulling backward to self-preservation and the status quo. The great paradox of museums is that they implement culture's program of self-preservation by preserving the very thing by which culture ungrounds itself, the artistic gesture. The museum thus manifests modern culture in the grip of a capitalist dynamic of historical production.[35] Museums replicate the tensions of capital, with its fits of accumulation and expenditure, stockpiling and liquidation: museums preserve culture in a

permanent state of rootlessness, that is, they choose rootlessness as the principle by which to conserve culture. In capitalism as in the museum, rootlessness turns into a principle, into permanent impermanence.[36] It is a culture at once oblivious and remembering, one whose means of commemoration entail a forgetting, liquidation. As such, the museum shows that there is no culture without uprooting, without forgetting, and that consequently culture is always, in a (Nietzschean) sense, artistic culture.

The Art Police

Enclosing art inside the museum walls no doubt removes it from the participative life of the polity. It brackets artworks off as qualitatively different from other objects: more precious, more fragile, more unusual, more ill-suited to survival, more alien, perhaps in a troubling way. <u>The museum is not only the place where art is curated; it is also where art is imprisoned.</u> Society locks away those elements deemed either too dangerous or too precious to move freely in the public domain. In the case of art, the distinction between the dangerous and the precious, or between the defensive and the protective, tends to blur. It does not seem farfetched, as one critic proposes, to liken the museum to its nineteenth-century cousin, the prison.[37] This quarantining of art constitutes a political gesture because it defines social spaces, their mode of integration and their contents. In this respect, the argument regarding the socialization of art in the museum age is irrefutable: museums have contributed to the alienation of art. They remove artworks from involvement in the polis, neutralize their political thrust, freeze their contents as esthetically remote forms. By its very existence, the museum legislates against the direct participation of art in the *polis*.

Putting art behind bars, the museum protects us from art. A naked plump beauty in Rubens causes no stir among the museum visitors, whereas similar nudity on a billboard would call for an emergency session of the city council. This shows that the museum shields the visitor from the nudity in Rubens. It erects an esthetic barrier behind which the work of art is as surely neutralized as the sociopath is behind the prison bars. The museum secures the concrete foundation of esthetic detachment,

with the warranty that one may feel safe around artworks (it is only when artworks directly challenge the convention of the esthetic neutral gaze that the citizenry calls for more energetic measures of confinement. The Mapplethorpe affair, a few years back, is a case in point: witness how the curators, caught in the crossfire, scrambled to convince everybody that the photographs showed undeniably esthetic features and that, as a result, they could be relished with detachment, thus bypassing their challenge to the neutrality of the esthetic gaze).

The exclusion of art from the participative life of the polis is therefore tantamount to its estheticization. As museum culture develops, so the political thrust of art is dulled and weakened. In screaming blue murder over an art he did not understand, the nineteenth-century bourgeois implicitly acknowledged the power of art to intervene forcefully in the community. Art was not so estheticized that it could not, on certain occasions, still poke through the exhibition walls and spark social controversy. Today, exhibitions of fierce political intent, artworks that strike out against the separation between art and the polis, artistic forms that rampage through self-congratulatory bourgeois culture—all this is taken in stride by the museum mind. Esthetic detachment guarantees that, however loud the work of art shouts, its protest will be met with deadeningly polite applause.

In fact, however, the estheticization of art—its bracketing-off and silencing—does not begin with the museum proper. Plato's animus toward artists already contains the seeds of the future preservation of art behind the gilded bars of museums. Plato banishes artists from the Republic for peddling a second-rate reality among the community. This tarting up of truth, for Plato, amounts to prevarication:

We should be justified in not admitting him [painter, mimetic poet] into a well-ordered state, because he . . . sets up in each individual soul a vicious constitution by fashioning phantoms far removed from reality, and by currying favor with the senseless element that cannot distinguish the greater from the less, but call the same thing now one, now the other.[38]

Blurring the distinction between truth and its facsimile, the work of art tends to become indistinguishable from what it mimics. The political stakes implicit in this blurring of model and copy are what condemn art

and artists to isolation. Hence, we note, the *Republic* only seems to dismiss artworks for their illusory nature; in reality it banishes them because of their excessive reality, the fact they can take the place of the real thing. This is more explicit in the *Laws*. There, the truth-claim of art not only impinges on the truth-claim of politics, but also forces the legislator to recognize in politics a production of truth inherently akin to the one effected by artists. As a result, art is ostracized for being a competing form of truth-production. Politics, as the officially sanctioned form of truth-production, does not tolerate competition. To the artists' query whether they may enter the city, the legislator responds thus:

Respected visitors, we are ourselves authors of a tragedy, and that the finest and best we know how to make. In fact, our whole polity has been constructed as a dramatization of a noble and perfect life; that is what *we* hold to be in truth the most real of tragedies. Thus you are poets, and we also are poets in the same style, rival artists and rival actors, and that in the finest of all dramas, one which indeed can be produced only by a code of true law—or at least that is our faith. So you must not expect that we shall lightheartedly permit you to pitch your booths in our market square with a troupe of actors whose melodious voices will drown our own.[39]

In declaring that the tragedy of politics is the most real tragedy, the legislator recognizes that the difference between art's ability to create reality and that of politics is only a matter of degree. Politics, like art, produces truth through mimesis. Hence art is cast out of the polis because it resembles politics, and rivals politics in the production of truth. The make-believe dimension of art (whether mimetic or otherwise) is therefore tied to the place of its appearance: outside the polis—in the museum, for instance—the image-making aspect of artistic mimesis is benign because it is perceived as unambiguously illusory and apocryphal; in the forum, it is easily mistaken for politics, that is, for the "real" production of reality. Hence the creation of museums: they do not so much protect art from politics as politics from art.

Plato puts the work of art away so that its semblance may be recognized as just that. The work's mimetic character becomes politically weak in the museum, where mimesis loses its ability to produce truth; mimesis, formerly a species of truth, is reduced to mere representation, a copy. The

museum perpetuates the make-believe status of art: whatever is circumscribed within a purely esthetic sphere is branded as illusory and representational—not the truth, but its image. This constitutes the imagistic dimension of museums, one which has been a bountiful source of inspiration for the avant-garde (for example, Duchamp's ready-mades). Sealing the make-believe status of art, the museum also cements the opinion that, on account of its illusory character, art need not be taken all that seriously. Or so the Platonic legislator hopes.

The assumption that art is placed in museums in order to be recognized as illusion implies that, outside of its esthetic confines, the work of art may exist in another form and might, as Plato feared, merge with life, with the production of social reality. In ostracizing art, Plato is perhaps responsible for the rupture between art and existence in Western metaphysics, the discordance before which Nietzsche stood in "holy dread,"[40] the "distressing severance [*pénible scission*]" endured by Artaud.[41] Plato stands at the juncture where Greek art gives way to the beginning of metaphysics. Heidegger writes:

Aesthetics begins with the Greeks at that moment when their great art and also the great philosophy that flourished along with it comes to an end. At that time, during the age of Plato and Aristotle, in connection with the organization of philosophy as a whole, those basic concepts are formed which mark off the boundaries for all future inquiry into art. (*Nietzsche* I, 80)

The ability to perceive art unesthetically ends with metaphysics, with Plato and Aristotle. It grants the philosopher-king a monopoly over truth while stripping art of its relevance to life: art is what is illusory, deceitful, and second-hand. Truth is a transcendence to which the work of art, bound as it is to empirical existence, can have no access. Politics alone has a legitimate claim to the production of truth. In the meantime, outside the city limits, the fate of the work of art as disenfranchised, apocryphal, and derivative is sealed.

This excursion into Plato's account of the polemical origin of the esthetic work of art shows that art's severance from life is a historical product. Museums were created because art is political (in the Greek sense of the term), because it is so deeply political that it risks being confused with life (as in Plato's *Laws*). The Platonic edict against art shows that the mu-

seification of art started long before its full manifestation in the modern age. Although the rationalization of art does act in accord with the one that reorganized the world of knowledge during the Enlightenment, it is not entirely reducible to it. Museification occurred with the advent of metaphysics, in the act of declaring art's mode of making truth improper. On the day art became a mere copy of truth, and no longer its effectuation, the first museum was founded.

Plato's banishment of art bespeaks the concrete political thrust of esthetics. It is no longer possible to answer the question "why do we put art in the museum?" with the type of curatorial good conscience that blocks out any reality outside the mission of safeguarding artistic objects. As is apparent in the Platonic edict, art is evicted from immanent life in order to protect the legislator's exclusive right to the production of truth. The museum forces art to abnegate history, that is, to relinquish the power of truth-making. The latter becomes henceforth the privilege of politics and, later, of the scientist. The museum keeps art at a remove, not for the sake of enshrining its "eternal" essence, but for the sake of the practitioners of social control who, in creating an esthetic niche, secure the irrelevance of art in the face of dominant rationality.

The Origin of Museums

The Platonic legislator exemplifies the claim that museums coincide with the estheticization of artistic experience and thus with art's neutralization. A problem arises at this point: if indeed Plato was among the first to banish art to a second-hand existence, it follows that museification originated simultaneously with the discourse on art in Western culture. The autonomization of art thus corresponds historically with the appearance of art as art. While the Platonic legislator undoubtedly does art great injury, we owe to him the first formal reflection on art. That the political neutralization of art is entailed in art's emergence in discourse may serve as confirmation that any historical trace is the product of coercion: whatever leaves a mark rules out all other marks. Art's marked entrance into philosophy is such a forceful negation of art's claim to being. Without that negation, perhaps, art would still have to be known as art by us.[42]

Art began to leave a trace when it was pulled from the praxis of existence and shifted down to the status of image, that is, falsehood. This coincidence stems from the nature of art itself. Whether this is to be bemoaned is moot. The point is to see that art itself makes traces. Perhaps a non-esthetic appearance of the work of art is not to be found because art *is* an activity of making traces and leaving records. What was art before Plato and Aristotle? This question prompts Nietzsche to delve into the dark reaches of the Dionysiac, into the womb of art itself. What he finds there is hard to describe: it is all fleeting traces, rapture, oblivion, formlessness. There is no Dionysiac language as such. The roots of art extend into chaos, the night of the unshaped. Dionysus, who does not leave records, needs Apollo, the god of form, to shape the sheer unbound energy of artistic genius. In fact Dionysus's unrecorded rapture is known only through Apollo's restriction, neutralization, perhaps even denial of it. What emerges from Nietzsche's *Birth of Tragedy* is that, if indeed the Dionysiac is the earliest, most original mode of artistic expression, it is only thanks to the Apollonian that it comes to *form*. The Dionysiac frenzy may embody the truest form of living art; yet it stands in need of the Apollonian drive to reach representation. As Nietzsche writes, the Dionysiac undifferentiated chorus "discharges itself in Apollonian images."[43] The Dionysiac can only appear by grace of its interpreter, Apollo, who gives it shape and form, in a word, a voice (*Birth of Tragedy* 66). This realization in *Birth of Tragedy* informs Nietzsche's subsequent meditation on art, particularly about music. Even at the heart of musical expression (which, especially in its Wagnerian form, Nietzsche had hitherto taken to be the Dionysiac itself), Nietzsche writes that there lies the mediation of the Apollonian, the maker of traces:

Music is, of and in itself, not so significant for our inner world, nor so profoundly exciting, that it can be said to count as the *immediate* language of feeling; but its primeval union with poetry has deposited so much symbolism into rhythmic movement, into the varying strengths and volume of musical sounds, that we now *suppose* it to speak directly *to* the inner world and to come *from* the inner world. . . . In itself, no music is profound or significant, it does not speak of the "will" or the "thing in itself"; the intellect could suppose such a thing only in an age which had conquered for musical symbolism the entire compass of the inner life. It was the intellect itself which first *introduced* this significance into sounds.[44]

Thus even music's sensual immediacy is the product of an intellectual reinscription into rhythm and harmony. In itself music does not express the spontaneous, the unbridled, the liberated, and the true; it does it only mediatedly. Nietzsche goes even further: it now appears that the Dionysiac side of music is a retroactive invention of the Apollonian. Only a thoroughly esthetic mind, says Nietzsche, would invent the raw unesthetic immediacy of Dionysus ("the intellect could suppose such a thing only in an age which had conquered for musical symbolism the entire compass of the inner life"). The untrammelel beginning of art is a fantasy created by the master of form, the negator of the freedom of beginnings.

Nietzsche's dialectic of the Dionysiac and the Apollonian thus concerns art's historical emergence. Historically, that is, in the realm of traces, art can only begin with the Apollonian, the moment art casts itself in clear and permanent forms. Nietzsche's scheme no doubt looms large in Heidegger's history of the esthetic idea. The idea of the Dionysiac frenzy, the plunge into pure sensuous knowledge, the tumult and delirium of sheer expression, creeps through the Heideggerian evocation of the non-esthetic work of art, that is, the original work of art before Plato and Aristotle. Yet, as Nietzsche himself intimated in the early *Birth of Tragedy* and spelled out in the later *Human, All Too Human*, the Dionysiac or non-esthetic work of art is mediated through and through by its representation in the Apollonian, a representation without which there would be no trace of the Dionysiac.

Thus it is a telling fact that Heidegger says precious little about what the pre-esthetic work of art was for the ancient Greeks. In contrast to Plato, Heidegger offers only a negative esthetics: he tells us only what non-esthetic art *was not*. For example, Heidegger states that art before metaphysics did *not* have a discourse corresponding to it ("the magnificent art of Greece remains without a corresponding cognitive-conceptual meditation on it," *Nietzsche* 80), that, having no esthetics, the early Greeks still did *not* wallow in immediate sensuousness ("the lack of such a simultaneous reflection or meditation on great art does not imply that Greek art was only 'lived,' . . . On the contrary they had such an originally mature and luminous knowledge . . . that they had no need of 'esthetics'," *Nietzsche* 80). But as for positive statements about the early non-esthetic work of art, Heidegger only says that it is a "luminous state of knowing." This

mysterious gnosis is all the more remote as it eludes the very name of esthetics:

> The name "aesthetics," meaning meditation on art and the beautiful, is recent. It arises in the eighteenth century. But the matter which the word so aptly names, the manner of inquiry into art and the beautiful on the basis of the state of feeling in enjoyers and producers, is old, as old as meditation on art and the beautiful in Western thought. Philosophical meditation on the essence of art and the beautiful even *begins* as aesthetics. (*Nietzsche* 79)

Trying to pinpoint the birth of esthetics, Heidegger is forced to push it back as far as philosophy's first meditation on art. This seems to imply that, even before Baumgarten coined the name in 1750, esthetics already existed as an unnamed reflection: before the age of esthetics still lies esthetics as its own unrecognized substratum. It is as though the origin of esthetics was endlessly retroactive, or abysmal. Because of this, Heidegger is forced to recognize the pre-esthetic moment as already belonging to esthetics: in Heidegger's own words, there is no relation to art that is not "aptly" described by the name of esthetics. This is a tremendous admission: the pre-esthetic meditation on art was an esthetics that did not know its name. This perhaps explains the difficulty experienced by Heidegger in describing this non-esthetic pre-Platonic and pre-Aristotelian moment of the work of art as "luminous knowledge," about which it is said that it is neither absolute sensuous abandonment, nor the alienated discourse of criticism. The pre-esthetic moment is impossible to figure because it is only knowable from the standpoint of esthetics.

The difficulty of locating or picturing a pre-historical age of art replicates the tension in the concept of esthetics itself. Esthetics, as *aistheticos*, is the discourse of the senses, of feeling, of emotions, of matter as opposed to spirit. It is a language about that which has no language, about the prelinguistic pulse rippling beneath the linguistic, about matter erupting through spirit. To conceive of the prelinguistic as truly prelinguistic would be to adopt the standpoint of the prelinguistic, that is, to become speechless. But since it cannot do that, or even if it wants to *speak* about pure sensuousness, esthetics must leave the sensuous. Like the work of art that, in order to speak about sensuousness, must articulate it into the *language* of sensuousness, so esthetics cannot relate to that which it is about—the

speechless language of the sensate—without entering speech, that is, without silencing that to which it purports to give speech. The speechless is always stamped by language, inasmuch as the absence of language is a fact of language. As a language of the speechless, esthetics is always confined to this side of language. Esthetics, like the work of art, must leave behind the unmade in the very act of bringing it to the fore. In order to conceive of an unesthetic reception of the work of art, one would have to conceive of a speechless way of talking about art (this is the path bravely taken by poetry and—one may add—by modern art itself).

Heidegger encounters the same paradox in his own attempt at an overall philosophical description of art, "The Origin of the Work of Art." In it, Heidegger argues that the connection between art and being, the "work-being" present in the great Greek work of art, is a thing of the past. The museum, and esthetics in general, have snuffed out art's claim to being. Art is now a mere esthetic object, an "object-being." Even the most dedicated and sensitive approach to the work of art, Heidegger writes, cannot overturn what, in the work, has become sedimented into thinghood. All that is left of artworks is their objective shell, their object-being: "The whole art industry, even if carried to the extreme and exercised in every way for the sake of works themselves, extends only to the object-being of the works. But this does not constitute their work-being" (*Origin of the Work of Art* 41). The work of art's work-being is its potential for immediacy, for reaching into existence and shaping the look of what is. However, the work of art's work-being has been silenced by its museified object-being, by its estheticization:

The works themselves stand and hang in collections and exhibitions. But are they here in themselves as the works they themselves are, or are they not rather here as objects of the art industry? . . . Even when we make an effort to cancel or avoid such displacement of works—when, for instance, we visit the temple in Paestum at its own site or the Bamberg cathedral on its own square—the world of the work that stands there has perished. (*Origin of the Work of Art* 41)

In the world of esthetics, the work of art is replaced by its "thingly" element. It is no longer a mode of creating being:

Works are made available for the public and private art appreciation. Official agencies assume the care and maintenance of works. Connoisseurs and critics

busy themselves with them. . . . Art-historical study makes the works the objects of a science. Yet in all this busy activity do we encounter the work itself? . . . As soon as the [works] are captured by the sphere of familiarity and connoisseurship, . . . all scientific efforts to regain them no longer reach the work's own being, but only a recollection of it. (*Origin of the Work of Art* 40; 68)

Art's relegation to the domain of esthetics is collusive with its reification. Heidegger shares in the belief that the museum erects a barrier between the work of art and its true artistic nature, that is, that of being at one with the praxis of existence, of Being. The esthetic, museified appearance of art silences the real work of art and makes the object triumph over the work. The form is there but the real work of art, what Heidegger calls the "work-being," has vanished. The spirit of art, as Hegel already said, has flown out of the statue.

Once again esthetic philosophy seems to be suffering from a severe bout of nostalgia. Heidegger's premise is that the work of art is the emptied hull of its former being. In this sense, Heidegger's discussion *departs* from the end of art to describe what the work of art once was. It is as though he could only discover what living art is by examining its corpse. It is noteworthy that museification so thoroughly determines our esthetic experience that even a critique that seeks to go beyond esthetics must use it as a point of departure. Where one starts, as Heidegger himself instructs, continuously shapes, or haunts, the place where one ends up. The separation between being and art, between praxis and the esthetic object, is therefore considered, not from the side of being, which is forever unattainable, but from the side of the esthetic object. In other words, even the discussion concerning the non-esthetic work-being takes place, for Heidegger, from the standpoint of its esthetic object-being; the origin of the work of art is only known through its end, in the museum.

Heidegger runs into the same paradox in the structure of the work of art itself. As an illustration of the work-being, Heidegger explains that the temple reveals the earth: it makes the earth appear by standing on it and makes the sky appear by standing against it. Art thus *installs* the world, and makes it appear as *this* world. A truly heteronomous activity, art thrusts into the world. Yet, obviously, the separation between the temple and the earth does not precede the temple itself, since there has to be a temple for the sky and the earth to appear as such. Thus Heidegger con-

cedes that separation between the world and the work, between the un-measured and the measured, between the ground of being, already belongs to the work:

> We at once raise the counterquestion: how can the rift-design be drawn out if it is not brought into the Open by the creative sketch as a rift, which is to say, brought out beforehand as a conflict of measure and unmeasure? True, there lies hidden in nature a rift-design, a measure and a boundary and, tied to it, a capacity for bringing forth—that is, art. But it is equally certain that this art hidden in nature becomes manifest only through the work, because it lies originally in the work. (*Origin of the Work of Art* 70)

Art is the name to describe being's ability to come forth. The being that the work of art reveals, then, is from the start a product of the work: there may be being all around the work of art—an earth and a sky around the temple—but these only appear by contrast with the work of art. Being is not an environment that the work of art runs into. Being always exists in relation to the work, that is, in a mediated state. Perhaps, then, art never reaches being itself. It reaches, rather, a *production* of being: the surroundings that it makes appear are just that: a production and not the primal ground of being. To pine after an effusive rapport between art and life is illusory, for life as it connects with art is always already a product of the artwork and, as such, severed from the primitive ground of being.

In a sense, Heidegger reiterates what Nietzsche had said before him—that the immediacy of non-esthetic art depends on the esthetic to convey it. Heidegger only *seems* Quatremèrian in his nostalgia for a reconciliation between art and being, the mending of the raging discordance that so terrified Nietzsche. In reality, he concedes that such pre-esthetic, premuseum fusion of art and existence is ultimately the product of work, or more exactly, of art. Being, like the pre-esthetic work of art, is an *idea* of esthetic consciousness, of the museum mind. As Nietzsche himself stressed, the "in-itself" in art is always inscribed as such by the "for-itself," by consciousness. The work of art is mediated in relation to being. The image of pure being, in art, is the construction of mediated being, of created production. This dialectic also applies to the esthetic discourse on art. It begins with Plato and Aristotle, when art begins to leave a trace. This trace is a departure from being, from the non-esthetic, truly politi-

cal, truly contemporaneous, work of art. And yet only through the trace can one have access to the untraceable. It is only from the standpoint of Plato's esthetic museification that the nonmuseified work of art appears. It underscores the fact that we owe the first philosophical description of the non-esthetic work of art to the same Platonic legislator who vows to ostracize it behind the museum walls.

The Avant-Garde Attacks

The esthetic exclusion of art from praxis became the object of a fierce counterattack around the time of the first avant-garde. This is when estheticism's glorious separation of art comes under fire for inflicting a debilitating wound on the work of art. As Peter Bürger argues, the first historical avant-garde gathered momentum by challenging the separation of art from the praxis of life.[45] It denounced artistic autonomy as a sinister swindle: what enlightened rationality intended as art's freedom and self-determination increasingly looked like a prison. Artistic autonomy, it held, is in fact the result of an injurious trade-off. Art was given its autonomy only on the conditions that it relinquish its power over the polity. The museum may well be art's gift of exclusivity, but it is the clause of a settlement drafted by the enemy. The avant-garde thus appointed itself the bad conscience of the institutionalization of art. The museum became the effigy of everything in esthetic autonomy that was injurious to the individual artwork. From the right-leaning Marinetti to the socialist Malevich, no solution was found except to burn down the museum.

The avant-garde's originality consisted in assimilating its protest against the museum to art itself. The reconciliation between art and praxis was not attempted on the side of praxis (by militating politically against museums) but in the work of art proper. Art was entrusted with the means of breaking out of its own prison. From this derives the iconoclastic and confrontational aspect of the first avant-gardist works. The artwork itself cries against Art. This perhaps constitutes the greatest strength of the avant-garde but also its Achilles' heel. For in shaping itself after its protest against esthetic institutionalization, the iconoclastic work of art unwittingly chains itself to the museum. No provocation is ever

free from what it stands against. Like the unfortunate wanderer who sinks himself deeper into the quicksand pit with every effort to escape it, avant-garde art became an art of the museum precisely by struggling to wrench itself free of it.[46] The Futurist call to burn down the museums pushed Futurist works headlong into the hands of museum curators because the message only had significance inside the museum. For the avant-gardist cry that art is actually praxis, that the work of art is life, only makes sense if art is distinct from life in the first place, and furthermore within a context where the distinctiveness of art is secured. One rarely sees a greengrocer insisting on the reality of his vegetables. To argue for the reality of art, as the avant-garde did, is to ask for the museum since only there will the message be understood. Duchamp's ready-mades set the example of this dialectic. On the one hand, the ready-made object underscores the principle that the institution of art is actively involved in determining esthetic value. It says that the object's esthetic apartness is created by the museum—that is, by the institutional context surrounding the artwork's appearance. Its underlying thesis is that the museum is responsible for art's apartness. In the gallery, Duchamp's urinal (*Fountain* by R. Mutt) is art and therefore a statement about art; outside the gallery, it is simply a urinal. Once taken out of the museum it is reintegrated into the praxis of life, but does so no longer as art. As such, it is hardly a critique of museums. Because Duchamp's ready-mades rely completely on the museum for their critique of the museum to make sense, they condemn themselves to a life sentence in the museum. They implicitly say that the critique against art's autonomy can be made only within the site where this autonomy is the rule. The urinal may clamor about art's yearning to get back to praxis, to undo the imposed sanctity of the work of art; yet, if this wish were granted, it would fall strangely mute.

In the last analysis, the avant-garde's campaign against art's esthetic institutionalization amounts to a Pyrrhic victory: while it certainly brought attention to the numbing influence of museums over artworks, it thereby consolidated the museum, not only because avant-garde works relied on the museum context to sustain their message, but also because these works let this message absorb the whole of their artistic nature. Bürger's study demonstrates how, in the end, the avant-garde only buttressed the estheticizing tendencies laid down by bourgeois art, or uncovered cate-

gories which esthetics used to uphold art's autonomous status.[47] Anti-esthetic art concedes the fact that the anti-esthetic message can only be spoken *intra muros*, from within the museum. This co-optation by the museum supports the idea that the artwork's attachment to praxis is most powerful when it speaks, not from the fray of social forces with which the avant-garde work dreamt of merging (but in which it would end up drowning), but rather from the fracture of alienation. Only in alienation does art stand in its indictment against the state of social alienation that keeps art and politics separate.

Thus, in a sense, the museum preserves the memory of the memory of art's long-lost heteronomy (its immediate rapport with life) as an impossible realization. This is why any criticism of the museum runs the risk of losing touch with what the work of art seeks to achieve: the immanence of art to life. Such immanence cannot be simply posited by fiat. Art cannot wake up one day and decide it is one with life. What impels art to reach out of itself, and thus imbues form with its endless possibility for self-renewal, is the fact that art is not one with life in the first place. Art can only approximate the unmade, the immediacy of life, by making itself, by being made. Thus the task of reintegrating life is always undone. Similarly, it is only due to art's estheticization that the question of its immediacy to existence first occurred (just as, one may say, the image of nature arose, pressingly and vividly, after it had succumbed to its industrial looting). It is a good bet that in a world without museums, art would lose the drive to reach back into life. Indeed an art that is content with its own existence, an art that is totally reconciled with the polis, would run the risk of sinking into a sort of terminal form of classicism. This is why the reaction against autonomous art launched by the modernist avant-garde still sought refuge in the museum, rather than joining a world in which they would lose the will to outdo themselves.

The museum thus participates in the historical dynamic of modern art.[48] It embodies a dynamic pole in the dialectic of the individual work of art. Art's "museal" moment is that by which the artwork itself recognizes its apartness from praxis (from life, being, nature, or immediacy) as constitutive of the work. Art perpetually moves beyond itself because it perpetually protests against what it does to nature in order to be. Indeed, if art did not see itself as autonomous (that is, as tragically cut off from

life, or the "unmade") it could never have the will to recover the state of immediacy with life (to be one with the "unmade"), a will which fuels its historical progress as well as its artistic dynamic. In that sense, it is because art is museumlike that it strives toward life, and remains a living organism, a form-producing entity. Modern art derives its extraordinary vigor from such deep dissatisfaction with art. This discontent with its own museum nature, with its being a museum piece, accounts for art's raging progress toward the unmediated, toward the raw pure matter, which characterizes so much of modern art. Art's self-acknowledged severance from mere existence, and its desperate attempts at mending this separation, fuel in large part the impetus behind modernity's experiments.

Rodin's work is an instance. The tension between the necessity of being made and the necessity of staying true to an immediate experience of being constitutes the burden of the work of art. This burden is the dynamic drive behind many of Rodin's most accomplished pieces. His *Cariatide* eternally shoulders, and buckles under, the burden of the stone out of which it sprang. The ontological ground of stone is clearly not only what the figure stands on, what it had to leave in order to be, it is also what the figure has to support, Atlas's ontological task. The ground of being becomes a burden of being: being is something toward which the work of art is responsible, something whose weight the work of art carries. The stone out of which the *Cariatide* is made is neither left behind nor completely subsumed by the figure; it is shouldered like a duty. Nature in the work of art is a pending debt, forever unsettled, not the fecund ground out of which the work grows. Had the avant-garde's claim that art can be at one with life been proven right, and had it succeeded as an artistic form, art would have died there and then. Similarly, if the Surrealists had made good their claim that the subject can be at one with language, and that language can therefore speak unmediatedly with existence, no literature could have gone beyond *écriture automatique*. It is because artistic expression is autonomous, because no language can ever escape its own museum, because no sculpture or painting will ever have the ontology of mere life, that art still exists.

Consequently, any temptation to demonize the estheticization of the work of art also goes against art itself (which, in its effort to break free of esthetics, ties itself to esthetics). This is most evident in modernist

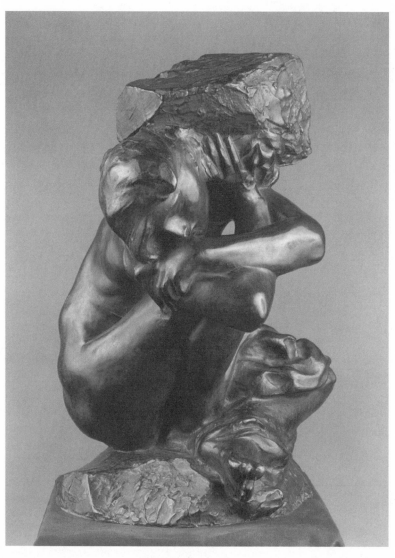

FIGURE I. Auguste Rodin, *Cariatide*, bronze, c. 1881. Musée Rodin, Paris (photo by Bruno Jarret).

works of art, which, perpetually responding to esthetics and the museum, would become unrecognizable even to themselves if the museum were simply abolished. In rejoining the principles it sought to oppose, the avant-garde confirms the argument that the relation between the museum and the artwork cannot be thought to be merely external or contextual. The museum cannot be taken out of art, any more than a piece of music can be played without signifying its difference from the din of the city or the quiet of the countryside. The museum in the work of art is the realization that the work of art is distinct from life in the very moment it seeks to be like life.

Duchamp's ready-mades highlighted the fact that institutional placing is crucial in bestowing an artistic character to the object. This observation, however, only sheds light on half of the dialectic between the museum and the work of art. The work of art becomes art in the museum space; yet this raises the question as to what creates this space in the first place. For, surely, if objects become art only by being in the museum, the museum would not exist without its works of art either. The museum affords the theoretical space in which esthetic being is preserved, but only works of art make the museum's space artistic. Like Duchamp's urinal, Andy Warhol's stacks of Brillo boxes would lose their esthetic character outside of the gallery. This, for Warhol, was perhaps the signal that the work of art must eternally annex the space of exhibition. The critic-philosopher Arthur Danto pointed out that "we cannot readily separate the Brillo cartons from the gallery they are in."[49] The museum space around the Brillo boxes is not one into which the work of art merely fits as in an encasement. The Brillo boxes participate in the space of exhibition and in fact draw it in as a part of the exhibit proper. In the case of installation art, the space between the museum and the work of art is intensely interpenetrable (hence the absence of barriers: one can even walk through the Brillo carton pyramid).

To assume that the work of art is one with the museum just because the museum insures the esthetic ontology of the object is to overlook how the space of the museum is itself molded and sculptured by art. Just as the work of art structures the space around it, it structures its own relationships to the viewer. Hans-Georg Gadamer uses the theater as a case in point.[50] In theater, the beholder is drawn into the rules of the artistic cir-

cle which, like a game, includes the participants. As Merleau-Ponty noted once, we do not see a work of art, we see *according* to it.[51] To some degree, the space in which art is experienced belongs to the work of art. This principle is evident in performing arts, where the spectator has to inhabit the unfolding time of the performance; it is also evident in architecture, where the work models the space in which it is perceived; or again in a piece of sculpture which, as Warhol's Brillo boxes show, does not simply take place in space but molds the space around it, gives it texture and visibility, and "situates" us in that space.[52] Warhol's Brillo boxes ask us to consider the esthetic space of art not as something extraneous to the work of art, but rather as an effect of the work, one of its creations. Thanks to the work's thrust into its surroundings, the museum is always *de facto* a place of praxis, not a neutralizing force field. It is an effect of the work of art, not a prior situation to art.

Perhaps then can we begin to reconcile art with its estheticization by seeing that the museum is part of the work's praxis, and therefore part of art's thrust into political existence, into "life." Art's reinclusion into life can occur, not by destroying the museum, but in making the museum the place where art takes part in praxis. If anything, the avant-garde should have taught us that the museum is not that autonomous to start with. It, too, is part of social life.[53] The museum creates a public and publicness, it is itself the product of social forces and economic determination. Art in the museum is eminently socialized: after all, it publicizes art. Hence there is a way in which museums can be regarded not as a symbol of art's estrangement, but as the laboratory of art's abrogation of esthetic apartness. For museum art still models the ways in which we come to art and abide in art. As such it is heteronomous, a denial—quixotic as it may be—of the esthetic barrier.

Monumental Time

Halfway between the temple and the bank vault, museums aim at safeguarding the artwork's undervalued physical and spiritual standing. No doubt, in purporting to offer a permanent safe haven to artworks, the museum also enthrones the surrounding social order—bourgeois democ-

racy and capitalism—as being itself cut from the same eternal cloth. The burgeoning of museums throughout Europe at the time of the industrial revolution reveals the new bourgeois order's need to anoint itself with the halo of the "eternal." Appointing itself the guardian of all past ages, bourgeois society hallows itself: it becomes the *reason* of history, its telos and purpose. By objectifying the past, the modern mind devises an antidote to the secular view of history as progress and contingency. The foundation of the Louvre Museum in 1793 belongs to a revolutionary era which, in the midst of upheaval, needed to fashion a stable image of history. The museum lifts history itself out of temporal becoming. From this stems the messianic, eschatological character of museums.[54] The museum believes in history, yet behaves as though history were over. Perhaps it holds onto history as something that is also of the past, and secretly believes that time itself has come to an end. It builds a secret monument to the end of history.

In lifting art out of the hurly-burly of historical survival, the museum strips the artwork of its historical existence. It replaces historicity by historiography. Living historical existence turns into historiographic timelessness. This contradiction explains the twofold character of museums. They have been accused of being both too heavy with historical dust and too historically spotless, excessively historicizing artworks while cutting them off from the historical life in which artworks are born. Museums are historical insofar as they exhibit artworks according to historiographic principles (using such criteria as period style, chronological markers, and technique). On the other hand, they are ahistorical inasmuch as they raise artworks above the flow of historical becoming. The museum seems contradictory because it lectures about the historical nature of its objects while denying the very same objects the immanent historical connection about which it seeks to educate.

Yet the antinomy of the museum only depends on a particular concept of history. Museums are historically contradictory only if one holds that history exists in homogeneous time, that is, only if history is assumed to coincide with the scientific, chronological notion of continuous time. If anything, the apparently contradictory character of museums indicates a continuing need to reflect on history. We thus begin by asking what constitutes a *historical* object.

It is commonly said that the museum turns artworks into monu-

ments. Monumentality surrounds the artwork with a ceremonial aura that keeps the spectator at bay. To a large extent, this aura derives from the design of space. As much as today's museums have taken to heart the avant-gardist desacralization of the subject-object dichotomy, a contemplative distance remains. A prohibition on immediate contact protects the work's presentation (that is, the use of staging techniques, dividers, glass shields, camera monitors, and electronic sensing devices that create a no-man's-land between the work and the beholder seem excessive even from the standpoint of security). Although it manifests itself spatially, the apartness of monuments stems in fact from a temporal disjunction. A historical monument appears remote because it makes room for an absence, something unaccounted for by its immediate presence.[55] It is no longer simply in the present; it also gives body to a temporal distance, a rupture, the caesura of history. What is this caesura?

A monument is an object taken out of history, by history. Yet it stands for history, and is pervaded with historical spirit. The monument's historical character is our knowledge that the object no longer belongs immanently to history: being a monument is, paradoxically, being separated from history. Were the monument to be truly immanent in its historical background it would vanish back into it. On the contrary, in becoming a historical monument, the object is removed from its native ground in history. History in the monument remains present as what has been left behind, and appears to us through the veneer of loss. Only that which is threatened with oblivion is recognized as historical. The historical is thus what cannot abide in historical life, what is in danger of disappearing and never being known again. The monument stands equally distant from the past as from the present. The monument stands out of the past but equally claims an exceptional status in the present. For the monumentalized object stands out of the present as well: not everything about it can be assimilated into the present. The mountain outside my window is not a historical object: it has been assimilated fully into the flow of time. Ahistorical beings (such as natural landscapes) flow through a perpetual state of becoming. They are immanent in time. By contrast, the outstanding character of the monument lies in what cannot be completely remembered about the past: what, in the past, has not been indifferently incorporated into the present. To be historical, an object must

have seceded from time: it cannot be one with its temporal becoming. The historical object is therefore one that belongs neither to its original setting—from which it has been singled out—nor to the present—in which it resists assimilation.

The historical is the stuff of the past which, by being remembered in the present, desists from being in the present: it is what cannot be re-constituted in the present. The real basis of historical remembrance is not what is remembered but what is left unremembered—the immemorial. Paradoxically, then, we call historical only those elements of the past that make their way into remembrance as the not-fully-remembered. Things that are remembered and commemorated de facto signify their problematic relation to memory. A monument is etched by oblivion, and only an oblivious culture can give rise to monuments. It takes a culture as oblivious as modernity to create such numbers of museums for everything, and monumentalize the past to the degree it did. As the historian Pierre Nora notes, we build "lieux de mémoire" (places of memory) because there are no more "milieux de mémoire" (real environments of memory).[56] No doubt this remark evinces the nostalgic illusion that there once existed a form of remembering immanent in existence. Yet it does point to the alienated status of memory in modern times, an estrangement concretized in monuments, museums, and "lieux de mémoires." Only by coming to terms with the obliviousness inherent in remembering did our culture become a historical culture. The monument tells us that we remember by losing touch with what is remembered; that we remember when memory no longer holds us. Monuments resist memory as much as they celebrate it. For the truly and fully remembered is in no need of being remembered: it abides in the smallest thing, as the substratum of reality.

That we create museums for every parcel of reality (so-called eco-museums, which collect and document local artifacts: agricultural tools, mining equipment, automobiles, domestic utensils)[57] shows that every thing in our self-liquidating culture is now threatened with oblivion. That every thing deserves monumentalizing means we view reality as something already forgotten. The real itself becomes a cultural heritage—the reminiscence of something which is no longer quite possible in reality. Industrialist culture has so little faith in its ability to remember that, like the neurotic scribbling his every move on a notepad, it commits every thing to

the holding tank of commemoration, including itself. In the end culture becomes synonymous with the museum: culture views itself as one of those untouchable objects of the half-forgotten past, as the economic power-house is turning out planned obsolescence at an ever-increasing pace.

Monuments, then, celebrate the excess of irreducible, untranslated past which cannot be fully remembered. Monuments are historical ob-jects because they cannot be integrated into the present, because they fail to participate in history as it unfolds. *Anachronism* is the essence of the historical object's historicity. In order to commemorate, the monument must first signify that it is synchronous neither with the past nor with the present in which it demonstrates. Initially the museum recognized the anachronistic nature of all remembering. The early museum was just such a series of abrupt historical juxtapositions. Soon, however, the museum compensated for the dislocation it inflicted by arranging the galleries in a clear-cut chronological order. It sought to mend the historical uprooting it caused by means of historiography and, out of guilty conscience, started ruling out any form of historical "inaccuracy." The historical mis-cellany, the cabinet of curiosities, the artistic jumble, all met with harsh sanctions. So did historical paintings that did not conform to a scientific notion of homogeneous chronological time. Already in 1820, the painter David, who made a career of painting authentic historical scenes, railed against those painters who "commit anachronisms they never should have allowed themselves, such as introducing modern popes into scenes de-picting much earlier events."[58] David disqualifies those paintings as his-torically inaccurate and anachronistic. Anachronism is anathema to the museum age. It is no coincidence that David also served as curator of the Louvre at a time when perceptions of history other than the chronologi-cal type had become undesirable, irresponsible, unscientific, even inartis-tic. What was it that the museum age found intolerable about these paintings if not a reflected image of the anachronism the museum itself inflicted on culture? The museum represses representations of the histor-ical caesura which, in actuality, it introduced into culture as a whole.

Yet these "inaccurate" historical paintings of the premuseum age still tell us something about history. Let us take the example of Giovanni Pannini. Pannini's paintings are rather typical scenes of antiquity and ele-giac ruins. Some of these paintings evidence the anachronism unaccept-

able to the museum. They set ancient events and characters among ruins, whereas, of course, these buildings were in mint condition at the time of the depicted events. *Alexander the Great Before Achilles' Tomb* (1740) depicts the ancient heroes living in settings not as they were at the time but as they would be many centuries later. By staging past events in the scenery as it would become in the retrospective glance of modern times—a ruin—the painter puts the historical distance *inside* the very event. The historiographic distance provides the background of the historical appearance. Alexander the Great walks in a landscape shaped by our historiographically alienated perspective. He lives in ruins, in the very image of time past. Pannini's painting seems to question whether Alexander the Great can exist outside our present outlook on his life; it asks whether the very ruination of our outlook does not enable the representation of the event *as* a historical event.

In presenting ancient figures amid ruins, the painting hints that the past exists only in the present's retrospective glance. Insofar as the past lies only in the act of remembering, it is indeed wholly contained in the present. The past, as a product of the present, is always a ruin because it always appears *anachronistically*, in the present. Alexander the Great exists only in the landscape of our memory. Thus, while Pannini's image may not be chronologically accurate, it is nonetheless *historically* correct. The painting seeks no immediate contact with the age as it was; the gesture of the historical event is framed by its irreducibility to the present. In other words, the painting knows that the experience of history is anachronistic.

By the same token, the present is denied entrance into the past. The past is extremely close to the present since it only exists through the present; yet it is also incredibly remote, since the very act of handing it over to the present means that the past cannot be grasped as what it authentically was. In that respect, the past is always a ruin, that is, an element that signifies its presence in the present as a damaged, *inauthentic* image of what it really was in the past. Indeed, the ruin is shaped just as much by what is still standing as by what has been worn away from it: its standing there is a staging of loss, unapproachability made into a monument. As Benjamin shows, the historical object's retrieval and exhibition is fundamentally determined by this unapproachability:

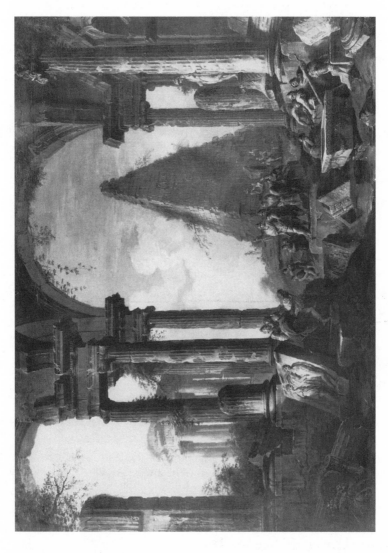

FIGURE 2. Giovanni Pannini, *Alexander the Great Before Achilles' Tomb*, oil, 1740.

These data . . . are lost to the memory that seeks to retain them. Thus they lend support to the concept of the aura that comprises the "unique manifestation of a distance." This designation has the advantage of clarifying the ceremonial character of the phenomenon [aura]. The essentially distant is the unapproachable: unapproachability is in fact a primary quality of the ceremonial image.[59]

Aura rests on the fact that only what was lost can be found again; it exists through its historical lostness. Through aura, historicity is preserved as the figure of a "no more" indefinitely suspended above the present: in that sense history is preserved with the urgency of its threatened, passing existence. History is the remembrance of the loss involved in remembering. It is the memory of forgetting.

Equally removed from context and unassimilated in the present, a monument is historical in the deepest sense possible: it preserves the unapproachability inherent in history and makes it an intrinsic part of its appearance. The ceremonial character of the monument consists in keeping intact the historical caesura, the dis-remembering at the basis of historical commemoration.

We are now perhaps better suited to understand how the museum monumentalizes artifacts. Monumentalism stems from the artifact's historical displacement. The museified artwork is a monument because it relates to its historical period disjunctively, through the loss of historical connection with the period it is said to embody. All that the museum has to offer history is homelessness, homelessness as the basis of historical existence. Alexander the Great is homeless in the field of ruins, yet this homelessness is the very ground of his historical existence. Even if the museum discounts them as inauthentic, Pannini's paintings teach the museum a lesson: they remind museum culture that, in spite of its need for an authentic bond with the past, historical existence rests on a fundamental inauthenticity, that is, on a dialectical dislocation. Pannini proves himself more dialectically mature than Quatremère by pointing out that a monument does not inhabit its time. Its existence is not in the past, which does not exist, but rather in the dialectic caesura of remembering that which exists only in the backward glance of remembering. History is caesura, that is, the work of inauthenticity.

The Caesura of Art

The debate about the historicity of museums is bound up with the artistic sphere. What makes artworks particularly susceptible to being monumentalized? Is art, from the start, monumental? Is art always historical? Does it secede from the simple present, representing what is not simply present about the present? "The ages," Oscar Wilde writes, "live in history through their anachronism." Is art this anachronism?

In itself the artistic form delineates a particular experience of history. The work of art does not make for a historical emergence like any other. Its historicity, let us say for starters, is properly artistic, that is, it stems from the concept of artistic newness. Insofar as the work of art produces its own concept rather than deriving it from a blueprint or preset idea, it is *unprecedented*. This *shock* inherent in any work of art is crucial to its understanding. Without this inaugural character, the artwork would not be essentially distinct from other forms of human production ruled by skill, craft, that is, technology.

Kant insisted on the inaugural nature of the work of art in his Third Critique, in the problem of knowledge and technique:

Art regarded as human skill differs from science (as *can* from *know*) as a practical faculty does from a theoretical, as technique does from theory (as mensuration from geometry). And so what we *can* do, as soon as we merely *know* what ought to be done and therefore are sufficiently cognizant of the desired effect, is not called art. Only that which a man, even if he knows it completely, may not therefore have the skill to accomplish belongs to art.[60]

Kant suggests that not even the artist can say how the artwork was made. The experience of making one artwork cannot be applied to the next. Artistic making cannot sediment into a body of knowledge, into technology. No *a priori* can create art, where each work creates and in fact *becomes* its own rule of making. By contrast, Kant argues, technological knowledge can answer for its creations. In technology, the object's actual production is preceded and legislated by a rational, end-oriented blueprint. Knowledge as it pertains to the production of things, both material and spiritual, stands for the authority of precedence over inauguration, and *theoria* over *praxis*: Technological products are anticipated; they fall

under the authority of tradition. By contrast, art is a technique that is not supported by knowledge, that is, by guidelines directing its particular realization. Its actual emergence cannot be accounted for by a knowledge preexisting. Kant even claims that knowledge can be present at the time of the artwork's creation and yet have no hand in that creation ("Only that which a man, *even if he knows it completely*, may not therefore have the skill to accomplish belongs to art"; emphasis added). Lest Kant's conception of the work of art be mistaken for estheticism, we can see it taken up by Heidegger—no friend of estheticism—who also insists that the work's basic character constitutes "a being such as never was before and will never come to be again" ("Origin of the Work of Art" 62) and that consequently, "whenever art happens, a thrust enters, history either begins or starts again" (77).[61] If the work of art were not new, then it would correspond to an *a priori* notion and would thereby stop being original. However much an artwork may be influenced by preceding art, it cannot be a mere copy, or the sum of its historical sources. Otherwise it would be industry, and as such would not surpass the material reproduction of mere existence. Yet art's newness is not a passion for the newfangled either, no mere rebellion against models (otherwise it would shackle itself to tradition, negatively). Art's newness is the very condition of the work's ontology: the fact that, in the artwork, the concept is the form and does not precede it.

The work of art eats into history, at once interrupting and shaping it: it makes history by breaking the mold of history, by being ahistorical. Pulling itself up by its own bootstraps, the artwork conjures up the technique necessary to make itself be. As such, it cannot be reduced to the historical period in which it blossoms. On the one hand, the work of art belongs decidedly to its era, marking it historically, fashioning its outlook, fueling its progressive dynamic, etc. On the other hand, the work of art also exceeds its period insofar as the historical refashioning it offers is necessarily unprecedented. The work of art contains the paradox of historical dialectics: to leap forward, history must reinvent itself; and such reinvention breaks away from the status quo of historical permanence. The work of art is historical insofar as it gives history its outlook and gathers its material from history. And yet it is unhistorical insofar as, to be genuinely inventive, it must not fall within the horizon of the already known. Be-

cause nothing can account for this production prior to its happening—insofar as, following Kant, the artwork's production occurs as *freedom*—nothing is less historical than art. History is causality erected to myth; the work of art, on the contrary, is acausal (or it is its own cause). Therefore the work breaks into history, *makes* history, as what cannot be accounted for by history, as what deviates from it.[62] That historical analysis cannot entirely account for the emergence of a work (in the comprehensive way it can for a political event or social phenomenon) means neither that history is foreign to the work of art nor that art is above historical determinations. Rather, art is the caesura of history: the historically unrecognizable way in which history emerges.

Thus the monumentality of artworks is not reducible to their being in a museum. The monumentality of the museum itself stems from the work of art itself, from its character as historical caesura. A work of art does not belong to its place of birth, as a mere product does. An artwork does not come to existence by obeying the historical determinants operative in its time. As genuinely inventive, the work represents what its era could not produce in a deliberate and historically determined manner. Art belongs to its time insofar as it represents the dynamic by which its era secedes from itself. The work of art is tied to its age by its difference from the age. This difference, one can argue, is the historical dynamic itself, the movement by which history takes place. History happens, it moves forward, through historical distress and upset, by shocking itself, by shattering or altering whatever held true until then. History inheres in the work of art because, in it, history stops looking like itself. Hence if the work of art is ahistorical it is because the movement of historical self-invention is ahistorical itself. Or, to put it otherwise, the work of art is genuinely historical precisely because it does not just rest in its historical bed but instead forces history to become unrecognizable to itself. Thus the work of art is a monument to its era, that is, it embodies what, in this era, is not *proper* to its own time. A work of art is monumental when it is truly art, long before it enters the museum.

Art therefore encapsulates the ahistorical way in which history takes place. The historical and ahistorical duality of the work of art sheds some light on the contradictory nature of museums—that museums are both too historical and not historical enough, that they both overhistoricize

and dehistoricize artworks. The museum exhibits the artwork in a historically anaphoric, chronologically rigid fashion; and it exhibits the artwork as an autonomous, unique, irreducible, and unbound object. The museum's historical contradiction is rooted in the work of art's jointly historical and ahistorical inaugural character: art is historical because it makes history, and because it embodies the historical dynamic of a given epoch. It is ahistorical because it makes history by sloughing off history and because its historical dynamic cannot be accounted for historically. The museum cannot opt wholly for either historicism or antihistoricism because they coexist in the artwork. Thus the museum's handling of artworks is far from being merely repressive. On the contrary, the museum contradictoriness is a form of allegiance to art's dialectical defeat of historical syntheses.

The Caesura of the Image

The argument concerning art's rejection of historical synthesis does not disqualify the scholarship concerning the historical determinations of the artwork—the sociological and contextual patterning of the artwork, periodization, identification of movements in the history of artistic production, schools, models of diffusion, and so on. Art's mediated relation to history reinforces, rather than undermines, the particular relevance of history to art. Indeed art's powerful historicity underpins such relevance. For this reason it is unfair to treat art's nonimmediacy to history as a mere slogan of esthetes. The argument concerning art's active historicity—the caesura of history—takes seriously the claim implicit in the discipline of art history: it questions precisely just how art relates to history and indeed how history occurs in the work of art. Without such a question, there is a risk one might go on accusing museums of being too historical and not historical enough without uncovering the insight buried in this contradiction.

In order to grasp fully the historical character of artistic form, we must consider again the particular nature of art. The work of art is an image. Even nonmimetic art, such as music or an abstract painting, remains an image because it makes itself so as to *appear*. Ordinary objects appear

as a result of being. By contrast, works of art *are* in order to appear. In art, appearance is inherent to, and even causative of, being. An image does not simply inhabit the world as, for instance, a tree, whose appearance is a simultaneous by-product of its being. The work of art's place in the world is determined by its appearance. This means that, as it comes to be, the work of art consciously *assumes* its appearance in the world and therefore its relation to the world. What the work of art does to the world, that is, its appearing to the world, does not take place between the work and the world (as in the case of the tree). Rather, the work's relation to the world is a conscious activity of the work. In fact the work itself is the result of this activity.

A consequence of art's self-conscious appearance is that it prevents the work from being immediate to the world. Whereas the tree's appearance in the field is just as immanent to the tree as to the field, the artwork's appearance begins in the work of art alone. Its appearance is not the product of circumstances; it belongs inside the work's decision to be. As a self-consciously appearing object, the work of art is somewhat held back by its own consciousness.[63] Even when the work of art makes a gesture of stepping into reality, the reality it reaches is a mere image of reality. We find no better description of this phenomenon than in Rilke. This is what the poet sees in Rodin's statue of a walking figure:

One would say of this gesture that it is wrapped into a hard bud. He walks. . . . He walks as though all distances of the world were within him and he distributed them through his mighty step. He strides. . . . His arms speak of his step, his fingers spread and seem to make the sign of striding in the air.[64]

Walking is not a gesture made by the sculpture with its body. Rather, the gesture of walking makes the body of the statue. As a result, the gesture of striding reverberates throughout the body: it is that from which the body appears. Every single fold and surface of the sculpture bears the knowledge of walking. Consequently, the "world" into which the statue strides is not the objective world in which a person walks. It is a space that issues from the gesture of the statue itself. This is why Rilke says that the sculpture's stride contains all the distances of the world. If it did not contain all the possible spaces of walking, the statue's step would be basically external and incidental to the statue, and the statue would not be

one with its striding. Only because walking suffuses the entire statue is the space in which it walks inherent to the statue and not to the external world. The environment in which the statue steps lies within the statue's own boundaries. Even in the most material art form there is, sculpture, the space of the world is contained within the circle of the artwork.

How does this produce a historical statement? The statue's walking has no future in the world, or in walking (as Rilke says, it has gone to all the lengths in the world). What is accomplished by the walking statue is not left behind, and yet it makes no headway into the present. The walking does not take the statue into the world but leads it further inward. Hence, the gesture the statue makes toward the present never enters the present. Our present is, as it were, suspended at the end of an impossibly long trajectory which the work of art will never traverse completely. The statue is about to step into the present. Like the past it haunts the present and yet cannot penetrate it. The gesture of the statue is forever closed, yet this completion is forever suspended. It is finished and yet its gesture indicates it is never quite entirely concluded. This haunting duality (ever hovering above the present, ever unable to achieve the present) is the experience of historicality: a passedness addressed to the present, springing toward the present, and yet never becoming fully *of* the present. The historical event is, like the work of art, surrounded by the "plasticity" of its form.

Thus it is as an image that art is a monument, that is, an appearance of historical existence: something passed that preserves itself in the present as passed. The museum responds to this appearance by adjusting to it. It is said the museum inflicts a historically distanced look on works of art. Yet, as the analysis of the image-character of art proves, the historical distance is intrinsic to the structure of the image. In this sense, the museum merely echoes the historical nature of the artwork. In isolating artworks from living history, it respects the aura of historical apartness inherent to the image. Turning the artworks out of the museum into the praxis of life would be to pretend that the artistic form is immanent to the temporal present, that Rodin's statue walks in our contingent empirical time. Insofar as this is not the case—that is, insofar as the statue has walked as far as it is possible to go ("all the distances of the world")—it belongs in the museum, in the theoretical space of art, in monumental space.

It is true, however, that the museum exacerbates the historically distanced nature of artifacts. One only need consider the collections of non-artistic objects: matchboxes, bottle caps, stamps, dolls, radio sets, cars, and so on (the list includes all existing objects). A collection removes the objects from the hustle and bustle of use-value and provides the place where, as Benjamin writes, "they are free of the drudgery of being useful."[65] There the thing becomes an image of what it used to be. The collection hypostatizes the image inherent in every object (as what that object resembles), making it the very essence of the thing. In a collection of clocks, for instance, the actual clock is taken over by its image, its "clockness" as an ideal appearance. It is no longer meant to tell the time but simply to look like itself. The image-being of the collected object marks off the emergence of history: the object embodies a piece of immobilized time that hangs over the present and never matches it entirely. Not only does the collected watch stop telling the time; it tells of a time that has stopped as well as of a stoppage of time itself. This stoppage of time is the time of images.

But what do we mean in saying that the collected clock begins to look like itself? Are objects capable of self-consciousness under some circumstances? Since it is obviously not the case, the sentence must be meant metaphorically. But then what does the metaphor reveal and what does it say about how we choose to see objects? That the collected clock or, say, the snow shovel in the gallery looks like itself seems to mean that it loses regard for me, that is, for the uses that I might make of it. It seems the object can exist as such only at my expense, that is, if I give up my prerogative as a subject (to grab it and shovel snow with it, for instance). It becomes a disused object or an object out of work, hence—if history be the realm of use, of what still *works*—a historical object. To be an image is to resign from the present, phenomenologically but also socially (presumably the British royal family became more imagelike and therefore more profoundly historical since its actual political role ended). To look like oneself, to be an image, is to withdraw into history. And history is where the subject cannot enter, the magic kingdom of the In-Itself where, at least fantastically, the subject cannot enter.

Perhaps, then, the image-value taken by the object in the museum explains the museum's special bond with art. In emphasizing the image,

the museum respects the historicity of image-being: it replicates the process whereby a work of art upholds itself as a resemblance. The historical character of images allows us to correct the view that the hoariness of museum art derives from its stuffy historiographic context. The aura of ancientness surrounding the work of art also (and perhaps essentially) pertains to the historical nature of images.

Art's perpetual straining toward the present is a figure of dialectical history: it maintains itself in the present by keeping apart from the present, just as the historical entity (event, figure, or object) survives in the present only by not being absorbed in it. The historical figure of Napoleon, for example, is hemmed in by the present (without which it would no longer exist) and yet it does not inhabit the present (or else it would be utterly forgotten). This haunting of the present is the imagic suspension of the work of art: it is an experience of historicity. The artwork is historical not because it fits into its historical niche, but because it is an appearance of the caesura of history. Perhaps, then, the museum's historical character is not due primarily to its chronological arrangement, the erudite exhibition of its treasures, the knowledge of the past it highlights in artworks, but rather to the experience of dialectical history present in artworks. Museums cannot stop being historical yet cannot replace artworks with history because the appearance of history is itself artistic—or because the appearance of art is *dialectically* historical.

Proust's Museum

What the figure of the collector is to Balzac, or the machine is to Zola, so the image of the museum is to Proust.[66] The museum in *A la recherche du temps perdu* is solicited by the subject matter itself: the presence of the past rippling below the surface of experience, the auratic emergence of memory in the midst of life, the object's welding with its mnemonic image. The museum lays out a space of memory where the object exists as an image, untrammeled by the cares and distractions of existence. To be sure, there is much of the esthete in Proust's affection for the museum. Thus Marcel is fashionably decadent in preferring reproductions of the Balbec church portal in the "Musée des monuments français" to the

real thing. Yet Proust's keen artistic sense and intensely *lived* experience of artworks allow him to step beyond estheticism. More than a mere ideological *parti pris*, his taste for museums is rooted in a deep experience of art. It stems from a confrontation with the work of art itself, rather than from a cultural bias. The question of museums is most thoroughly taken up in *A l'ombre des jeunes filles en fleurs* (Within A Budding Grove):

Yet in all areas our age is badly obsessed with the desire to bring things before our eyes in their natural surroundings and thus to suppress what is essential, the mental event that singled them out of those surroundings. Today one "shows off" a picture amidst furniture, trinkets and drapes of the epoch, in a dull decorative display arranged by the hitherto ignorant lady of the house now spending her days in archives and libraries; but the masterpiece observed during dinner no longer stirs in us the exhilarating joy that can be had only in a museum where the rooms, in their sober abstinence from all decorative detail, symbolize the inner spaces in which the artist withdraws to create the work. (I, 644–45)

Against the mawkish belief that the artwork is best enjoyed in a reconstructed historical habitat, Proust prefers the decontextualized space of the museum. His affection is justified by the affinity he perceives between the gallery and the work of art. For Proust, the work of art is like a quotation that forgets its source and thereby demonstrates the strength to found its own origin. This forgetfulness constitutes "what is essential" to the work of art. The "mental event that singled them out" is the artistic gesture by which the work comes to be. According to Proust, the museum is suited to the artwork because it treats it neither as decorative effect nor as historical token. The museum's decontextualization reflects and preserves the uprooting origin of the work of art—*the mental event that singled it out.*

Proust's analysis foreshadows the twentieth-century curatorial practice of decontextualizing artworks. It precedes by a decade the definite full-scale attempt by the Louvre at shedding the "collection cabinet" look that had so far predominated, mostly in the "en tapisserie" style of hanging paintings. In many instances, the nineteenth-century museum still behaved like the Proustian hostess striving to create "contextual" chic. Often it is simply because, as in the Louvre, the works hang in the aristocratic setting for which they were intended (for instance, Rubens's mon-

umental Marie de Médicis cycle, which was made expressly for the room
in which it now hangs). Museums such as the Louvre, being monuments
and, as such, museums of themselves, give the impression that they are
the historically natural habitat for the works they house. In this sense, the
classical museum naturalized the historical process of museum conserva-
tion. In 1851, the British Museum inaugurated a new wing built in neo-
classical style to accommodate a new collection of ancient statues. The
sculptures were arranged with an eye toward achieving the picturesque
setting of a reconstructed Greek temple. In fact, Quatremère congratu-
lated the curators of the British Museum in his "Lettres écrites sur les
Marbres d'Elgin" (Letters on the Elgin Marbles): the reconstructed Par-
thenon provided partial reparation for the statues's transplantation. This
"installation-as-reconstruction" seems to show that, at an early stage, the
museum guiltily sought to mend the historical connection which its very
existence severed.

Like the bourgeois hostess Proust describes, the landscaped mu-
seum acts on the belief that artworks inhabit their historical space imma-
nently. It is therefore no wonder that the historically correct museum
blurs the distinction between artworks and decorative objects. While the
blurring of this distinction is not false in some art forms, particularly in
the case of medieval or non-Western art, it is nonetheless misguiding and
contradictory: by exposing objects it emphasizes their singularity; yet by
window-dressing them it says that their value derives from contextual as-
similation; it thereby shifts their worth to the contextual relations that, as
often as not, are supposed to act as a guide, a way of "figuring out" art.
Once again art is made into an ornament to history and not an objection
against its mere reproduction. But even apart from these ideological
questions, recontextualization betrays the visitor by promising a ready-
made understanding of art and an unearned coziness with art. It pretends
that the work of art can be brought closer to us, not by engaging its inner
density, but by assimilating it to our idea of a meaningful setting. While
it is true that contemplating an African mask abstracted from its ritualis-
tic and religious functions makes little sense, a simulated environment
can only afford false intimacy. Playing Bach with instruments of his day
("as Bach himself heard it") will never get us closer to his music because
one cannot bracket out the two centuries of musical listening that have

shaped the minds and ears of listeners. Neither will scouring the Sistine Chapel allow us to see the frescoes as Michelangelo saw them. Similarly, hanging artworks back in their castles and churches in order to make us judge the work from the "right" historical standpoint is misguided since it overlooks the fact that castle and church themselves are now historical objects removed from us as from the artwork itself. Not only is such restorationism false in relation to the idea of history, but it is also injurious to the work of art. It instills the notion that the work of art inhabited its time and space immediately, like a tree in the forest.

Modern and contemporary artists like El Lissitsky and Daniel Buren approach the problem differently. Seeing that the museum cannot be de-estheticized, they design works specifically for the gallery space. Stressing a symbiotic connection between work and gallery, Buren observes that, in the regime of aristocratic patronage, works were created to reflect their patrons' lives and palaces. Now Quatremère's all-important principle of "destination" is taken into account by the work of art itself.[67] In designing artworks specifically for a museum setting, Buren certainly draws attention to the fact that, in modernity, the artist more often than not makes artworks for museums. Yet this effort hangs onto the nostalgic assumption that, in another age, the work of art's contextual placing was all immanence and immersion. By making the museum this place of origin, Buren supports the notion that there is, after all, a natural habitat for art. At bottom, such strategy still treats art as an afterthought, or ornament, to historical praxis, rather than its essential model. In the end, it threatens the emancipatory dimension of art, its strong, emphatic historical thrust that outstrips mere documentation. Perhaps that is what desublimation of art means: its strong historical inauguralness reduced and neutralized, it becomes just another "interesting" object fully accounted for by social self-reproduction. It becomes a patron of the museum, rather than its conscientious objector.

This is perhaps what Proust already dreaded in the "dull decorative display" of the fashionable salon that hangs paintings "among furniture, trinkets and drapes of the epoch." On account of the historically disjunctive character of art Proust opts for the relatively bare space of the museum. For at least the museum does not pretend that our relation to

artworks is immediate. Proust suggests that the museum is the home of the work of art not because it is the proper environment, but because it is the most minimal environment possible. The museum represents the absence of a place and thus best suits the historical caesura of the work of art. The museum cannot constitute a natural habitat for the reason that the work's origin denies the *naturalness* of origin. The museum's minimal space founds a *locus aemenus* for art's historical caesura. Thus the work of art does not settle into the museum as though the museum were its Ur-context. Proust's critique avoids the trap of a second-order contextualism by saying that the artwork only belongs to the museum because the museum presents the least possible amount of context: artworks belong to museums because there they are most free from belonging.

The Experience of Art

Justifying the culturally and historically abstracted space of the museum through the "inner spaces into which the artist withdraws to create the work," Proust may be said to subscribe to a stale conception of the pure work of art—autonomous, detached from experience. Yet lumping Proust with the advocates of estheticism would be unfair to his œuvre, which consistently places art precisely at the heart of *lived experience*. Proust is led to the museum in the name of experience (hence of praxis, of a living with artworks such as the avant-garde dreamt about) and not because of some ideological adherence to estheticism. If Proust warns against the illusion that the work of art can be brought closer to human experience by placing it in an integrated environment, it is because the *experience* of artworks itself gives rise to an estrangement, a caesura of experience. This is one of the recurring esthetic motifs of *A la recherche du temps perdu*. For Proust the work of art cannot become a prop in the search for a "genuine historical experience," because the artwork questions the very notion of experience as participation and immediacy.

Proust's experience with Vinteuil's sonata sets the example. The scene takes place during one of the narrator's afternoons in Madame Swann's drawing-room, and recounts Marcel's first experience with the Vinteuil sonata:

On one such day, by chance she played for me the section of Vinteuil's sonata with the little phrase which Swann had loved so much. Often, however, if the music is complex and newly heard, nothing is perceived. . . . What the first time probably lacks is not the necessary understanding, but memory. (I, 529)

Right from the start, artistic experience is marked, if not by surrogacy, at least by second-handedness. Vinteuil's music reaches the narrator's ears through the previous experience of Swann's blissful enjoyment of the same piece in the preceding volume, *Du côté de chez Swann* (Swann's Way). Even then, Swann's perception of the sonata had been modulated by memory: he had heard it before, would hear it again, every time enmeshed with reminiscences of earlier listenings. Hence Marcel's encounter with the musical phrase stands against the background of a preceding encounter with the same phrase, an encounter that had similarly entwined memory with art. Artistic experience, one would like to say, is highly mediated—so much so, in fact, that such mediation replaces the act of perception proper. Marcel does not perceive anything, he does not hear the music the first time around because there is no music without memory. It is as though there could never be a first time in art: "often one hears nothing . . . the first time." Artistic reception is initially the experience of a void of experience. Art begins only when memory seizes hold of the experience as something that once took place. This mnemonic mediation of the initial non-event can only be the remembrance that nothing took place, a memory of a nonmemory:

So far, however, I had never heard this Sonata; where Swann and his wife could perceive a distinctive movement, that movement stood as far removed from my acute perception as a name vainly recalled and blanked over by nothingness, a nothingness from which, a hour later, the reluctant syllables will spring unbidden and unawares. (I, 530)

Marcel's memory of the artistic non-event contrasts with Swann's competence in artistic perception. Marcel's unsuccessful mediation of the artistic event is itself mediated by the successful experience of others. This double exclusion, from the artistic object on the one hand and from the community of esthetic reception on the other, constitutes a further distancing from the work of art. Marcel is placed in a void outside the artistic as well as esthetic circle. The encounter with the artwork begins in ut-

ter destitution. Then, out of this lack of experience, made more goading by the remembrance of others, the work of art emerges, like a name. It springs into memory, out of a bed of oblivion, as a remembrance of the nothingness that happened in the past. Because the work of art is never experienced outside of mnemonic mediation, it is remembered as the nothingness of experience ("nothingness") which marked the initial encounter ("the first time").

We may take note of the mimetic complicity between esthetic reception and artistic creation: in much the same way that the work of art emerges for the receiver as a leap out of nothing, the same work proceeds from the "space abstract and sober" of artistic creation. This similarity paves the way for the distinctively Proustian assimilation of the artwork with its esthetic reception. What rescues Proust from the banality entailed by his mistaking art for the phenomenology of its perception, for the feelings or thoughts it arouses, is that his mistake is not made in the service of the subject; on the contrary, it undermines the subject's grasp over the artistic object. Even if the artwork is eclipsed by the subject's experience of it (to the point where, in Proust, the narrator's consciousness becomes the veritable work of art), it does not follow that the subject may declare victory over the artwork or that the artwork has to fall into step with a subject-centered level of experience. On the contrary:

Even after I heard the Sonata through and through, it still remained all but invisible to me, like a monument almost entirely effaced by distance or a hazy mist. This explains the melancholy bound to the knowledge of artworks, and of things that unfold in time. When finally the most secretive part of Vinteuil's Sonata unveiled itself, I had already begun to lose the fleeting trace of what my preference had distinguished, all of it blown away by the forces of listening habit quite beyond my heart's command. Thus, grasping only successively at the beloved moments of this Sonata, I never possessed it as one body: it was like life. (I, 530)

Even after the Sonata has been heard through and consciously taken in, the nagging reminder that this completion is spread over many unsuccessful listenings prevents the subject from entertaining the illusion of having corresponded with the musical piece. The artwork is divided between intimations of its completeness (the monument seen patchily

through a veil of fog) and the retrospective realization that final under-standing was achieved only in broken segments already slipping away ("lose the fleeting trace of what my preference had distinguished"). The artwork's mediation by consciousness takes place by revealing the inade-quacy of this mediation. Art is the caesura of the subject.

In Proust, the work of art never does rise to the occasion. It is marked by a lack of occasionality, a persistent untimeliness. The subject never quite coincides with the experience of art. Even at the level of the subject's perception, art leaves the subject behind. Art constitutes for the subject *the poverty of experience itself,* the absence of contemporaneous, living-through experience that breaks experience. What Proust challenges above all is the notion of presence associated with experience. Those who insist on the historical embeddedness of artworks implicitly subscribe to a particular idea about art and sensuous presence: if the work of art be-longs in the praxis of life, so the argument goes, it is because the work of art is tied to the subject's live response. Ultimately, taking their senses for the yardstick of truth, the advocates of art's "presence in history" argue that art is present in life because it is felt, perceived, touched, seen, and heard in the present of perception. Proust demolishes all of this by show-ing, in his own way, that even the sensuous experience of art is a dialectic of postponing and avoiding the strictly sensuous data.[68] At an extreme, he even argues that the artistic experience entails a breakdown in sensuous continuity. This commentary on a painting by Monet comes from Proust's earlier novel *Jean Santeuil*:

And, though the sun shines through, we do not see the river still asleep in dreamy haze, anymore than it sees itself. On this patch here it is already the river, but there the view is blocked, one sees nothingness, a mist obstructs the vista. On this corner of the canvas, it is a matter of painting neither what is seen, since there is nothing to see, nor what is not seen, since one must paint only what one sees; it is a matter of painting *the fact that one does not see*: that the failing eye, which can only swim in the haze, is as sadly there on the canvas as on the river: that is the beauty of it.[69]

A caesura lies at the core of artistic perception. In so noting, Proust speaks against the common run of Monet's devotees who praise the master's skillful rendition of seeing, of retinal stimulation and visual perception.

He insists that the primary statement of Monet's vision is that seeing does not attain the object seen. This not-seeing comes to the fore after Impressionism when, from Expressionism, Surrealism, and Abstract Expressionism, art increasingly dwells in the unempirical. And yet the caesura of perception also takes place in traditional representational art. In religious traditional art the artist trying to represent the divinity (the never-to-be-seen itself) first experiences that he does not see what he must render visible on the canvas. To paint the Holy Trinity, angels, the saints, or even God is to paint something beyond empirical human perception. It is, as Proust would put it, "a matter of painting that *there is nothing to see*." In other words, there is no sensuous connection between the canvas and what is depicted. In order to imitate life, art forgoes life: it first says that it is no longer one with life. The documentary connection between the work of art and its period is never one of mere presence, never simply contemporaneous. The sensuous bond between art and the world cannot serve as proof of art's integration in life because this sensuous bond is mediated inside the work of art (in this sense the artwork is an emblem for Proust's conception of mental life as a whole: "Truth does not exist for us until it has been recreated by thought," II, 756). Thus the history of art records the various ways in which consciousness is abstracted out of its sensuous situation. This is what makes art a judgment on history, rather than a simple historical product.

For Proust, melancholy pervades the experience of art because, in it, the subject misses himself. The melancholy physiognomy of most artworks, even the lighthearted ones, may consist in the fact that art carries the knowledge of the missed experience of experience itself.[70] That this missed encounter, or caesura, has been mistaken for the "eternity" of artworks is a confusion that Proust makes impossible to repeat. For the artwork's relation to time is not one of Olympian detachment (that is, "eternal life is no more given to artworks than to man," II, 255) but one of dissatisfaction with the inability to fulfill experience.

Thus, if art forms are tied to the historical and social context of their emergence, it is precisely insofar as they are not—or cannot be—subsumed by it. Without this caesura, nothing distinguishes art from prettified historiography, from being a mere ornamental documentation.[71] Art's heteronomous character—its involvement in history and

praxis—is not a given; the artwork's entanglement in context is significant precisely because it is not decreed by the context alone. The artwork's heteronomy derives its power from operating at a self-conscious remove from the social nexus (to which it beckons), and thereby reflects a choice: its historicality is meaningful because it pertains to will, not blind necessity. Art's connection to history is itself mediated by art. Otherwise the work of art would be no more historically significant than, say, the bedroom in which the artist slept, his silverware, or the gas lamp that stood outside his window. It is out of a reductive notion of the artwork that the restorationist advocates that the work of art be placed in its original setting. The Proustian hostess presenting her artworks *in situ* is ignorant of the principle that art's embroilment in history represents precisely a freedom from blind immersion in history. Only then is art's relevance to history marked by critical awareness and therefore by a genuine historical dimension. Art is tied to history through its caesura, or cut, from history. Art thereby saves history from absolute historical determinism, which would mean nothing but entropy for history. To hang the work of art back in its castle, or among like objects of a similar period, overlooks the fact that the work of art was originally a reaction against being a mere thing among those things.

The dialectical historicity of artworks explains why the museum offers art both for contemplation (in acknowledgment of its autonomous character) and for explication (in support of its heteronomous character). This dichotomy orchestrates to a large extent the theoretical dilemmas and tribulations rocking the discipline of art history, torn as it is between formalism/synchronic structuralism and social-historicism.[72] The formalists bring themselves to concede that the very notion of art's autonomy is a historical product. The historicists are forced to acknowledge the unsurpassable quiddity of the artwork. No philosophically satisfactory reconciliation can be forged as long as the artwork is construed solely as a passive object. Proust offers such a reconciliation with his view of art as a manifestation of historical existence itself, that is, of estrangement.

Unlike a product of historical circumstances, art *wills* its presence in the world. Since its embroilment with life is self-consciously effected by the work of art, art cannot be simply immanent to life. Precisely to the

degree that the work of art's heteronomous dimension is willed by the work of art itself, it is an expression of autonomy.

Thus art itself asks that one overcome the antagonism between the esthete who is loath to acknowledge the social and institutional determinations of esthetic pleasure, and the historian who would reduce art to a set of cultural practices, historical behaviorism, and institutional control. The controversy over whether the work of art belongs to the museum cannot be put to rest so long as the ontology of the work of art and the phenomenology of its experience are unacknowledged. The artwork's originality militates against the inclusion of art into the backdrop of existence: insofar as the work of art is original, it embodies something that cannot be subsumed entirely by its historical determination. The determination of history is taken up self-reflectedly into the form of the work of art, whose relation to history is therefore not simply symbiotic and necessary, but deliberate and critical, critical even of the subject whose self-presence in experiencing art is unhinged by the extreme demand art places on mere perception: the paradoxical experience of a work of art is that it concomitantly demands to be looked at and looked away from.

The museum highlights the genuine heteronomous dimension of art by revealing that art's involvement in life, history, and experience is not an empirical given but something the work of art attains by being dialectically distinct from it. This dialectic founds the strength of the work of art, its straining toward existence in an original, inaugural, and emancipatory way. Realizing that the work of art cuts across the distinction between a heterogeneous (history-based) and immanent (formalist) critique, Adorno suggests an insight into the very nature of the work of art: "The contradiction according to which every work wants to be understood purely on its own terms but none can in fact be so understood is what leads to the truth content."[73] The work's inability to attain pure autonomy or pure heteronomy is its truth, the mode of its creation. In this sense the debate about the museum, about whether the work of art should be kept apart from or immersed in life, is really about what Adorno calls the truth content of the work of art: that is, its non-identity or caesura. The museum's internal contradictions (that is, the debate about the museum) are a monument to what is truest about the work of art: its unreconcilability.

Art in Ruins

As the rationalization of knowledge spread in the nineteenth century, museums became increasingly historiographic: no longer was it sufficient to collect the past; it had to be collected scientifically. By contrast, the early modern museum knew nothing of such historical didacticism. As James Clifford points out, objects in the *Kunst- und Wunderkammer* were looked upon as emanations of a fabulous, supratemporal present:

The archaizing system has not always dominated Western collecting. The curiosities of the New World gathered and appreciated in the sixteenth century were not necessarily valued as antiquities, the products of primitive or "past" civilizations. They frequently occupied a category of the marvelous, of a present "Golden Age."[74]

The marvelous is a dimension at once past and present. The early eighteenth-century depictions of cabinets of paintings still retain a taste of the old *Kunstkammer*: the pictorial fulfillment of the archaic, childlike dream of bounty, the pirates' stack, the king's treasure-trove, or the alchemist's den, the treasure bound together by the magical spell of ancestors. The *Kunst- und Wunderkammer* reflects a historical consciousness that did not consider the present to be qualitatively distinct from the past. It shows how perhaps the past once cohabitated with the present.

Not so with the modern museum, whose schoolmarmish orders dispel the nimbus of historical imprecision that surrounded the cabinet of paintings. In the museum, the visitor is charted a course determined by chronological and national principles. The history of the Louvre Museum illustrates historical rationality's repression of the *Kunstkammer*: art is no longer the emanation of a magical past suspended above the present; it is the image of a past placed at the end of a chronological and historiographic pointer.

The Louvre Museum's first important decision was to revamp the untidy Grande Galerie. In proposing to remedy a problem that had erstwhile not been one, the museum linked the exhibition of art to a complex historiographic taxonomy. No longer were objects to be collected by kind, size, or look, but by their historical provenance. The rational mind abjured disorder as a remnant of feudal obscurantism and aristocratic

mismanagement. The Conservatoire in charge of supervising the museum disapproved of the haphazardness of the galleries where works were hung together with no regard for stylistic, epochal, or national coherence:

The Gallery was one vast clutter . . . a furniture warehouse rather than a gallery, a hodgepodge mixing in all things. . . . No doubt the need to cover up all the partitions had gathered this teeming multitude of little paintings which were only glimpsed at.[75]

This sudden need for order, which is simultaneously the first recognition of disorder as such, had doubtless been long in the making. The Conservatoire started by expurgating from the museum works that did not fit historical and narrative pigeonholing. The style of hanging paintings frame to frame, floor to ceiling, was regimented according to stylistic regroupings and explanatory labels, the absence of which had previously made the galleries a forbiddingly incomprehensible place. History, and a historical understanding of art, became the prime interpretive ratio in the name of which the *Kunstkammer* was reorganized into a museum, a place of study and contemplation. The work of art was henceforth stamped with a historically documentary character belonging to a rational and coherent history of artistic development. Art thereby concretized the historical past: indeed, in the museum, art became a thing of the past.

A painting executed by Hubert Robert in 1796 gives an arresting image of this historical transposition—that is, of the commingling of the past with esthetics, of history with art. The *Imaginary View of the Grande Galerie of the Louvre in Ruins* depicts the crumbled remains of the museum's grandest gallery. Robert was no stranger to the ruin genre painting; if we are to make anything of his nickname, "Robert des Ruines."[76] The painting shows an indoor view of the gallery: a wide alley almost completely obstructed by rubble, truncated statues, tumbled columns and vases. A few anonymous figures roam in the ruins, picking over the debris, gathering around a campfire. In the center of the canvas, an artist is seated on a large block, drawing a picture of some miraculously intact sculpture. Robert's painting was first exhibited at the Salon of 1796, in the very gallery it represents. It reflects the situation of presentation and also comments on the curatorial framing of art. Where is art today? the painting seems to ask. It lives in ruins, it perhaps is a ruin itself. While flatter-

FIGURE 3. Hubert Robert, *Imaginary View of the Grande Galerie of the Louvre in Ruins*, oil, 1796. Louvre Museum, Paris.

ing the public taste for ruin landscapes, Robert's painting nonetheless is a dissenting voice in the official chorus of cultural restoration: at a time when the museum was being promoted as the latest invention, as a symbol of revolutionary freedom from the old ways, Robert chose to depict the museum as a ruin—as already historical defunct.

The landscape shows the devastation following a cataclysmic event. But what event? Surely it did not take place in antiquity, as the codes of ruin painting usually implied. This event is more closely tied to the present: in 1796, the beholder was not faced with an image of the past, since the Louvre had never been a ruin. In fact, to depict the Louvre Museum as a ruin in that time of historical renewal may reflect a development in the presentation of art. What does Robert's painting imply by depicting the Louvre as a ruin just when it becomes a museum? The painting be-

longs to a period of cultural revolution: precisely when the jumbled salon of paintings got replaced by the streamlined, historically guided museum. Through the renovating supervision of Hubert Robert himself, and later of Jacques-Louis David, the Louvre became a place where artistic works hung in a clear historical light. They are in fact historical documents, embodiments of historically arrested forms. The very appearance of art *is a* historical phenomenon, a ruin.

The ruin is not solely an appearance of history. It is history sculpting its own appearance in a concrete form. The ruin is carved by the historical distance through which the building had to travel on its journey to the present. What we first see in ruins is that time has passed; we see the ruin as ruin thanks to the passage of time. It is historical distance that appears and becomes object. Insofar as the ruin is shaped equally by what remains and by what has been stripped away, by the presence of what still stands as well as the absence of what no longer remains, it makes the process of passing—of historicity—appear. A ruin makes visible the loss incurred by the object in the process of traveling from the past to the present, the very distance between then and now. By representing the museum as a ruin at the time when the museum is a brand-new invention, Robert puts the caesura of historical distance into the picture of art's exhibition. The painting *Imaginary View of the Grande Galerie of the Louvre in Ruins* creates a historical disjunction between the present of the Galerie and its ruined image. We feel art reaches us through great historical distances: that, in reaching us, it has been imprinted by a historically alienated character. The Louvre becomes a ruin as soon as it becomes a museum because all museums are essentially tied to the dialectic of ruins. In anticipation of Hegel's declaration that art in the age of esthetics is a thing of the past, Robert's painting shows that, in the museum, the artwork is an object sculpted by obsolescence: it is the appearance of passedness as such.

Art's ruin is tied to the estheticization of artworks. Jacques-Louis David's revamping of the Musée Napoléon into the Louvre proves this unmistakably. The Musée Napoléon sought to teach the people about their nation *through* art. In playing a directly informative role, art took on a decidedly heteronomous value: it was integrated into political praxis. As the founding bill stipulated, the museum was put under the legislative au-

thority of the Interior Minister to "inventory and gather in suitable ware-
houses the objects of science and art suitable for *public instruction*."[77] The
overwhelming number of historical genre paintings in the early nine-
teenth-century museum illustrates the historical and historically edifying
value invested in museum artworks.[78] In the Revolutionary Museum, art
and the *polis* keep in close collaboration. Art is thought capable of con-
cretizing the people's political identity; it contributes to the shaping of the
nation by showing edifying scenes of its history. The mobilization of art
in the service of politics is typical of the de-autonomization of artistic ma-
terial in revolutionary times, when art participates directly in the reinven-
tion of history, not simply as a document, but as a living historical force
(the de-autonomization of art is typical of revolution, when history itself
behaves like art, inventing itself). This explains why, to the avant-garde,
only a revolution could guarantee the integration of art and praxis. This
also explains why, when a revolution settles into a political status quo, it is
bound to repress the very art on which it relied for its momentum: as
Lenin turned into Leninism, so Russian Constructivists were silenced.

As the turmoil of the Revolution gave way to the Restoration, so too
the status of art in the newly revamped Louvre changed. Hitherto a po-
litical tool, art now became a mere esthetic object. Jacques-Louis David
remodeled the Louvre on the principle that the teaching of art alone
ought to be the essential mission of a museum. No longer is the museum
to be a seedbed of political fervor. Art is demobilized and put under the
scrutiny of historical sciences. The new Louvre Museum (the one in
which Robert's painting was exhibited) chose the study of art, and art
alone, as its *primum mobile*. In *Imaginary View of the Grande Galerie of the
Louvre in Ruins* the people, the anonymous stragglers, roam over the mu-
seum ruins, utterly ignorant of the remaining artworks: art no longer con-
cerns the political destiny of the citizenry. It seems history itself is a ruin,
a thing of the past. Estheticizing history itself, the museum exists after the
cataclysm, after the end of history and art.

Robert's painting only has the artist pay attention to the artworks.
The museum perhaps confirms the exclusively *esthetic* relevance of art. By
insisting that the Louvre's mission be founded on the teaching *of* and *about*
art, it effectively sealed off art, making it autonomous. This esthetic de-
tachment, however, does not mean the exclusion of history pure and sim-

ple. The new museum cancels art's involvement in historical praxis but then reintroduces history into the work of art, only this time as a historiographic sediment. Art is no longer the force of history but a bearer of its representations. In other words, art begins to represent *what is left* of history. The purely esthetic gaze involves the historiographic gaze, Robert implies. Museum art is a ruin, namely, the appearance of history as image, as self-distance. Robert's painting depicts the ruin that the work of art becomes in the rarefied air of the museum. Ultimately the ruin in *Imaginary View of the Grande Galerie of the Louvre in Ruins* is the painting itself; the shock experience of historiographic alienation is the esthetic appearance of art.

Framework

The autonomization of art does not mean that art breaks free from historical determinations but that historical determinations move from the level of content to that of form. The work of art is no longer asked to push the dynamic of history. Instead it need only comply with historiographic coding. Art as historical praxis diminishes while art as historiographic discourse expands. Form becomes the cause of art's integration in the discourse of art *history*: curators often favor artworks whose form illustrates historical theses about chronological evolution of styles, genres and morphologies, while excluding those with no clear historical attachment. Thus the transition between the Revolutionary Louvre Museum to the Restoration Louvre Museum follows a paradoxical exchange: the direct involvement of art in the political and historical construction of the age meant that the artistic *form* of the work of art, if not its representational content, was relatively free from historiographic scrutiny; whereas the upholding of the esthetic divide between art and historical praxis means that the artwork's form is laid open to historiography, to the point where historiographical considerations determine the artworks' esthetic relevance.

In the process, as Valéry once put it in "Le Problème des musées," Venus becomes a document: "We are becoming scholarly. In matters of art, scholarship . . . appends an unlimited library to the great museum. Venus turns into a document."[79] Art's autonomous character joins forces with historicism: indeed the historicizing lay-out of the museum galleries

is based upon the properly *esthetic* features of the work of art, i.e., upon their autonomous form. Ironically the museified autonomy of art which initially expels historical praxis from art winds up insuring the supremacy of historiography over art. Thus, to complete Valéry's thought, Venus becomes a document, not by surrendering directly to history, but by fleeing to the ether of pure form.

Throughout the nineteenth century, the museum follows the historicist imperative to arrange the artworks according to sociohistorical principles. The museum is laid out like a journey through history, down a brightly lit path winding its way through schools and styles, national characters and chronological markers.

This is what lies behind the debate over the museum's crowdedness that raged in the early twentieth-century artistic world (right around the time of the avant-garde's onslaught against the museum). This is also what prompted the Louvre to adopt a more streamlined and sparse model of presentation. Thus speaks Maurice Donnay, *académicien*, at the turn of the century:

After lunch, I went to the National Collection to look at paintings. When will painters understand that there is nothing worse, and more lethal to a painting, than the company of other paintings. . . . A frame is not enough to isolate the painting.[80]

The officer of culture finds himself in the paradoxical position of protecting works of art against the institution in charge of art's sanctity. It is as though the fetishization of art in the museum eventually turns against the museum; such fetishization now demands absolute autonomy, even from the museum. As a result of having overpostulated the unique, sacrosanct essence of the work of art, the esthete is led to defend it against art itself.

The paradoxical underpinnings of this concern also appear in Valéry's protest against the museum. Valéry dislikes museums because they compromise the unique status of the artwork (a status that museums helped to bring about). His visit to the museum is one of overwhelming confusion. The artworks' exceptional character, which is the cause of their selection, turns out to be severely compromised by their sheer numbers:

Something strangely senseless comes out of this grouping of dead visions. They jealously grapple for the gaze that brings existence to them. From every corner

they are clamouring for my indivisible attention. . . . The sense of sight is harassed by this abuse of space in a collection and, similarly, intelligence is offended by this tight packing of important works. The more beautiful works are . . . the more apart they must stand. They are objects made to be unique by their creators. (*Œuvres* 1291–92)

Valéry stands in awe of the sacred uniqueness of the artwork; yet he thinks it so feeble a force as to be destroyed by the mere company of other works. In other words, the notion that the work of art is strictly autonomous in its particularity is good and valid so long as it is not practically demonstrated. The call to protect art against life leads to the call to protect art against art. The artwork's uniqueness turns into some foggy sublimity so singular that it cannot tolerate bearing proof of itself. Protesting against the museum's crowdedness actually casts a doubt on the esthetic strength of artworks: they are no longer believed to be strong enough to stand up for themselves.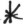

The conclusion that art kills art does not lead Valéry to doubt his faith in esthetic autonomy. Rather than imploding the category through an immanent critique of esthetics, he tries to shore up its weaknesses by harking back to an archaic connection between art and architecture, Quatremère-style:

Suddenly I see a glow. A tentative answer comes to me, from the background of my impressions, and asks to be spoken. Painting and Sculpture, says the imp of Explanation, are abandoned children. Their mother, Mother Architecture, is dead. So long as It lived, It gave them a place, use and obligations. Their freedom to roam was denied. They had a specific space, a permanent well-defined lighting, their topics and harmonies. . . . So long as It lived, they knew what they were all about. . . . (*Œuvres* 1293)

Valéry calls for an enframing of the artwork that would be at once authoritative and natural: the artwork ought to be restored to an overarching architectural and historical context. Mother Architecture alone is capable of placing artworks in their right places. This analysis, carried out in the name of art's preservation, nonetheless winds up demoting art to an ornamental adjunct that derives its identity from context. In trying to save the artwork's nonsubsumable character from art, Valéry loses it to its contextual grounding, thus implicitly conceding the work's subsumability. In the

name of the artwork's sublimity, Valéry paradoxically espouses the touristic trend of contextualizing this sublimity in a manner quite antithetical to the sublime (for the sublime, by definition, breaks all frameworks). In the end Valéry betrays the work of art itself while trying to defend it. Had his critique of museums focused on the artworks themselves, perhaps he would have realized that an artwork's uniqueness is not a decorative product of its circumstances, but of the thrust of its formal originality.

Valéry's (untypical) disregard for the artwork in the name of Art can also be heard in Donnay's defense of esthetic autonomy. He declares that "the frame is not enough to isolate the painting." This statement invests the framework, that is, the context, with the power of delimiting art within its own space, a principle that thereby defeats any kind of limit whatsoever, since, in this case, isolation proceeds from context. What is art, the inside, is given over to the frame, the outside. Hence, again, in trying to rescue the work of art's uniqueness from the museum, the esthete must concede that art's uniqueness is accidental, a product of its surroundings. As the work of art is made dependent on its framework, it slips entirely into the slim margin marking it off from a context to which it becomes *de facto* tied. When the nonartistic world insists on the artwork's artistic autonomy, this autonomy is merely ideological; the assumption is that the context has the upper hand in its dialectic with artwork. So long as its context is something external to it, an artwork can never be heteronomous, for in this case the context remains undialectically other to the artwork. And no artwork can be genuinely autonomous so long as this autonomy is a product of context, for an autonomy manufactured from the outside is no longer autonomy.

During his visit in the museum, Valéry sees the paintings jockeying for his attention: they are incompatible, warring factions. Why should artworks be incompatible? Each work makes a claim so exclusive that it cannot be compared with others. It is therefore a *weak* singularity, one that does not dare prove itself. Perhaps the works share too much essence not to wish each other's death. They have been made, by the ideology of uniqueness, too much alike to be peaceful neighbors. Valéry writes, "This is a paradox: the more these gathered independent marvels become mutually antagonistic, nay enemies, *the more they look like*. . . . This painting, it is often said, KILLS the others around it" (*Valéry* 1291–92). Valéry

understands, however indirectly, that the esthetic homogenizing of art is responsible for the discord among artworks. The esthete insists on the singularity of each artwork but also claims this singularity to be the essence of all artworks. Once singularity is asserted as an abstract principle indiscriminately applicable to any and all art, it reverts into its opposite, similarity, which condemns the works to an all-out war for recognition. Modern museums have remedied this situation, but not by solving the esthetic contradiction responsible for it, but through expediency: artworks are held in private confinement and bare space is used prophylactically, as a *cordon sanitaire* separating each work from every other and all from the visitors. Trained by the syntax of presence and presentation orchestrated in museums, we expect the artwork's uniqueness to be signaled overtly. The modern museum has taken to heart Donnay's remark that the frame is not enough to separate artworks. The difference between artworks becomes abstract, almost a matter of faith. Thus cocooned, artistic uniqueness seems to convalesce, rather than shine, on the museum walls.

The frame was originally designed as a limit. Bulky, baroque ornate frames owed their existence to the tightly packed exhibition space. The more the frames encroached upon one another, the more they staked out their territory with flamboyant defiance. Only a limit that knew itself to be constantly threatened could need such display. The more its claim at protecting the artwork was challenged, the greater was the show the artwork made of its apartness. The fiery gilding and convoluted frieze of the classical frame reveals that art then belonged in a powerfully dynamic space wrought with conflict. The gold of the framing is the spark that flies from the clashing artworks. In this sense, the contentiousness of one artwork against the next became an object of beauty itself. The frame stood out esthetically, it created around the work an intermediary world of esthetic forms, of dazzling, efflorescent shapes. The gilded frame was an intimation of the experience of beauty. Not only did it say that art was transcendent but also that its transcendence was beautiful.

Such transcendence bespeaks a historical state of consciousness that still believed in the concrete possibility of the ideal. Today this ideal has fallen into disrepute. Social criticism has exposed the alliance of idealism with repressive state machinery: the ideal was a promissory note for the individual who had nothing to hope for from earthly justice and happi-

ness, a sublimation of suffering. Yet, precisely in marking itself off, the ideal also showed there was a possible world outside the one upheld by the status quo. As such, the transcendence of art was also a critique of the status quo, a quiet indictment of the empirical world of means and ends. The golden frame clearly marked off the separateness of art, not as something necessarily powerless and removed, but as hopeful and defiant. There is a similarity between the gilded ornateness of the traditional frame and the drum roll announcing the trapeze artist's dazzling jump: both were intimations of the extraordinary, the dangerous and the superior. The gilded frame spoke of an art uncowed by the pressure to blend in and keep quiet. Brash and loud, the ornate framework upheld the utopian promise of art above and beyond the material reproduction of existence. By comparison, the utopian space of art today looks sheepish: it seems to imply that art's transcendence has become an abstraction, something unfathomably distant, almost too ethereal to manifest itself. In the credo of estheticism, the work of art is a singularity, an island of subjectivity in a world immune to its claim. As soon as the singularity of the art becomes an esthetic abstraction, the frame loses its purpose. Because it becomes useless (because it is never crossed) the frame slims down to a bare outline, and is sometimes even absent. Suspended on a long stretch of wall, the work floats in spacelessness. Any frame that may still adorn it is merely vestigial—decorative prop or historical nostalgia. Art's difference, it seems, has given up the fight against the social totality: it retires into the charterhouse of a silent, neutralized isolation.

Baudelaire's poem "Le Cadre" (The framework) seems to articulate the transition between the gilded frame of yore (which bespoke an intensely differential experience of art) and the modern self-effacing frame (which relates to prophylactic confinement):

> Comme un beau cadre ajoute à la peinture,
> Bien qu'elle soit d'un pinceau très vanté,
> Je ne sais quoi d'étrange et d'enchanté
> En l'isolant de l'immense nature. . . . [81]

> As a beautiful frame brings to a painting,
> Of a lauded master made,
> Something strange and beguiling
> By bracketing it off from immense nature. . . .

Baudelaire echoes art's apartness from ordinary life. The frame thus serves to impress art's differential nature, a difference that puts the artwork in touch with what it is not, with its publicness. Yet, for Baudelaire, the frame (or publicness of art) emerges as a problematic space. The framework brings a surplus to the artwork, which by definition needs no such supplementation ("painting . . . of a lauded master"). This supplement, however, is a principle of uncertainty: it adds a difference that is in itself sublime ("je ne sais quoi d'étrange," or "something strange"). About the gesture of framing, the poet only says that it is strange, that it differs, that it is sublime (the "je ne sais quoi"). As sublime, the frame sidesteps its own place, it breaks the frame of its own ontology. Hence the strangeness of art is itself strange. The frame underlines a difference but withdraws from this difference at the same time, canceling itself out at the very limit where it draws a line between the canvas and "immense nature." The frame-lined difference of art ends up consuming the frame that makes it occur. On the frame, difference differs from itself. The artwork is different from the world not because it simply stands out from it, but because its difference itself is sublime, because its difference is different, because art's strangeness is strange.

In Baudelaire, the beauty of the frame (or of the difference of art) consists in its sublime disappearance. Hence the work of art's singularity cannot even be marked by the frame. This amounts to suggesting that art's publicness is itself unlocalizable, unmarkable. Baudelaire represents a moment in the history of art where art's publicness has left the transcendental sphere and has yet to succumb to the ideology of its isolation. Art is no longer the separate realm behind the gilded frame, but it has not yet become the abstract realm that cannot even mark off its apartness (the frameless painting floating in the white ether of the modern gallery). Baudelaire's frame is still a frame (it still marks off the publicness of art) and yet it disappears precisely from this very marking. It simultaneously states the presence of art and denies that it can be pinned down to an empirically defined place. In Baudelaire, the space of art is artistic. And yet it is artistic because it has not lost touch with the nonartistic space. The work of art's autonomy is a dialectical moment of its heteronomy. In this, the experience of the frame—or of the museum—parallels the experience of the individual in the crowd, the "foules" which represented for Baude-

laire an everlasting object of fascination. The crowd, like the museum-framed artwork, embodies the dialectical construction of individuality, the publicness of isolation.

By contrast, the modern gallery fetishizes the artwork's difference to such a degree that it endangers the difference itself. To uphold the difference of art (its frameless, boundless, utopian floating in bare space) is to wreck its real difference, which is difference from all affirmation, even the affirmation of difference itself. The utopia of art is real in Baudelaire because it is not yet ideological. It borrows from the intense publicness of the classical frame only to turn it into a sublime principle, thus unlocking the ambiguity of art's publicness in the midst of publicness itself.

The debate concerning the esthetic framing of art has evolved into an *artistic* concern. In many a contemporary artwork it is the subject and material of the work itself. This shows that the museum has moved inside the work of art or, correspondingly, that the work of art has taken over the space of its estheticization. Frank Stella's frame paintings represent just such an effort at pulling the enframing of art into the work of art itself.[82] Knowledge of the artwork's heteronomy (its bordering on the world) is here the artistic matter itself, something debated in the work of art. In a true dialectical fashion, the outer moves inward. In the same stroke, the work of art turns itself inside out, its entire space is occupied by its border with the outside world.[83] The work of art becomes its own marginal difference from the world and from the space of art itself: it is an endless negotiation between the two, the antagonistic interzone of their entanglement. Stella's work is the dialectic tension between autonomy (which is consumed by the outer frame) and heteronomy (which is drawn inside the self-defined, self-involving frame of the work of art). Neither inside nor outside the frame, the work of art merely takes place in the space of difference between the world and art.

In bringing the frame into the artistic space, Stella concretized the vague anxieties concerning the publicity of art. Those anxieties have crystallized on the frame: the history of framing art no doubt contains the history of the anxiety concerning difference: it is about how we stand before art and where art stands in our life. Once again it may prove worthwhile to reawaken the ghost of the museum's ancestor in order to approach this question. Reenter the *Kunst- und Wunderkammer*.

The Decline of Subject

Donnay's comment that "the frame is not enough to isolate the painting" is representative of the esthetic mood that prevailed over the re-designing of museums everywhere in the twentieth century. Sparseness was everything. The modern museum takes seriously Valéry's complaint that grouping artworks together is injurious to art. These curatorial scru-ples led to the decision to exhibit only a portion of the museum's overall collection at any given time and to lay out the galleries in such a manner that artworks do not impinge on each other (this was the intention of the Beaubourg Museum, which, using moveable partitions, wanted to custom-design a "privacy" around each artwork). By the 1930's, the Louvre had finally discontinued the "en tapisserie" style of juxtaposing pictures from top to bottom of the gallery walls.[84] Since then, a minimalist esthetic has prevailed. It opposes the earlier, seemingly more indiscriminate, habit of covering an entire wall with paintings. The blithe jumble of the pre-modern salon of paintings is now regarded as slovenly. It took roughly a century for the museum to make the earlier "cabinet of paintings" style look outlandish and shocking to modern taste. This change explains the feeling of cultural estrangement one might experience in looking at "cab-inet d'amateur" genre painting. Such painting, still common in the sev-enteenth and eighteenth centuries, speaks of a different experience of art's publicity. The salons painted by Saint-Aubin on the occasion of the yearly art show in the eighteenth century reflect the old miscellaneous style, where every inch of the walls is covered with assorted canvases in an im-possibly crammed display. "Cabinet d'amateur" painting seems to leave no choice to us (patrons of the modern museum) but to gape in bewil-derment. In looking at the display, the eye shuttles restlessly between the detail (the individual painting nearly obfuscated) and the whole checkered tapestry. The gallery is supposed to stand as one panoramic display; yet no synthesis is seemingly possible between the individual work and the jum-ble. Our eyes blink. We are finally forced to concede the truth of Valéry's reaction: "They jealously grapple for the gaze that brings them existence. They clamour for my indivisible attention from all sides"(*Œuvres* 1291).

We are almost grateful when, as in David Teniers's *Kunstkammer* painting *The Archduke Leopold-Wilhelm in His Gallery at Brussels* (1651),

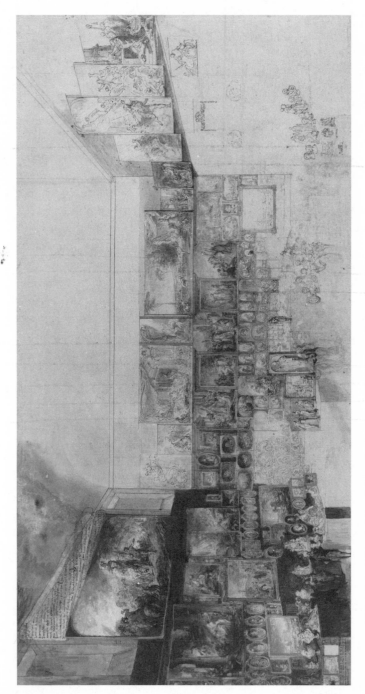

FIGURE 4. Gabriel de Saint-Aubin, *Salon of 1765*, watercolor. Louvre Museum, Paris.

the painting includes the figure of the collector in the center of the picture: he provides the focal point on which to anchor the disparate jumble. Ownership, we understand, unifies the clutter: the only thing these paintings all have in common is their owner. Man stands at the governing center of art, the only punctum which, in Teniers's painting, provides depth in a world of surfaces, a *deus ex machina* that turns the sum of parts into a whole. The problem of art's publicity is solved anthropomorphically: the subject's ownership domesticates the autonomy of object. Valéry's dilemma of synthesizing the warring claims of separate works is solved by the human figure, just as all tensions in the kingdom are finally appeased in the monarch.

By the same token, however, the subject is no longer absolutely distinguishable from the object. Teniers plays on this ambiguity by framing the collector amid his collection, the door frame acting as a picture frame around the subject. Whereas Teniers's other *Kunstkammer* paintings set the collector clearly apart from the canvases, this particular one depicts the collector on the same scale as most of the larger characters in his paintings. The collector disappears into his collection. The human figure synthesizes the collection at the level of intellectual projection; yet at the level of perception, in the display of painted forms, the human figure joins the collection. He to whom the collection belongs, belongs also to the collection.

This reciprocity points to an entanglement of subject and object found only in ownership. This, at least, was Benjamin's idea about ownership: "The phenomenon of collecting loses its meaning as it loses its personal owner. Even though public collections may be less objectionable socially and more useful academically than private collections, the objects get their due only in the latter."[85] Is the decay of the private collector a decay of ownership? Bourgeois mentality in its early phase valued accumulation and ownership as the mark of social fulfillment. The early bourgeois subject saw the world in terms of possession and nonpossession. It never occurs to Crusoe that the island on which he has just been stranded can be anything but his dominion. He relates to his objective environment first and foremost as an owner, thereby transforming it into an extension of himself as subject. That is why an attack on any part of the kingdom was construed as an attack on the king's body, that is, against the

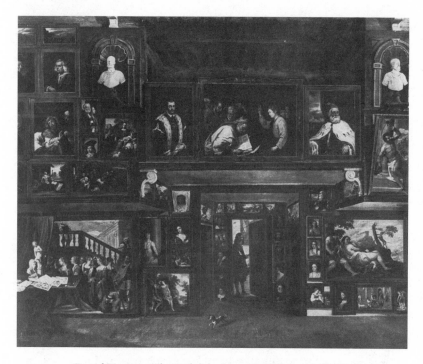

FIGURE 5. David Teniers, *The Archduke Leopold-Wilhelm in His Gallery at Brussels,* oil, 1651. Alte Pinakothek, Munich (Foto Marburg/Art Resource, New York).

sacredness of subject-object. By contrast, the owner in advanced capitalism is a mere plenipotentiary. From the president of a democratic nation to the private homeowner, the individual is just a *manager* of resources that, thus objectively defined, can be passed on to the next competent person. No longer to be eternally possessed, but rather to be grabbed and disposed of, the object loses the glow of familiarity that ownership gave. Subject and object are no longer bound together by sentimental ties. Already in Balzac, the miser is somewhat of a vestige: the infantilism implicit in his hoarding conjures up images of a precapitalist world of hunting and gathering. Likewise, to Benjamin, the collector is a relic of the immanence between subject and object occurring in precapitalist ownership.

With the decline of ownership comes also an increased alienation between subject and object. Something that may account for the aloofness of art in the modern gallery is the fact that it does not belong to anyone, not even to the museum trustees who sometimes approach artworks as sound investment. No doubt the emancipation of art from ownership means that art can begin to stand on its own, its artistic integrity no longer overshadowed by the collector's prestige. That art is not to be "had" agrees with the emancipatory thrust of art. On the other hand, the separation of art from ownership contributed to the autonomization of art and the frigid division of subject and object. Today the subject no longer has a place in the space of art, except one that is strongly marked by exteriority. Looking at art has become synonymous with being an intruder in the realm of art. If we have qualms about the crowded walls of Archduke Leopold's gallery, it is because we, as esthetic subjects, have been trained to occupy an estranged position toward art. However socially repressive it was, ownership made for a far less stark dichotomy between subject and object. As such it replicated the experience of art itself: in the artwork subject and object do not contemplate each other at a distance but constantly exchange positions; this is the dialectic of creation that, in the successful artwork, braids subject and object almost seamlessly. That the space of art has become resolutely discontinuous from the observing subject seems to indicate an estrangement between subject and object that perhaps exists even at the level of the individual work of art itself: this is what is known as the de-anthropomorphization, or dehumanization, of art in modern times. If the modern artwork looks so remote on its deserted stretch of museum wall it is also because it plays out the division between subject and object (hence the not-so-naive response that modernist art "does not speak to the viewer").

In the *Kunstkammer*, the collector stands in the midst of art: he shows that the space of art can be inhabited, that it is immediate to the human world. No invisible wall cordons off the subject from the artwork. Certainly, the sense of familiarity with art in the *Kunstkammer* stems from historical conditions, the fact that art then hung in the living space of those who collected it. By contrast, today's prudish estheticization of art so pervades one's experience of artworks that to bridge their remoteness is to be either an iconoclast or a felon. The modern museum leaves a

choice of attitudes that comes down to either obsequiousness or obse-
quiousness overcome. This shows a sentiment toward the object that is al-
most resentment. In the modern gallery, the object is enthroned as almost
a fearful god who has won the battle against the subject. Meanwhile the
subject, who fears his turn is next to become a social automaton, a mod-
ern unit of production, bows respectfully. How different it is from the
confident civility of the aristocratic connoisseurs in Watteau's *L'Enseigne
de Gersaint* (1721). Unencumbered by petrifying distance, the visual arts
are part of a more general art of living that includes the arts of dressing,
of conversation, and of seduction. This familiarity toward art, however,
shows no iconoclasm. This perhaps is the closest we can come to the rec-
onciliation of art and life which the avant-garde dreamt of. To us, the
scene in Watteau's painting looks like the blissful age prior to industrial-
ization, when the subject was still unaware of the formidable ascendancy
the object would be capable of exercising over that subject. Today one can
no longer *befriend* artifacts in this manner: industrialization has imbued
objects with an aura of aloofness and supremacy quite beyond the sub-
ject's control (the whole industrial apparatus of mass production stands
behind them). Thus we either respond to them with resentful boorish-
ness, by casually breaking and disposing of them, or fearful worship, by
toiling every waking hour to secure them.

　　In comparison with Watteau's scene at the gallery, nineteenth-cen-
tury representations of the space of art depart sharply from the casual
portrayal of art and social life commingling. The place for art is now of-
ficialized: it fulfills a ritual of separation between subject and object. The
museum is a place where the subject goes to contemplate and study art.
Both attitudes conform to a mode of passive alienation that perpetuates
the separation of subject and object. For one thing, the museum is de-
signed to discourage any relation, except for exclusion, between the visi-
tor and the artifacts.[86] The subject is asked to participate in his own neu-
tralization: the gaze is first and foremost repression of the desire to touch.
The museum trains the subject to abnegate his primitive craving to en-
gage his surroundings actively. The museum teaches compliance: in giv-
ing up touching and accepting the abstraction of gazing, the individual is
meant to relish his own repression and sublimation. This came with an
impressive bureaucratic apparatus. "The Golden Age of museums" wit-

nessed the implementation of a pervasive cultural plan overseeing the organization of museums throughout France.[87] Those museums whose disarray smacked of the country store or recalled the premodern cabinet of collection were chastised. Uniform policies and guidelines enforced a rationalized and compartmentalized presentation of artifacts. A state commission insured that the same standards of esthetic reception applied everywhere. Increasingly, pets, bags, and walking sticks were confiscated at the door. The visitor had to observe religious silence and self-restraint in those same galleries which had previously been the site of unchecked vocal ebullience.[88] Holding court or conversations in the galleries became subject to ridicule and sanction. For fear of being thought a philistine, the bourgeois acquiesced to his own silencing. Sacralization of art goes hand in glove with the neutralization of individualistic behavior. The enthronement of the artwork entails the desubjectification of subject, its normalization. The bourgeois order liberates access to art, yet does this on behalf of individuals who ought to hold themselves in check. The quasi-religious atmosphere in the museum is thus one where the subject is actually taboo. Individual behavior is allowed only in a highly sublimated, idealized form. In any case, the stately, sacrosanct presentation of the artworks basically leaves no choice but that of submission to authority (of history, of the state, of knowledge, and so on). Thus, even in his hours of leisure and relaxation, the subject is entreated to participate in his own self-abnegation. Bourgeois leisure in the museum is as much a prohibition of pleasure, that is, of the sensuous, self-willed subject, as bourgeois work.

The ideal visitor in nineteenth-century representations of the museum is, accordingly, the copyist. Countless images of the museum represent the esthete silently studying and copying a single artwork. The copyist embodies the ideal museum subject, marked by focus, exclusiveness, and, most of all, obedience to models. The esthetic singularization of the artwork thus entails the neutralization of the bourgeois subject who is defined by his power of self-abstraction, compliance, and exclusive focus on a single object. These are the skills drilled into the modern worker, who is rewarded according to his ability to specialize. The modern subject too is autonomized, mostly for the sake of production. Like the museum artifact removed from all context, the bourgeois subject acts monadically in

his social existence. The subject's estrangement from others finds an analogy in the idea that artworks ought not to touch, that they ought to steer clear of each other's path. The moment Leopold-Wilhelm's gallery becomes every citizen's museum marks the moment when art begins to scream against its collective presentation. In other words, the work of art begins to behave like a fiercely individualistic monad when its appointed viewer becomes a monad himself. This monadism of the modern subject, however, is a sham, a slogan. For the modern visitor is synonymous with anonymity. It is no longer Leopold-Wilhelm facing us, but the face of the people, the faceless individual turning aside, the black-coated nobody who stands for every body. The modern individual is one who insists increasingly on his individualistic apartness even though, in the last analysis, this individualism is what individualizes him the least, what is least particular about him. The museified work of art, like the alienated viewer, cannot stand the presence of other artworks and becomes a unicity that cannot even prove its uniqueness.[89] The decay of the *social* idea of community is collusive with the *esthetic* intolerance toward the crammed display of the *Kunstkammer*.

Estheticizing the Bourgeois

That the work of art is intensely individual, intensely its own, is no longer proven by putting it into contact with other works. Art in the modern gallery is a monad removed from the space of contention and division, a *vox clamens in deserto* muffled by great distance. The modern gallery's notion of individuality is one of alienation: the work of art, like the individual in the public sphere, is asked to keep to itself. Even the content of the work of art is deemed to be the product of such deep individualism that the only proper mode of dealing with it is to isolate it as something *sui generis*. The work's individuality is no longer put to the test by placing it alongside other works; it is enforced *de jure*. The modern work of art mirrors the alienated state of individuality in advanced industrialism, an individuality taken to be self-evident but which cannot prove its reality. The historicist and estheticist purification of museum walls points to the ideology of the individual in the public sphere. As a

public space, the museum puts forward an allegory of the social space in which individuality—the "frame" that appears when beings are brought in contact—has become an ideological token. The work of art speaks as something fiercely particular, but behaves like the bourgeois individual whose particularity ("originality") has atrophied from disuse because, in fact, it is a statement of conformity.

By contrast, the artworks in the *Kunstkammer* sought neither conciliation nor estrangement from one another. They were true public subjectivities, that is, singularities that emerged out of their publicness. In nearly touching, the paintings had their separation in common. The singular artwork was not singular because it had been declared an idol; its singularity emerged out of the density of those nearly interlocking frames. Inasmuch as there was almost nothing between two canvases but their difference, this difference stood out as being the product of the works themselves. Their difference was negotiated, actively communal, antagonistic rather than apologetic (as in the ideology of art's apartness). Similarly, only in a society where individuality is challenged instead of enforced (through suburbanization of behavior), does it prosper. An individualism that has its sanctity handed to it is feeble and hollow. It bespeaks a social totality in which true individualism is taboo. The incommensurability of the work of art, as of the individual, is excised the moment it is enshrined for its own sake.

The estheticization of art thus parallels the estheticization of the bourgeois subject. It neutralizes true individuality under pretense of its defense. The standardization of museum behavior which began in the late nineteenth century—silence, unhampered mobility, absence of chatting, eating, prolonged stopping, and so on—results in the depublicization of the artistic experience, but also the depublicization of the viewing subject. Even in the public sphere of the museum, art is meant to be consumed privately. Just as the work of art basically keeps quiet on its lonely stretch of wall, so the individual in the public sphere is asked to behave monadically. One never has to behave so privately as when one is in public. The bourgeois social sphere has all but reversed the meaning of individuality and publicness: the public arena is where the individual is asked to be extremely repressive of public expression of the self, of publicness; and the private sphere is where the individual is free to behave openly with his or

her environment, that is, to behave publicly. The right to be an expressive public subject has been transformed into the obligation to be private about it. Individuality is the tacit acceptance of doing away with any demonstration of individualism. Individuality has thus been estheticized: in other words, it has become publicly ineffectual. (The private sphere also is affected by the repression of individuality in the name of its protection. In letting the individual have his or her publicness only in the private setting of home, one's privacy is unavoidably scarred by frustration and nostalgia. The idyllic character of home, of one's privacy, comes from the nostalgic reminiscence that such privacy was once free to be public.)

The museum stands for the esthetic privatization of the individual. The privateness of the museum visit is duplicated on the museum walls, where the intensely particular (the work of art) is asked to keep to its own. The museum realizes in relation to art the ideological feat performed on the subject: the muzzling of individuality by overindulging it. Artistic uniqueness becomes ideological, the forced imposition of a pious aura around the artwork. Marc Chagall perceived quite well that the neutralization of the artwork on the bare wall somehow implicated a neutralization of the individual. This is what he expressed in response to the revamping of the Louvre:

I don't care much for that big dusting-up at the Louvre. It is unrecognizable. I loved those paintings tightly scrambling over the walls all the way to the rafters. Everything was vertical, and intimate. But the present tendency is to hang one painting on the wall. I am told what to see, everything is signaled. Thus isolated and shown off, the painting tells me: "respect me." I, for one, liked to search and find.[90]

This wish ("search," "find") is that of the individual who once found amid the clutter of the cabinet d'amateur the opportunity of discovering a piece that would have significance for him alone. The value of the artwork was heightened by the experience of its discovery. The "cabinet of painting" museum suggested an artistic experience in which singularity was not given immediately, but emerged out of dialectical involvement with publicness. The publicness of the artworks, as Chagall sees, was an opportunity for encountering art on a dynamic basis. The single artwork emerged

out of intimacy with other works, out of the publicness of art. In actively extracting the work from the many, Chagall experienced an engagement, a discovery and even invention of the work of art. Finding alone the one object that would outshine all others, the old-style museum-goer exercised the individuality of his publicness. The discovered gem said something *about* the viewer who had discovered it; by contrast, the overexposed art piece of today's museum says something to the museum-goer—"view me, respect me." The viewer's reception of the work is a standardized and stylized attitude to which he is forced to conform. The false (that is, ideologically manufactured) individuality of the artwork artificially singularized on the bare wall parallels the ready-made, abstract individuality of the museum-goer: one size fits all. The sacralized artwork screams at the visitor in the voice of repression of individuality (all under the pretense of accommodating the individual's private consumption of artworks). And it is the repression of art, disguised as protection of art's particularism and of the individualism art stands for.

In the modern museum, the work's difference becomes an idyll, a discourse that knows itself to be false. The deserted architectural landscape of the modern museum, where works are set off as far as possible from each other, is too contrived not to remind us of the cluttered world it wants to avoid. Now that any shop commands at will the admiration previously reserved for the cornucopian *Wunderkammer,* isolation and minimalism become virtues—an exorcism of the commodity. The museum assumes the appearance of a monastery to avoid being mistaken for a mall chock-a-block with mass-manufactured goods. Whereas a leisurely stroll through the "cabinet d'amateur" was acceptable, in the modern museum it would look too much like the stupefied response standardized in the shopping arcade.

Recent artistic production indicates that art seeks to escape the rarefied atmosphere of the modern museum. This is apparent in, for instance, the works of Andy Warhol, which embrace serialization, hence multiplicity, in their very substance. The modern work of art favors series, and openly manifests its belonging to a sequence of other artistic works. Accordingly the painting is best exhibited serially, along with other paintings from which it differs all the more for its being intrinsically bound to the series. The modern work of art then does not demand to be set apart

as a matter of right, just because it exists: on the contrary, it conceives of itself as a member of a series, a member that derives its singularity from its being *in* difference with other paintings. The serial work of art overcomes de-individualization, not by preaching the gospel of the single incommensurable work of art, but by mimicking it. By focusing on the same gesture in every work of art, the contemporary artist looks for dissimilarity in similarity itself, a dissimilarity that bursts forth from the series and makes each element distinct enough to risk being mistaken for each other. The work's difference comes from its being *in* difference, from the indifference that may strike the eye as one steps into a modern art gallery. The effect is not so unlike that of the *Kunstkammer*: one does not know which one to look at, or whether they are all to be looked at collectively. Neither way is correct by itself. Rather their collective difference, their dissimilarity in the midst of collectedness, is a resistance to abstract, compulsory similarity, a resistance that is possible only where there is true difference.

The image of the *Kunstkammer* remains for us somewhat of a puzzle and a regret. The strip mall and department store have spoiled whatever enjoyment one could have taken in the crammed collection. Estheticism is the bad conscience of the mass market and, even when cheerfully championed by pop art, this bad conscience is not so easily forgotten. It seems as though estheticism cannot be given up without declaring the defeat of art in the face of the industrial leveling of all existence. The religion of art-for-art's sake began not so much to make up for the secularization of art and social life in modern times, but to rescue art from the trivialization of objects and object-making. To question the singularity of the artwork is to undermine the difference between the artwork and the commodity, a strategy that only a very shrewd ironist, like Warhol, can attempt without canceling the very idea of art altogether. It is in any case significant that Warhol did away with the idea of artist, and even of the individual, when he renamed his studio "the Factory" and began turning out artworks in the same way Henry Ford produced cars. The serialization of art, modeled on that of commodities, suppresses the individual who takes refuge in estheticism's claim for the individuality of art. The contemporary gallery, with its stylishly sparse environment, shows that

postmodernism and pop art have to some extent overcome the faint-heartedness of estheticism.

Flaubert captured the uneasy conscience of modern artistic reception in a way that still seems relevant today: the collector in "Bibliomanie" who sacrifices his entire collection for the acquisition of one single object. Here, esthetic fixation on the single artifact rules out the idea of the museum itself, of the publicness of art. But there is also the chaotic universalism of Bouvard and Pécuchet's encyclopedia. Their museum unleashes a saturnalia of miscellaneous objects tumbling over a world where hardly anything is not worth collecting—indeed, a world that is its own collection. The stories of "Bibliomanie" and *Bouvard et Pécuchet* sketch out the two dead ends where esthetic thought corners itself: the impossibility of presenting absolute singularity without destroying it and the anarchy of a desingularized, desublimated world. Nothing or chaos; the sublime or its grotesque liquidation.

The Identity in Question

"Museums," Carol Duncan writes, "can be powerful identity-defining machines."[91] The museum is an identificatory powerhouse, a builder of community, "a political resource whereby national identities are constructed."[92] Thus the creation of museums in the nineteenth century is tied to the rise of nationalism and the forced identification of individuals with a civic, national character. Already in 1815, the return to Antwerp of paintings confiscated by France during the Napoleonic campaigns prompted the type of public rejoicing and triumphant parading formerly granted to royalty.[93] The people saw their national heritage, their collective identity, embodied in artworks. This assimilation of cultural heritage and national identity undergirded the creation of museums. A visit to the museum henceforth became a way of paying ritual respect to a collective identity, mostly prefabricated and handed down to the people whose observance of a cultural agenda was dictated from on high. To this day, the museum is a totem invested with the authority of the great historical ancestor giving his blessing to the cultural politics of the current regime. In the museum, France is no longer simply a geopo-

litical entity. It is a mythic body, an emanation of the wisdom and reason of history itself.

More recently, museums have awakened to the repressive dimension inherent in the idea of national institutes of art. Just as the museum was once a powerful tool of neutralization, it can also act as a no less powerful agent of emancipation.[94] In the last decades, curators have made room for counterhegemonic exhibitions which give voice to the voiceless. Identities are claimed for those trampled by the march of the World-Spirit. The museum now cries *mea culpa*.[95] No longer does it cater to the abstract citizen consumer, the so-called civilized subject who viewed alternative cultures as primitive, infantile cases of arrested development. The museum's task is now to foster the dignity and recognition of overlooked communities, to look for an identity that suits the multiplicity of identities in a heterogeneous society. The museum's self-critique extends to its mode of exhibition.[96] The ecomuseum is an answer to both the problem of hegemonic culture and the lack of authenticity attributed to artifacts in museum exhibition.[97] In many instances, the ecomuseum functions as a locally operated community center that not only preserves the past but also actively promotes consciousness raising, public participation, and economic and social development. The museum has evolved from the role of guardian of the past to that of patron of present local life. There, art is not to be contemplated reverently but engaged, discussed, even touched, created, and exchanged. Through the ecomuseum, consciousness reawakens to the necessity of integrating art and artifacts with the praxis of existence.

There are examples of tribal museums which, operated by the indigenous people themselves, exhibit art in a manner consistent with traditional modes of displaying the potlatch and tribal properties. In such instances, the museum acts as a "ceremonial house," rather than the hall of dead culture.[98] The museum's involvement in mediating community identity is carried to the point where it lets itself be mediated by these identities. The Western idea of collecting historical knowledge and art is reinterpreted according to the local understanding of history and art. In such cases, the museum becomes nearly indistinguishable from the ways of life: it is the ceremonial space of the potlatch, a vivid participant in the community's self-creation. Ownership, which had not been seen since the

days of the private collector, returns to the museum. The Kwagiulth people of Northwestern Canada, for instance, designed an exhibition of tribal artifacts according to family ownership.[99] There is no denying the power of such instances, where tribal cultures take over the institutions of Western culture and reinscribe them according to their own customs and needs. Community-conscious ecomuseums strive to return art to the practical life of those whom it concerns. Authenticity, as well as political and social justice, are what drives the ecomuseum: by giving a voice to its patrons, the museum still tries to abrogate the esthetic distance separating the artifact from its beholder. Breaking through the glass cage, the museum wants to make itself into a genuine part of the community's self-invention: identity would not be something nominally given, but a process of creation and participation, contention and revision. Diversity is celebrated over sameness, multiplicity over monoculturalism.

The question remains, however, whether the community-conscious museum has successfully defeated the ideology of identity promoted by the traditional museum. Certainly it has *relativized* the notion of identity by altering it quantitatively, by multiplying it. But is this quantitative change sufficient to diffuse the repressiveness of cultural identification? As Ivan Karp writes, "the *individual* experience of viewing a museum exhibition is organized by memberships in (that is, identification with) *communities.*"[100] This states that museums deal in *identification* rather than identity. Identification entails the mimetic absorption of the individual into an ideal image of the group, the prototype, the ancestor, the father. Conceived as identification, that is, as power gathering, identity entails repression: it groups and categorizes and therefore eliminates and coerces. The discourse of "empowerment" of identities that surrounds the "revised" museum underscores the fact that the museum is still in the business of transforming individuals into collective identities (even if it is to serve socially emancipatory aims). The focus on empowerment through identification casts doubt on the ecomuseum's promise of liberation. Can identification avoid repression, apology, and essentializing? Identification empowers at a political level, that is, insofar as it serves the need for political leverage. That identification with the group is deemed a "good" thing by those who place the group (and whatever profit might derived from it) above the individual (less easily managed than crowds). Al-

though it is true that there is no individual well-being without the dialectical interaction of the group, identification demands of the individual that he or she surrender the experience of self-individuation, that is, the very dialectical principle that binds the individual to the group as it separates her from it. The empowerment that cultural identification promises is a generalization: it necessarily cuts across, perhaps even annuls, the manifold contingency of personal experience. Once made into a fetish, identity undermines the very individuality it purports to support. Celebration of identity becomes joyless and sinister when it insists that dignity exists only inside the law of identification.

This is not to embrace a mood of postmodernist *laissez faire* that would blithely throw all identity out the window. But it points to the fact that, however celebratory it is of alternative identities, the museum still involves forming political constituencies by means of alienating modes and techniques. That the seat of museum power has changed hands, from the mandarins of high culture to sympathetic curators of living exocentric cultures, does not mean that the repressive structure of identity creation has been altogether reformed. If only because the museum visitor is addressed as a *public*, he is asked to identify with an abstraction, a disembodied and truncated sublimation of himself. Even cultural difference, when it is made into an object, a fetish, reverts into its opposite: compulsive identification with difference actually stifles difference. The proof is that the social status quo has accommodated itself quite well to the claims of cultural diversity coming from the left side of the political field. While museums and university curricula celebrate multiculturalism and counterhegemonic identities, affirmative action programs, the rights of individuals against corporations, and the principle of social justice are losing ground in courts of law. That the cultural establishment is intent on preserving museums and educational institutions, even when those are ostensibly opposed to that same establishment, shows that the museum still acts as a neutralizer. Cultural difference is sublimated as a thing of culture, an object of exhibition, a principle of abstract identification. And abstract identification, or sublimation into culture, is agreeable to the political establishment. The fixation on cultural authenticity and identity can be synonymous with oppression because it abstracts the individual and demands of him compliance with an ego-ideal. It creates an individ-

ual whose gratification is tied up with his degree of absorption in group identity.

To be sure, the community's direct involvement with the choice and contents of museum exhibitions has transformed the museum into a place of contention and revision that, in theory, militates against the idea of the individual as a product of identification with authority. Yet it is still arguable whether the ecomuseum and the diversified community museum can avert the trappings of the traditional museum. The ecomuseum revokes the image of the ideal citizen as subsumed by canonical culture; but it does not do away with the fetish of identification which, on the contrary, it ratifies with the discourse of authenticity and "empowerment." True empowerment of the individual, however, entails the resistance of the individual to cultural and political assimilation. Otherwise it remains as oppressive as the obedient identification promulgated by the traditional museum. It is noteworthy that the idea of the community-based ecomuseums in Europe actually got off the ground during the most authoritarian days of twentieth-century history: it originated with the activist folk museums created by the Vichy regime, the network of homeland museums (*Heimatmuseums*) in Nazi Germany, and Mussolini's Museo di Roma.[101] By promoting "roots" and identifying the individual with a folksy, contextualized, and locally meaningful culture, these museums advertised culture as compulsive identity formation. The old Quatremèrian idea of exhibiting objects *in situ* with an eye for "authenticity" once again came into vogue (the idea was to "bring displayed objects to life by displaying them in context . . . i.e., by reconstructing the setting from which they had been extracted").[102] Excessive identification with culture stultifies individuation, turning it into a static essence or blood-and-soil substance rather than an emancipatory and creative activity.

This is no doubt a lesson to the ecomuseums of today, which, touting difference, make difference into a cultural fetish, hence a piece of reification. Shifting the focus from canonical culture, the museum must also strive to avoid the ideology of immanence and absorption into *any* culture.[103] One of the museum's tasks today is to debunk the sacrosanct aura of culture which it is partly responsible for establishing. By doing this, the museum would prove itself more attuned to the art it exhibits: isn't art, in the last resort, a resistance against the sanctity of culture? Does

not art incise culture, break it? The museum's responsibility is to upset, and not only cajole, the cultural status quo and the very notion of cultural identity, which has proven to have dangerous affinities with authoritarianism. But this can only come through a radical critique of identity. Perhaps, like art, the museum ought to become a site of resistance to the sanctity of identity itself: it would then perhaps become truly cultural, that is, on the side of invention.

2

Bringing the Museum Home: The Domestic
Interior in the Nineteenth Century

Dwelling in the Nineteenth Century

> Collecting has completely pervaded the customs and leisure of the French
> people. It is a vulgarization of the artwork or scientific object which previous
> centuries reserved for museums, the nobility and artists.
>
> Jules and Edmond de Goncourt, *Journal*

No study of museum culture in the nineteenth century can do with-
out considering the bourgeois interior. The "democratization of collecting"
that Rémy Saisselin identifies in nineteenth-century society helps account
for the flourishing of home collections in interiors increasingly conceived
as private museums.[1] It is as though the bourgeois individual could only
feel at home after assembling a houseful of bibelots, trinkets, ornaments,
and gimcracks, and after surrounding himself with a luxuriance of the
priceless, the semiprecious, and the junky. It is as an *owner* of a great many
objects that the bourgeois individual inhabits the home. To dwell is to
possess. Home and property strike a perfect constellation in the concept
of the private collection. For ownership to shine, the bourgeois dweller
must supplement it with collectorship: he therefore needs a display of ob-
jects linked to him by sentimental ties. Collecting is a way of taking pos-
session of the world, a way of domesticating the exotic by keeping a tribal
mask on the mantelpiece, of securing the distant past through an antique
statue, and of enshrining personal memory by means of a souvenir. All this
has the effect of making the home the center of a wide temporal and geo-
graphic circle at the core of which the world is encapsulated in miniature
form. The home thus becomes the domestic keeper of all things far and
near, the center of gravity of ownership at the basis of the bourgeois world.

What further likens the domestic interior to a museum is its taste
for things historical. Various histories of interior design all concur on this
one point: cultural plundering, stylistic borrowing, and historical pastiche
constitute the *primum mobile* of nineteenth-century interior design.[2] The
household gods are historicism and conservation, a mixture of picture-
postcard exoticism and erudite panache, Flaubert's *Salammbô* applied to
home decoration. Like a museum, the home aims at freezing and con-
serving an image of the past in a display of collectibles. Maupassant's de-
scription of Zola's bedroom exemplifies this historical regressionism:

In his Paris apartment, his bedroom is hung with ancient tapestries, a Henry II bed stands prominently in the room where old church stained glass windows cast myriad colors on a thousand fancy bibelots, quite unexpected in this den of literary rigor. Everywhere antique cloths, old silk embroideries, each piece of furniture is crammed with bibelots.[3]

Even at the home of this champion of progress, the interior is an image of historical nostalgia and lingering attachment to the old ways. Conceived as a showcase of the past, the home embodies the great conservative force in society. The private sphere sides with regressionism, as though counterbalancing the drive for innovation taking place in the public arena, in railway stations and public monuments (such as the unabashedly modern Eiffel Tower). Home is where things abide, where they stay the same; it is an idyllic retreat from the progress of science, social upheaval, and industrialism. In this sense, the interior is the place of historical memory. All manners of obsolescence collide in the nineteenth-century boudoir. Louis XV– and Louis XVI–style furniture remained in vogue for most of the century, interlaced with borrowings from the medieval gothic, dewy glimpses of the rustic life *à la* Marie-Antoinette, admixtures of Roman classicism and troubadour romanticism. "It is fashionable to buy antique furniture, and any bank clerk now feels obligated to have his own *Medieval-style bedroom*," Théophile Gautier observes in 1854.[4] In *La Peau de chagrin*, Raphaël admires the juxtaposition of a beguiling little Gothic boudoir with a Louis XVI parlor in a fashionable Parisian apartment. This is the age when the Moorish arch meets the neo-Grecian Venus de Milo plaster, the Gothic-German candelabra hangs over the Chinese pagoda sideboards, and the Taj Mahal candleholder keeps company with the shell-work souvenir from Biarritz. Romanesque whiffs waft across the neoclassical mantelpiece, Walter Scott mingles with the Arabian Nights, a Gobelin tapestry hangs over a Ming-dynasty vase, itself perched on an Abyssinian column; *Sturm und Drang* meets Delphic repose, Chateaubriand's voyage to the Orient, Ossian-style, meets Dumas's swashbuckling, "Hugo-Gothick" views of Notre-Dame de Paris cast sumptuous shadows over Delacroix's racy harems: all shimmers in the penumbra of gas lamps as in a dreamscape. Nineteenth-century decorative mix-and-match finds its trashiest expression in Ludwig II's fairy-tale castles, where feudal coffers financed the apotheosis of bourgeois stylistic

bastardy. As Baudelaire put it, the nineteenth-century drawing-room is all "hullabaloo and hodge-podge of styles and colors, a cacophony of tones, instances of enormous vulgarity, banal design and posing, all kinds of commonplaces."[5] The undeniably kitsch effect of this bric-a-brac is hallucinatory in the opening sequence of Balzac's *Peau de chagrin*, hilarious in the homespun museum of Flaubert's Bouvard and Pécuchet, brazen in the Technicolor daydream of *Salammbô*, apocalyptic in Nana's mansion's "pandemonium of various epochs."[6]

Already in 1836, however, Alfred de Musset took a somber view of this historical mimicry, writing, "Our century has no style of its own. We have not branded our houses, our gardens or any other object with the stamps of our era. . . . We possess things from all centuries, except our very own, a fact which has never been seen before."[7] History for the nineteenth century means imitation, not creation. And even when it is being creative, Marx observes, the nineteenth century knows nothing better than to drape itself in the garb of the old.[8] What is most original about the nineteenth century is its absolute lack of originality. De Musset diagnosed the historical disease which, a few decades later, Nietzsche proposed to cure.[9] The nineteenth century, Nietzsche warns, is purely imitative; it confuses history with learned pastiching of period styles. Indeed, style itself has become synonymous with historical derivation. *Style*, as the power to give form to life, has been debased to the mere ability to imitate. "Our century has no style of its own," says De Musset; it is a shapeless century, a spineless epoch, one which has not found the strength to give form to itself.

Pulled in all historical directions, the bourgeois interior embodies a loss of historical grounding. What could it mean to be in and of the nineteenth century if the nineteenth century is content with imitating other models? It is easy to laugh at Bouvard and Pécuchet's grotesque museum, their amateurish collections, their hapless ingestion of encyclopedic erudition . . . in short, their slavish worship of history. They lose themselves in this antiquarianism, they lose even their language as it sediments into a mass of clichés and linguistic bibelots, a language utterly dominated by imitation. History, at the end of Flaubert's career, devours language and robs the century of its proper tongue, sentenced to endless psittacism. Kitsch is the surrender to historical imitation; it reveals the shallowness of

an age that has not bothered to grow its own roots. The bibelot is an imitative object, a decorative cliché whose models are so variegated and mismatched as to defy all notions of authenticity or restitution. The bibelotized interior points to a failure to make oneself at home in one's own life and times. In this sense, home turns into its opposite, homesickness. Instead of laying down a geographical and historical ground, the home embodies ontological scatteredness: no art of its own, no self-created image, no vernacular identity, no stylistic center of gravity, no home of one's own for the nineteenth century.

Thus, the interior is like a museum, not simply on account of its *Kunstkammer*-like clutter, nor simply because its decor has the appearance of an esthetic display, but because it manifests the nineteenth century's inability to deal with the historical past otherwise than by imitation and appropriation. Like the museum, the interior is the symptom of the vacuity of an age wholly engrossed in contemplating the past rather than cultivating the present. In 1899, the social historian Paul Bourget understood quite clearly the historical and philosophical significance of nineteenth-century home decorating. Bourget models his analysis of the bourgeois interior on the philosophical critique that accused museums of preserving artworks only as uprooted, inauthentic objects. Bourget sees in the bibelotized interior the proof that a mood of cultural and historical alienation pervaded culture, even one's home: "This dilettantish scholarly spirit has spread among us to the point of generalizing the museum well beyond public and private collections, indeed by introducing it in every detail of home furnishing, and inventing the bibelot."[10] For Bourget, the bibelot is an object that, like the museified work of art, has been removed from the fountain of life:

Here [in the interior] the work of art is taken out of its special place, uprooted out of the world for which the artist had conceived it. Consequently it is isolated from the string of related impressions which, explaining its existence, created a living atmosphere for it. (*Essai de physchologie contemporaine, Œuvres complètes* 379)

Heaped along with a multitude of other objects, the bibelotized object strikes no special bond with the home-dweller: "He understands it like a dead language instead of thinking by it like a mother tongue" (379). The museified interior, Bourget argues, fosters a spirit of critical and dilettan-

tish detachment from the arts, an aesthetic alienation: "It is no longer the realm of genius and creation, but dilettantish criticism" (379). Consequently, the home-dweller entertains only an external, purely critical relation toward the object instead of an empathetic, experiential one.

The museumlike home paradoxically fosters diffidence, rather than familiarity, with objects: between the home-dweller and the bibelot lies an aesthetic and historical separation. The bourgeois observes his objects, he does not live with them: the home becomes a spectacle of itself. It is where the individual retires to contemplate "home" as an already distanced historical image of itself. This of course has the effect of turning the interior inside out: home is no longer the ontological center of existence but one of the polarized and alienated objects of an already full-grown society of the spectacle.

To Bourget, like De Musset before him, the bibelot is the clearest indication that the nineteenth century has been incapable of developing a vernacular style:

The bibelot puts something of the Far East, a taste of the Renaissance, a whiff of the French Middle Ages or of the eighteenth century on the corner of a table! The bibelot has transformed the whole of interior decoration and given our homes an archaic physiognomy both so strange and so innocuous that our nineteenth century, by collecting and surveying all possible styles, has forgotten to create a style of its own! (380)

The bibelot is the consummate homeless, or inauthentic, object: indifferent and untrue to its origins (which are, as often as not, apocryphal and approximate), the bibelot's main character lies in derivation. Borrowing from all stylistic periods, the bibelot speaks of an age besotted with historical mimeticism. The interior is the place that shuns the present because it cannot achieve a present of its own. Furnished with objects uprooted from far-off lands whose provenance is likely spurious, the interior is strangely rootless, having no original way of founding itself.[11] A locus of historical escapism, the interior is that by which the dweller fails to dwell in his own century. That such historical escapism came to be felt most in the home is what turns the interior into contradiction. It points to a crisis of dwelling in the nineteenth century, a crisis with tremendous bearing on the bourgeois individual's philosophical situatedness. For a

home is not simply a house. It is an image of how we dwell, how we inhabit the world, how we view ourselves in the world. In this sense, the nineteenth-century interior captures the philosophical image of what it is like to dwell in the nineteenth century and, furthermore, what it is like to *be* in the nineteenth century. The interior represents a basic anthropological document: it tells us about the ontological (and therefore sociological, psychological, historical) self-grounding of a particular society at a particular historical juncture.

In the nineteenth century, the present is a strangely uninhabited place—uninhabited to this day. The decenteredness registered in the nineteenth-century interior anticipates the modern home, which acts as a mere stop-off place between one's present and future job assignment, a standardized shell designed by experts for an ideally abstract consumer. Indeed, it is no surprise that the paean to the bourgeois home emerged at a time—the nineteenth century—when the notion of home began to waver. The popular nineteenth-century representations of the idyllic home (rose-tinted views of fairy-tale cottages etched on plates, calendars, and miniatures) now seem to be pure fantasy: they are of an age when the feeling of being at home had become illusory, something already destroyed by the massive relocation of rural population during the successive waves of industrialization. The industrial rationalization of social life abolishes nomadism, but does not replace it with stable domesticity. Indeed, it prohibits dwelling permanently. The nineteenth century invents a most destitute form of homelessness that does not even offer freedom of movement. Only in the midst of such dire homelessness does the image of the snow-blanketed, thatched-roof cottage, windows aglow with the promise of a warm hearth, have a sentimental appeal.[12] The question is why images of the home are almost invariably suffused with nostalgia? Have we always lost our way home, or the home itself? And if so, how?

How We Dwell

The home is a fundamental anthropological document: it addresses the very question of the *anthropos*, of human existence. What is a human being if not the animal who has learned to dwell? The home is a response

to the human need to dwell in a human-made environment, that is, in a humanized world. We humans inhabit the world as a way of being human. The equation between our humanness and dwelling no doubt bespeaks a bias for settlement and fixation that is bourgeois through and through. The forces of capital and population control celebrated the home as the grounding force of civilization, in a manner that implicitly but conclusively ruled out any form of human existence other than domestic sedentary dwelling. The private residence serves as imaginary bulwark against ontological anxiety, fear of dispersion, and dread of uncenteredness, which to a large extent define the bourgeois psyche. Perhaps the nineteenth century is responsible for making the home the synonym of dwelling: it represents the undisputed means by which the modern age chooses to dwell.

What does the private home tell us about the mode of dwelling taking shape in the modern period, that is, in the era of capital? The domestic interior is associated quite rightly with the privatization of social life and indeed a desocialization of the individual. In the modern imagination, the interior comes to symbolize abstraction from the social and freedom from the burden of public life. In other words, the interior is the place where society manufactures desocialization. Whereas "building" is a social activity, dwelling, at least insofar as it concerns the private home, produces a disconnection from the social. Family and friends may congregate in the interior, yet it strangely remains a place of solitude, of the private autonomization of existence. In a sense, dwelling in the interior is like reading: even in the midst of publicness, it is a private act.

The interior is the place where anthropology, as the study of human social interaction, is faced with a vacuum.[13] Insofar as it enforces the compartmentalization and isolation of human existence, the interior is an ambiguous anthropological object: a deanthropologizing of the *anthopos.* In itself, the history of dwelling in the nineteenth century is the history of popularizing the private residence as the natural habitat for human existence. Culture (from politics to art and commerce) in the nineteenth century is everywhere flavored by the desocialization of existence. As bourgeois existence centers increasingly on the privacy of home, so it accepts autonomization as a ruling fact of existence. The English word "home" entered the French language around 1830. The foreign sound of the word

speaks the language of advertising: a dream is being peddled, the possibility of a cozy haven away from the generalized commercial and industrial transplantation of human lives. This is the rose-colored view of autonomized existence. The truth is that privatization of existence stems from the submission of individual autonomy to the dictates of the economic totality. The more existence is subjugated to the vagaries of market fluctuation, the more the "home" increases in mythical value. The Universal Exhibition of 1889 chose the home as the theme for its Social Economics Exhibition: capital creates a dream of self-governed privacy just as it destroys its reality. The mythologization of "home" rises in exact proportion to the massive disruption and dislocation of human lives, the draining of the populace from rural to urban areas, the shifting of laborers from industry to industry, town to town, the severing of the individual from communal networks of social organization. The celebration of home is, in the end, a function of the forces that dismantled it.

The home rises to the status of social fetish just as history condemns human existence to anthropological homelessness. Autonomization turns the individual into a cog in the world of capitalist rationalization. Though it seemingly removes the individual from participation in the socius, the interior colludes with the social forces of capitalism that still insist on the singularity of the individual. The corporate world's current fantasy of sending its middle management back home from the office to live behind a barricade of fax machines, computers, phones, and video conferencing screens is not a reversal of the historical trend; rather it is the culmination of desocialization that began with the interiorizing and privatizing of domestic life in the nineteenth century. Initially radio and television seemed to promise the possibility of penetrating the world from the comfort of one's private nook. What they have done in fact is to annex the home even more deeply to the essentially unprivate functioning of the market. Autonomization of existence works hand in glove with the specialization of the labor force: severed from the horizontal network of associative life, the privatized individual is wholly subjugated to the vertical lines of economic power pouring into his living room. The bourgeois interior in the nineteenth century tells us what it means to dwell in modernity, or again, what it is to be modern: how and, perhaps, why modernity chooses for us to dwell in homelessness.

Our anthropological homelessness has not escaped the attention of philosophy. In truth, Marxist thought originated as a cry against the social conditions that manufactured it. More recently, Heidegger sent alarmed signals concerning the uprooting of existence in modern times.[14] For Heidegger, dwelling is the eminently human activity. To us the earth is more than a natural ecological system; it is a place where we work in order to abide. Animals live where they happen to be. Human beings, by contrast, make the place where they live. They dwell: "We do not dwell because we have built, but we build and have built because we dwell, that is, because we are dwellers."[15] Because we have to *build* a dwelling in order to live in the world we do not dwell naturally. A building always is proof of our severance from the world of nature, a severance caused by our inability to dwell naturally (unlike animals who live, struggle, and die wherever they happen to be). Heidegger concludes, somewhat paradoxically, that our need to dwell expresses our basic homelessness in the world, the fact that we must actively create a home for ourselves: "The real dwelling plight lies in this, that mortals ever search anew for the nature of dwelling, that they *must ever learn to dwell.* What if man's homelessness consisted in this, that man still does not even think of the *real* plight of dwelling as *the* plight?" ("Building, Dwelling, Thinking" 161). The home, in a sense, testifies to the basic homelessness of human existence. Because any human housing is built on the absence of natural ground, on the uprootedness of human existence, the home is an insight into how humans accommodate themselves to their essential uprootedness. In itself, Heidegger's analysis speaks of a mood dispirited by homelessness; for even our efforts at dwelling are grounded in the fact of our primordial failure of dwelling, a *Dasein* for which the "da," or thereness, is indeed never to be achieved.

Nevertheless, there is a homelessness more dire than our basic homelessness, one that is suggested by the second half of Heidegger's statement. The absolute plight, Heidegger says, is to remain blind to our natural homelessness, that is, to be so homeless that one forgets one's homelessness, to roam without knowing one is roaming. The nineteenth-century domestic interior provides us with the chance to confront the homelessness of our social existence, and redeem us from that absolute homelessness into which we would fall if we forgot our homelessness.

Bachelard suggested that "by remembering 'houses' and 'rooms,' we learn to 'abide' within ourselves."[16] Home is, in the end, a metaphor for existence as something that is not merely given but must be founded. As such, it evokes that other interior for which it has long been the metaphor: consciousness. The related topics of the museum, homelessness, and interiority all intersect in the domestic interior. The museum implies homelessness because the museum abstracts the object from its native ground and favors historical contemplativeness over active cultural production. Interiority is included here because the museum entails the inner space of conservation, protection, and contemplation found in inwardness. The domestic interior brings into play the three strands of museification, historical homelessness, and interiorization of existence. In the following, Balzac's *Inventaire de l'Hôtel de la rue Fortunée*, Edmond de Goncourt's *La Maison d'un artiste*, and Huysmans's *A Rebours* will guide our exploration of the nineteenth-century interior.

Writing the Interior

> The fields are gone and the streets are empty, let me tell you
> about our furniture.
>
> <div align="right">Mallarmé, "Poésies"</div>

In *La Comédie humaine* the secret life of bourgeois manners plays itself out in a panoply of domestic interiors. Of all the many indoor landscapes in Balzac's writing, one hits particularly close to home, biographically and conceptually speaking: the several hundred pages in Balzac's correspondence devoted to observations, deliberations, descriptions, arguments, and so on, over the furnishing and decoration of the author's residence known as *Inventaire de L'Hôtel de la rue Fortunée*. It would be a mistake to assume that this text, since it is an inventory, does not deserve the same attention given Balzac's more canonical output, a mistake against which Proust forewarned long ago: "He [Balzac] does not put as much love, truth and illusion in describing the furniture of Cousin Pons or Claës as in the description of the gallery in his house on rue Fortunée."[17] Unlike Zola's inventory, for example, Balzac penned the inventory of his house himself. Undertaken as good husbandry, the inventory

soon became an exercise in description. As such, it is very much in keeping with the spirit of the description as tabulation that informs the entirety of *La Comédie humaine*.

Despite the many disclaimers by which the author tried to reassure his distraught fiancée, who feared her husband-to-be was spending their entire fortune furnishing their crowded interior with superfluous trinkets, bibelots, and furniture, Balzac himself was a consummate collector. Madame Hanska had good reason to worry: most of the letters Balzac sends her in 1846–47 obsessively recount ferreting out, purchasing, financing, collecting, and itemizing the cornucopian array of objects he crammed into the rue Fortunée residence. Tireless accounts of his cunning in "bricabracologie," examples of his collector's savvy in searching out and securing the priceless find, endless tabulations of his possessions, inventories and checklists of bibelots, curios, finery and decorative knick-knacks, long-winded recapitulations of accounts paid and unpaid—in the end this correspondence amounts to little more than a maddening rehashing of minutiae that goes on for hundreds of pages.[18] Each object is meticulously assessed, measured, anecdotally historicized, archeologically described and priced accordingly. The thousands of objects constitute a numberless cast far more replete and detailed than even that of *La Comédie humaine*. His unrelenting pursuit of collecting, as well as his need to recount it all in detail, turns the correspondence into an endless catalogue, a true match for "faire concurrence à l'Etat-Civil [compete with the National Register]," and surely quite enough to trouble Madame Hanska and make her doubt the author's sanity.

The inexhaustible bounty of details is a product of the same encyclopedic spirit that made Balzac survey the entire breadth of French society for eventual recapitulation in a grand novel of novels. It bespeaks the need to set things in writing, as though the interior had to be written out in order to be fully possessed, internalized. The compulsion to itemize the collection seems no less strong than that to assemble it, and it gives language a momentous role in the art of collecting, as though language were to give the collection its consummate collected form. It is not simply in jest that Balzac refers to the rue Fortunée interior as his "opus" (*Lettres* 450); and it is not mere intellectual coquetry that made some commentators describe his residence as the novel on which Balzac lavished his

greatest attention: "This house was one of the great novels to which M. de Balzac devoted the most work in his lifetime, though one he never finished."[19] As a matter of fact, Balzac's novels, written for mercenary purposes, pale before the pure pleasure of assembling and copying the interior: "This is how I am, and the delicious hour (2 h.) spent writing [about my home interior] contains all my current happiness" (*Lettres* IV, 74). The writing of the interior rises above the novel-as-trade and yet remains dependent on it for financial continuation. The author, as he himself observes, writes novels "under the tyranny of necessity" (*Lettres* IV, 72) in order to pay off the debts incurred by his collecting. The novels, which we read today as true expressions of art, Balzac abandoned to the stigma of necessity; while we dismiss as domestic trifles those passages written in disinterested passion (*L'Inventaire de l'Hôtel de la rue Fortunée*).

As Théophile Gautier observed upon visiting his friend's house, Balzac's home decoration produced astonishing results:

One day, he entertained us at his home, and we saw a oakwood-paneled dining room, with a table, a fireplace, sideboards and chairs made of carved wood; a drawing-room dressed in golden-dotted damask, with doors, cornices, rafters and window frames carved in ebony; a library fitted with glass-paneled shelves encrusted with shells and copper in the Boule style; the library door, hidden in the bookcases, is impossible to find once it is closed; a bathroom in yellow mixed stone and stucco moldings; a domed boudoir, hung with old paintings once restored by Edmond Hédouin; a gallery lit through a skylight which we later recognize in the collection of *Cousin Pons*. There stood all sorts of curios on the shelves, Sèvres and Saxony china, pale marbled goblets, and in the carpeted staircase, great urns from China and a magnificent chandelier hanging from a red silk wire twist.

—Have you emptied Aboul-Casem's treasure troves? we jokingly asked Balzac, in the midst of such splendor.[20]

Paintings, furnishings, statues, mirrors, embroideries, rugs, china, curtains, draperies and moldings—all things patiently amassed as though, loaded like an ark, Balzac's interior were to sail off, salvaging the contents of nineteenth-century home furnishing for future archeologists to reclaim. In *Choses vues*, Victor Hugo also emphasizes the munificence and profusion of his fellow writer's house:

He had lavishly decorated his digs and made them into a charming mansion. . . .
We walked through a foyer, climbed up the stairs spread with a red carpet and
cluttered with art objects, vases, statues, paintings, little shelves covered with
jewel works.[21]

The taste for a crowded decor sees to it that no recess, nook, or cranny, no
surface, table, or shelf is left unadorned. This proliferation of objects par-
allels the giddy excitation that seizes the shopper of mass-marketed goods:
the "adorable babel du bibelot [adorable Babel of bibelots]" (the expres-
sion is Robert de Montesquiou's) happily participates in the century's cul-
ture of consumerist accumulation. Something almost frantic is at work in
Balzac's furnishing of L'Hôtel Fortunée. It is not yet the drunken rapture
of those shoppers in Zola's *Au bonheur des dames*, but it is no longer the
bourgeois satisfaction with having chased away the specter of want. Like
all the overcrowded, smothered interiors in the nineteenth century, Bal-
zac's home bespeaks compulsion, a principle gone awry, a profusion that
is not simply blissful or ludic but somewhat desperate: the surrender to
overabundance by means of overabundance.

Balzac's letters concerning acquisition and collecting—in them-
selves a most thorough document in the history of interior design—cul-
minate in the even more detailed *Inventaire de l'Hôtel de la rue Fortunée*.
This inventory completes the epistolary description of the interior (edi-
tors have wisely appended the inventory to the correspondence). A com-
prehensive catalogue, *L'Inventaire de l'Hôtel de la rue Fortunée* lists and de-
scribes *every* object in the author's interior. Instead of listing its entries
taxonomically (as Zola's inventory does, for instance), Balzac chooses to
list his possessions according to their place and arrangement in the house.
Hence the categories are not "paintings," "tapestries," "fabrics," "furni-
ture," "ironworks," "woodworks," "books," but "vestibule," "reception
hall," "dining room," "bathroom," "boudoir," "bedroom," and so on. It
proceeds room by room as though a visitor had walked through the house
and jotted down every thing on the way. Edmond de Goncourt followed
the same idea in his *La Maison d'un artiste*, which, as minutely compre-
hensive as an inventory can be, nonetheless presents it all as a guided tour
through the house. It combines the exhaustiveness of an account book
with the vivid eyewitness touch of a tableau, joining the taxonomist with

the decorator, the realist with the home-dweller, the one who catalogues the world with the one who makes his home in it.[22]

As no paraphrase or description can do Balzac's inventory justice, two excerpts follow, the first from the early half of *L'Inventaire* (the one more strictly cataloguing) and the second from the latter half (the one more tableaulike):

A sculpted mahogany *chair*, in Middle-Age style, very ornate craft and encrusted like the bed

A mahogany planter

At the door, *curtains* over a canopy, same on the furniture

A *portrait* in an oak frame, carved and gilded, the frame being appraised at

A bronze gilded and chiseled *chandelier* representing cornucopias

Four golden bronze *candleholders*, with six candles cut and tapered in the same style as the arms

On the mantel, a *decorative piece* made of two marble golden bronze *candelabras* matching the chandelier and the candleholders

A white marble gold-rimmed *clock* whose scene represents Kronos seated on the World

Two china *vases* with Mexican motifs

A golden bronze *ashtray* with bronze *shovels* and *pokers*

Two *torches* with laminated golden and bronze leaves

A Boule *chest* with tortoise-shell inlays adorned in golden copper on which is an old China *vase*, a black and gold lacquered base assorted with a Gouthière trim in golden bronze

A three-legged mahogany *tea-table* covered with an embroidered napkin

A *medallion* of David in bronze with a round oak trim

Over the mantelpiece a *mirror* framed in rich wood moldings style Louis XIV whose motif represents two doves over a love trophy

The *carpet* in this room as in all rooms on the ground floor is a beautiful white rug with flower design and covers the entire room [not appraised]

The *fireplace* as all fireplaces on the ground floor except for the dining room have [sic] a velvet mantel cloth matching the room color scheme, adorned with tassels and gilded studs[23]

And later:

On the left side of the fireplace, a piece of furniture, style Henri II, square, in ebony, with the inside decorated in finely chiseled golden copperwork, with gems and jeweled encrustations in four compartments with four lockets: one Florentine encrusted with mother of pearl and copper representing flowers, the second in elm rootwood, adorned with a small crown-like trim engraved with a golden framework, duplicated inside. The third is a German locket entirely covered with sculptures, the last one is a cedar locket. This piece of furniture is topped with an iron box, 39 centimeters lengthwise by 24 centimeters in width, the lock is secretly hidden. The lock fills the inside of the lid and releases latches on all 4 sides, the casket is further adorned with sculpted gilded ironwork, against a background of crimson iron

At the far end of the room, across from the mantelpiece, a big ebony furniture piece, holding 24 drawers in the lower half, which is enclosed by two doors taken from a fifteenth-century piece carved lavishly, adorned with golden copper figures. The upper half is a three-tiered bookcase. The doors are in glasswork, the sides are decorated with golden bronze and the front panel *idem*. (644–45)

Though it may be hard to conceive of a more meticulously obsessive description, Edmond de Goncourt easily outdoes it in the inexhaustible, tirelessly detailed, and comprehensive survey of his own interior, which runs over six hundred pages. Here is a glimpse of Goncourt's description, caught here in the "cabinet de travail," or study:

On the ceiling is a furious swirl of Korean lions in a field of peonies. Against this black velvet background, among enormous many-colored flowers, two squat monsters with bloodshot eyes, resembling an animal life form carved out of barbarous rock, writhe and huddle fiercely, trampling down the dazzling flora,—all woven and bristly with gold in various hues. Thus nailed in the sky, it looks like the black sky in a fantastic country, this stage robe of a Japanese tragedy actor whose terrible and fearful wardrobe was brought back to France by M. Siche.

The study is only made of books. On all four walls from top to bottom, volumes are stacked, within easy reach.

All the books are from the eighteenth century. . . (*La Maison d'un artiste* 211)

A description of nearly every book in the library follows, complete with excerpts and description of frontispieces, long-winded quotations from

manuscripts, transcribed letters, and so on and so forth. Each of the thousands of objects in the house receives the same meticulous description as the painted dragon in the passage above. The infinite desire to possess finds an outlet in the infinitely detailed description. These inventories are written for purposes beyond matters of legal practicality. It is as though Balzac or Goncourt only began to inhabit their worlds by possessing, and could only possess by describing: the interior must be inwardized through writing. This is the way the author, as owner, places his stamp on even the most minute object in his house. The will to exhaust every particular of his interior boils down to the desire to make that which is external—the object—into a product of the self, a linguistic entity. This means that ownership, or the translation of objectivity into an inner landscape, operates at the basic level of the self's construction. "J'ai et non pas je [I have rather than am]," says César Birotteau, echoing Balzacian subjectivity as a whole. Excessive realism aims at an apotheosis of ownership, of being at home, by making the word one's property. It is no coincidence that one of the first enumerative-realistic descriptions of objects in European fiction takes place on Robinson Crusoe's island. There, too, realist representation was a tool for annexing the object-world and placing the subject at the center.

In applying *stricto sensu* Grandet's "voir bourgeoisement la vie, et la chiffrer au plus vrai [to consider life in a bourgeois manner and estimate its true price]," Balzac carries the principle of realism to the extreme. Absolute focus on the detail, craftsmanlike rendering of the minute, the belief that reality is entered by way of its smallest door, the illusion of an almost palpable contact with matter—all these are part and parcel of realist writing. Objects do not simply ornament the storytelling; instead they themselves are the story. But *L'Inventaire* goes even further. Proust stressed the accumulative, rather than synthetic, nature of Balzac's prose:

In Balzac's prose . . . all elements co-exist, undigested and untransformed. . . . Balzac uses every idea that comes to his mind and does not attempt to integrate and dissolve it into a style where they would harmonize and suggest his meaning. Quite on the contrary, he says it all plainly, and no matter how miscellaneous and disparate the image, yet always felicitous, he adds it to the pile.[24]

Balzac's sentence is juxtaposition rather than condensation, hoarding rather than distilling. In Balzac's prose, the object as such is *undigested*: for this reason, it remains somewhat external to the narrative (the subject's sphere) as though Balzac had intuited that, in the nascent world of commodities, objects begin to have an objective existence of their own. Condensed into a linguistic nucleus that resists absorption in the sentence, the object breaks up the subject's license to synthesize words around his governing center. Language itself becomes intractable and objectlike. This gives rise to parataxis, which is always inherent in juxtaposition and comes starkly to the fore in *L'Inventaire*. Even for a prose craftsman like Goncourt, the object's unabsorbable reality presents somewhat of a syntactic snag. To write the life of objects is not so easy. For objects have no life; they are, instead, a resistance against the subject, an *objection* to subjective life as a whole. This explains why realism, when it reaches its extreme, breaks language apart. Concretist realism bursts as a force antithetical to the subject's manipulation of nouns and orderable and synthesizable entities. Pure juxtaposition is a result of the subject's failure to stamp cohesiveness—his imprint—onto the sentence. The desire for harmony—the wish that the world could be smoothly patterned around an appreciative observer—gives way to syntactic atomization. No marker symbolizes any connective continuity between day-bed, chair, planter, chandelier, portrait, and shelf. We are assured that each belongs to the same spatial continuum—the *pièce d'entrée*—yet such continuum is broken up by the paratactic style of enumeration. Balzac thoroughly describes his objects with the same literary concretism which he brought to his novels. Yet this precise individual evocation fails to create the homogeneous wholeness which realist description promised.

L'Inventaire is the extreme outcome of Balzac's penchant for juxtaposition. Proust spotted in Balzac the loose brick which would bring the whole edifice down: while his prose accumulates, it does not integrate. On the contrary, realism promised integration. Its enveloping vision derives from an esthetic of absorption, the desire to be all-inclusive and turn multiplicity into unity. This is the panoramic sweep sought by Balzac in the famous introductory description of *Le Père Goriot* or by Stendhal in the opening of *Le Rouge et le Noir*: a reality at once continuous and legi-

ble, or legible because of its continuity. This is why the extremeness of *L'Inventaire* must nevertheless be checked against Balzac's more classical moments. As an ideal, Balzac's realism has in sight a transcendental overview of the subject's domain, a domesticated world. Realist tableau-making sought a form of synthesis. Let us step into a fashionable Parisienne's boudoir and see how narrative description unfolds: "Each room had, in an opulent English fashion, its own particular character and the silk drapes, the fribbles, the shape of the furniture, the smallest decorative detail were in harmony with a single original idea."[25] Whereas *L'Inventaire* focuses *in medias res* on the singled-out detail, fictive description never forgets the dialectic of part and whole. In the end, the main purpose of description is to bear the rhetorical proof of its own unity. In this instance, the sentence runs full circle from its initial preconstituted unity (to each "room" is ascribed a "unique character") through an exploratory journey into diversity (the various elements represented by "drapes," "fribbles," "furniture," and "smallest decorative detail") and then back again to the preemptive unity of the whole ("a single original idea"), thus bringing repose to the homogenous whole. The describing eye pretends to travel through differences, details, and particulars but in actuality never loses sight of the whole. The whole in this case does not derive from the mutual determination of its parts. Rather, the unity is imposed from without, preceding and guiding the actual efflorescence of form. This type of unity is ideological; it does not organically follow from the open-ended experience of creation. The objects are only there to bear evidence to the harmonious monism of the described interior. Diversity in description is an anticipated moment subsumed in an ideological agreement about the homogeneity of things: "nothing ruined the whole of this pretty display of decoration" (*Peau de chagrin* 149). Balzac's fictional descriptions rest on an *a priori* type of homogeneity. It is as though the interior were seen through a microscope backwards, where it is viewed whole and entire, as if by the eye of God. Unlike *L'Inventaire*, which gropes and fumbles its way through the interior piecemeal, experientially (to the point where the fragment overshadows the whole), Balzac's fictional descriptions serve up a totality that is ready-made, preprocessed, the cold product of idealism palming itself off as concrete observation.

In *L'Inventaire*, each object takes center stage: it blocks out the to-

tality of which it is supposed to be a part. As such, *L'Inventaire* conveys a particular truth about the philosophical experience of the interior: the world is always awfully close, the object always blindingly near, crowding the subject. The interior in *L'Inventaire* is an experience in shortsightedness that prevents the subject from glimpsing beyond the objects proper. In the novelistic description, by contrast, it is all held at a distance. One might say that the literary description of *La Peau de chagrin*, for instance, *miniaturizes* the interior for the sake of subsuming it whole. By the same stroke, however, the appearance of absolute proximity (the interiority of the interior) is liquidated. This is no longer the realm of interiority but that of *objectified* interiority: the dollhouse.

The Dollhouse

Miniaturization of the aesthetic experience is the paradoxical result of aesthetic culture's aspiration to totalization: only when the object is small enough can it be taken in as a totality. Claude Lévi-Strauss identifies the miniature as the undergirding notion of artistic expression:

Yet the question arises whether the scale model . . . does not embody, in all cases, the epitome of the work of art. It seems all scale models have an aesthetic purpose—where would they get these constant properties if not from the dimension itself?—and correspondingly, the overwhelming majority of artworks are also on a reduced scale.[26]

Esthetic miniaturization does seem to have a special appeal to nineteenth-century consciousness. Consumers developed an almost pathetic fondness for small things: trinkets, scale models, bibelots, dollhouses, even the panoramas are all expressions of a consciousness that seeks to cram the world into a compact object graspable at a glance. The scale model, in art as well as in knicknackery, shines with the promise of an entirely comprehensible experience. The desire to fit the world into a pea-sized replica betrays an aspiration to settle the dialectic of experience by replacing it with a ready-made overview. In the miniature, the object is experienced from above, detachedly; that is, it is not experienced at all. Description is the contribution that literature brings to the spirit of totality by miniaturization of experience. The sentence that concludes the interior de-

scription in *La Peau de chagrin*, "nothing ruined the whole," may well be read as a final commentary on the task of description itself: the reduction of reality to something graspable in its totality. However extensive or detailed it may be, description is always a journey through identity, from the totality it presupposes (the setting always comes first) back to the totality it celebrates as a matter of mindless settlement. Consequently, description is able to exhaust the totality from which it arises: "I was surprised at the sight of a small modern drawing-room where some artist had exhausted the science of modern interior design" (*Peau de chagrin* 157). Description succeeds in rising above the situatedness of its gaze to encompass the whole of the interior, exhausted not so much by the "science of modern interior design" as by its disembodied, external gaze.

However, gazing at the interior from above strips the interior of its interiority. The betrayal of the inward character of the interior by miniaturistic description finds its best expression in that quintessential trinket of the nineteenth-century home, the dollhouse.[27] In allowing the interior to be grasped externally, the miniature turns the interior into an objectified form: here the encompassing structure of one's situatedness is itself encompassed. One's home, that is, one's inclusion into an immanent situation, is now the object of a transcendental overview. The pleasure derived from the dollhouse recalls the child's enjoyment in opening the Russian dolls and discovering that even the mother can be enwombed. A miniature is an object that carries in its appearance the external vantage point from which it is observed: the detached gaze is literally inscribed in the miniature's form. It is an overbearing eye seeking epistemological mastery over its environment. As Lévi-Strauss stresses, the miniature reverses the empirical process of cognition (which goes from parts to whole) and gives the dream image of a world directly apprehended in its totality: "[Reduction] results, it seems, by somehow reversing the epistemological process: in order to know a real object in its totality, we tend to proceed from its parts . . . on the other hand in the scale model, knowledge of the whole precedes knowledge of the parts" (*Pensée sauvage* 35). The idyllic character of the miniature stems from this: it untrammels consciousness from its immediate involvement in the world. In normal conditions, my presence in the world of objects is one of constant fumbling, groping, and unexpected discovery.[28] Experiencing the world

means cutting one's way through the thick of things. In the miniature, by contrast, everything behaves like the standard Balzacian description (such as the passage concerning Fœdora's boudoir in *La Peau de chagrin*): every element has an assigned place within the totality: the world is synthesized and sanitized of shock, of unexpectedness. Seen from above, from an airplane or from God's cloud, the world makes sense but it is also flattened and falsely demystified. It gives an image of the world without experience and therefore without the human element, as though the bourgeois subject has fantasized his or her own absence in gazing at the dollhouse: one can grasp its interior as a totality only because one could never fit inside. The pleasure is similar to one relished in the old fantasy of attending one's own funeral: to sneak a peek at what one is fundamentally unable to see, to be conscious of oneself as a completed, sublimated totality.

The dollhouse is actually only a miniature of a miniature. For miniaturization is already at work in the full-scale interior. It is active in the bibelot, decorative *sine qua non* of the interior. Etymologically, "bibelot" stems from "bimbeloterie," toys, the stuff of children.[29] "Bimbeloterie" refers to a miniature world that is effortlessly seizable by hand and mind. More often than not, the bibelot actually takes the form of a straightforward miniature. Here again the example of the Russian dolls applies: ever smaller worlds are contained within each other. The bibelot instantiates the idyllic nature of miniaturization: it embodies real objects on a scale suited to their immediate domestication, a world interiorized to allow prompt consumption. A china locket is an image of the treasure-vault or the dungeon in a domesticated form, the pretty little ceramic jug is a Grecian urn one can pick up with one's finger. It is no coincidence that large monuments, such as the Eiffel Tower or Saint Peter's, tend to end up as miniature souvenirs. For in fact the bibelot in itself involves the dream picture of a world reduced to domestic sizes. Miniaturization acts on the bourgeois wish for a Lilliputian world, which is always a politically domesticated world (from the Seven Dwarves to the Smurfs, migdetism entails images of clean-cut, simple societies). The bourgeois at home never stops playing house. As the bibelot reveals, the interior is in itself a magnified dollhouse, a cutely domesticated universe over which the inhabitant can fancy himself the benevolent master, a mixture of Robinson and Gulliver.

The bourgeois may have ambitions on a planetary scale. In daily life, however, he takes comfort in littleness. To master the world, bourgeois consciousness first redraws it in small-scale reproduction. There is nothing like governing the world from the cozy retreat of one's little nook. Even when he goes to the moon, as in Verne's *De la terre à la lune*, the bourgeois outfits the interior of his rocket like a boudoir. However grand, the *nouveau riche*'s chateau reminisces about the "petite maison," the cottage where one dreams of living out one's pension. The industrial magnates who built their mansions to look like hunting lodges or mountain chalets only reflect the pathetic bourgeois taste for the cute and small, even amid the palatial. In comparison to the neoclassical grandeur of the First Empire, the architectural mood of the bourgeois Second Empire already shows a taste for the small-scale, even when erecting the monumental. Where Empress Josephine's chambers retained the public splendor of antique queens, Empress Eugénie's rooms are, by contrast, pure middle-class coziness. Haussmanization is after all a dream of generalized domestic life, which includes the taming of the Parisian landscape: its basic component is the private flat, the "petit chez-soi." The ideal occupant of a Haussmanized quarter is the domestic dweller who can walk around a tidy new Paris with its underbelly expurgated. It is not yet the museumlike Paris of today, yet it already bears the character of a domestic fetish, the nation's artistic centerpiece and display case in one. Compared to the teeming, shady Paris of Balzac, the Paris laid out in Zola's *L'Œuvre* or *Au bonheur des dames* is almost an idyll of domestic familiarity: the flâneur ambles through it as though he never left his rooms. This corresponds also to the cityscapes painted by the Impressionists (Pissarro and Renoir in particular), which all paradoxically have a look of interiority, as though the air itself had been domesticated. The building of the Eiffel Tower concludes this miniaturization of the city landscape: at last one would be able to grasp at one glimpse what, at street level, had so far been a swarming chaos. All things look small from above: the fantasy behind the Eiffel Tower was not so much that of city reaching up into the sky, but that of a city encapsulated under its own miniaturizing lens.

However, the dollhouse, like all miniaturization of experience, leaves a bittersweet aftertaste. One enjoys the dual satisfaction of picturing oneself in the interior—for consciousness always yearns for the haven

of inwardness—while simultaneously mastering from the outside that interior space wherein one feels secure. Inwardness is thus betrayed exactly where it is celebrated, and interiority is secured at the cost of its objectification. Susan Stewart is right to stress the craving for an "infinitely profound interiority" at work in the dollhouse.[30] The full picture, however, is that the ever-deepened interiority fantasized in the dollhouse results in the projection outward of what should have remained inward, that is, the interior experience of interiority. Homeliness is lost as soon as it is represented from the outside, as in the dollhouse. Bachelard understood it quite well when he opined, "Real houses do not readily lend themselves to description. To describe them would be like showing them to visitors" (*Poetics of Space* 13). A dollhouse is an objectively detached description of the house: it cracks open the home's inner shell to let in the peering eye of exteriority. In doing so, the dollhouse sucks the interior out of the house.

Thus the dollhouse is an exorcism as much as a celebration of interiority. It is a toy and, like all toys, it is an object of detachment. Only because the toy is not real—not the object of real fear or real desire—can it hold our playful interest enough to release us from the gripping intensity of real life. Thus what we first find in the toy is a distance, an objectifying, miniaturizing gaze. Beyond this distance (which the toy embodies) lies disenchantment, the antithesis of toyland. Such was the *morale du joujou*, "the moral of toys," for Baudelaire:

Most kids really want *to see the soul of it* [the toy], some after some time in the game, others *immediately*. The life expectancy of a toy is proportional to the speed with which this desire takes over. . . . The child fidgets with the toy, scratching and shaking it, dashing it against the wall and throwing it on the ground. . . . The spell is broken. The child, as the mob laying siege to the Tuileries palace, makes a supreme effort; soon he pries it open, he gets the best of it. But *where is the soul*? Hereupon stupor and sadness set in.[31]

A toy is an object removed from the *hic et nunc* of empirical experience— an object removed into the distance of its own image. The child who breaks toys searches for the object behind the image. He believes that the real thing still lives somewhere inside the miniature, just as the bourgeois believes a remnant of the interior is preserved in the dollhouse. But the child breaking through the toy's distance finds nothing but disenchant-

ment; rather than discovering the reality beneath the image he finds only that the soul of the toy *is nothing but the distance of the image made into an object.*

Objectification, even if it gives pleasure, nonetheless betrays the concept of the interior by projecting it outward and thus stripping it of its very interiority. The dollhouse *represents* homeliness at the cost of rendering it unhomely, de-inwardized. Representation, which always miniaturizes, runs against the concept of home, which is nearness, or immanent experience. Can one ever represent the (experience of) home without destroying it? As a social phantasy, the home stands for the proper, the original ground, an ontological gold standard. Representation, by contrast, is always the space of the improper, the duplicitous, the errant, the ontological equivalent of the fiat paper currency. The question is whether, building itself as an image of itself, the nineteenth-century bourgeois interior actually signals the end of the home, the destruction of the interior by its very sacralization. That most representations of the home in nineteenth-century iconography are marked by melancholy and nostalgia points to the ambivalent, even paradoxical, act of representing the home. Description pays a high price for the pleasure it brings—the joy of epistemological clear-sightedness—by missing the ontological wish vested in the interior: to be at home, not outside looking in. It follows that to describe interior is to utterly miss it. For to grasp the interior as a whole ("the *whole* of this pretty decorative display") one must leave it, and forsake its interiority.

Pointillism

> What a style! It's only nouns.
>
> Apollinaire

L'Inventaire de l'Hôtel de rue Fortunée, however, is apparently no miniature. It makes no attempt to grasp the interior under an overall panoramic lens. Rather than surveying the interior from above, the inventory goes through the experience of its discovery, with no preconceived image of what "la science du décor" or any circumscribed floor

plan might be. The reader lumbers through the thick of a great mass of objects without the aid of place markers. The room itself, it appears, does not preexist the furnishings standing in it. It is as though, in refusing to clear a space prior to the object, Balzac had understood that space flows outward from objects and does not precede them (as Heidegger notes: space begins with marking limits).[32] Insofar as no overall design encompasses the objects, the visitor is thrown headlong into immediate contact with the details. It is as though I experience the dollhouse from the inside, piece by piece. No comprehensive picture, no spiraling view from Paris down to the neighborhood, to the street, to the pension Vauquer and into the kitchen, as in *Le Père Goriot*. Here, the unintroduced self-standing object thrusts itself head on against the gaze:

A fire screen with five leaves . . . 50

On the mantelpiece a mirror with gilded frame . . . 150

The mantelpiece is covered with woolly green studded and tasseled velvet

Two simple muslin curtains hanging at the porthole windows . . . 10

Three mahogany chairs covered in beige and green damask. . . 400

Objects rise up *in medias res*, as though *L'Inventaire* sought to rediscover the experience of objects glimpsed in their original, unmediated light: things existing in and of themselves, almost naively, as though I had just newly awakened to the fact of their existence.

The stripped down nominal simplicity of the enumeration conjures up a pathos of essentialism: *chalice, candy jar, basket, watch, box, runner, table, chandelier, drapes.* Behind this count lies the obsessive concern that the world must be anchored in absolute entities, in an unbreakable In-Itself. This In-Itself, however, is every time a particular if it is to be vigorously envisaged: not an idealistic concept but rather, in each separate case, one object alone. Meanwhile the illusion of organic totality—the blurring of forms, the interlacing of lines, the fading of outlines—crumbles: it is a myriad constellation of parts without a whole. Even at its most synthetic, toward the end of *L'Inventaire*, the interior remains a collection of unaggregated details or, more exactly, of details that demand to be dealt with individually. It is a pointillist survey, composed of single self-sufficient objects. The interior thus begins anew with each new element, which nei-

ther harks back to a symbiosis with the whole nor strikes connections with other objects. At close range, the interior seems to float like a cloud of atomic particles: not a chorus of reconciled voices but a cacophony of fiercely individualistic notes.

Most noticeably at the beginning of *L'Inventaire*, the space between each entry, and correspondingly between objects, is unmarked. No connector, no "and" or "next," comes to bind the objects together. As the grammatical marker of addition and juxtaposition, "et [and]" is the poetic sign of space itself: the copresence of objects. From the Sanskrit *ita*, which means "beyond," "et" signifies the coordination of things; it entails a continuous stretch of space at once separating and uniting a range of objects. "Et" produces the first conceivable chain of being by binding things together into a grammatical whole. *L'Inventaire*, however, leaves out the "et"; it allows objects to retract themselves from the mortar of coexistence: pure multiplicity without unity. Assembled piecemeal with each object itemized, the interior *is* the collection, the flattened-out sum of objects making it up: *sideboard, chandelier, table, engraving, china tea set*, a perfunctory count of placeless objects. The interior is not a space but the unrelated concatenation of details without a background, details without space. Goncourt's *La Maison d'un artiste* produces the same result: six hundred pages of nearly microscopic focus on each object makes the reader lose sight of the interior. For the mind soon tires of the steady close-up on the single object and vision slowly blurs, not because of imprecision, but contrariwise, for excessive precision (Raphaël's confusion at the Antiquaire encapsulates it best: "Nothing complete presented itself to the mind . . . he was smothered by the debris," *Peau de chagrin* 72). Slowly, the room is crowded out of the interior, *L'Intérieur* performs laconically the accumulation which *Bouvard et Pécuchet* rendered in mock-catastrophe: "The all too numerous details prevented them from seeing the whole."[33]

Thus, in the most extreme form that it seems to reach in *L'Inventaire*, Balzacian realism seemingly ends up turning against realism. Rather than unfolding an indoor scenery, *L'Inventaire*, or even *La Maison d'un artiste*, pitches the eye against the constellation of details suddenly made too large to see the whole. The realist lens draws too close to its object and shatters itself against it. The concrete object, fetish of realism, de-

stroys the *imago mundi*. It proves to be the element that *objective descrip-tion* cannot assimilate. In "The Collector and His Circle," Goethe de-scribed the slippage that leads the Imitators (the realists) to being mere Dotters (pointillists):

Since it requires great accuracy and care, they [the Imitators] are closely related to another class whom we have called the Dotters. Their primary interest is not so much imitation as workmanship. Their favorite objects are those that require the most dots and lines. I am sure this class will remind you of my uncle. The artist in this group seeks to fill space infinitely, so to speak, and tries to convince us visually that matter can be divided ad infinitum.[34]

By believing that the world amounts to the precise sum of its parts, the re-alist elevates surveying to an art and becomes a dotter. His enemy is empty space which he pointillistically pinpricks till there is no emptiness left. In the search for precision, imitation subverts itself, since, as imitation, it must maintain some distance from the original, according to its own prin-ciple (Diderot's well-known paradox that mimicry is most faithful when the copy is not exact). Much like those Seurat paintings where the sys-tematic dotting flattens the illusion of depth, *L'Inventaire* ends up blocking the viewer's entrance into the space of the interior. Miniature craftsman-ship is carried out at the expense of Euclidean representation. Huysmans's criticism of Seurat may just as well apply to the concretist text:

Strip his figures of the colored fleas with which they are covered, and underneath there is nothing; no soul, no thought, nothing. Nothingness in a body of which only the contours exist. Thus in his picture of the *Grande Jatte*, the human ar-mature becomes rigid and hard; everything is immobilized and congealed.[35]

Pointillist concretism pushes the material basis of representation to the foreground: all elements stand on the equally flat surface of paint; there is no space behind the dot. In trying to preserve the materiality of the object in its minutest aspects, the concretist work encounters the refusal of that materiality to crystallize into the world of make-believe. Like Hamlet when asked what he is reading, the pointillist writer answers "words, words," the same way Huysmans ends up seeing only dots on the pointillist canvas. In Balzac's *L'Inventaire* the concrete substance the col-lector sought to render with loving precision hardens against the make-

believe of representation. In that sense, *L'Inventaire* is not a description of the interior but a concrete portrait of a lack of description. Trying to enshrine the cherished interior in representation, Balzac and Goncourt end up making it unrecognizable, a place of unhomeliness. The In-Itself turns against its inventor, bourgeois philosophy, and its esthetic beneficiary, realism.

Nature morte

> The owner always dies from clinging to his objects.
>
> Marcel Proust, *Le temps retrouvé*

The home thus becomes unhomely: as it seeks to represent itself absolutely, it loses sight of itself. This means that the subject, as the locus of sight, is turned out of doors. Unlike prose description which always allots a place to the observing subject, micrological concrete realism replaces the subject with a mechanical pseudo-scientific process of tabulation. At the heart of concretist aesthetics is the desire to perceive the In-Itself as such, hence outside of the subject's perception. Elimination of the subject is written in filigree through the inventory. But this is also true of the actual interior. Because the bourgeois individual constructs his home increasingly as a still life image of itself, he rebukes the notion of habitation: the home becomes like a furniture showroom, an ideally uninhabited spectacle. The perfect interior, like the perfect still life, is one from which the subject is absent. The topos of *memento mori* has long since been an intrinsic element of the still life genre painting: it constitutes an injunction against our vain attachment to terrestrial things and a reminder about the fleetingness of existence. The object in still life therefore carries a message about human transience: objects remain but we must depart. Given this, consciousness is bound to develop a deep apprehension toward the object. I suspect that things will remain identical after I am no longer there to look at them. My death is, as it were, inscribed in the In-Itself of things. As Norman Bryson explains, the *memento mori* is actually the reminder that the subject's absence is implicated in the seemingly self-contained life of objects:

This lifelessness [in still life] is not only a matter of actual death: . . . the things of the world appear as having no living bond with this watchful subject locked up inside the self. . . . Such killing objectification comes to threaten even the subject who looks at the world as though from the standpoint of personal anni-hilation. It is no accident that in Dutch still life of the seventeenth century, the death's head can feature at the center of the scene.[36]

The viewing subject foresees his own death in the object's self-sufficiency. The still life painting gives a picture of a pre- or post-human world. Ob-jecthood triumphs and the subject falls (*cadere*, cadaver) and becomes a corpse or a skull, that is, an object.[37] As a still-life representation of itself, the interior partakes of the *memento mori* implicit in "nature *morte*": in-deed something in the interior silently wishes the subject's absence. Poe's *Philosophy of Furnishing* exemplifies it. In this essay, Poe offers a prescrip-tive description of a modern home. Before he begins, however, he takes care to banish the home-dweller, by making him go to sleep. The picture is clear enough: objects abide during the subject's absence. Deep down, there is a wish to forget the subject, to reach a level of absolute experi-ence, which, insofar as it dispenses with the subject's side of the dialectic, is illusory. Poe's reflex of spiriting away the human figure presages those luxurious uninhabited houses pictured in home-decorating magazines, homes devoid of the very human subject to whom they promise bliss. It is as though objective existence, to which the bourgeois aspires, reaches its perfection in the absence of the subject, who is always liable to make a mess or knock something over.

In truth, the bourgeois dreams of inhabiting the house as one of his bibelots, which anyway are beginning to crowd him out. If the subject already bows under the pressure of his accumulated objects in Balzac's and Goncourt's inventories then he is pushed to complete prostration in Huysmans's *A Rebours*. There, passive contemplation is the sole activity of the interior dweller. *A Rebours* tells the story of an esthete who, seeking refuge from the leveling influence of the modern world, shuts himself up in his private residence. There he reviews his possessions and describes them at length. Save for a few episodes of personal reminiscence, the bulk of the novel is utterly nonnarrative. The object has superseded the subject. The novel turns into a catalogue of which, in the end, the esthete

des Esseintes is just another item. At bottom, des Esseintes becomes a bibelot—a bibelotization of life which in fact takes place, on the back of a pet turtle whose shell des Esseintes encrusts with jewels. The ornamented turtle, an animal that is always at home, is here exactly what the home-dweller dreams of becoming: a living bibelot, who, as such, cannot disturb the interior. Domestic tidiness is after all the bourgeois ideal which dictates that the interior should remain always as it is, as though no one lived there. This explains, for instance, the habit, still frequent not so long ago, of shuffling across the hardwood floor with little velvet pads under one's feet: they guaranteed that the shine of one's floors would remain untainted by human presence, as though the home-dweller were a regrettable addition from which the home must be protected.

These images somehow bring to mind Nietzsche's idea of bourgeois home-dwelling: "When a wholly modern man intends, for example, to build a house, he has a feeling as if he were walling himself up alive in a mausoleum."[38] Neutralization of the subject—politically, socially, and also ontologically—is the hidden ideal of interior dwelling. This mummification of the subject is unmistakable in *A Rebours*, whose hero's sole occupation is his physical degeneration, his becoming-object in the mausolean home. The situation is similar in Edmond de Goncourt's *Maison d'un artiste*. Goncourt's description of the house is a way of paying homage to his dead brother's memory. Like a funeral monument, it is haunted by the dead who, in the end, returns as though he were the true resident of the interior: "Among these rooms, there is one in particular with a bed whose curtains are drawn. . . . It is the garret room in which my brother liked to work, the room chosen by him to die in and left intact just as it was the day after he died" (*Maison d'un artiste* 304). The undisturbed decor is bound up with the dead brother: it is maintained by death, that is, by the subject's ghost, who is a true interior dweller. To see things in an unchanging state, as in still life, is to see things through the eyes of the dead, that is, through the eyes of an object. For the bourgeois domestic dream of an interior perpetual iconic display is really the dream of a deserted interior, an interior inhabited by an absentee, a wholly sublimated self.

This cushioning of human presence in the interior in part explains

the smothered look of the nineteenth-century interior itself. It was the age of plush, when drapes, canopies, cushions, carpets, tapestries, and coverings spread over every corner of the indoor scenery. All sounds, even the sound of one's footsteps, are muffled. It is as though the interior hushed the presence of its inhabitants. The interior spreads a mollifying haze over the wall, mantelpiece, tables, floor, and ceiling, dressing the rooms in a fluffy ambiance of distancelessness where the home-dweller has no option but that of dissolving. The cushioning and silencing of human presence under layers of plush means that one no longer has to take one's place in the interior. Those paintings by James Tissot or Manet that depict dowagers and maidens sprawling, and indeed almost drowning, on sofas evoke a world where one's presence need no longer be *maintained*. Slouching and lounging are *de rigueur* in the bourgeois interior which, unlike the earlier world of domesticity portrayed in Ingres or Gainsborough, frees the individual from the burden of having to sit up straight. The bourgeois is meant to disappear, half-smothered in fluff or drowsily floundering in velveteen. Having lost the battle against the object, the subject happily agrees to fade into the decor, taking on the unresisting consistency of drapery. It is Tissot's world (on whom Delacroix's women-as-oriental-decoration *Femmes d'Alger* had not been lost)[39] of triumphant domesticity, where the young lady of the house blends into the accoutrements, her dress seemingly an extension of the carpet or the wall hangings. One of Tissot's paintings, appropriately titled *Hide and Seek*, depicts a mother and her children half vanishing in the plush of a drawing-room. The crepuscular haze of gas lamps in Charles Giraud's paintings of indoor salons (particularly the 1859 *Salon de la princesse Mathilde*) swallows the guests, who seem mere festoons on the sofas or trimmings against the backdrop of draperies. The unease that objects still inspired in Balzac's Raphaël de Valentin ("the sound of his footsteps echoed in his mind like some distant noise coming from another world . . . unsure of his own existence, he was like these curiosities, neither altogether dead, nor altogether alive," *Peau de chagrin* 73) is finally overcome. Assuming one's presence, taking one's dwelling in charge, is no longer required; the interior is where the self shirks even from simply being there. It mollifies presence.

Camera Obscura

> There is no place like home!
> There is no place like home!
>
> <div align="center">J. H. Payne (1823)</div>

> A study of the great disease of abhorring one's home.
> Reasons for the disease. Steady spread of the disease.
>
> <div align="center">Baudelaire, *Mon Cœur mis à nu.*</div>

Domestic comfort is then not so much a way of cultivating the he-donistic self as it is a way of shying away from presence: either one plays dead for the sake of the domestic still life or one plays chameleon in order to match the decor. Des Esseintes only seems to cultivate the self through his exquisite explorations of sensuous pleasures (smelling his perfumes, tasting his spirits, ogling his bibelots). In reality, such sensuousness is not meant to indulge the body (for which des Esseintes has boundless contempt) but to allow the restless soul to escape the confines of the body. "Anywhere out of the world," the poem that des Esseintes chooses to frame on his mantelpiece, is a wish aimed at escaping the ultimate abode, that is, the body. What the interior dweller wants to avoid most of all by sinking in the illusionist theater of the boudoir is the necessity of having to take one's place in the world.[40] It is a paradox that the place where one chooses to dwell, that is, the home, should be used precisely to run away from any sense of dwelling, including the very ground of habitation itself, occupying. In this sense, the escape from dwelling is also an escape from *being*.

The overly furnished interior landscape is an invitation to forget oneself and flee the world of practical reason. Decoration is an escapism, if only because it is meant to conceal the basic structure of the building. Architecture, which embodies what of *necessity* must be there for the building to stand, is eclipsed by the decorative, what does not need to be there and thus what enables the flight from the crude necessities of life. The decorative is escapist because it is superfluous: its very extraneous-ness implies a utopian element, that of having escaped the world of ne-cessity and need, of survival and material struggle. By its sheer super-

fluity, decoration aims at counteracting the business world, the throngs of office workers, rond-de-cuir, and industrial yeomanry which des Esseintes yearns to forget.[41]

In order to be truly escapist, the interior has to reject the architectural basis that provides its ground. A late outcropping of the baroque, the overdecorated interior makes the extrinsic supersede the intrinsic.[42] The gaudy abundance of the boudoir betrays a phobia of fixed surfaces, that is, anything architectural that stops the depth-seeking gaze of escapist daydreaming. The bourgeois wants to look at his interior as an ever-receding, distance-producing landscape. To do so, he avails himself of every variety of form, plait, and fold, as well as materials, velvet, satin, or damask, whose shimmering undulations always promise an inner world of infinite recesses within recesses. Derealizing the space of architecture, the bourgeois keeps the interior in a permanent crepuscular light: this is where the excessive use of curtains finds a practical rationale. Des Esseintes solves the problem of intrusive daylight by sleeping during the daytime and bathing his interior in the glow of gas lamps at night. Contrasting with the cheerfully sunny ideal of the eighteenth-century domestic, the nineteenth-century home is a dark and somber affair. The taste for darkness ties into the interior's illusionist, antiarchitectural logic. Conceived as a camera obscura, the interior is a place of fantasy where one repairs to be anywhere except in the here and now. Chiaroscuro is the dream state of infinite horizon and infinite flight: the object is there only enough to signify the uncertainty of its thereness. Wavering between being and nonbeing, the interior suspends the architectural space in which it takes place.

The suspension of space from the interior extends to the profusion of the decor. The Aladdin's cave of trinketry, exotic gimcracks, and swanky objects d'art is a place in which contents supplant the container. Indeed, in the era of all-out bibelotization, the formulation "space of the interior" becomes somewhat of an oxymoron. In Goncourt's *La Maison d'un artiste*, the Babelic bazaar spirits away the architectural structure: "a dining room . . . just as I like them," Goncourt writes, "where the walls and ceiling are hidden under tapestries" (*Maison d'un artiste* 18) or again "my bathroom is literally covered over with china and watercolors" (*Maison d'un artiste* 157). The architectural foundations of the room are all but

taken down by the decoration. Walls, ceiling, floor, architectural boundaries, all physical markers of enclosure are beaten out of the interior by the legions of bibelots: "The study is all books," adds Goncourt, quite unmetaphorically. In masking the wall, the bourgeois seeks to erase its boundaries; by the same stroke, he wills away the basic architectural frame. As Heidegger insists, space is essentially an effect of enwallment since "a boundary is not that at which something stops but, as the Greeks recognized, the boundary is that from which something begins its presencing."[43] Insofar as space is first and foremost what springs out of the limit, the interior erases space by knocking down the architectural limit. The interior seeks to be a limitless space and thus a space no longer. It is a place in spite of architecture.

The negation of architectural space reinforces the interior's escapist character. Ever thirsty for the quaint, the mysterious, the exotic, and the souvenir, the interior is less a house than an imaginary gateway to some never-never land. In Huysmans's *A Rebours*, the story of a dilettante's seclusion in an overfurnished interior, the dining room is a room built within a room; as such, it is an illusion of a room:

This dining room looked like a ship cabin with its vaulted ceiling, rigged with semi-circular beams, the paneling and floor in pitchpin wood, its little window opening through the woodwork, like a porthole on a hull. Just like those Japanese boxes set into one another, this room was boxed in a larger room that was the actual dining room built by the architect.[44]

Des Esseintes's strategy consists in not inhabiting a house but an interior, a pure decor without an underlying architectural structure. It is as though the wall still bore too strong a reference to the detested outside world. As a result, the distinction between the inner and the outer has to be further inwardized. The actual architectural shell recedes into a fantasy horizon, it lies somewhere beyond, vanishing into distancelessness. Des Esseintes's dining room sails off on fantastic seas, the very near has discovered the "Sesame" that opens the door to the very distant. Home (which des Esseintes would never dream of leaving) is an endless dream of departure, a permanent journey in cloud-cuckoo-land. It proclaims not architectural thereness, but decorative unworldliness.

On his mantelpiece, des Esseintes has framed Baudelaire's poem,

"Anywhere Out of the World." This poem-object decorates the interior with the wish for absolute placelessness, which is a wish against architecture: a place wrenched out of the world, a place in the nonworld, in effect, a nonplace. As an architectural object, the interior strives to undo the notion upon which it is built, rejecting the architectural demand to found places. This highlights the interior's paradoxical and self-defeating character. Is it possible to conceive of an architecture *out of the world*, namely out of any place, outside of architecture itself, whose role consists precisely in putting the world into place? Can architecture stand beyond its own ontological ground? However paradoxical the answer to these questions may be, it need not be negative, since, as we shall see, architecture negates the idea of exteriority it initially seems to buttress.

Architecture, Denis Hollier explains in *Against Architecture*, is pervasively used as a metaphor to describe grand overarching systems, such as the universe, nature, thought, the body or knowledge: "There is no system whose description does not resort to the vocabulary of architecture. Architecture is, in this case, an archi-structure, the system of all systems."[45] Because, as arch-metaphor, architecture encompasses the articulation of all discursive practices, it becomes impossible to conceive of an outside to the architectural metaphor. Again, Denis Hollier remarks, "This metaphor shapes the system of every discipline it touches upon. This leads to the repression of everything errant and playful, any form of exteriority. . . . There is no room in the system for the outside of the system" (70). Insofar as architecture-as-metaphor allows no form of exteriority, there comes a limit at which it negates not only the idea of the exterior but also the idea of the limit itself. Which, in turn, negates the very idea of architecture, whose concept consists in setting up the dialectics of interiority and exteriority through the limit. Architecture-as-metaphor is therefore the limit where the idea of the limit itself is withdrawn. The interior marks off the absolute limit of architecture, beyond which the architecturally defined opposition between interior and exterior breaks down, along with the idea of architecture itself. The interior as the arch-metaphor of architecture contains architecture but brings it to its ultimate limit. The interior is the limit of the architectural limit, of architecture anywhere out of the world, where architecture no longer stands.

In abolishing the wall or, at least, concealing its presence, des Es-

seintes hopes to make real the promise of Baudelaire's poem: a place out of the world, out of the place itself, out of anywhere that is somewhere, a nowhere. In a similar vein, a decorator of the 1840's named Jean Zuber introduced panoramic wallpaper that unfolded a continuous scenic view around the room, with a choice of such favorites as "Italian Landscape," "French Gardens," "Greek Landscape," or "Chinese Decor." Here the wall signifies its opposite: it is no longer a boundary defining a place but a limitless horizon. Where architecture begins to set up a world, decoration erases this world and opens it up to the infinitely distant. Of course, Huysmans out-decorates Zuber. Des Esseintes cuts the umbilical cord between the interior and the world as he dresses the window as an indoor decorative piece, a picture-postcard fiction of the outside. By embossing the windowpane with stained glass and outfitting his maid with a hood, des Esseintes gives himself the illusion that, as the servant's shadow moves past the window, he lives in a medieval monastery. The interior forcefully enlists the exterior for its own decorative purposes and the outside world is internalized as a bibelot (a process also active in Mallarmé's poem "Windows"). The window, properly an opening to the outer world, here becomes a means to further isolate the interior and indeed turn the outside world into a feature of the indoor decoration, fulfilling René's metaphysical wish with decorative flourish ("Happy are they who end their journey without ever having left the harbor").[46] In pulling the outside world inside the monadic interior, des Esseintes submerges the ground of existence in a chiaroscuro of distanceless decoration.

Generalized inwardization, however, soon turns into a nightmare of solipsistic impotence. Once inwardized, the world can no longer function as an exterior referent. Des Esseintes could not leave the house even if he wanted to—and when he does, he discovers there is no longer any world there. Halfway through *A Rebours*, des Esseintes decides to open the window of the interior in which he has spent the whole novel: "He pulled the window wide open, happy to breathe in the fresh air. . . . He slumped down, swooning and almost dying, on the window rail" (*A Rebours* 160–61). After having been won over to decoration, the window cannot revert to its original architectural function, that of giving access to the outside. It is as though reality were to exist henceforth only by way of its fantasmatic enframement. Magritte's *La Lunette d'approche* nicely illus-

trates the always already inwardized nature of the real. It depicts a half-open window: through the windowpane one can perceive puffy clouds and trees; however, looking through the space between the glass and the windowsill, which normally gives an unmediated glimpse of reality, one only sees inchoate darkness. Reality without mediation, that is, without the inward frame of consciousness, does not exist. Solipsistically, the world is a thought from inside the interior. When at the end of the novel neurasthenia forces des Esseintes outdoors to seek some treatment, he finds nothing, space without a place: "There was nothing, nothing left, everything was gone" (*A Rebours* 240), as though he had said, *there is no world there.*

The bourgeois interior's evasion of architecture bespeaks a crisis of dwelling for the modern inhabitant. Home becomes synonymous with its own avoidance, with the liquidation of ground and world. Des Esseintes only resides in the here and now of the interior inasmuch as it allows him total abstraction from dwelling, that is, from occupying the *hic et nunc*. Being at home reverts to its opposite, being far away from home, from human-inhabited space. The bourgeois interior is the place where one stages one's refusal to be somewhere. *Anywhere out of the world*: the interior dweller dwells in homelessness, outside the place-establishing frame of architecture.

Interior and Interiority

> Existence is no longer exterior.
>
> E. de Goncourt, *Maison d'un artiste*

The interior's victory over architecture no doubt explains the difficulty of figuring space in Balzac's interior or Goncourt's house. For how does one designate the place one occupies without architecture? How does one signify "here" without a "there" to oppose it? In *Intérieurs parisiens*, the photographer Eugène Atget tries to represent the interior from within, without the use of the exterior by which the interior is an interior. The difficulty here is one of signifying the homeliness or "hereness" of home from within the home, that is, where there is no distance from

what must be represented. For the interior precisely takes away the possibility of setting up the distance that is crucial to representation. Ernst Bloch explains:

For without distance, right within, you cannot experience something; not to speak of representing it, to present it in a right way—which simultaneously has to provide a general view. In general it is like this: all nearness makes matters difficult, and if it is too close, then one is blinded.[47]

In a sense, *Intérieurs parisiens* is this difficulty made into a photograph, or a photograph of that difficulty. In trying to take a picture of the place where one is, Atget really attempts to represent the place where vision and consciousness take place—the place of the subject. The *Intérieurs parisiens* bridges the distance between the camera and the scenery by collapsing the field of vision and the object it seeks to seize. The camera takes the picture of a place rather than a thing in a place. Here, the place is the thing. But can the place that encompasses the viewer become a thing? The problem is solipsistic: how to represent the place where one is and, to some extent, which one is. Self-reflectively, the camera becomes the picture of its own chamber and the interior, for its part, becomes an image of the photographic chamber and, beyond that, of consciousness, which seeks to grasp the situatedness of its chamber. For each photograph spells out the same invisible message written across the interiorscape: *Hic Sum*—I am here, the place which I photograph. In a sense, *Intérieurs parisiens* seeks to photograph the lack of distance between the subject and the interior, between the camera obscura and the chamber. Indeed, those pictures silently capture the lack of mediatory distance inside consciousness itself. In this context, the fashion for dollhouses and miniatures appears all the more significant as a means of circumventing the impossible nearness of the interior from the inside. The dollhouse enables the interior dweller to encompass "hereness" and erects a miniaturized distance that is denied in the full-scale model.

But the "hereness" of the interior, or the difficulty of nearness, leads away from the mere problem of representation to that of defining modern consciousness. What is the self to the self, or the *soi* in the *chez soi*? The problem of the interior is nicely captured by Goncourt in the foreword to *La Maison d'un artiste*: "Existence is no longer exterior" (7). This

sentence, which means to stress the domestication of life in the nineteenth century, denies to the subject the predicate necessary to the very concept of subject: insofar as *ex*teriority is the basic condition of *ex*istence, existence is stripped of its own impetus the moment it denies externalization. To *ex*ist entails the *ex*teriorization of consciousness, the casting outside of consciousness as a self-representation. The interiorization of existence brings existence to the same limit towards which the interior pushed architecture—on the brink of groundlessness. Yet, the fact that existence takes up a metaphorical space that denies itself is far from being inconsistent with the toil of the modern philosophical ego. Goncourt's paradox of existence without an exterior reflects the distress of solipsistic reason, so locked up as it is in positing the self's self-enclosure that it can only posit the cognition of exteriority as an inner detour which consciousness takes in relation to itself, *in itself and at home with itself,* "en soi et chez soi."

Modern consciousness dreams of an existence without limit, yet in which it would be everywhere at home. Philosophy seeks to rationalize this dream since, as Novalis defined it, "philosophy is essentially nostalgia—aspiration to be everywhere at home."[48] Philosophy is the possibility of thinking and being *chez soi* in its own mind; of being in and grasping the place from which it speaks at the same time; of being, finally, in the place from which it departed and to which it yearns to return. In a sense, the interior is the philosophical quest, the yearning for the absolute immanence of home. The difficulty of designating the hereness of the interior is tantamount to the philosophical predicament of trying to achieve the *in situ* of thought, where consciousness may speak *about* itself and yet be one with itself. Such immanence to the self is, however, as Novalis says, a nostalgic and ultimately vain goal: in order to designate my place as "here" I must step out of that place and thus disrupt the original hereness; in order to speak *about* myself, I must be, in a sense, beside myself. This paradox cannot be exhausted or overreached. The subject *grasping* itself in its *chez soi* is sheer nostalgia, pure loss, an unretrievable bibelot. As far as the subject *being* itself in its proper place is concerned, however, the bibelot remains impervious to the strongest blows philosophy may deal against it. One can never leave one's place and, for that reason, can never grasp that place either. Unless, of course, the transcendental alibi be

reinstated. For it is no mere coincidence that, having exhausted himself on the "hereness" of *A Rebours*, Huysmans started writing the novels of his religious conversion, quite fittingly titled *En Route* and *Là-bas*, which brings the divine limit back into the world so as to assign a circumscribed place to subjectivity from the "là-bas" of the divine nonpresence.

In order to understand further the interior architecture of the self, one may turn to the architectonics whereby the self is produced in its socialized form. In *Discipline and Punish*, Foucault traces the extension of the concept of the norm throughout modern society, or what he calls a "disciplinary" society. He demonstrates how disciplinary power is not merely a negative, repressive force but a positive system of individual self-production. Power is no longer expressed by the fortress that quarantines convicts, the mad, or the sick; authority is no longer transmitted down a vertical process of subjugation from the crown to the lowliest subject. In contrast to the system of caste, hierarchy, and privilege that characterized "classical" society, modern society lays out a space of absolute communication that, as Foucault emphasizes, "opens up disciplines and makes them operate diffusely and multiply, fulfilling many tasks in the entire body politic."[49] Modern disciplines are, in a sense, self-disciplining. One famous instance is Bentham's Panopticon, whose working principle rests not on banishing the criminal from society's sight but on subjecting him to the light of constant visibility and communication. First, remove the signs of repression; next replace them with the false freedom of self-discipline: these are the two basic steps in the recipe for a normative society. The norm, unlike the law, is not enforced by violence. Rather, it is a model of production abandoning all oppressive techniques, which, as a rule, presuppose a wild state of nature to be trained and domesticated. The norm does away with this notion of a system of repression superimposed upon a preexisting and once free subject. Under normative rule, the subject does not precede the regulatory discourse that both produces and defines it. As such, the norm does not repress—it does not fence in unruly nature behind limits—but rather creates the subject from the inside out. There is no nature prior to the normative definition: even the outside of discourse is a production of discourse. In his study on sexuality, Foucault shows that we are not divided between, on the inside, a true sexual nature, and on the outside, a

set of discursive practices that repress that underlying nature. On the contrary, sexuality only exists insofar as there is a sexual discourse. Sexuality is immanent or interior to the discourse about sexuality. As Foucault insists, there is nothing beyond the curtain, or, as we may be tempted to say, there is nothing outside the window: all there is to know is already inside the house, inside the discourse of the self about the self by which nature is created. Disciplinary society is solipsism writ large.

As a result, disciplinary society does not purport to outflank or fend off an unruly outside. It strikes out altogether the antinomy of inside and outside on which classical authority rested. Because it is immediate to the subject's production, the norm cancels the polarity of interior/exterior. Normative space "arranges things in such a way that power is not added on from the outside, not like a rigid form of restraint weighing on the functions it takes over" (*Surveiller et punir* 188). The norm gives rise to a nonarchitectural practice of social space, namely, a space where all liminal markers have fallen out. Social space is not to be fenced in or restrained, for it is, from the very moment of its formation, conceived by the norm. The model of the embattled city gives way to that of the unlimited, endlessly inclusive city. Social architecture, because it is immediate to its discursive conception, responds to no outside. That does not mean, however, that walls are no longer erected around controlled environments. It means only that the partition is no longer the founding element upon which normative space is built. Under the norm, partitioning does not lay out a space of seclusion and exclusion but of distribution and communication. Architectural practice, like power, does not rest on limits but on the transparency of its parts. Panopticism applied to the whole social sphere is a normative system liberated from the obsolete dialectics of oppression and resistance. Here no limit rises up between here and there, between the subjugated and the subjugator. No longer formally separate, abnormality, madness, or disease have become cases of an all-encompassing neutral taxonomy. Abnormality is anticipated and constituted from inside the norm. As Geoffroy de Saint-Hilaire puts it, "there is no exception to the law of nature."[50] Everything can and will be brought into the fold of normality, unable to constitute a nature in itself, an exception. The very notion of the outside is preempted for it is really a figment dreamt up by the endlessly inwardizing norm.

Normative space shapes a type of socialization where power is no longer external to the things it brings to existence. Thus, though it is not *stricto sensu* a disciplinary space, the interior provides an architectural metaphor upon which the various disciplinary spaces are built: the prison, the hospital, and the reformatory are all embodiments of an architectural practice embedded in interiority. The bourgeois interior is thus more than another nineteenth-century architectural cliché, somewhere along the grim line-up from the prison and the barracks to the hospital. Insofar as those are built according to a pattern of nonreactive all-inclusiveness—a thought without windows—the interior ought to be considered as the overarching architectural metaphor that contains them all: prison, barracks, hospital, and society as a whole.

The interior is the architectural metaphor by which the century thinks its architecture, and also the very thought which conceives such architecture. Such thinking is that of the subject upon itself, of interiority, or of the dearchitecturalized place of solipsism. "Within four walls," Mallarmé writes as a title to his first poems, sealing them up with one stroke of the pen in the interior of a book, a book that has nothing to say to the world but instead coils into its own language—replacing the world with its word. It is ultimately a book out of which the subject cannot hope to take the smallest step, a volume *out of the world.*

The Interior and Its Doubles

> For double the vision my eyes do see,
> And a double vision is always with me
>
> William Blake, "Letter to Thomas Butts," Nov. 22, 1802

Paradoxically the bibelot conforms to the escapist logic of the interior. While it seemingly points to materialist worship, a craven love of objects and concrete existence, in actuality it *derealizes* the object: its appearance and material are fake, illusionist, trompe-l'œil. The bibelot stands in for the object it mimics, but the spread of bibelots means that all objects are now their own stand-ins. The In-Itself is evacuated from what seems to be its shrine. This anxiety concerning the In-Itself also

manifests itself in the triumph of coverings, *housses* and cosies. There is in Balzac's interior, for instance, no table that does not come with a close-fitting cloth, no mantelpiece that is not upholstered, no window that is not cloaked by several layers of curtains, lining, and canopies: "At the window two curtains cut from the same cloth with Louis XVI curtain hooks. Two additional outer curtains and two great embroidered muslin drapes topped with a tassel rim" (*Inventaire* 627). In this, Balzac's interior is typical of a time when the fashion eminences cheered hyperbolic drapery:

The fireplaces have housses of gold-fringed velvet, the chairs are covered in lace, wooden wall-paneling is hidden beneath marvelous worked fabrics overlaid or woven with gold . . . curtains are fabulously beautiful: they use them double, even triple, and they curtain everywhere. The door conceals itself behind a curtain; the book-case often covers itself with a curtain; there are sometimes as many as eight or nine areas of curtaining in one room.[51]

The decorative precept is: the beautiful is the concealed. Layer upon layer of curtains hang over every corner of the house, draperies gathered in bunches and folds wrapping the room in dense chiaroscuro. The curtain spreads a dusky sense of depth into which the gaze vanishes, lulled away from the bare object. This is the beginning of the habit of gathering curtains at the middle section and letting them hang rich and ample over the door or the window. In effect, the door is always ajar, wavering. The interior sets up a realm of halfway situations, the intermediary, ontological ajarness.

The triumph of curtains reveals a thirst for endless mediation. The curtain indulges the flight into three-dimensionality, not to supply more reality, but to turn reality into wide-scale trompe-l'œil. In the process something is avoided, the question of objecthood as such is smothered. Along with the museum and the department store, the interior is a place where the subject comes face to face with the object. This confrontation is not an easy one, for the object is a mystery. Dialectically, its concept may well originate in the subject; yet the subject cannot help imputing an excessive reality to the object, a residue of realness beyond the concept.[52] This is what the Kantian In-Itself embodied: the belief that beyond the subject-object dialectic there persists an unreachable, unknowable core of objecthood, a *real* in the Lacanian sense, something traumatic because ul-

timately unaccountable. In the interior, in this world handed over to objects, the Kantian In-Itself lying dormant at the core of every object suddenly wakes up, like the evil genie. The bare core of objecthood threatens the subject's claim to universal mediation: the fear is that a kernel of undialectical objectness may cower at the core of the *mundus intelligibus*. This is the fear inherited by Neo-Kantian philosophy, exemplified here in C. Rosset:

Insofar as it is singular, reality has no guarantee but itself; it is in no way justifiable and therefore cannot be expected to be in any particular way. . . . That something exists I paradoxically recognize by the sudden impossibility of explaining that it is.[53]

Reality is the blind spot of language, which, for its part, takes the real to be the inexpressible (language is romantically inclined to believe that an object acquires more reality the more it eludes linguistic description). Reality is what cannot be canceled and replaced by the signifier: it is the "non-identical," in Adorno's terminology. What follows is a strange ballet of seduction by which language invokes metaphysics to mesmerize reality back into its fold. When the real finally wakes up, it finds itself half-enclosed in the Platonic cave, divided between a real half and a not so real half. The scalpel of metaphysics divides singularity from itself: the reality we perceive is no more than a representation, a copy whose original shines on the other side of human understanding. The trick consists in charging the referent (reality) with being a mere image (shadows on the cave walls) so that language may seize hold of it as one of its own.

Duplication, triplication, reproducibility in general, is the lure by which singularity is caught—a lure called metaphysics. That which I cannot seize in its particularity, I will reproduce so many times that I can do without the particularity itself, the singular In-Itself. This is what makes the Platonic cave a very cozy place, a regular domestic interior for philosophy. Metaphysical convenience is the mastermind behind the interior's opulent decor. What it cannot seize in itself, bourgeois consciousness multiplies so as to diffuse its singularity. The taste for automatic symmetry and cute similarities sees to it that objects nearly always come in pairs, triplets, quadruplets, and sometimes a whole spawn of identical twins which turn the room into a regular decorative echo chamber: one is never

enough (Charles Blanc, author of the 1882 authoritative *Grammaire des arts décoratifs*, insists that "above all there must be order, a sensible order. . . . The lack of symmetry would be impolite to guests").[54] The interior is a homespun version of the law of mass-produced duplication which, as the nineteenth century wears on, relegates the idea of a singular object to the status of archaic oddity. Where copy-cat reproduction does not prevail, the object is ensconced in a series of secondary objects. Objects tend to breed subcategories of objects, object helpers, object cases, wrappings, doublings and linings, as though the object needed to scurry away from itself. In Balzac's interior, no object is cushioned and wrapped quite like the bed:

The bedding is made of a flexible box spring, a false bolster, two woolen mattresses, a bolster and two down pillows, two blankets covered with an embroidered comforter in blue silk adorned with two flounces on the side. . . . The alcove is hung with China blue damask lined with white silk and inner curtains in Caen lacework. (*Inventaire* 626–27)

Mimetic repetition reigns supreme: the object is either encased, dressed, coated, sheathed, overlaid, enfolded, lacquered, or lined by a representational framework that sets it off: "The mantelpiece, as all mantelpieces on this floor except for the library fireplace, is adorned with a velvet mantle . . . trimmed with tassels and golden studs. . . . Each border is hidden by green, two-hued festoons" (635). A cushiony layer of velvet always swathes accessories and appliances as though ensuring their physical containment: "the handrail [in the stairs] is covered with red wool velvet" (629), "an inlaid desk . . . covered in apple-green velvet with gilded studs" (636), "the back side of his door is lined with red wool velvet framed with red silk embroidery" (640), "the seat [in the water-closet] shaped like an armchair is lined with green velvet and gilded studs." Benjamin sees this taste for velvety surfaces as a desire to encase the object with something that will later bear its imprint, somehow to prove that the object does exist: "Is there an object for which the nineteenth century has not devised a box or a casing? They come for watches, slippers, egg-holders, thermometers, game cards. And, when there are not boxes or casings, envelopes, carpets, blankets and sheaths are invented."[55] The *étui*—a casing or box—is a miniature version of the interior's general encasement. Again the Rus-

sian doll set—fetish of bourgeois decoration—best encapsulates the organizing structure of the interior: a series of boxes encased in one another in decreasing sizes and increasing interiority. Each additional item of contents acts as the container of a yet smaller item. For Benjamin, the velvet covering is essentially a way for the subject to put its imprint on the object, a means of domesticating objecthood. There is another way in which the étui signifies the subject's presence: the étui takes the side of the subject by drowning the object's intractable thereness. An object is henceforth more and less itself: more because it is a conglomerate, less because the conglomerate drowns its singularity.

In reaction to the nineteenth-century interior, modern minimalist design initially sought to elevate the object to the status of monolith—various *objets insolites* popping up in the middle of a bare room. The endeavor remained promising enough until the overpostulated essence of objective authenticity began to trap the object in a sediment thicker than the cushiest encasement. In the end, the fashionable In-Itself of the object, puffed out by the jargon, turned into a secondary form of étui shutting out the object.

By enveloping itself in cases, wrappings, boxes and the like, the object itself dissolves: it becomes a network. The nonidentical is turned against itself and becomes finally dialectical. The velvet sheath is a domestic Shroud of Turin that replaces the object by its form. Form, not substance, is the *primum mobile* of the bourgeois interior, however much the bourgeois fancies himself a man of substance. It is not so much the temple of objects as the laboratory of their liquidation. The étui keeps putting off contact with the object which, in the end, turns out to be some other object's étui. The curtain and double-curtain, the lining and double-lining, the object and its case, the case and its velvet covering, are all a certain way of playing hide and seek with the object, a *fort-da* game for adults.

The dialectics of encasement aims at deflecting the threat of singularity through mimesis: everything has a copy. Escapism is thereby injected into the core of objecthood. At the extreme, escapism seeks to run away from decoration itself: it is doubly escapist, shunning the decorative object for being still too present, too unremittingly itself. The case, étui, decorative framing, or velvet upholstering lines the object with its shadow,

a friendly kind of doppelganger insuring that the singular is never addressed as such but only through the dialectics of the other. It is indeed a source of great metaphysical comfort to believe that our world is but the shadow of a larger drama played out by the gods beyond the walls of our cave. The singularity of the real is deflected when it is taken to be a mere double of a purer reality for which we are, ultimately, not accountable.

Faced with the muteness and obstinacy of things, the interior dweller neurotically delays contact with reality through multiple sheathings. A watch needs a locket to protect it against damage. But it needs two more to remove it from the singularity of its being: "A *watch* in three boxes, the second one in pure gold representing Joseph sold by his brothers, which once belonged to the queen of England, wife to Charles I" (643). The watch is locked up three times, as though thrice removed from itself. This, in effect, asks the object to keep silent about its muteness. That best-selling item of knicknackery—the statue of the three monkeys, one covering its eyes, the next one its ears, and the third one its mouth— best exemplifies the objects' silencing. While the trinket's obvious lesson is that wisdom lies in circumspection, its less obvious lesson is that serialization gives to objects that circumspection we expect of them. In a sense, the stylistics of kitsch—overemphasis, numeric overkill, hybridization of functions, superfluous detailing, and so on—constitute an overall strategy for avoiding the object proper. The thing is camouflaged and stifled under its decorative regalia. The object worship normally associated with kitsch should be viewed in its proper light: a way of smothering the object under its own splendor.

Eden Indoors

> Behind all utopia, there is always a taxonomic design: a place for everything and everything in its place.
>
> Georges Perec, *Penser/Classer*

The interior realizes the dream of the bourgeoisie: each thing in its place and a place for each thing. Decoration is fashion applied to the task of objectively compartmentalizing life. In his inventory, Balzac follows

the logic of taxonomy already at work in the interior. Cataloguing is implicit in the structure of nineteenth-century interior decoration: the teeming profusion of objects actually involves a hierarchical rationale whereby furniture and bibelots are laid out according to a network of ancillary combinations that are strongly determined. Above all, no category is without subcategories: a curtain necessitates a lining and an inner curtain, which in turns calls for a lining, and so on. A table calls for a rug to support it, a trimming to set it off, a velvet cloth to cover it. The bibelot is invariably paired. If it is unique, attendant objects (such as a frame, credenza, or locket) will congregate around it to dress up its singularity and thus negate it. The essence of nineteenth-century decoration lies in the compulsion to subdivide and to accessorize. What strikes the eye as kitsch clutter is in fact a paranoid cartography of the domestic sphere where space is converted into its own index. The urge to add more objects expresses the need to realize every possible combination and fill every square in the decorative grid. Here is an example taken from Balzac's "green parlor":

In this room the lower paneling is painted grey and the upper half tapestried in apple-green velvet. Every border is hidden by a two-colored trim. This wall fabric is framed by a 4 cent. braid running along stripes of golden copper. Above every trim, the stripe is secured by square hooked nails at all angles. (635)

Each element is decorated by the next, which is itself decorated. What drives the interior decorator toward ever more detailing is the concretist reflex to secure the object by appointing other objects around it, and the encyclopedic compulsion to secure the world by subdividing it endlessly. As with the characters of *La Comédie humaine*, every object in the interior calls for neighboring specimens and subspecimens in a well-wrought chain of being: it is a world handed over to the taxonomic spirit.

In a sense, the profusion of objects stems from the fact that everything in the interior is potentially a collectible. As such, every object calls for other objects of the same species. There is never simply a snuff box or a bowl in Goncourt's house but always a gaggle of similar snuffboxes or bowls. The impressive inventory of vases, pots, and chinaware in the "cabinet de l'Extrême-Orient" is an instance of this self-replicating, scissiparous interior. As collection, the interior is ruled by similarity: each

object needs a double and a whole spawn of clones. The clutter is only apparent. The interior dweller's maxim is that no object shall be left un-paralleled and, thereby, unserialized in leveling similarity. Indeed the interior is the dominion of the identity principle: in it the Same rules over profusion. While it seems to worship curiosities, the unusual or ex-ceptional, nineteenth-century decoration is already preparing the advent of a world without curiosities, a world where, as in the standardized suburbs, the existence of oddity is ruled out from the start by town-developers and zoning regulations. And the bibelot, as mass-made object, is chief among those enforcers of the identity principle: it brings into the home the modes of serialized production to which it owes its existence. Behind the cute world of symmetrical duplication looms the homoge-nization of existence, the general evening-out of singularities, the desub-limation of difference.

Homogenization, however, is not the bourgeois's sole motivation. Instrumental reason somehow thirsts for redemption. This, too, is at work in the collector's interior. By bringing singular attention to each of his trinkets, Balzac presumably seeks to restore the aura of uniqueness which serialization tore up.[56] It is a matter of salvaging the small details of exis-tence from a world that makes all objects indifferently replaceable. Mi-nute detailing is associated with an artisanal mode of production that, by the late nineteenth century, already looked badly endangered. In lovingly scrutinizing every element of their interiors, Balzac and Goncourt enlist concretist representation to safeguard this soon-to-be obsolete world of handmade craft. The Lilliputian imagination is redolent with the archaic desire to take refuge in a world where even the smallest things, the trifling, still matter. In paying heed to the dispensable and the overlooked, the miniature harks back to the premodern, pre-industrial world: its domain is the fairy-tale castle or, as in Pinocchio, the craftsman's workshop. Mag-nification of the smallest trinket in depictions of the interior aims at rein-stating the object to the gleam of a particularity. The minute description of the interior, in Balzac and Goncourt particularly, is also an antidote against the desublimation of objecthood in the world of generalized duplication.

Attention to the single detail is furthermore consistent with the sen-timental nature of collecting. Ownership—the bond between subject and

object which Benjamin describes as the essence of collecting[57]—grants the object a precious singularity normally given to sentient beings. Although a given class of objects might be replicated several times throughout the house (there are many chairs, tables, or candelabras), there are no two interchangeable objects in the interior, no two comparable, mutually replaceable items. Hence the *candélabre* in the dining room can in no way be likened to the *candélabre* in the boudoir. Although morphologically identical, the two words are not to be swapped. Because it rests in a list, each object belongs to a realm of limited supplies. Each is counted singularly and, therefore, irreplaceably. The words of a list are not interchangeable markers designed to stand in for several objects at the same time. Referring to a singularity, the word behaves as though it were used for the first time, the same way names are used for a limitless number of individuals and yet always remain personal and exceptional. Indeed, marked off as singular, the object is *named* rather than evoked. A name can be repeated *ad infinitum* and yet subtracts nothing from the singularity of its bearer. The name contains an image of a linguistic totality whose single occurrence is set apart from the existence of all other referents: because this totality excludes the rest of language, the name does not connote a person but is tied to that person by seemingly immanent bonds. The name is the remainder of an archaic language in which all words existed as names. As Walter Benjamin intimates, God speaks in names, as did Adam before the Fall: "In God only things have a name."[58] To be on the side of God is to escape the necessity of communicating through a language of words. In God's language of names, each object brought something of its singularity into the linguistic material. After all, the Garden of Eden or Noah's Ark only had two items of each species. Cosmogonic tales often picture the universe miraculously cured of duplication. It is only after the Fall that Adam and Eve, as good industrialists, went forth and multiplied. Reproducibility is actually linked to stigma, a fact of which the collector seems to be the melancholy recipient. In naming and listing the objects in his collection, the collector seeks to wipe the patina off them while restoring language to its childhood. The list enumerates the world, pointing at this and that object with no narrative continuity. Like Adam's first words, the child's language merely acts on the fact that there are things in the world:

Il y a une horloge qui ne sonne pas
Il y a une frondrière avec un nid de bêtes blanches
Il y a une cathédrale qui descend et un lac qui monte
Il y a une petite voiture abandonnée dans le taillis, ou qui
descend le sentier en courant enrubannée.
Il y a une troupe de petits comédiens. . . . [59]

There is a clock that does not ring
There is canopy of branches with a nest of white animals
There is a cathedral that goes down and a lake that goes up
There is a little carriage abandoned in a copse, or that runs
down the path, ribbons flying.
There is a company of stage actors. . . .

Rimbaud's *Enfance* brings childhood, the list, and poetry in configuration. Perception is stripped down to the bare enumeration of objects in the essentialist focus of *il y a*, "there is." The child looks at the world non-narratively: the repetition of "il y a" inhibits the unfolding of syntactic and ontological relations. All things exist on an even plane. Truly utopian, this vision involves a democratic balance of part and whole, of singularity and totality. As such, it is relegated to the past, to childhood. This, too, makes the collector into an archaic figure. Although he stands for modernity—on a par with the flâneur, the banker, or the prostitute—the collector actually embodies a nostalgic impossibility. His language, comparable to the child's pointing at things, is a pre-language consisting solely of proper names.

In describing his interior, Balzac does not run a survey of exchangeable entities, but recites a roll-call of identities. The intense focus on the object removes its word from the realm of connotation. Balzac's inventory harks back to a utopian language. Thus the word *candélabre* does not generically qualify its bearer—it is just not *a* candelabra—but stands for the particular candelabra set on the Louis XVI cabinet in the green room. It is its name. *L'Inventaire* speaks in the childhood of language, a world that precedes connotation and metonymy, that is, literature. Perhaps *L'Inventaire* harbors the secret wish to do away with description altogether. Here the collector seeks to supplant Balzac the author; in looking for an undamaged pre-Adamic remnant of linguistic experience, Balzac wishes to undo literature and gain access to pure lan-

guage. This, in many ways, summarizes the philosophical escapade of *Louis Lambert*, whose eponymous hero ends up speaking the childish—or utopian—language of names, a language quite beyond the grasp of literature, by the author's own admission. For language is first and foremost the universal: it replaces the object by an abstraction, a signifier intended for exchange and circulation. By contrast the collector aims at reclaiming the object's singularity, its resistance to language.

As singularity, the object must remain undescribed. Description is too dialogic and metonymic a process to account for singularity; it always involves a doubling of the object into what it is not, has been, or will be, what surrounds it and what offsets it. In *L'Inventaire*, the seemingly descriptive paragraph following each object is actually an evocation. Like an identity card, the inventory designates rather than describes its object. In refraining from portraiture, the identification card acknowledges the inadequacy of description before singularity. Like God, singularity suffers no images, and an identity that accepts duplication implicitly forsakes its own concept. Ultimately, the portrait—which is traditionally supposed to render and preserve an identity—expresses the price the individual has to pay for its enshrinment in the language of representation; namely, that it ceases being a singularity. Thus a literature that does not want to betray its object will replace description with enumeration.

The originary potential of lists can be first seen historically: enumerations and catalogues are the earliest occurrence of writing, used in bookkeeping, domestic inventories, and official records.[60] The long inventories of names, things, and deeds in ancient texts, from biblical scripts to the Homeric epics, bear witness to the catalogue as origin of writing. A list fantasizes the plenum of a world liberated from the contingency of becoming and narrative development. A language where words are unheedful of one another is a primitive language, the genesis of language as Adam enacts it in a world not yet narrativized. Adam's first words are just that—words unattached by the paradigms of grammar, names of living things in the universe, light, earth, sky, water, and animals in the garden.

Starting anew with each item, the list repeatedly extricates itself from the void. It skirts the limit of language, the edge where the articulation of its prose is undone and simultaneously about to begin. When

reading a list, the eye keeps falling into the gaps between entries. One must ask again and again how to emerge out of that blank void that refuses even to explain the absence for which it presumably stands. Balzac's inventory weaves in and out of language, between the freestanding word and the void surrounding it:

> The *drapery* is in very rich Cordoba leather
>
> A wooden *chandelier* with eight candles
>
> Twelve *chairs*, each with different ornaments although similar in shape
>
> An oak *table* seating twelve with six sculpted sides and four carved legs

The list is language on speaking terms with the beginning of language, a dialogue between language and nonlanguage, absolute nominalism bursting out of silence, the word against nothing, creation against the uncreated. Hence its use in the Bible: the list appears whenever there is a need to express the cosmogonic separation between the chosen and the forsaken, between what takes part and what falls apart. Its recurrence in demiurgic literature stems from its symbolic power to enact creation. Just as, in Adam's early utterance, language is born in a listlike form, so the world was first enumerated. The God of Genesis created beings and objects fully shaped and itemized: his was not a nursery but a magician's hat from which objects are pulled out one by one. Thus God did not describe the world when he conceived it but laid it down in categories, by number, weight, and size. The world is God's inventory and the list still bespeaks demiurgic ordering, the essential stillness of things as they first were: an image of prehuman stillness.

Insofar as it places itself at the beginning, the list is bound up with the themes of procreation, genetic flux, and creation. In the list of Jesus' ancestry, narrative turns into a list recapitulating the line of procreative acts:

And Jesus himself began to be about thirty years of age, being the son of Joseph, which was the son of Heli, which was the son of Matthat, which was the son of Levi, which was the son of Melchi, which was the son of Janna, which was the son of Joseph, which was the son of Mattathias which was the son of Amos which was the son of Naum which was the son of Esli which was the son of Nagge, which was the son of Maath, which was the son of Joanna which was the

son of Rhesa which was the son of Zorobabel which was the son of Salathiel which was the son of of Neri, which was the son of Melchi which was the son of Addi which was the son of Cosam which was the son of Almodam which was the son of Er which was the son of Jose which was the son of Eliezer which was the son of Jorim which was the son of Matthat which was the son of Levi which was the son of Simeon which was the son of Juda which was the son of Jonan which was the son of Eliakim which was the son of Melea which was the son of Menan which was the son . . . which was the son of Mathusala which was the son of Enoch which was the son of Jared which was the son of Maleleel which was the son of of Cainan which was the son of Enos which was the son of Seth which was the son of Adam which was the son of God. (Luke 3)

Here, presumably, is the first chain of being, which turns narrative into listing or perhaps reveals that creation calls for listing, not storytelling. What creation, then, does Balzac's inventory recount? What re-creation of the world is attempted here? Balzac's list is a utopia of rebirth, objects out of the soup of industrial commodification, of indifference, of commodified language.

In *L'Inventaire*, language seeks a neutral ground of objectiveness—an *originality* of objectivity—by resorting to quantification. The precise notations, measurements, and minute detailing—"a fireplace 2 meters and 23 centimeters wide by one meter 50 centimeters tall, 1 meter 23 at the opening and 45 centimeters deep on the mantelpiece"—surely aim, not at describing the collectible, but at encircling it by means of pseudo-scientific markers, by the numeric. Even before Mallarmé and Valéry, poetry recognized in mathematics an absolute language and hence a prelapsarian language. Through mathematics, language hopes to strip off its subjective element. It succumbs to the ideal of science which dreams of a cognition without a subject. It wants to mimic the In-Itself. Hence scientific language uses the numerical to establish the primacy of object over subject. Balzac is not immune to the scientific dream of untainted objectivism. Grandet's motto, "to see life in a bourgeois manner and estimate its true price" entails a quantification of the objective world, not only for the sake of commercialization, but also for that of ontological stability: to corner the In-Itself by means of numbers.

In the end, concretism shuns mimesis. *L'Inventaire* is an extreme version of *La Comédie humaine* but by no means a deviant one. As an ex-

treme, it sheds light on what sometimes only barely crops up in the novel: the substitution of objective language for expression. Science eradicates the adjective, the stronghold of the literary mind, that is, of imprecision. It waits for the day when an object is evoked by means of numeric parameters only. In the meantime, instrumental reason—which by no means originates in nineteenth-century positivism—is satisfied with establishing the ontological inferiority of the adjective. Grammar decrees that the adjective is a mere appendage to the object it modifies; it is something external and superadded to the nominal core. Adjectives hang loosely around like ornaments which, as such, remain eerily separate from the object: "A noir, E blanc, I rouge, U vert, O bleu [A is black, E white, I red, U green, O blue]" (Rimbaud). This grammatical hierarchy is ontologically biased: it holds the object to be different from and, as it were, more basic than its features. This prejudice is also found in the rationalized mode of industrial production: there, too, the object is severed from its attributes. The same car model comes in different colors, with different fixtures, yet all have the same name, as though the basic model existed prior to its characteristics. Grammar's dichotomous structuring of the noun and adjective underwrites the functionalization of ontology, as though perhaps the factory assembly line (the systematic appending of attributes onto a nominal core) stemmed indirectly from the functional reification of ontology operating in grammar.

Balzac's inventory's use of the adjective is a way of bridging the separation of adjective and the noun. The numeric notations make describing the object superfluous; even when it is present, the adjective seems to want to merge with its object, of which it would be viewed as an inherent part, not an external appendage. Hence, "the two little forked golden copper torches" in the second-floor antechamber do not carry the adjectival qualifications "small" and "golden" as external marks but as an intrinsic part of their identity, as a part of their being the irreplaceable and singular little candelabras in golden copper in the first floor drawing-room. The adjective is no longer a paradigmatic modifier ("big," "mid-size," "tiny," "short," "enormous") for it does not retroactively qualify the noun; it is a synchronous part of the nominal cell. In many ways "the two little forked golden copper torches" reads as one nominal statement. As the adjective coalesces with its object, Balzac often fuses them syntacti-

cally: "On this shelf is a three-piece decorative trinket in pink marbled celadon set in golden copperwork, old-fashioned set" (*Inventaire* 643). The object becomes a single hyphenated word whose components cannot be swapped or interchanged at the describer's whim. The adjective does not describe; instead, it dissolves in the object's singularity.

To be sure, the merging of adjective with noun reveals a nominalist spirit, the belief in absolute entities standing against the subject. For demise of the adjective entails in part a retreat of the subject, he who qualifies. On the other hand, the absorption of the adjective into the nominal cell also participates in the collector's redemptive project. A commodity, put together in stages on the assembly line, can never amount to anything more than the heterogeneous sum of its parts. This is what Benjamin had in mind in speaking of the "hollowed-out objects" of nineteenth-century commodity culture.[61] The hollowed-out object is, like the grammatical function, an empty structure onto which qualifiers are attached for marketability. The object is assembled rationally, *described* by the designers of mass appeal in such a manner that its features are *added* functionally onto the object. In the collection, by contrast, the notion of fetishistic attachment not only singularizes the object but, owing to its unicity, bridges the industrialized divide between substance and predicate. For Balzac, the object must be rescued from grammar and, for this, the language of literature must be overhauled, beginning with its devotion to the adjective. In jotting down his objects in a terse, sullen manner, Balzac sides with them against literature, ultimately against himself, master of prose that he is. Writing "poorly" (this is the gist of Proust's appraisal of Balzac's style), the Balzac of *L'Inventaire* aims to wrench the object out of language, which, with instrumental reason as its co-conspirator, is the enemy of the object—a way of further liquidating it. No doubt the attempt to salvage the primacy of the object is doomed from the start. Its failure stems from the illusion that primordial experience can be recouped, as though the subject, by its very existence, did not stand in the way of such recuperation. For even when language aims at presenting an extra-linguistic piece of reality, it still remains language. This explains why Balzac must alter language at the deepest ontologico-grammatical level. Realism, when carried to the extreme, must turn against language itself.

Clues

Minute detailing of the interior brings to mind a related artifact of nineteenth-century drawing-room culture, the mystery novel. *L'Inventaire* isolates the object from its context: it magnifies it, throws (*ob-jecere*) it under the gaze of the concretist eye. The object becomes as glaringly obvious and cumbersome as the mislaid bibelot, the out-of-place detail upon which the reader of detective stories is made to stumble at the start of the mystery novel. The detective story, just like the collector's inventory, revolves around the isolated object, the sought-after clue that will explain reality; it is the drama of misplaced details, of objects lost and found, which the inquisitive mind summons for questioning. In the detective novel, the interior decor is the place where the truth about the subject can pop out in the form of a misput object, a tiny thing that will blurt out the whole hideous truth. The inspector's magnifying glass and the connoisseur's monocle encapsulate the shortsightedness that realist miniaturization mistakes for vision. In realism, as in the detective story, truth abides in the smallest things, in the imperceptible: an invisible fingerprint, an overturned trinket, dust brushed off a vase, a passing flutter in the housemaid's countenance. This matches the epistemology of *La Comédie humaine*, in which the largest truths are first encountered in details (the detail-as-plenipotentiary-of-the-Whole undergirds most nineteenth-century scientific disciplines, from archeology to paleontology, phrenology, psychology, psychoanalysis, and modern medicine). For Balzac, totality lays dormant in the detail. "Isn't the whole of China contained in one Chinese woman's slipper in pink damask and sporting embroidered cats on the top?" Flaubert muses.[62] Uniformity of things in industrialization means that every detail reflects the Whole. It obeys the dictum that nothing in the industrialized world may elude the whole. Thus the detail is not taken up for itself, but only as a signpost to the totality. The detective is a fetishist only in appearances: he attends to details only to eradicate them by establishing a totalized, thoroughly rationalized world, that is, a world where no detail disturbs the Whole.

The detective story is ripe with this faith in the rational coherence of totality. It rests on the philosophical postulate that, in a society ruled by the identity principle, each will find his rightful place in the end. The

detective story begins in disruption: more often than not, it is the domestic interior itself which has been turned upside down. The archetype is the story of Goldilocks: the broken chair, the missing porridge, details that will lead the three bears to discover the intruder. The detective is a housekeeper's dream: to put right what has been shuffled, to tidy up by singling out the telltale detail. Detective work is an exorcism of the interior: an expulsion of irregularity and restoration of a peaceful, perfectly legible setting. The detective does not lose hope that a panoramic outlook can be extracted in the end, because she never stops believing in an *illo tempore* of narrative coherence. The clue is the remnant of a broken narrative, the minuscule gate through which the whole story will out. The detective starts at the end of the story and works his way back to the beginning, tries to return to the origin of the narrative that produced the isolated clue and left it stranded. In doing so, the detective aims at recalling an earlier state of things to which the present is blind. Faced with the illicit inauthenticity of home, the detective brings back certainty by means of a narrative tie with the past. His role is that of the museum curator who assures us that, in the end, continuity with tradition and the past survives even in the midst of misplacement. We may have forgotten or bowdlerized the past, something may be rotten in the domestic interior: yet, in the end, the detective mends the severed knot and rescues the interior from the realm of inauthenticity.

Unlike the detective, however, the collector is not moved by the nostalgia of restoration and does not look backward to a fantasized original moment. The collection does not aspire to an originary wholeness. The object in the inventory neither harks back to a moment of fulfilled wholeness nor looks forward to an accomplished state of the collection. *L'Inventaire* does not yoke the microscopic focus to a panoramic outlook (unlike the detective who eventually arrays the separate clues in a meaningful story). Because each detail is self-constitutively original, the collection must start anew with each separate entry. Consequently, temporal development is brought to a standstill. The present object coincides with its past.[63] The omnipresent present tense in Balzac's, or Goncourt's, inventory points to such a suppression of the past. On this score, Susan Stewart argues, collecting is an oblivious activity: "The point of collecting is forgetting—starting again in such a way that a finite number of ele-

ments create, by virtue of their combination, an infinite reverie" (*On Longing* 152). Collecting gains its escapist flavor from its obliviousness. The collection disentangles itself from the past, makes a clean slate of things, and though historically minded, does not share the detective interest in historical sources, but rather in new beginnings.

Ruling out the sentimentalism of restoration, however, the collector falls under the spell of another kind of nostalgia. For if, unlike the detective, he does not try to recover an *ante rem* narrative that has been lost, the collector nonetheless believes in an *ante rem* prior to commodification. Benjamin construes the collector's task as one of rescuing objects from the whirl of use-value and exchange-value:

To him fell the task of Sisyphus which consisted of stripping things of their commodity character by means of possession of them. But he conferred upon them only a fancier's value, rather than use-value. The collector dreamed that he was in a world which was not only far-off in distance and time but which was also a better one.[64]

The fastidious *L'Inventaire* bespeaks the utopian notion that a remnant of non-identity can be salvaged from mass production and exchangeability. Indeed, industrialized conditions of production effected a momentous change on the material of production itself. As the object became more and more the product of a mechanistic, alienated process of production and distribution, its concreteness began to waver. Philippe Burty, an official art critic of the Third Republic, complained that the century was losing touch with objects because mass production generalized the use of inferior and deceitful materials, "pseudo-leather," "pseudo-bronze" and "pseudo-wood."[65] This increasing desubstantialization of objects in the nineteenth century recalls Marx's epigram "All that is solid melts into air" (*Communist Manifesto*), a destruction of the ontological primacy for which, in the end, *Das Kapital* attempted a desperate defense. In uncovering the desubstantializing logic of the commodity, Marx was speaking on behalf of the In-Itself, already badly compromised by Hegel's synthesis of Spirit. Marx's critique of the commodity rests on the observation that inauthenticity of experience begins to take hold where human consciousness had hitherto found a stable ontological ground: the object which, from Descartes to Kant, had been the refuge of the concrete In-

Itself, no longer carries the same undevaluable standard. In the nineteenth century, objecthood stops being a creditable value.

Acceleration in the output of mass goods means that, as genuine craftsmanship is replaced by market design, authentic materials make way for synthetic approximations. Plaster played the role that plastic fills in our time: imitation and adaptation to any form whatsoever. The object's appearance is no longer a guarantee of what it actually is. Stealing their appearance from more expensive materials, glitter, plush, plaster, and tin inject spuriousness into the core of the object's substance. Objects become their own simulacra: the bibelot embodies this standardization of make-believe, this smothering of objecthood under its own chintzy display. As pseudo-objects crowd the interior, the bourgeois finds himself surrounded by a world whose substance is compromised, manufactured by foreign hands for a spurious existence. The "out-of-the-worldness" experienced in the interior is tied to the basic disingenuousness of the bibelot. Fake and forsaking all claim to originality, the household object casts a shadow of inauthenticity on the home. It thus deprives home of the spiritual grounding it is expected to provide for human existence, the feeling that there at least one could find a shelter from the rootlessness of modern existence. The rustic home of nineteenth-century popular iconography (the gingerbread cottage) represents exactly that which modern living has phased out of existence: a handmade home, a house-hold life of autarkic bliss, a home that is at once the producer and the consumer of the goods it houses. On the contrary, the bourgeois interior is crowded with objects that bear no special affinity with the particular home. Made in enormous batches for numberless consumers, the bibelot is the Trojan horse by which mass stylization infiltrates the home. "A house," Bachelard argues, "is imagined as a concentrated being. It appeals to our consciousness of centrality" (*Poetics of Space* 17). The centrality of experience, however, is precisely what the bibelotized interior denies: there is nothing now in the center but loss, a gap in the middle of the image of centrality.

Confronted with pseudo-ism, bourgeois consciousness is bound to develop a new anxiety concerning the object. This anxiety is unleashed in the fantastic tale. In detective stories, the object is a physical threat: the innocuous silver bowl or the Bardedienne bronze can turn against its owner and become a murder weapon. But it is the fantastic tale that turns

objective estrangement into something truly disquieting and unnamable. In the tales of Poe, Gautier, and Maupassant, the domestic knickknack becomes an object of dread and horror. The home becomes the antithesis of a place where one could "feel at home." It is noteworthy that the century that tried to universalize private dwelling and domesticity also created the most vivid and ghastly images of the unhomeliness of home. Théophile Gautier's stories of the coffeepot or the exotic paperweight that comes to life bespeak the anxiety of the homeowner cut off from his objects by a veil of suspicion and hostility.[66] In many ways, this fear is exorcised by the detective novel, which assuages the anxiety concerning objects: in indexing the interior as a series of clues, the detective strips the object of its opaque aloofness and thus pacifies it. Living among fakes, the interior-dweller *qua* detective believes in putting some truth-value back into things: even though the object is filled with murderous intent and deception, it can be made into a witness to truth in the end. The detective peels off the skin of impenetrability from the bibelotized object, and restores the interior-dweller's confidence, if not in objects, at least in his control over them. A master in both genres, Poe seemingly devised the detective novel to cast out the demons left by the fantastic tale. Dupin shall have none of the ghostly vagueness in which a whole house founders, as in "The Fall of the House of Usher." In "The Murders in the Rue Morgue," two savagely butchered *bourgeoises* are discovered in their upper-floor apartment, locked from the inside. The mystery is complete, intractable, spooky: the interior itself seems to have massacred its inhabitants. But just as the fog of the supernatural is about to enshroud the story, the detective works out a rational explanation, one grounded in the all-too-natural (an escaped ourang-outang climbed though the window).

The detective, then, exorcises the interior of pseudoism before it turns nefarious. Not everyone, however, fears pseudoism. The decadent esthete offers an alternative response, by cheering for fakery. Where the detective sought an antidote, the esthete seeks total immersion. To des Esseintes, concreteness is a disease whose only cure is more illusion, more bibelotization, more rootlessness. Ultimately, every object is supplanted by its simulacrum, and the bibelot replaces existence itself. Des Esseintes's half-willed trip to England is rendered unnecessary by a stop in an English-style tavern, in Paris: no need to risk crossing the Channel

when the scents and sights of England can be had, in reproduction, just down the street. Bibelotized Englishness supplants the actual experience of being in England. When the real and its copy, the object and its bibelotized version produce the same stimuli, reality becomes obsolete indeed.

The dematerialization of experience is accompanied by a turn to solipsism. Des Esseintes cares not for the objects themselves but only for their sensuous images. Reality might as well not exist so long as the intricate machinery of simulation keeps feeding des Esseintes's sensory system. What the bibelot's triumph over the object actually means is the vaporizing of all objective experience, in fact a derealization of objecthood: "Aboli bibelot d'inanité sonore [Bibelot abolished with sonorous emptiness]."[67] Behind the bibelot looms the commodity's spell of unreality. Like the fetish, the commodity stands for something unfulfilled, for the infinitely elusive object of desire. It is, by definition, a need that cannot be satisfied in the great void-producing engine of market consumption. The bibelot embodies this hollowing-out of concreteness in the midst of its apparent triumph. It stands for commodification and dematerialization of an objecthood that is but "inanité sonore," an echo.

Losing Touch

> My house looks at me and no longer knows me.
>
> Victor Hugo, *Tristesse d'Olympio*

The analysis concerning the dematerialization of objecthood confirms our initial hypothesis: the paean to domestic life in nineteenth-century popular culture betrays a deep-seated anxiety concerning material existence, the fear that a secure, abiding life among things is no longer possible. Nestled behind the moat of its illusionary indoor landscapes, the bourgeois home begins to look illusory itself. Homey comfort is haunted by provisionality. In the end, Emma Bovary, barricaded in her swanky interior, stands powerless before the onslaught of creditors. Her mail-order bibelots and fashion-catalogue decor are auctioned off, the entire home scattered to the winds. To be sure, this provisionality derives

from the inherently makeshift dimension of decoration, something that likens the interior decor to a momentarily planted circus tent. As opposed to architecture, decoration is temporary almost by definition: the furniture can be shifted, the bibelots can be swapped, the upholstery refurbished. In making the interior a decor the bourgeois unwittingly condemns his home to impermanence.

Indeed, precisely insofar as the interior fashions itself into a dream landscape, it admits its debility before the world it yearns to leave behind. The home is no barrier against the world, the private castle is defenseless, because illusion, no matter how convincing, is never as strong as the iron will of the business world. In the end, des Esseintes's bazaar offers no resistance against the outside world. He is turned out of doors, the bibelots are scattered, the contents of the house dispersed. The entire novel buckles under the irrepressible charge of the social totality returning to claim its due:

The door suddenly swung open; far in the distance, framed by the door, men . . . appeared, handling boxes and carrying furniture, and the door slammed shut on the servant who carried off boxes of books. Des Esseintes fell down on a chair, crushed. —In two days, I will be in Paris; come, he said, it's all gone; like a tidal wave, swells of human mediocrity are rising to the sky and they are going to wash over the haven whose dikes I am opening, in spite of myself. (*A Rebours* 240–41)

Retrospectively, the novel looks like a long protraction of the interior's inevitable wrecking. The interior is the pathetic confession that home dwelling is scarred by its impossibility, that the tidal wave of the social totality has capsized Noah's traveling show.

Like all escapist ventures, the interior ties its fate to what it seeks to flee. This is true of des Esseintes, of course, but also of Balzac, whose interior is always overshadowed by the fear of creditors coming to repossess the unpaid-for bibelots (his letters to Madame Hanska are full of misgivings concerning the archenemy of the home, the note holder). This fear is perhaps what triggers the need to secure the fragile interior by means of the written word. The unwavering passion with which Balzac, Goncourt, or Huysmans detail their domestic interiors points to the anxiety it means to ease: the anticipation that all may be taken away, that the interior is

built on a lack of concrete ground. It is as though the realist's attention to the minute did not rise out of a newfound familiarity between subject and object but, on the contrary, out of the subject's estrangement from the object. This insight was already the subject of Hegel's analysis of the Flemish still life painting:

Satisfaction in present-day life, in the commonest and smallest things, flows in the Dutch from the fact that what nature affords directly to other nations, they have had to acquire by hard struggles and bitter industry and, circumscribed in their locality, they have become great in their care and esteem of the most insignificant things.[68]

The concern for the smallest details, for minutiae, stems from the shaky connection itself between subject and object. The object carries the memory that it was acquired only at the cost of great labor. Thus, even finally possessed, the object still feels unreal since it was for so long only a wish and, as such, insubstantial. In Hegel's scheme, the still life provides the antidote against objects' lack of solidity:

The lustre of metal, the shimmer of a bunch of grapes by candlelight—to grasp this most transitory and fugitive material, and to give it permanence for our contemplation in the fullness of its life, is the hard task of art at this stage. . . . It is a triumph of art over the transitory, a triumph in which the substantial is as it were cheated of its power over the contingent and the fleeting. (*Aesthetics* I, 599)

In this way, Hegel reverses the commonplace notion according to which still life painting reveals an increased intimacy between the bourgeois and his domestic world. Still life painting has a sharp eye for concrete reality because reality has become insubstantial. Realism responds to the insubstantiality of material existence, disclaiming that all things hold fast under the sun. The realism of still life is a countermeasure: its truth is that the subject has no sure footing in the material substratum of existence.

Adorno treats literary realism the same way Hegel treated visual realism: as symptom of loss of reality. Realism becomes possible after one's immediate relation to reality has begun to falter:

Concreteness is the substitute for the real experience that is not only almost inevitably lacking in the great writers of the industrial age but also commensurate with the age's own concept. [The writer] has to describe the world with exagger-

ated precision precisely because it has become alien, can no longer be kept in physical proximity. Analogously, the drawings of schizophrenics do not create a fantasy world out of isolated consciousness. Rather they scribble the details of lost objects with an extreme precision that expresses lostness itself. It is that, and no direct resemblance to objects, that is the truth of literary concretism.[69]

Leaving aside Adorno's untypical bout of nostalgic idealism (what on earth can "real experience" possibly mean? Was there a time when literature stood closer to reality? Is not literature, among other things, the realization that immediacy is constructed retrospectively as an effect of subjective mediation, as an insight into this mediation?), his analysis nonetheless makes it possible to overturn the commonplace understanding of realism as familiarity with the real. Realism actually reacts to the loss of its referent: reality is only noticeable when its immediacy to consciousness is lost, and concretist representation arises from the ashes of the object it claims to hand over.

It was Marx who insisted that, in a world where every object is *de facto* a commodity, the tangible existence of the object is no longer its core truth:

The value of commodities is the very opposite of the coarse materiality of their substance, not an atom of matter enters into its composition. Turn and examine a single commodity, by itself, as we will, yet in so far as it remains an object of value, it seems impossible to grasp it.[70]

Commodification entails the destruction of the gold standard of objecthood, that is, tangible materiality. The bibelot embodies this new ungraspable nature of objects. Thus, the tin cup that pretends to be a chalice fears the human touch like a litmus test. This is why, following the logic of their unreality, bibelots in the interior are not to be touched. The interior-dweller lives in the house as though he were on a sightseeing tour in a castle or a historical monument. In filigree throughout the decor is the same message: *Regarder mais ne pas toucher*. The bibelot is from the start a superfluous object whose use-value lies in signifying absence of use-value. This lack of practical purpose removes the object into an image. The tray-table is not there for anybody to sit down to; rather, together with the precious Sèvres ware, it is there to compose the iconic image of tea-time. Its use-value lies wholly in its iconicity.[71] Similarly, the

object displayed is not there to be used (the crockery, the china minia-
ture, the lacquered lockets) but to make up the scenery of bourgeois com-
fort held as an ideal representation of itself. Balzac's interior is crowded
with such tables, niches and sideboards whose sole task is to appear in an
eternal state of imagelike self-representation. A table with a jug is no
more practical than its counterpart in a Chardin or Vermeer still life: "A
little table in pear-tree wood, in rounded legs carrying a tray, a sugar
bowl, and crystal glass" (*Inventaire* 645). The precious uselessness of such
a presentation—a table presumably too small for one to sit down to, an
empty glass, an unused tray, a sugarless sugar bowl—turns reality itself
into a stage decor:

On the mantelpiece: as a center piece, a pink-bottomed Sèvres vase, held by two
golden copper children, two marbled grey celadon flute-shaped figures forming
a flask, set on two little golden copper pillows, two old-fashioned torches, nicely
chiseled, representing children, a silver cigar-holder with children at the four an-
gles, two candelabras whose old Saxon china shaft is adorned with drawings by
Watteau. (642)

The mantelpiece is the still life snapshot of a mantelpiece. The real inte-
rior doubles into a represented self which, better than any étui, smothers
the object in itself. Thus the real interior shrinks behind the ideal form of
its representation in a curious inversion of Platonism. For whereas Plato's
cave-dweller mistakes the shadows on the walls for real things, the inte-
rior-dweller knows the object to be real but neurotically takes it to be a
shadow of itself.

The rue Fortunée interior does not deserve the nickname "musée"
(*Lettres* 42) simply because it boasts a painting gallery, but because, as in
a museum, each object becomes its own presentation in its own image. It
is no doubt one of the paradoxes of the domestic interior that the bour-
geois celebration of groundedness in material existence should express it-
self in imagistic derealization. The bourgeois enjoys the concreteness of
existence only by lifting this concreteness into the realm of spectacle and
thus derealizing it. This finds a clear demonstration in the whatnot, or
the Empire cabinet, which begins to crop up in the bourgeois interior
around the mid-nineteenth century. The purpose of this glass cabinet, of-
ten lined with mirrors on the inside, was to display one's bibelots and

souvenirs in a setting of their own, marked off from the rest of the interior. In the whatnot, the object stands as a representation, an icon. The "what," precisely, is a "not": it is quiddity caught in the spectacle of its own eradication. In the fantasy historyscape of the interior the presence of objects is merely italicized. To hold something at a distance, however, is to stand in fascination as well as dread. The object kept inside the glass cabinet is like a strange and potentially dangerous animal. The dark side of the bourgeois's awed reverence toward his bibelots is fearful diffidence. The *cordon sanitaire* around the whatnot bespeaks fear and love of the object all at once. What is dreaded in the enshrined bibelot is the world of industrial production to which the bourgeois enslaved himself to gain the privilege of building a refuge from it. The bourgeois recognizes in the bibelot the face of his terrible master. The whatnot is an altar to the Penates, but the domestic gods have been vanquished by social totality. A piece of alienation itself, the bibelot consecrates this alienation on the altar of representation. The iconic interior is a ritual of obedience to the objective dematerialization of things in industrial capitalism.

Erected as a spectacle of domesticity, the interior is by the same token no longer pure domesticity. It points to an alienated connection between the subject and its dwelling. One cannot dwell in a spectacle: it is a (non-)space of derealization and alienation. In the interior, the subject is prevented from *dwelling* with objects, it is, as a whole, an Empire cabinet. The realist may seek to get a closer, more secure and inwardized, picture of the domestic scene. However, the act of representing "home" only accentuates the representational, unreal nature of the interior-as-whatnot. Like the Empire cabinet, representation involves an exorcism and a mourning: it immobilizes the object and loses contact with it. The cult of the reality principle is in fact estrangement from the reality principle. Descriptions of the interior only put the interior at a further distance, bibelotizing once more the bibelot. Efforts at conjuring the homeliness of home, its warm interiority, destroy the very familiarity it seeks to attain. The home, like a rainbow, disappears as the child reaches for it. Concretist realism is thus childish melancholy: like the child he believes in the availability of things, but the effort to secure it only brings on a further distance. Melancholia is a response to loss which cherishes this loss. This makes all representation melancholy, since representation puts the object

within reach of perception, yet removes it from presence. Realism—the fondness for the world's reality—rests on an alienated relation to reality. Concretist minuteness and alienation from the object are two sides of the same dialectic.

Gérard de Nerval might have had this in mind when he defined melancholia as an excessive rapport with reality: "Melancholy hypochondria. It is a terrible disease: it makes you see things as they are." Realism and melancholy share the same schema. The world's alleged alienation from consciousness is the measure by which consciousness verifies the empirical actuality of the world: melancholia results from the situation in which alienation from the object is the only available proof of objective actuality. "Things as they are" does not represent an intimate connection with the object but rather an alienation that pits the object against consciousness. In melancholia, consciousness mourns its lost ability to seize the world but interprets this inability as evidence that the world is. Melancholia is a way for consciousness to sentimentalize its necessarily *mediated*, and hence disconnected, relation to the world. This mediation, one might add, *founds* consciousness even if consciousness tries to disprove it as a subsequent trauma. In pining after a lost object, melancholia is the resentment that consciousness feels toward its own existence (consciousness being originally nothing but that very resentment). Realism is therefore melancholy about the subject; it is the secret wish that the subject did not exist, that the interior were uninhabited so that everything may exist in an unclouded, objective light. The true inhabitant of the interior is a corpse: Balzac writing his postmortem inventory, Jules de Goncourt's ghost in the bedroom, or des Esseintes's cadaverous self.

Material Life

This is what you get for trying to see things as they are: the eye-less orb of the skull in the still life painting, the annihilation of the subject for the object's sake. In applying strictly the esthetic program which the young Balzac had outlined for himself in *Le Traité de la vie élégante*, "each thing must look as it really is," the Balzac of *L'Inventaire* ends up dis-

pensing with the subject.[72] True realism is a spectacle viewed by a corpse, a cancelled subject.

Behind concretism lies the hope that subjectivity can be neutralized so as to square impartially with the object. Balzacian realism is a breviary to this hope, as here expressed in *La Recherche de l'Absolu*: "Art stripped itself of all idealism in order to reproduce only the Form. . . . Man only perceives what is. His thought bends so scrupulously to the needs of existence that no work of his ventures beyond the actual world."[73] Concretism is dead set on closing the gap between the concept (objectivity) and its material basis (the object): the object is to be objective, and therefore untainted by consciousness. Gobseck, a great pragmatic figure in the Balzacian *dramatis personae*, prides himself on seeing things as they are: "You see figures of women in those embers, but I only see coals in mine."[74] Objectivity implies that the subject must bow to the law of reification; it believes that truth lies in simplicity, in the unmediated. *To perceive only what is* means that truth lies in reification; and that reification holds the key to ontology. To see a thing truly is to see it *not* from the subject's standpoint, that is, to see it from no standpoint at all. The objective mind is self-loathing: it is the subject forgetting itself in the object it reveres.

But reification, whether in society or literature, is always a sham. It deceives by concealing its real master, capital. Like Balzac, Gobseck pretends to be "l'historien de ce qui est [the historian of what is]" who looks only at the concreteness of the fireplace coals ("You see figures of women . . . but I only see coals . . . "). Gobseck's coals, however, turn out to conceal something even more coveted than women's figures: money. What the miser pointedly used as an instance of mere realism (these are merely coals and nothing more) actually turns out to hide gold and silver: "I could still hear the fantastic enumeration which the dying man had made of his riches, and I looked in the direction of his staring eyes and saw a pile of ashes, astonishingly sizable. I grabbed the poker and, digging into it, I hit a stack of gold and silver" (*Gobseck* 126). The glowing embers were but ashes thrown in our eyes, something to distract us from what really lies behind the thing-as-it-is. Beyond it lies the dissolution of reality into exchange-value—money. Realism, or the concreteness of experience, turns out to be a facade, hiding a nefarious kind of philosopher's stone:

an insubstantial substance capable of transforming all things, no matter their particularities, into the abstract, universal exchange-value.

Balzac's *Eugénie Grandet* furnishes another example of realism's deceit. Nothing is too small or insignificant to escape Grandet's miserliness. Representation is therefore forced to pay heed to the minutest, most mundane details of existence: a few ounces of flour, the wick's length on the oil lamp, a threadbare armrest, the meager strip of rag carpet, the streamer-shaped iron bars on the door, all must be accounted for. No parcel of the real is too small to pass notice. Miserliness is the very essence of realism: everything must be counted, surveyed, stored, studied, classified. Yet the miser's fetishistic attention to detail has the effect of putting reality at a remove, putting it under lock and key. Concrete reality stands out when it is out of reach, when it is there only to be counted, not fused. In the end, however, Grandet's niggardly attachment to every detail of his household actually conceals an absolute contempt for reality, for eventually, even his gold, fetish of fetishes, is sold off to buy stocks and bonds. The miser's fondness for the smell, taste, and feel of material life (one that is to be preserved and economized) gives way to the bourgeois's exclusive interest in capital appreciation. All fragments of reality around Grandet are transubstantiated into exchangeable capital: the novel's natural setting, the beautiful landscape around the Loire river, is in the end no more than timber and crops. Even Grandet's daughter, the full-bodied Eugénie, acquires the incorporeal quality of the transactions and speculations of which she has been the object ("the pale cold glitter of money was destined to take the place of all warmth and color in her innocent life").[75] Fetishistic attachment to the real conceals the utter dissolution of reality by the leveling force of abstract exchange-value.

The same process occurs in Balzac's *Inventaire*. Here also description gives the impression of a loving attachment to the particularities of things, yet once again all differences are ultimately reduced to the same thing: money. Each item is followed by its price, which price is added up with the rest at the bottom of each page, and computed throughout the folios, along the unbroken, right-hand-side column, until it amounts to the interior's total monetary value: "220,400 f." Every object, bibelot, furniture or trinket is absorbed into that final sum, having poured out its singular worth into a number subsumed in the total. The crucible melts

the inventory's myriad reality into one insubstantial quantity. The abstraction of money guarantees the imprint of universality over any object, thing, or person. Its formlessness allows all things to enter the market of exchange-value, to be converted into the universal monetary equivalent, the Marxian *Common Something*. "Must everything end in money?" asks the narrator in *Gobseck. L'Inventaire* answers: it must and it will. Absorbing all conflicts, money translates every concrete identity into the formless sum: 220,400 f. is the final word on the interior; in the end it *is* the sum of the interior, *l'unité de composition* of Balthazar Claës's alchemical dream.

Hence a formlessness haunted the object during all this time. In the end, the painstaking precision of concretist realism boils down to abstraction, the very opposite of fondness for things. The bibelot sheds its lovely reality for the sake of inclusion into a financial sum. Capitalism's forces of uniformity advocate what is most antithetical to them—individualism, the dignity of the singular before the mass, the concrete, and so on—while reorganizing the social landscape in a manner that annihilates those very same values. This is one of the lessons of *Illusions perdues*.[76] Liquidation by capital hides behind the archaic devotion to the particular, the detail, to singularity and the concrete. The capitalist who, in *Eugénie Grandet*, forces us to linger over the most humble details of existence is the same capitalist for whom reality is a mere means to an end. In *La Recherche de L'Absolu*, the Claës family's antique collection—the very image of a precapitalist world—is all dissolved in the crucible of Balthazar's alchemical experiments. It is indeed the world of objects already being digested by the world of exchange and equivalencies. Capital achieves what Balthazar's alchemy could never do, the total homogenization of all natural forces and principles.

Realism therefore is born from something that denies its existence. It appeared in literature precisely when reality came under siege. Consciousness pays notice to the object when objecthood in itself begins to disappear. Insofar as objects are produced solely for their exchange-value, they are effaced as soon as they are born, given up to the *Common Something* of market value. The object is merely the shadow, or alibi, of its own insubstantial market value. Realism is a historical consciousness that witnesses a whole world—indeed *the* world—passing away. The object thus

appears as a *historical image*, under threat of extinction, surging forth precisely as it founders in obsolescence. Indeed the object *is* history; coming into view is also its passing away. The realist gaze is historical through and through, a saturnine vigil of the object's disappearance. The present is *preserved* because it has already become obsolete. What Balzac chronicles is a world already cadaverous:

The tableau has been extended. Instead of an aspect of individual life, it is about one of the most intriguing sides of this century, an aspect already wearing off, just like the Empire wore itself out; hence we must hurry to paint it before its liveliness turns into a corpse under the painter's very eyes.[77]

Representation turns into a race against the ineluctable freezing of a social landscape. And yet only in a world forever slipping into its funeral image does realism find all its place. For only then does the image become conscious of itself as an image. Nostalgia for the golden age (Balzac's well-known reactionary stance) and Balzacian realism are cut from the same cloth: the possibility of the world represented *as* world takes place at the same time as when representation loses touch with the world. Balzac's golden-ageism is not so much a longing for some past historical era; rather, it is a longing for the present itself, for *presence*. The eye notices what historical obsolescence has already distanced. Concretist realism is a by-word for the representation of social lostness and representation *as* ontological lostness. This explains why, as here in *Eugénie Grandet*, realism looks with the historian's eye. To the realist the world is a museum:

There are houses there which were built three hundred years ago, and built of wood, yet are still sound. Each has a character of its own, and their diversity contributes to the essential strangeness of the place, which attracts antiquaries and artists to this quarter of Saumur. (27)

Realism sees through the eye of the artist turned antiquarian, to whom the world acquires representability insofar as it is outdated. Correspondingly, literature develops its passion for the detail when such detail already begins to fade, a museum oddity in the watery world of market forces. Reality bears on itself the emblem of its own obsolescence, of its inability to adapt to the world of means and ends. In reality, as in the museum, the object becomes an untranslatable hieroglyph: "Further

along the street one notes the doors, studded with huge nails, on which our ancestors recorded the passion of the age in hieroglyphs, once understood in every household, the meaning of which no one will now ever again unravel" (28).

More than the testament of a lost world, the Balzacian object is the inscription of the world's lostness. The object thus appears simultaneously with its historically estranged character: as in the museum, the realist appearance of the object is the appearance of a historical distance. Radicalizing Georg Lukács' analysis according to which Walter Scott's portrayal of past history evolves into Balzac's portrayal of the *present as history*, one can argue that the present in the realist novel is the ability to see things *anachronistically*, as though they were no longer.[78] Realism comes to existence in the historical distance with which the present regards itself. The realist lives in Hamlet's temporality, a depressive temporality, where "the time is out of joint": such disjointing is the dissynchrony of the present to itself, the basic estrangement with the world that fills the present with historical distance, with obsolescence.

In truth, the melancholy disposition of Balzacian realism, its pining for the present, is in keeping with the essence of literature, and desubstantializes everything in a linguistic image. The melancholy disposition of realism is the melancholy of literature mourning the object it had to sacrifice in order to fulfill itself. Literature is, in that sense, the product of an antiquarian who projects onto the object the distance that makes the object representable. In realism, as perhaps in all artistic expression, the world is out of joint: it becomes a museum. Uprootedness undergirds representation, to the extent that an image is always an image of a world out of reach, a waking up from childhood. As in the museum, the appearance of the thing, in an unclouded light, hinges on alienation, on historical out-of-jointness. Products of the same historical consciousness, the museum and realism also turn out to be products of the same dialectic that binds subject and object in common alienation. This is the subject of the following reading of *La Peau de chagrin*.

3

Balzacana

Divorce Story

Essential exoticism lies between the object and the subject.

Victor Segalen

Modern esthetics is haunted by a ghost, the leitmotiv of art's death. Hegel's famous pronouncement that art is a thing of the past historically coincides with the estheticization of art by the museum. For Hegel, art no longer served the purpose that the pre-romantic generation of philosophical thinkers had assigned it. "Aesthetica," in Baumgarten's terminology, meant the reconciliation of the sensuous with the intelligible, of the senses with the cognitive. The esthetic work thus represented an arena in which the subject could witness its reconciliation with the object in a nonrepressive, harmonious fashion. Indeed, the object of classical esthetics is one in which thought is immanent to form, and where the material element itself possesses a cognitive dimension, a power of expression. The work of art involves a blissful reconciliation of mind and matter. As Hegel explains:

For the artist in his production is at the same time a creature of nature, his skill is a natural talent; his work is not the pure activity of comprehension which confronts its material . . . in pure thinking; on the contrary, the artist, not yet released from his natural side is united directly with the subject-matter.[1]

However, it is just this immanence of thought in matter that Hegel relegates to the scrap heap of history. For Hegel "the conditions of our present time are not favorable to art" (*Aesthetics* I, 11) because pure intellectuality has dispensed with the object's mediation. Hegel's proposition that "thought and reflection have spread their wings above fine art" (*Aesthetics* I, 11) means that, in the present age of esthetics, cognition no longer needs an immanent rapport with the sensuous. Philosophy has replaced the work of art in fulfilling the subject's synthesis of the particular and the universal, of the sensuous and the intellect.

That "works of art no longer fill our highest need" and that "art is a thing of the past" (*Aesthetics* I, 11) means that the esthetic object has been left behind by Spirit. Having achieved perfect self-awareness, the intellect is in no need of material embodiment. This means that, no matter how

well the spirit of philosophy may have synthesized subject and object in the mind, it nevertheless discards immanent rapport with the object. However hard Hegel tries to recuperate concrete existence into the work of the spiritual totality, matter remains something from which, *volens nolens*, Spirit has become estranged. The work of art henceforth embodies the lost union between subject and object. Whereas it once manifested concretely the religious life of spirit, the statue is now a piece of dull matter; whereas it had once stood for their reconciliation, the work of art is now the theater of the alienation between the subjective and the objective, between thought and matter (a fact made evident by subsequent esthetic forms, from the objectivist distancing of realism to the shock techniques of defamiliarization in the avant-garde). But art, even when in the museum, is a thorn in the side of philosophy. For the museum is the place of an estrangement between subject and object. If artworks look estranged, distanced, unfamiliar and untouchable in the museum, it is because the modern appearance of the work of art itself embodies the experience of alienation between subject (Spirit) and object (sensuous experience). In a sense, the museum is the temple erected to the subject's distance from the objective. It monumentalizes the subject's old immanent, mimetic, and animistic rapport with objecthood.

The esthetic character of the dialectic between subject and object furnishes the theoretical tools with which to analyze the image of the museum in Balzac's fiction, the famous description of the antique shop in the opening chapter of *La Peau de chagrin*. All the major thematic and philosophical motifs in this novel as well as Balzac's prose in general are therein mapped out. Across the Skin's surface, the dialectic of subject and object provides Balzac's fiction with its conceptual dynamic, that is, the esthetic complex known as realist representation. The museum here is an emblem and a test case of the realist consciousness.

Cornucopia

> A large portion of our literature remains incomprehensible without understanding the jumbled-warehouse look of our installations.
>
> P. Bourget

Rather than finishing himself off, a young man at the end of his tether, "almost dead," wanders into an antique shop.[2] Thus Balzac's *La Peau de chagrin* (The wild ass's skin) begins with a temporary postponement of the subject's death. A gallery of objects is the site of this stay of death: it is therefore the place where a price is put on the subject's head, a place where the subject's life is counted and *measured*. Unsurprisingly, we read in time that Raphaël pawns his life against an object: the Ass's Skin. This talisman gives him boundless power: every time Raphaël expresses a wish, the parchment fulfills it. The young man thus acquires a virtually boundless dominion over the existing world, over reality. Reality is, in fact, one with his mind: he need only think a thing for it to *be*. There is a drawback to this arrangement, however: the Skin shrinks a little with every wish granted, and with it, Raphaël's life itself shortens. Eventually the Skin dwindles to nothing and the young man, after a long effort to repress his desires, and so extend his life, dies.

Raphaël finds the Skin in a gallery of art, the description of which occupies a large portion of the introductory chapter. This tableau stands prominently at the entrance of the novel, no doubt one of those daunting descriptions that earned Balzac his bad reputation among schoolchildren: he truly has no qualms about burying the story under endless layers of descriptive blankets—as though, perhaps, the story *was* the decor. As Raphaël makes his way through the floors of the antiquarian's shop, he is overwhelmed by the Byzantine clutter of the rooms, bursting with trinkets, artworks, and collectibles:

He was able to give himself without constraint to his last terrible meditations. He had the soul of a poet and here, chance had given it an immense pasture on which to graze: he was to see in advance the ossuary of a score of civilizations. At first sight, the showrooms offered him a chaotic medley of human and divine works. . . . A Sèvres vase on which Madame Jacotot had painted Napoleon was standing next to a sphinx dedicated to Sesostris. The beginning of the world and the events of yesterday were paired off with grotesque good humour. A roasting-jack was posed on a monstrance, a Republican saber on a medieval arquebus. Madame Dubarry, painted in pastel by Latour, with a star on her head, nude and enveloped in cloud, seemed to be concupiscently contemplating an Indian chibouk and trying to divine some purpose in the spirals of smoke which were drifting towards her. Instruments of death, daggers, quaint pistols, weapons with se-

cret springs were hobnobbing with instruments of life: porcelain soup-tureens, Dresden china plates, translucent porcelain cups from China, antique salt-cellars, comfit-dishes from feudal times. An ivory ship was sailing under full canvas on the back of an immovable tortoise. A pneumatic machine was poking out the eye of the Emperor Augustus, who remained majestic and unmoved. Several portraits of French aldermen and Dutch burgomasters, insensible now as during their lifetimes, rose above this chaos of antiques. . . . All the countries on earth seemed to have brought here some remnants of their sciences and a sample of their arts. It was a sort of philosophical dunghill in which nothing was lacking. . . . " (69)

This is but a very small portion of the formidable description. The impracticality of quoting it *in extenso* stems from Balzac's design, and perhaps also from the philosophical form of the novel. The reader, who cannot account for the collection's magnitude except by giving up the task, finds sympathy in Raphaël's bewilderment: "nothing complete presented itself to his mind" (72). The more Balzac seeks to be exhaustive, the more he, along with Raphaël and the reader, loses sight of what he is trying to be exhaustive about. The objective world, when approached objectively, cancels the subject. It is wrong to say that, just because it is thorough, the display is panoramic. For in fact no subject is able to seize it with one glance, and its sheer numberless clutter makes it ungraspable. Objective totality is one that the subject cannot force into a subjective synthesis.

To be sure, the predominance of quantity in Balzac's prose is not unrelated to the burgeoning world of mass production at the time. There, too, the objective totality seems to make hay of the autonomous individual who, faced with the massification of existence, promptly understands that, to survive, he must comply. Quantity is a virtue in the logic of commodities. By its sheer profusion, Balzac's antique shop anticipates Zola's department store, Au Bonheur des Dames, where the quantity, not the quality, of goods is their main attraction. Balzacian description already models itself after this irrationality. In contrast to classic literary description, the antique shop passage does not so much arrange its contents as register their presence accumulatively: the rhythm is that of a highway pile-up rather than harmonious window-dressing. The bazaar's kaleidoscopic aggregate ("a confusing display," "a sort of philosophical dunghill," "monstrous displays") exemplifies the process of almost mechanical accu-

mulation that cranked out the entire *La Comédie humaine*. Benjamin's observation that "literature ought to be called *ars inveniendi*"[3] is carried to an extreme in Balzac's descriptive technique: like the flâneur, he takes it all in undiscerningly and, like the collector, he is loath to leave anything out. These two attitudes, which have been drilled into the department-store shopper, already shape the Balzacian "literary art of the find." Proust sensed this when he focused on Balzac's aggregations: "Balzac uses every idea that comes to his mind, . . . he juxtaposes things."[4] He is drawn to inclusiveness at the expense of discrimination. His descriptive style thus uncovers the material core of literature-making, its basis in *bricolage*. Like the avant-garde technique of collage of which it is the distant forerunner, Balzac's text draws attention to the piecemeal manufacturedness of its product, the antlike labor behind the story. In it, the narrator is demoted to the level of an indiscriminate hoarder, a verbose gawker. Perhaps already the teeming world of mass production compels the literary crafts-man, the tableau-maker, to adopt the crude quantity-bound look of the wholesaler: Balzac's descriptive gluttony gurgles the July Monarchy motto, "Enrichissez-vous [get rich now]." The sheer enormity of Balzac's literary output is emblematized by this famously overextended description of the antique storeroom. See how much I can hold. See what vast quantities my work is capable of digesting. This is the image of a bulimic world, cloyed with its own abundance, at once fascinated and horrified by the flood of objects released by the economic powerhouse.

However, there is something at once passive and unrelenting about Balzac's systematic recording of the shop's inventory. The subject seems to exercise no discernment and to put up no resistance against the world of objects. Raphaël, we are told, is overwhelmed by the collection, crushed by the profuseness of the galleries. His reaction compares to that of the describing subject bowing to the onslaught of objecthood. It foretells the fate of a young man who actually lets his self be taken over by an object, the magical Skin. At work the principle behind *La Comédie humaine* is the precedence of *production*: wholesale inclusiveness over esthetic discernment. This demotes the demiurgic author to the status of bystander. "Chance is the greatest novelist in the world," Balzac declares in the "Avant-propos" to the novel: "French Society was to be the historian, while I would simply be its secretary."[5] The writer fancies himself a mere

recording device. Raphaël is to his Skin what Balzac is to the world of objects: a hostage chronicling an unremitting process. The society of mass production is the greatest novelist in the world, Balzac could have said, and I am but the list-maker. Indeed the ideal of realism (that is, the author's effacement by selfless objectivity) is achieved in *La Peau de chagrin*, wherein a subject ends up cowering under the power of an object, the triumphant Skin.

What could have turned into Rabelaisian delight in abundance is marred by the suspicion that quantity has turned into a blind affectless mechanism. Abundance in Balzac is no longer simply what it stood for in the premodern world, that is, the assurance of having once again beaten back want and famine, the bulwark of a well-stocked granary against intemperate nature. With the industrial revolution, abundance takes on the character of a mass-engineered and mass-marketed condition that has outgrown strictly individual purposes. The very notion of mass begins to pose a threat to human life. Plenty has been systematized and rationalized too much to be justified by individual need alone. On the contrary, it points to something beyond the control of the single individual. For that reason it becomes threatening. Objects seem to be acting of their own accord, produced by other objects whose mechanisms exclude humans or to which humans are shackled, as Raphaël is to the Skin's relentless, unstoppable progress. Abundance is henceforth the symptom of a world that has surrendered to the implacable, self-ruling logic of object production. The overwhelming description of the antique shop at the start of a tale about one man's horrendous enslavement to an object already says this: the battle against the flood of objects has been lost, we are all swimming in it, "this ocean of furnishings, inventions, fashions, works of art and ruins" (72).

At the same time, Balzac's notorious tendency toward the inventory (that is, the very idea of an encyclopedic *Comédie humaine*) shows he sought to combat the historical trend of mass quantification. It is as though, in an appeal to archaic thought, Balzac sought to tame the spell of the commodity market by mimicking it, the way a witch doctor imitates evil spirits in order to expel them. Balzac's inexhaustible *Comédie humaine* bespeaks a moment in the history of the subject-object dialectic when the subject still believes it can stay afloat in the flood of mass pro-

duction. It is not yet Zola's Bonheur des Dames department store where the inundation of goods drowns customers, autonomous subjectivity, and social life. By virtue of its antiquity, Balzac's shop evokes the waning faith that some autonomy can be salvaged out of the flood. On the one hand, the antique shop betokens the commodity market where everything is for sale. On the other, it seeks to clear out a space of artistic worth in the midst of chaos (indeed, as Raphaël reaches the upper floor of the shop, he encounters genuine, unique artworks).

Balzac's mixture of the bric-a-brac with the art gallery is telling in itself. It is as though, in defining itself as a reaction against the factory, the museum became factorylike. The time is when the museum increasingly modeled itself on the idea of being a shrine and a haven for works of art. Yet, Balzac's mixture of the priceless and the junky seems to indicate that, however far the art gallery wants to run from mass production, it is scarred by this need to escape. It is precisely by fleeing the commodity world that the museum reveals that world (just like estheticism is haunted by the vulgarization of objecthood carried out in the day-to-day world). *La Peau de chagrin*'s cabinet of antiquities conflates the museum with the market, cultural preservation with cultural liquidation, art with its trade. It is a temple to the religion of history and a market of history's all-out sale.

A World of Objects

A museum is almost a textbook case for realist description: there the eye looks upon a world made of objects undisturbed by human presence. Indeed a description of a gallery of objects may serve as an allegory of the objective stance called realism. That the world is, is ascertained by the staid and placid presence of objects. Objects are the grounding center of objectivity and objecthood is the fetish of objective realism. In a sense, the gallery of objects takes objective representation itself as its object.

In realism, the object becomes a presence to be reckoned with; it is moved from its traditional position in the background closet of props to center stage. If the epic is the world of the triumphant subject, the modern novel may be that of triumphant objecthood: material and economic parameters, not spiritual worth and personal destiny, give form to the

subject. The steady waning of psychology as *primum mobile* of the novel-istic narrative indicates how much the subject is to conform to the objec-tiveness of reality. Emma Bovary dies from not acknowledging what Eu-génie Grandet never forgot: that, in the material world of the bourgeoisie, one can no longer behave like a self-willing subject. Zola's characters, who are psycho-physiological automatons, constitute the ultimate installment in the nineteenth-century novel's reification of subjectivity. Correspond-ingly, it is no longer possible to write as though a creative subjective force ran the show. Flaubert's wish to abolish himself as the subjective voice of the novel confirms this insight. So does Zola's attempt to purge his prose of authorial arbitrariness, so that the story may evolve according to purely scientific parameters. In Balzac, the long-winded inventory is a symptom of this waning of subjecthood. Long before Robbe-Grillet or Perec, in whom the inventory confirms the ideology of a world overcome by mass production, Balzac's massive descriptions pointed to the triumph of ob-jective forces over the subject. It is no coincidence that labor supersedes inspiration in the minds of post-romantic authors. Labor—Balzacian or Flaubertian or Dickensian labor—rides on the principle of compulsive and systematic output whereas inspiration carried on like a patrician tran-scendental ego happily free from toil. In the end, the author himself is de-moted to an instrument in the overall process of textual production, no longer its origin and end.

From the smaller elements, such as the listlike tableau, to the larger assemblages, such as the literary compendium of *La Comédie humaine*, the inventory stands paramount in Balzac, a man who tested his literary craft writing a quite substantial "Petit dictionnaire anecdotique des En-seignes de Paris par un batteur de pavé" (Small anecdotal dictionary of Parisian shop signs, by a street rambler), who once dreamt up a "Traité de la démarche" (Treatise on ways of walking) cataloguing the Parisian ways of walking in twelve volumes and one thousand seven hundred il-lustrations;[6] and who wrote a systematic inventory of his home. On the one hand, this tabulating mania betrays a desire for panoptic totalization. On the other, it orders the subject to surrender to objectivity if it wants to conquer objects: it is never as an *author* that a subject writes an inventory, but as a mechanized recording apparatus. One must be systematic in writing an inventory, one must carry on as though one were an object.

What takes place at the level of textual production is mirrored at the level of the narrative: for though Raphaël may well have gained absolute control over objective existence by acquiring the Skin, he becomes an object himself because the Skin, as it turns out, acquires his life.

The omnipresent object-world asserts itself in the massive descriptive sequence at the outset of the novel. It denies to the impatient reader the right to be whisked off into the stream of a swift narrative. That *La Peau de chagrin* begins with the overwhelming invasion of objects across the space of representation is consistent with the story: that of an object (the Skin) laying claim to the subject (Raphaël) and dictating the form of his existence. The story, which is about the becoming-object of a subject, begins with the becoming-object of the entire world. Implicit in this sudden massive objective invasion is a deadly tug-of-war between subject and object, between a subject-centered experience and an object-based world.

Raphaël walks into the antique shop to assuage his mind and soothe his senses. "Wishing to shake free of the titillation produced by the action of his physical nature upon his mind, he walked towards an old curiosity shop with the intention of finding something to feed his senses" (68). Although the objects initially lend themselves to this contemplation, in the end they revive Raphaël's suicidal mood and color it with a tinge of philosophical failure: "The marvelous objects the sight of which had just revealed the whole of known creation to the young man plunged his soul in the dejection which the scientific vision of unknown creations produces in a philosophic mind. More than ever he wished to die" (76). The museum visit ends up reminding the subject of all that is impenetrable about the objective world: the subject, rather than asserting its power of observation, faces a rebuke. At the end of the epistemic round-up, the subject has no closer hold on the object-world ("the scientific vision of unknown creations"): the very known world itself is unknowable. In short, the concept of object itself seems to exclude subjective mediation, even the very presence of the subject who, cast out, can only wish for death. The subject's failure to assimilate the objective manifold is evidenced at the level of form as well, in the unassimilated and cumbersome presence of description itself. The novelistic form is hard put to integrate the lengthy description of the shop in a truly narrative fashion. The novel is forced to split between narrative and description; that these two cate-

gories exist separately bespeaks a basic cleavage between subject (the agent of narrative) and object (the stuff of description).

Nothing in Balzac speaks more eloquently about this tension at the heart of the realist form than the awkwardness of his transitions between narrative and description, that is, between the subjective side of action and the objective realm. Often these transitions are so cumbersome that they need their author's formal apology, as, for instance, in the "Pension Vauquer" description of *Le Père Goriot*: "In order to explain how old this furniture is. . . . I would have to draw up a description, which would delay the story too much, and hurried people would never forgive me."[7] Sentences such as this one abound in Balzac's prose. Narrative views description as an interruption, for which the author must excuse himself. Such apology stresses the failure of the literary form at binding narrative (subject) and description (object) in a seamless way. If Madame Vauquer and her boarding-house explain each other ("you can't imagine one without the other"), Balzac nevertheless has not devised a literary form suitable for expressing this subject-object osmosis. The rhetorical distinction, soon to become canonical, between narrative and description is the result of the epistemological fare of Balzacian realism, in which a subject gains an objective outlook on the object at the cost of being separated from the world. Objects appear in the novel as something incompatible with the subjective-narrative element. This underscores a deep philosophical estrangement between the two.

This estrangement structures some of Manet's full-length portraits, such as *Portrait of Théodore Duret*.[8] This 1868 painting is arranged in such a way as to defeat a homogenous binding of the human figure with the background of still life. The man's head (to which the eye is naturally drawn) hovers in the upper middle part of the canvas while the small table is tucked away in the lower left-hand corner of the painting. The eye cannot move from one to the other, from the figure to the still life, without acknowledging its inability to take in both simultaneously. The eye must travel restlessly between the two; in so doing, it enacts their separation. Each part of the painting disturbs the contemplation of the other. It distracts from it, and refuses to enter into a homogenous combination with it. This cross-eyedness uncovers a formal alienation between the subjective and the objective. The painting is a portrait and

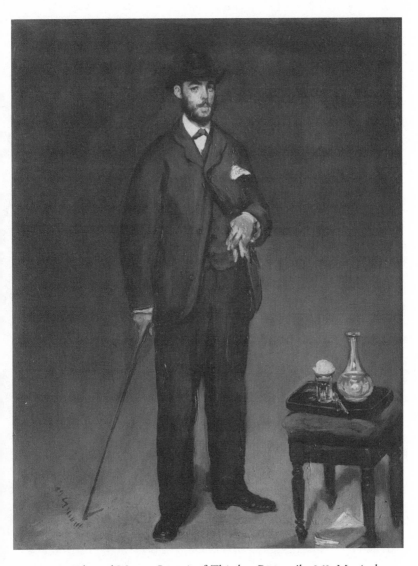

FIGURE 6. Edouard Manet, *Portrait of Théodore Duret*, oil, 1868. Musée du Petit Palais, Paris (Photo Bulloz).

a still life, yet it is not both. It is subjective-anecdotal and objective-empirical, but it does not tie these two elements together. Each section is repressed by the other. Like Balzac's text, Manet's painting enacts an estrangement between the subject and the object.[9] The awkward leap between the subject's face and the object's still life is a pictorial counterpart to Balzac's self-consciously strained transition between narrative and description. Through both Balzac and Manet, a historical dissociation between subject and object is given form. This form, we understand, is realism itself.

Balzac's awkward transition between description and narrative bespeaks anxiety toward objective existence, unmitigated by the theoretical distance that allowed subsequent writers, such as Perec or Robbe-Grillet, to find the estrangement of objecthood mildly euphoric, and an excuse for displaying technical virtuosity. But precisely because Balzac remains diffident toward the object, he experiences objecthood more urgently than such novelists of the "nouveau roman," who tend to dominate the object-world detachedly, as a quaint esthetic experiment. This variation in theoretical distance accounts for the difference in tone that renders Balzac's wrangle with the object deadly serious and Perec's manipulations demonstrably entertaining. Our task here is to discover the root of Balzac's dread of objects—what exactly about Raphaël's experience in the antique shop makes him wish for death ("more than ever he wished to die")?

The Old and the New

Balzac's desire to include everything shows an affinity with the wholesaler's point of view. The sheer magnitude of the description ("products from all over the world were packed in these showrooms," 78) reflects some hankering after totalization. Historically, this hankering corresponds to the age of the great encyclopedic projects. Yet, although it heralds the world of mass production, Balzac's antique shop looks like a premodern cabinet of curiosities. The odd mixture of the precious and the throwaway (works by Michelangelo and Rembrandt are piled together with a salt shaker, a crossbow with dry rot, and other detritus) re-

calls the baroque clutter of the old-style cabinet of curiosities.[10] The appearance of the antique shop is that of archaic Europe, an age of crotchety collectors hidden among their assortments of rare birds, Roman antiques, tribal amulets, and sea shells. The historical reality is that of a commodity shop: for everything in the gallery, including the soul of history, is up for sale. This disguising of the new by the old is not uncommon in Balzac, where the most radically new economic and symbolic relations often take on the appearance of the archaic. To make a bundle of money, as Grandet's story demonstrates, it is no longer enough to save: one has to play the securities market. And yet, in *Eugénie Grandet*, stockmarket speculation and virtual money still hide behind the facade of a Molièresque miser. It is as though Balzac had intuited the historical deceit of capitalist development that hides its irrationality behind the comforting, archaic images of rustic precapitalism. Just as Balzac's Grandet, Gobseck, or the Antiquarian purveyed modern capital while reassuringly decked out as outdated Shylocks, so contemporary Wall Street firms quietly melt all things into the thin air of market bonds while putting up the charmingly obsolete facade of an Edwardian drawing-room. Similarly, in Balzac, the historically new takes the appearance of the historically remote. In *La Peau de chagrin*, the trading of history itself is dressed in the gothic garb of a *Wunderkammer*, the cabinet of wonders.

What makes Balzac dress up the new as the old may have to do with a basic law of historical optics. The principle that has been good for sociological representation since Montesquieu (that a country is seen more clearly through the eyes of a stranger) is also good for historical observation. Modern capitalism is best seen as an archaic image. The hooded, monkish antique dealer recalls the obsolete figures of the necromancer and the usurer in the paintings of old masters (Balzac compares him to "Gerard Dow's *Money Changer*," 78). Yet his Faustian pact offers neither immortal life nor the punishment of Hell, but instead palms off the thoroughly modern anguish of enslavement to objecthood. Although the handing over of Raphaël to an object, the Skin, reflects capitalism's reification and mechanization, it seems to emanate from the night of medieval superstition. Appearing as the historically remote, the subject's enslavement to the Skin seems a historical phenomenon. It is as though Balzacian realism only began to perceive and understand the contempo-

rary by pushing it back into the past. This principle is nowhere more evident than in *Le Chef-d'œuvre inconnu* (The unknown masterpiece), where radical newness—it skips nearly a century of art history, cutting from Delacroix to Kandinsky—is such that for fear of not being understood at all, Balzac pushes the appearance of the abstract work of art all the way back to the early seventeenth century. In a story specifically about seeing and seeing the new, the new dresses up as the very old in order to be seen. Similarly, although the antique shop is archaic in appearance and moreover *devoted* to the old, its resonance is unremittingly modern—as modern as the taste for antiquity.

Though the Antiquaire's shop is a place where every item is marked for sale, and thus pertains to the liquidation of history, its appearance is that of a "mysterious cabinet" (78), a belated image of the dusty cabinet of curiosities wherein each item is singularized for being, precisely, its own "curiosity." In the end, Balzac's antique shop may very well conceal the destruction of the *Kunstkammer* in the guise of a *Kunstkammer*: it is the marketplace disguised as a cabinet of curiosities, the selling-out of history dressed as an auratic refuge for history. This may explain the ominous taint of the antique shop. It is, after all, not a place of conservation but of a sinister swindle: the theft not only of Raphaël's life, but of history as a whole, pawned, monstrously undersold, bargained off "for the price of a load of firewood" (73). In the antique shop, history is a deceit: the shop makes you believe in the antique roots of the present, in its hoary wisdom and time-tested rationality, even while it liquidates history.

"On the Quai Voltaire, in the nineteenth century"

Attention must be paid to the location of the Antiquaire's shop, not only on the historical map, but also on the geographical map: "This vision was taking place in Paris, on the Quai Voltaire, in the nineteenth century, at a time and place which should surely rule out the possibility of magic" (79). Boundaries of space and those of time are here coterminous. Hence the antique shop stands in a jointly geographical (Quai Voltaire) and historical (nineteenth century) position. As an antique shop, the shop pertains naturally to the production of history. Or, more precisely:

as an antique shop *in the nineteenth century,* the shop is an appearance of history as history appears in the nineteenth century. If Balzac raises the question of a historical *reflection* apropos the Antiquaire's shop, it is perhaps because, situated on the Quai Voltaire, it stands directly over the *reflection* of the Louvre Museum in the waters of the Seine (just before he steps into the shop, Raphaël is still scrutinizing "The Louvre, the Institute, the towers of Notre-Dame, . . . the Pont des Arts," 67). The antique shop stands in front of the institutional site of the historical appearance of art, the Louvre Museum, that cultural beacon of nineteenth-century modernity, the new solution to the old question of the historically remote. Vaulting between the Louvre Museum and the antique shop, the Pont des Arts, the bridge of art, binds the two places in mutual reflection.

As forefather to the museum, sitting right across from the Louvre, the antique shop is a living illustration of the museum's repudiated ancestry. It represents what had to be brushed aside in order for the museum to be, a historical return of the repressed "on the Quai Voltaire, in the nineteenth century." The early history of the modern museum is by and large about the repression and eradication of the cabinet of curiosities. Thus the "mysterious cabinet" reflects both the past and present of the museum. For that reason everything taking place in it can be held as referring critically to museographic experience: it is both a critique of the museum's present, which it reflects from across the Seine, and a historical critique of the museum, of which it dredges up the repressed ancestry. In this sense, Raphaël's walk through the shop is a lesson in the history of art history. As a museum, the Louvre lays out the place where history is preserved and presented, where the historical past becomes manifest in objects. Paris in the nineteenth century was certainly the center of the European art market—a role to which the Louvre Museum, for a while the only one of its kind in Europe, contributed: though patron and protector of the arts, Paris is also the great wholesaler of art, buying, selling, speculating and profiting from the exchange of artworks. Indeed it is the place where art is for the first time treated as a full-fledged commodity in an open market. As such, the antique shop, where every object is for sale, stands for the economic reality of a world in which history, art, and art history have become consumable objects.

Tellingly, Raphaël's interest in the antique shop combines the con-

templative attitude of a museum visitor and the moneyed interest of an art dealer: "He walked towards an old curiosity shop with the intention of finding something to feed his senses, or else to pass the time before nightfall bargaining over the price of *objets d'art*" (68). Aesthetic pleasure mixes with commercial intent. Across the waters of the Seine, the esthetic aura of the Louvre fades into the mercantile reflection of the antique shop. In reality, of course, the Louvre is just as much in the business of trading art and history. Like the antique shop, the museum opens a space where artistic genealogies are bought and histories get a new sticker price. For all its protective nimbus, the museum nonetheless is a vehicle for the uncertainty of historical value. It highlights just how fragile historical tradition is, how liable to forgetting, misprision, and reinterpretation historical value has become. Balzac could not miss the fact that the Louvre Museum was after all still a recent product of revolutionary fervor. Its institution entailed the eviction of entire sections of the collection for political, historically contingent reasons. The portrait of a king, only yesterday revered as an icon, today may be relegated to the storage room for its unfashionable forms or undesirable political overtones. Paradoxically, then, the museum is the place that strips history of its sacrosanct value by subjecting it to esthetic and political reappraisal. If the king's portrait can be re-evaluated on its esthetic or social value then no sacral history, as embodied in the work of art, is unassailable. Whereas the king's portrait was once an artistic testimony to kingly authority, today it is merely a portrait. Attention to esthetic value alone deprives the king's portrait of its aura, that holy mixture of the artistic and the historical. For Balzac, this translates into a process of devaluation of historical value:

A little writing-desk that had cost a hundred thousand francs and had been bought back for a five-franc piece stood next to a secret lock whose price would formerly have sufficed for a king's ransom. . . . An ebony table, a gem of artistic creation, carved from designs by Jean Goujon, which had cost years of toil, had perhaps been picked up for the price of a load of firewood. Precious caskets and furniture wrought by the hands of magicians, were jumbled together with contemptuous indifference. (73)

Once admitted as an esthetic commodity, the object—be it art or history—is stricken with impermanence. As a *value*, history loses grounding

and succumbs to the vicissitudes of historical becoming. By enshrining but also reappraising history, the museum paradoxically drives uncertainty into history. History itself takes on the variability of the monetary sign it has elected as its symbolic agent. The fungibility of history must be accepted as soon as money becomes the overarching determinant. An object that once ransomed a king is thrown on a pile with two-bit trivia; and the things that still bear the magic of their making ("wrought by the hands of magicians") are heaped like kindling. The gallery of art lays out the site where both art and history are desublimated.[11]

For Balzac, historical degeneracy is no longer signified by sin or natural scourges, but by money. Money is what inscribes death as the main force behind human history. The spirit of history is defiled by economic forces which, for Balzac, all aim downward. History is a devaluing currency. Although the antique shop and the museum are in the business of preserving history against itself, they nevertheless end up bringing woes upon it. Today even the priceless can be appraised and therefore devalued: one talks of fluctuations in history and art as matter-of-factly as fluctuations in the housing market. This is because the museum has habituated us to the treatment of art and the past as commodities. As for those whom the revolutionary days of the museum still struck as cultural liquidation, for Balzac this situation was truly shocking. In the antique shop, the past is prey to the contingency of preservation and, in fact, falls victim to its own preservation. The antique shop is therefore an image of how the past is lost: *how history is lost in its very preservation.* The museum in Balzac stands for the catastrophe of history.

The Museum-Goer

Raphaël's sole reason for entering the store was to distract himself: "He walked towards an old curiosity shop with the intention of finding something to feed his senses, or else to pass the time before nightfall bargaining over the price of *objets d'art*" (68). To encounter objects is secondary to the wish for entertainment. Subjective indulgence motivates the entrance into the world of objects. Raphaël approaches the object as a sensualist in whom things are absorbed as pure perception: *to feed his*

senses. The other reason behind Raphaël's interest—to haggle over a bargain—rather confirms the priority given to the subject in the encounter with objects. Raphaël's mercantile interest, which reminds us that everything in the antique shop is for sale, passes over the concreteness of the object on the way to its exchange-value. Exchange-value, one need remember, brackets off the concrete object; it is the product of a general abstraction that reduces phenomena to permutable quantities. Hence, whether he seeks sensual indulgence or commercial distraction, Raphaël is not interested in the object per se, in its material thingness. One would say that, upon entering the museum, Raphaël's interest is anything but *esthetic,* in the genuine sense of the term: it is not a discourse of the concrete.

This negation of the object as such is fully acted out in the rest of Raphaël's visit, which proves to be a free ramble of subjective daydreaming. The antique shop episode is not a description of the collections per se but of the subject's reaction to them. In fact, the object itself tends to disappear behind Raphaël's stream of consciousness:

But suddenly he became a corsair. . . . Rocked in the cradle of peaceful thought, he turned once more to study and science, longed for the easeful life of a monk, free from pain and pleasure, sleeping snug in a cell and gazing out through its Gothic window on to the meadows, woods and vineyards of his monastery. Confronted with a Teniers canvas, he donned a soldier's uniform or a workman's rags. He had the fancy to wear the dirty, smoky cap of the Flemings, to get fuddled with their beer. . . . He ran a finger across an Illinois tomahawk and felt himself scalped by a Cherokee's hunting knife. Enchanted to discover a rebec, he entrusted it to the hand of a chatelaine, thrilled to the tuneful ballads she sang and declared his love for her in an evening setting beside a Gothic fireplace. (72)

The object itself is actually bypassed; it is merely a step on the way to a carousel of free-wheeling mental associations. Objective forms are demoted to a Rorschach test whose only role is to stimulate the imagination, as vacant husks waiting to be filled with subjective projections. The story of objects being replaced by Raphaël's daydream is the story of the *res cogitans* taking the place of *res extensa.* The world dissolves into a solipsistic fantasy, and "he walked along as in the enchantment of a dream" (73). Taken to an extreme, Raphaël's subjective stance toward objects rolls over into a version of Fichtean ego philosophy in which anything outside

of the subjective sphere exists solely through the subject's awareness of it.[12] At once colonized and emptied of its material contents, the subjectified object is little more than a receptacle: "He . . . made all the formulas of existence his own and so generously dispersed his life and feelings over the images of that *empty, plastic nature*" (73, emphasis added). A purely plastic form is indeed all that is left of the object once its contents have been siphoned off to make room for the subjective ego.[13]

As mere contours scribbled over with subjective projections, the objects already behave like the Skin, the collection's ultimate piece. It is well to remember here the Skin's dialectic. Carved into its surface is an inscription that states that the Skin is to fulfill its owner's every wish. Every time it grants a wish, however, the Skin shrinks a bit. It is an object that dwindles to nothing as the message carved on it is proven true: in other words, it is an object whose thingness is entirely absorbed by its linguistic significance. The Skin materially dwindles while its spiritual dimension, scribbled by human agency, inflates. The Skin's magic is to negate itself in the service of the subject. As such it is the symbol of the liquidation of objecthood by the transcendental subject, a principle that is at work throughout the antique shop passage, where objects only mirror the psychological, and even physiological, movements of the subject: "He continued to perceive things in strange colors or starting into slight movement, an effect no doubt of the irregular circulation of his blood" (68). Just as the Skin is thus entirely possessed by subjective life, so the material world is a mere figment of Raphaël's internal physiology. The subject only partakes of the material world insofar as the latter helps to consolidate the claims of the absolute ego, the one for whom appearances in the world have their source in the subject's psychological disposition: what I see is actually a projection of my inner state. Raphaël's objective stance is actually wholly geared toward subjectivity, the triumph of the Protagorian motto: "man is the measure of all things." In truth, Raphaël's behavior in the shop is consistent with his idealist leanings. In his youth he wrote a treatise entitled "Théorie de la volonté" (Theory of the will), which intends to prove that all phenomena can be controlled by the subject's will and that all reality is reducible to thought. Subjectivist solipsism is not only the conclusion of his treatise but also the spirit in which it is written. Of the conditions under which he wrote, Raphaël says:

Study endows everything around us with a kind of magic. The shabby desk at which I wrote and the brown cloth that covered it, my piano, my bed, my armchair, the quaint designs of my wallpaper and the rest of my furniture came to life and became like humble friends to me. . . . Often, as I let my eyes travel over a piece of warped moulding, I chanced on new developments, a striking proof of my system. . . . By dint of contemplating the objects around me I found that each of them had its distinctive appearance and character; they often spoke to me. . . . Was I not captive of an idea, imprisoned in a system. . . . (138)

Convinced of the omnipotence of thought, Raphaël soon comes to believe in the compliance of objects. Objects speak to him, agree with him, mold themselves to his system of thought. External reality is putty in the hands of the demiurgic activity of the mind. It shrinks to a mere figment of idea and already behaves like the Skin: it breathes with the life of the subject and acts in accordance with it.

Significantly, the object's *reductio ad nihilo* which provides the story with its plot (that is, the shrinking Skin) is first observed in the context of a gallery of art. Hence Raphaël's solipsism may be said to constitute a form of *esthetic* behavior, an extreme image of the bourgeois esthetic eye which sees in the work of art nothing but a blank slate for imaginary projections. Make me dream for a while, asks the bourgeois subject from the work of art, take me to distant lands, beyond the horizon of historical landscapes, to the warmth of a cottage fireplace or atop icy mountain peaks: Raphaël is soldier, is laborer, is Flemish burgher, is Indian, is knight. Perhaps the visit to the museum was once not so foreign to the escapism of today's movie house. This would explain why the official art of the yearly salons was an art almost entirely dominated by the dreamy and the idealistic, the fabulous and the historical—legendary, pastoral make-believe and biblical fantasy. Pompier art is, whether in the eternal image of the setting sun or the gaze dreamily staring off into the blue, an art devoted to romantic distance, to inspiration, to castles in the air. An official purveyor of highbrow escapism, the nineteenth-century museum takes part in sheer entertainment, on a par with the panoramas, the fun house, and the shopping arcade.

This has important bearings on conceptions of the work of art. Demoted to an inspirational aid, art is supposed to clear the conduit between the self and his imagination. The artworks exhibited in the antique

shop ("a number of paintings by Poussin, a sublime statue by Michelangelo, several enchanting landscapes by Claude Lorrain, a Gerard Dow which resembled a page of Stern, Rembrandts and Murillo, some dark Velasquez canvases," 73–74) are mere fodder for Raphaël's fantasy ("he walked along as in the enchantment of a dream," 73). His acute subjectivism is typical of the bourgeois esthetic subject who, because it is after all the work of human subjectivity, feels authorized to appropriate the work of art as a mere extension of the psyche. Down-graded to a plaything, the work of art is a receptacle of subjective projections (what the bourgeois traditionally favors as an art to which "one can relate"). Correspondingly, the intolerance toward the opacity of the modernist work ("it does not mean anything!") bespeaks the infantile demand that the work of art be a mirror to the subject, a psychological relaxant:

Here a child modelled in wax lay sleeping, saved from the cabinet of Ruysch, and this ravishing creation reminded him of the joys of his early years. . . . Admiring farther on the delicate miniatures, the arabesques of azure and gold which enriched a priceless illuminated missal . . . , he turned once more to study and science, longed for the easeful life of a monk. . . . Confronted with a Teniers canvas, he donned a soldier's uniform or a workman's rags. . . . He shivered with cold looking at a snowscape by Meiris, or waged war gazing at a battle scene by Salvator Rosa. (72)

The objects' concrete particularity is overshadowed by whatever meaning can be extracted: historical ("a salt-cellar from Benvenuto Cellini's workshop brought him back to the bosom of the Renaissance," 71); spiritual ("one painting showed the heavens opened and in it he saw the Virgin Mary bathed in a cloud of gold . . . lending an ear to the lamentations of the sufferer on whom this regenerate Eve smiled gently," 71); or sentimental ("confronted with a Teniers canvas, he donned a soldier's uniform or a workman's rags," 32). Raphaël considers the works not for their formal peculiarities, but for the chimerical visions that can be spun around them:

But here, cool and graceful, a marble statue posed on a wreathed column, radiantly white, spoke to him of the voluptuous myths of Greece and Ionia. . . . Armed with the power of Arabian talismans, the head of Cicero evoked the memories of republican Rome and unwound for him the scroll of Livy's histories. (70)

The work of art is a mere enabler of private daydreaming: "As he fingered a mosaic made of different lavas from Vesuvius and Etna, in imagination he emerged into sun-drenched and tawny Italy: he was an onlooker at the Borgias' orgies, he rode through the Abruzzi, sighed after Italian mistresses. . . . " (70). Raphaël uses objects only to better transcend objectivity itself: "the longing that had caused him to visit the shop was fulfilled: he left real life behind him, ascended by degrees to an ideal world" (70).

In using the particular work of art as a mere springboard to the ideal, Raphaël embodies that school of esthetics for which art is well and good so long as its material content cooperatively makes way for narcissistic mirroring (it favors the type of art that not only reflects a favorable image of humanity but supports the functionalist ideology of transparent communication: "I like this painting because it speaks to me" is its typical response). Raphaël's self-absorption culminates in the scene where Raphaël looks at a painting by Raphaël de Urbino: "He came to a Virgin by Raphael, but he was tired of Raphael" (74). The duplication of names reflects the confusion that makes the eye mistake the excitation of the optic nerve for the perceived object, or which makes the art amateur mistake his esthetic feeling for the work of art. In looking at art, Raphaël never stops looking at himself, not for what the work of art could teach him about the philosophical fabrication of his subjecthood, but for whatever subjective fancy it reflects.

Needless to say, this escapist stance is anti-esthetic by today's standards (the progress and development of dream-making technology such as cinema, photography, and computer imaging having freed art from the responsibility of providing make-believe and mere entertainment). Indeed, bypassing the work of art, Raphaël's esthetic response runs counter to the essence of esthetics: dealing with the concrete and the particular, not as subcategories of the transcendental subject, but in themselves, in their opaque substance (something Balzac intuited when he represented the painter Frenhofer's chef d'œuvre as an uncrossable, overbearingly concrete wall of painting). To be sure, however, disregard for the concrete often passes for esthetic perception. Indeed, all artifacts, and particularly works of art, give the illusion that material existence can be reduced to the subject's understanding since they are the product of subjective activity in the first place. Nonetheless, sentimental subjectification of the work

of art degrades art to the level of a psychological stimulant (shiver in front of a winterscape by Meiris, fight in a battle scene by Rosa). Precisely insofar as the work has made itself into an actual external appearance, it is a reaction against the subjective interiority from which it is born. An absolutely subjective work of art would not be *made*. Thus to reduce the artwork to the sensations it mimetically inspires in the subject is to reinstate the subject where the artwork had overcome it (something which, in a Kantian vein, Goethe warned against in insisting that no work of art should be judged by the feelings it arouses in the subject).[14]

Altogether avoiding what, as a result of becoming an object, is no longer strictly subjective about the work of art, the naïve museum visitor enjoys the illusion of a piece of objecthood completely permeated by subjectivity: the subject lives out the fantasy of a world reverberating everywhere with the subject. Raphaël's self-enwrapped consciousness is a picture of the bourgeois museum-goer for whom art, as much as technology, is a triumph of the subject over material existence, the bending of matter to the will of logos.

Taxidermy, Art, and the Illusion of Nature

Bourgeois esthetics is, to sum up, solipsistic illusion: the sensible world is a mere reflection of the intelligible. Domination of nature is what, in the end, looms behind the dialectic of subject-object in the bourgeois artistic experience. That the first objects glimpsed in the antique shop happen to be stuffed animals hints at this fact: "At first sight the show-rooms offered him a chaotic medley of human and divine works. Crocodiles, apes and stuffed boas grinned at stained glass windows, seemed to be about to snap at carved busts, to be running after lacquer-ware or to be clambering up chandeliers" (69).

Stuffed nature is nature emptied of its living content and refilled with something manmade. Like the work of art, the taxidermic piece exists thanks to the subject who replaces organic matter with an illusion of it. Only the shells of their former selves, "plastic and hollow," the stuffed animals are harbingers of the ultimate object in the collection: a hide whose material existence is consumed in fulfilling the human script

carved on it: like a stuffed animal, the Skin is haunted and galvanized by the subject. It is not nature but nature existing by and for humans.

A description of objects of art that begins with petrified nature, or nature made into culture, evidently brings up the question of object and subject in the work of art. The rapport between subject and nature is paramount in the classical esthetic discourse. Already with Kant, successful art is culture with the appearance of nature. Kant's recommendation that art "must not seem to be designed, i.e., that beautiful art must look like nature" is the ploy whereby, by means of art, human production seeks to palm itself off as nature.[15] The perfect work of art is human activity that hides its origin and so reconciles with nature. Similarly, the taxidermized animal is an image whose perfection lies in the successful concealment of human activity. Although it is nature stripped of its organic life, the stuffed animal must look natural. The good taxidermist, like the Kantian artist, is a subject who conceals his own activity in and through that activity. Taxidermy pertains to art insofar as, inhabited by the subject, it nevertheless seeks to pass itself off as a simple object. Quite tellingly, "to stuff an animal" in French is rendered as "naturaliser," human labor counterfeiting itself as "nature," as the absence of labor, the same absence of human agency on which the classical work of art prides itself. In fact, before the separation of natural sciences from art, it was not so rare to find taxidermic pieces among artworks in the old *Kunstkammer*. That art and taxidermy once belonged in the gallery perhaps points to the same archaic origin: domination of nature by imitation of nature.

The appearance of taxidermic objects at the outset of the collection mirrors Raphaël's and, by association, Balzac's treatment of the objective world. Just as a stuffed animal is an object inhabited by the subject, so are all the artworks inhabited by Raphaël's "moral galvanism" (76). Raphaël does not encounter objects on their ground, as material things; rather, he empties them of their objective substance in order to take possession of them as subjective forms: "He made all the formulas of existence his own and so generously dispersed his life and feelings over images of that empty, hollow nature" (73). To the solipsist, the object is always "plastic and hollow," a vessel waiting to be filled with subjective projections. In this regard, Raphaël's attitude may be emblematic of the Balzacian treat-

ment of reality as a whole. It is well-known that, in Balzac, objective landscapes have always subjective significance (much like the Skin): there is hardly a corner of reality which, in Balzac's text, is not meaningful, that is, interpreted and "galvanized" by the subject. This subjective colonization of reality is complete when it passes itself off as an original feature of the object itself: interpretation of the object is seen as emanating from the object. The trick of naturalizing cultural landscapes can also serve well to naturalize the domination of nature by culture. This process is most clearly evidenced in the Skin: there, dominion over the object reaches a pitch of merciless contempt; for even the domination of the object appears to be a natural phenomenon, a characteristic of the object: "He brought the lamp close to the talisman which the young man was holding back to front, and drew his attention to characters encrusted in the cellular tissue of this extraordinary Skin, as if they had been produced by the animal whose skin it had once been" (83). The onager, the animal from which the hide was cut, seems to have inscribed itself. Human labor is thereby naturalized. The ego who believes that the world exists only by and for the ego is not satisfied until the object appears to be fashioned after the subject even *prior* to its encounter with the subject. The etching that spells the object's absolute submission to subjectivity (it shrinks in order to fulfill my wishes) receives the blessing of the object itself. Nature's domination by culture, which is almost always violently carried out (the branding of letters on a hide, or the killing and stuffing of animals), is itself passed off as an act of nature. Triumph of the absolute subject, of solipsism, dictates that nature, or the In-Itself, be subjectified even at the stage where nature is merely being itself. Accordingly, the inscription that commands the Skin to extinction seems to be a product of the Skin itself. The object's annihilation by subject is taken to be the object's own wish. Thus the absolute subject fulfills itself—on the back of a donkey. The Skin is ideology endorsed by flesh.

The Skin is also like the work of art: thoroughly subjectivized matter that from the center to the surface is entirely a product of culture but which, as Kant insists, achieves the semblance of nature: *a pure artifactuality with the appearance of nature.* "The purposiveness in its form must seem to be as free from all constraint of arbitrary rules as if it were a product of mere nature."[16] Self-effacing human activity is the ideal of

bourgeois esthetics: something like a stuffed animal, wholly human-made, yet with the appearance of the unmade. To be sure, the work of art bespeaks the bad conscience harbored by rationality toward nature: in the artwork, the spirit of technological domination (that is, the Enlightenment) seeks to make its peace with nature, trying to achieve a nonrepressive synthesis of subject and object. In its classical definition, the work of art also proposes an idyllic reconciliation of subject and object in the midst of a reified world where the objective (nature) is being utterly dominated by the subjective (technology). But for this reason the classical work of art is marred with guilt: it gives the illusory image of a nonrepressive synthesis in a world that denies this synthesis; it pretends that nature and the subject have been reconciled, thus making our domination of nature to be something agreeable to nature. The Skin is like the classical work of art in that it is domination of nature put to the task of concealing such domination.

Raphaël's intense interest in the engraving is most evocative in this respect:

"I confess," the stranger exclaimed, "that I can scarcely guess the process used to engrave those letters so deeply on a wild ass's skin."

. . . "What do you want?" the old man asked.

"Some tool to cut into the shagreen, in order to see if the letters are stamped or inlaid in it."

The old man presented his stiletto to the stranger, who took it and attempted to cut into the skin at the place where the words were inscribed; but when he had removed a thin layer of leather the letters still showed so clear and so identical with those which were printed on the surface that, for a moment, he had the impression that he had removed nothing. (83)

However deeply Raphaël carves into the Skin, he still encounters human language and the presence of subject. As in taxidermy or in the work of art, the subject's mediation can be observed down to the innermost core of the object. But a thoroughly subjectivized object is successful as a work of art only if subjectification appears to be a product of nature. In the Skin as in the classical work of art, the objective, natural appearance of nonartifactuality must abide at the most basic level for the illusion of naturalness to succeed. No matter how deep into the Skin's matter Raphaël

digs, he still encounters the inscription. It is as though the inscription came from the onager itself rather than from the carver's work. In classical esthetics, artistic perfection consists in the absolute homogeneity of surface and depth, part and whole, form and content, a homogeneity that only the subject can bring about, but which, to be complete, must conceal the subject's activity. The ideology of the homogenous work of art is congruent with the ideology of technological domination: in the Skin as in the artwork, the subject's tampering with nature looks natural. Classical artifice (the remolding of nature) must not look artificial: its domination over nature must be reinscribed as *natura naturans*.

Given its presence in a shop, the Skin is a commodity. As such, it is no longer the sum of its concrete particulars: it is an abstraction, a quantity of exchange-value ready to be traded. Everything in the store, as the old dealer reminds us, is spread over with monetary value: "'I covered that canvas with gold pieces,' said the dealer coolly" (80). As abstract exchange-value, the Skin is permeated by symbolic, monetary relations. It is full of the subject's transcendence. Yet, since the Skin's subjectification has to look like the product of nature, its abstraction into exchange value is disguised as a natural phenomenon. Exchange value, as a subjective abstraction, as product of labor, wants to naturalize itself. To do so, exchange value needs to appear consubstantial with the Skin. Not only the hide but also the animal from which it was sliced must be reabsorbed in the transcendental economy of the monetary sign. As we learn later, "the onager is ever more famous by the various kinds of prostitution that made it their object" (240). In the same way that the message that destined the object to its complete subjectification appeared to emanate from the object itself, the Skin's absorption into the transcendence of exchange value is blamed on the onager itself, an animal that *in vivo* sold itself to the highest bidder. The onager is an instance of living nature that made itself one with its exchange value, an object that is always already a commodity ("kinds of prostitution that made it their *object*," emphasis added). By means of this retroactive regrounding of the commodity in the living flesh, nature appears to have always already sold out to its commodification.

Everything in the antique shop passage, as in Balzac's prose, proclaims that in the beginning was the subject, or that, to quote from his

Les Etudes philosophiques, "In the beginning was the Verb": in the beginning was logos.[17] The trick is to pretend, in order to naturalize logos, that nature wishes it that way. The Skin has always already been inscribed, the onager has always already been a consumer's good. In the beginning, the Verb already nestled inside Being.

Subjective Fun Begets Objective Distress

But *La Peau de chagrin* does not merely sing the praises of the subject's domination over the objective world. The cautionary dimension is also unmistakable in the way the story punishes untempered subjectivism. Raphaël wastes away because of the Skin. He is a slave to the Skin and in the end must behave like an object in order to save himself ("an automaton of his own kind, he abdicated life in order to live," 217). Confidence in the omnipotent subject actually leads to entrapment in objective existence. Raphaël takes on the Skin to make himself into an absolute subject but ends up having to live a wretchedly objective existence—indeed, the life of an object.

The transformation of absolute subject into absolute object (so crucial to Balzac's tale) occupied philosophy long before the subject-object dialectics of post-Hegelian thought. It already existed in Pascal, interlaced with theological concerns. A fragment nicely captures the conversion of a completely subjectivized nature into dumb nature: "Once true nature is lost, everything becomes nature."[18] The loss of real nature is the human condition, brought about by the subject's desire to encompass divine omniscience, that is, the desire to reach the standpoint of the absolute subject. The result, however, is not humanity reigning triumphantly as subject. The Fall is, on the contrary, the abject dejection of the subject living as an object ("everything becomes nature"). A completely subjectified universe is not more human, but less so. Once everything is subjectified (technologized), once the subject is everywhere, everything returns to an undifferentiated continuum, something like matter, which is nature again. Thus Pascal's aphorism foresees the historical dialectic of technological reason which brings about a less humanized form of existence as it humanizes the entire universe. Where there is no object, everything be-

comes object. Absolute subjectivity begets absolute materiality. Raphaël becomes the Skin.

Wittgenstein also reflected on the turn of solipsism into realism in a famous aphorism: "Here it can be seen that solipsism, when its implications are followed out strictly, coincides with pure realism. The self of solipsism shrinks to a point without extension, and there remains the reality co-ordinate with it."[19] Once external phenomena have been thoroughly subdued (as in the Balzacian text, which rides on the assumption that the world is the subject's interpretation of it), the subject itself falls victim to this lack of resistance: the world-as-it-is-perceived, being the only world, becomes the world-as-it-is. Or as Pascal puts it, once true nature is lost, everything becomes nature. Like Raphaël-as-Skin, Wittengenstein's self shrinks down ("the self of solipsism shrinks to a point without extension") as it abstracts itself into solipsistic transcendence. The subject loses the *res extensa* for thinking the world to be a figment of thought. By the same token, however, the subject loses its place in the world of objects. Wittgenstein explains: "Where *in* the world is a metaphysical subject to be found? You will say that this is exactly like the case of the eye and the visual field. But really you do *not* see the eye. And nothing *in the visual field* allows you to infer that it is seen by an eye" (*Tractatus Logico-Philosophicus* 57). Once everything is merely the subject's perception of it, the perceiving subject itself disappears in turn. What is seen becomes simply what is: Esse es percipi. In a world where nothing stands over against the subject, the subject loses substance and cannot take his place in the world. The world is therefore subjectless. The subject winds up falling prey to a soulless confinement to what is. Like a dying star, the word collapses under the subject's solipsist domination but then suddenly explodes until it engulfs the subject's life. Like the Skin, the world shrinks to obey the subject's language; in the process, however, it constitutes the subject's sole existential horizon, its "skin." That the world exists in my view only, therefore, means that my view of the world is the world, the only world there is. Subjectivism becomes objective, when stripped of all dialectical exteriority. The world is my skin and my skin is all there is: this ineluctable inner subjective boundary becomes an objective one; the Skin is my realism, the totality of existence, an absolute or-

der of things. Raphaël believes the Skin will make the world perfectly adequate to his thought ("The universe is mine," 216). What he gets is his existential horizon enclosed by a paltry piece of skin.

This retribution is already apparent in Raphaël's cutting into the Skin to read further into the inscription. His compulsion to read deeper into the Skin is typical of the bourgeois subject, who needs to make sure that, however deep in the work, no kernel of objective matter is left unabsorbed by meaning. Raphaël's inquisitive violence toward the Skin bespeaks the manic desire to ascertain that no depth is exempt from the subject's imprint. No matter how deeply into the recesses of Skin Raphaël digs, he still encounters the mediation of subject. However, this subject stares back with the impassivity of a natural phenomenon: the inscription seems to have grown out of the onager itself ("produced by the animal whose skin it had been"). Here, the dressing-up of culture as nature turns against the subject: for the inscription escapes the subject's control, it is unerasable, unscratchable, and above all unremitting in its message. Raphaël is unable to disprove or alter its language.

Through the Skin, the subject's work is alienated from the subject. Human-made disasters, which are first and foremost disasters inflicted by man on nature, are often reinterpreted as nature's willful revenge against humanity. What has been triggered by human hands turns against the subject as something thoroughly alien to it (interpreting the storm as nature's revenge, we thus forget that the ship's wreckage is always entirely the fault of man, who put the ship out to sea in the first place). The Skin illustrates this perfectly: although thoroughly human-made and set on its course by human action, its stubborn shrinking is interpreted by Raphaël as a willful act of the Skin itself, the onager's revenge, a natural curse, something so deeply carved into the skin's layers that it seems to come from the animal itself.

The story of Raphaël's imprisonment in the Skin traces out the dialectic of artistic construction: the subject freely projects itself into the object, which it permeates (the Skin is held in the thrall of logos, of its human-made inscription) but then becomes unrecognizable and takes on the appearance of an object (the subject's own language appears to be something alien, a natural language, something which, in the end, outstrips the subject). The Kantian ideal of a natural art implies that, in the

end, the subject loses itself in the external object. Once naturalized, the subject cannot recognize itself as subject: this is particularly evident in the modern work of art which, thoroughly uncommunicative, seems to hold the subject at bay. The "wall of painting" which forbids Poussin and Porbus from entering the space of the painting in *Le Chef d'œuvre inconnu* is the perfect example of a work of art that, although the product of human work, rebukes human interpretation in the end. The surface of Frenhofer's painting is very much like the Skin in that it is intractable. The nightmarish outcome of Kant's "natural-looking" work of art is that it behaves like a natural phenomenon, that is, it opposes all human activity. As a matter of fact, it is because Frenhofer tries to create an absolutely natural-looking portrait of Catherine Lescaut that, in the end, he creates a painting that is so absolutely lifelike that it is indistinguishable from reality, from unmade objectivity and, as such, is absolutely impervious to human comprehension. Similarly, the Skin is the product of human intention but it frees itself from such intention. The subject is powerless to undo its program or indeed carve out its writing. Having colonized the object, the subject has fallen prisoner to its colony. Raphaël had adopted Skin to carry out his Protagorasian philosophic complex, that is, that man is the measure of all things. But now the Skin has become the measure of man: Raphaël's life is bounded by the Skin which very precisely maps out his existential horizon. Henceforth the Skin will show how much of an object the subject in fact is (the only wish it will not grant is the wish to no longer have all his wishes granted, that is, to no longer have his life enslaved to a shrinking object).

Thus the subject actually becomes the victim of its own violent subjectivism. The message written across the Skin promises unbounded dominion over objective life; at the same time, however, it spells the entrapment of the subject in the object. The more Raphaël exercises his will, the more he is objectively bounded; the more subject he aspires to be the more object he becomes. Raphaël's victory over the objective world is of a Pyrrhic sort: the objective world is a slave to his subjective desires but he has ceased to be a free subject in the end. Raphaël's fate is foreshadowed by the fact that, even before his foolish acquisition, he loses himself in subjective daydreaming. This loss of objectivity in turn tampers with the integrity of his subjecthood:

He so generously dispersed his life and feelings over the images of that empty, hollow nature that the tread of his own footsteps echoed within himself like far-off sounds from another world. . . . In the end, doubting his own existence, he was like these curious objects: neither altogether living nor altogether dead. (73)

Implicit in Raphaël's half-dead, half-alive condition is the reversal whereby absolute subjectivity turns into absolute objectiveness: *he was like these curious objects.* Having triumphed as absolute subject over the colonized objects, the subject is left like an object. The excess of subjectivity is the subject's undoing—a principle the novel illustrates in a parable of the "too much life kills life" sort. Raphaël-as-esthetic-subject pervades the Skin so entirely that he ends up being locked within it. He believes the object can act in total accordance with the subject's wishes but falls victim to the object's compliance. The more the Skin obeys its inscription, that is, the more it bows to human desire, the more the human being becomes slave to it.

The process that later holds Raphaël's life hostage to the Skin is already afoot in his suspended state between the subjectivity of the ego and the objectivity of the corpse, "neither altogether living nor altogether dead." As the story proceeds, the objectification of Raphaël's life increases. Just as his life is *concretely* bound by an object, the Skin, so his living substance presently takes on the quality of a thing: "Everything seemed artificial in this puny, sickly body" (217). Raphaël is forced to make himself objectlike in order to survive. He must repress all wishes, all residues of expression; he must become object: "Almost happy to become an automaton of a sort, he abdicated life in order to live" (217). What Raphaël is for himself is henceforth secondary to what he objectively has become, contained as he is by the material surface of the Skin. Absolute spirituality (Raphaël's subjectivist, even solipsistic, self-enwrapment at the beginning) has reverted to dismal materiality, into a thing. Raphaël's description of his own earlier solipsism—"I had abstracted my life through study and thinking" (87)—leads to his life being resolved and encompassed, not in thought, but in matter, in a stupid Skin.

From an absolutely triumphant subject who believes that the Skin can act according to the subject's wishes, Raphaël becomes an absolutely miserable subject who survives by making himself objectlike, by behaving in accordance with the object.

Transcendentalism and Materialism

> I am spiritually ill, carymary!
> or materially ill, carymara!
>
> Balzac, *La Peau de chagrin*

The reversal sketched in the antique shop is foreshadowed in the episode at the gambling hall immediately preceding it. There also Raphaël gives himself over to objects. He compresses his entire life into the last coin he tosses on the baccarat table ("'I bet that was the last shot in his locker!' the croupier said with a grin, after a moment's silence while he held the gold coin between his forefinger and thumb . . . —'A young idiot who's going to jump in the river'", 63). The coin stands for the subject as a whole. Raphaël plays his last coin. Should he lose it, he also thereby loses himself. In making himself into a coin, Raphaël brands himself a *homo œconomicus*, that is, a subject operating as a mere quantity in the mechanism of economic exchange. He is already stamped by the system that shapes human beings into exchangeable units.

In casting himself into the materiality of a coin, Raphaël is just one more Balzacian character for whom economics constitutes the overarching determination.[20] There is hardly any destiny in Balzac that is not cramped, contained, and mapped out by material economics. Raphaël's enslavement to the Skin merely magnifies the ontological submission to materialism typical of Balzac's world. Yet, like the Skin, money is initially nothing but matter dominated by the subject, an object invested and galvanized by subjective life. Whereas the tree outside my window may presumably (though I cannot prove it) go on being a tree even if I do not believe in it, the dollar bill in my hand will lose all reason for existence if I stop believing it stands for a monetary value. The dollar bill's existence (like that of the taxidermized animal or the talisman) is made entirely of my subjective input. The function of the money sign is furthermore to replace objects. It acts as a transcendental point capable of absorbing all objects and reducing them to abstract quantities (exchange-value). In a sense, money behaves like the transcendental subject embodied by Raphaël at the outset of his gallery visit: it converts everything back to itself. In this money is not altogether different from the transcendental subject.

By positing the transcendental ego, Kant intended to rescue the subject from the yawning abyss of matter. In repairing to a conceptual realm above phenomena, where subjectivity poses as a universal absolute, the ego saves itself the trouble of a perpetually unresolved sparring with the object. As Adorno noted, however, the transcendental subject posited by idealist philosophy is itself nothing more than a piece of social reification: "What shows up faithfully in the doctrine of the transcendental subject is the priority of the relations—abstractly rational ones, detached from the human individuals and their relationships—that have their model in exchange."[21] Terry Eagleton made a similar observation about Kant. He too believes that transcendental consciousness reflects in the spiritual sphere what takes place concretely for the subject on the economic sphere:

Kant's selfless [transcendental] subject, absolved from all sensual motivation, is among other things a spiritualized version of the abstract, serialized subject of the marketplace, who cancels the concrete differences between himself and others as thoroughly as does the leveling, homogenizing commodity. In matters of taste, as of commodity transactions, all individuals are indifferently exchangeable.[22]

There looms, behind the mercurial, disembodied transcendental ego, the grim reality of the faceless subject shackled to the economic assembly line. That Destutt de Tracy begins his 1822 *Traité d'économie politique* by reasserting the validity of the transcendental ego, for whom the world only exists in one's consciousness of it, is quite symptomatic: here again, the transcendental self is the ideological buttress for the economic self. Through a series of philosophical expositions, Destutt de Tracy derives the notion of property, and of the *homo œconomicus*, from the subjectivistic certainty that the world is, at any given moment, exactly what we think it to be. Statements such as the fact that thoughts "are always conformable to the existence of the beings which cause them, since that existence is not known to us but by them, and consists for us only in those perceptions"[23] serve as foundation to his claim that the subject may enter political economic society because he knows himself as a self-owning and self-possessed entity: "If it was not thus, if there was not amongst us a natural and necessary property, there never would have been a conven-

tional or artificial property. This truth is the foundation of all economy" (xii). For Destutt de Tracy, the constancy of the transcendental ego guarantees the possibility of the proprietary ego: one can possess because transcendentally one remains the same despite all the changes one may undergo empirically. The ego that rules supreme above all changing phenomena—and which believes them to be identical to its thought of them—is the anchor that fastens the integrity of property.

Raphaël's treatment of the antique shop's objects as mere reflections of his soul underscores the appeal the transcendental ego had for a writer like Balzac, who never tired of trying to pack the particulars of material existence into one overarching idea, or claim of spiritual ownership (as in *La Recherche de l'Absolu*). The antiquarian himself extols the power of thought to subsume all entities into one conceptual substance, concluding that "thought is the key to all treasures." Or again "'This head of mine is still better furnished than my showrooms. Here,' he said, tapping his forehead, 'here are the riches that matter'" (86)—a principle with which Raphaël acts in accordance from the start. Yet the art dealer who advertises the transcendental subject is the same dealer who sells absolute reification to Raphaël. This lauding of both Spirit and Skin in the same breath reflects a historical situation in which transcendental subjectivity actually entails the subject's submission to objecthood.

Raphaël, the transcendental, de Tracian subject makes possible Raphaël, the owner of the Skin: so much so, in fact, that *owning* the Skin will become indistinguishable from Raphaël's *being*. The philosophical lesson of the Skin is that *homo existans*, the one who is, has melded with *homo œconomicus*, the one who has. To possess the Skin is to be the Skin. This conjoining is emblematized in the Skin's talismanic writing. Even its inscription, which tapers down from Having ("Possess me and thou shalt possess all things") to Being ("So be it"), points to a dialectical entanglement of having and being, whereby the former paves the way for the latter. This means that the subject itself eventually falls into the economic net with which he set out to catch the universe. He who possesses the Skin is forced to lead an inherently *economical* life: Raphaël must learn to *manage* himself, as the industrialist learns to rein in the output of his coal mine or as the foreman learns to control the productivity of the workers

under him (mere human resources). The Skin is the allegory of a world in which the human being treats his own life as a resource that, as such, must be economized. Raphaël's life must become the object of long-term strategic planning. At least he must view his life as a material and *ipso facto* finite supply. The Skin, which gives the self transcendence over existence, also plunges existence into the direst of economical materialism. Through the Skin, existence itself becomes a tool, an objective resource, a technological asset to be judiciously managed. Balzac tells a story in which the transcendental ego is actually revealed to be, at bottom, a product of reification. After all, its protagonist is a young man who, having once absorbed his life "through study and thinking" (87), ends up absorbed by a piece of hide. This trajectory was already marked out by the base and tip of the pyramid-shaped inscription: spirit and matter, being and having. Raphaël the solipsist sinks into Raphaël the Skin-covered automaton.

What Balzac expresses in literature—that absolute spirituality leads to a reification of the subject—Marx expresses philosophically. For the latter, Christianity represents the common form of the transcendental, abstract ego:

The religious world is but the reflex of the real world. And for a society based upon the production of commodities, in which producers in general enter into social relations with one another by treating their products as commodities and values, whereby they reduce their individual private labour to the strands of homogeneous human labour—for such a society, Christianity with its *cultus* of abstract man . . . is the most fitting form of religion.[24]

Christian theology, which preaches self-abstraction and self-transcendence, actually serves the most soulless materialization of human relations. For Marx, the Christian abstract ego lays the groundwork of a social totality made, not of self-willed human beings, but of automated cells of efficiency. "Christianity must be the religion of misers," Balzac remarks in *Eugénie Grandet*, as though he understood that the stockpiling of repressed gratification serves Capitalism as well as Christianity.[25] The dominant role played by the miser in Balzac reflects the fact that material restrictions, in the form of dearth, shortage, and abnegation, are never so strongly felt as by those whose financial means should put them above

suffering need. The miser is essentially an abstract ego: his miserably material life is the result of sublimation. As such the miser provides the model for bourgeois individuality: he acquires his transcendental self in exchange for giving up the satisfactions of being a creature of flesh and blood. This barter is the very dialectic of the Skin which, in this respect, operates as the process of civilization itself. Now a prisoner of the Skin, Raphaël hopes to save himself by repressing all but the organic substratum of his subjective life: he curbs his every will and wish, and aspires to nothing outside the blind functioning of the Skin. In short, Raphaël is allowed to keep his subjecthood by shedding the subject in him.

The Skin is therefore synonymous with renunciation unto death, the subject's adaptation to his own impotence in the fact of the social totality. And, like culture and religion, the Skin promises self-transcendence to the subject who abnegates his autonomy. The Skin promises to its customer boundless expansion of the self, the transcendental ego of idealist philosophy for which the world is exactly the mind's idea of it, but only at the cost of sacrificing the concrete individual. The miser's logic replicates the very dialectic of civilization. It is therefore no surprise that the Antiquarian who barters the Skin preaches the miserly ethos of Grandet together with the virtues of the transcendental ego. He, too, is a character who, forsaking actual life, has resolved the entire world in his brain: "Thought is the key to all treasures and confers the joys of a miser" (86). Raphaël's lifelong belief in a wholly transcendental subject ("I have invested my life . . . in my brain," 85) is a prelude to his bondage to the dismal patch of hide: the abstract universal self is one with the misery of the factory worker physically shackled to the machine, as Raphaël is to the Skin. This is the dialectic of *La Peau de chagrin*.

The Instrumental Subject

The transcendental subject lording it over the object is a piece of pure reification, one destined to the assembly line of social reproduction. Raphaël's walk through the gallery, which is the story of the subject asserting itself over the object, must be read in the light of the episode directly preceding it. Raphaël's abstract ego is something he bought with

the last gold coin tossed on the gambling table. This gesture seals the subject's ritual integration into the realm of economic abstraction: Raphaël agrees to let his whole self be represented by the money sign. But the transcendental subject who permeates the substance of objecthood (the coin, the Skin) is no longer capable of retracing his steps out of matter. In accepting the coin or the Skin, Raphaël falls into abysmal concreteness: I equal a piece of metal or a patch of skin, I am a mere object among others. Thus, pawning his life against a coin and then against the Skin, the subject is henceforth measurable—and the Skin is nothing if not an instrument that measures the subject by the centimeter.

No doubt this is an inchoate critique of technological reification. The story of a human being miserably shackled to a thing describes a state of reification in which the subject has been taken over by the over-subjectified object (the Skin, the coin), a situation in which the subject can be treated like an object. Thus the synthesis between subject and object for which the alchemists, philosophers, and artists of the *Etudes philosophiques* searched in vain is formally achieved in the nightmare hybrid Raphaël-Skin. But what Balzac sought to express in literature had already come to pass in the social arena. As Herbert Marcuse writes, "reality has become technological reality, and the subject is now joined with the object so closely that the notion of object necessarily includes the subject."[26] Spiritual bondage between the hero and the hide ("the circle of your days, represented by this skin, will shrink in accordance with the force and number of your desires," 88) is followed by the material hybridization of subject and object ("the wild ass's skin which, now as supple as a glove, rolled up around his frenzied fingers," 89). The enigmatic story of the Skin is the story of the monstrous conjoining of subject and object in a technologized universe.

The Skin is a technological object insofar as it is designed to serve human interests. It is nature ordered to behave precisely in accordance with the subject's wishes. Measurable, quantifiable, and functional, it is nature bridled and molded by technology which, in the end, denies the autonomy of objecthood itself. Heidegger contends that there are no objects in the technological world. Created to act purposefully and obediently, the object is turned inside out: rationalized and therefore stripped of its otherness as object. Heidegger writes:

Whatever stands by in the sense of standing-reserve no longer stands over against us as object. Yet an airliner that stands on the runway is surely an object. Certainly. But . . . it stands on the taxi strip only as standing-reserve, inasmuch as it is ordered to ensure the possibility of transportation. For this it must be in its whole structure and in every one of its constituent parts, on call for duty, i.e., ready for takeoff. . . . Seen in terms of the standing-reserve, the machine is completely unautonomous, for it has its standing only from the ordering of the orderable.[27]

The Skin is just such a deobjectified object conceived of as standing-reserve, as an economized thing subordinated to the subject. As in advanced technological development, the Skin is a tool that behaves so much in accordance with the subject's intention that it becomes a subject itself. As such it is able to challenge and oppose the subject. It is noteworthy that Raphaël's unlimited power (granted by the Skin) stops precisely at the Skin: the one wish the Skin will not grant is that it stops shrinking. This is the particular juncture where the Skin-as-tool mutates into Raphaël-as-tool. Raphaël's power as subject comes to a stop precisely before the apparatus granting him his power of absolute subjecthood. He has fallen victim to the tool by which he seeks to establish dominion over reality. The human drive to power overpowers the human: in other words, the technologization of reality ends up annexing the subject as a mere instrument to this instrumentalization, in the same way that Raphaël becomes just an appendage to the complete subjectification of reality he sought in the Skin. Raphaël cannot stop the instrument by which he sought to make himself into absolute subject, he cannot shake off the appliance to which he bonded himself: this failure condemns him to reification. He, in fact, becomes an instrument to his tool.

A tool is that by which the subject makes the world his own. In the technologized world, however, the tool is no longer merely a servant. A machine creates the behavior according to which it is to be used. The subject who wishes to subjugate the world ends up instrumentalizing himself in the process. To make himself into the absolute subject—that is, to live in a completely "Raphaëlized" world—Raphaël must behave like a piece of machinery, an objective unit whose obsolescence is as planned as that of a modern appliance. An astounding analysis written by Balzac at the same time (1830) as *La Peau de chagrin* underscores the social critique embedded in the story of the Skin:

Once he starts working with his hands man abdicates his destiny; he becomes a means. . . . Workers are nothing but pulleys and stay welded to their wheelbarrows, shovels and pickaxes. . . . Like steam engines men shackled by labor are produced in the same energetic matter and have nothing singular about them. The man-instrument is a kind of social cipher. . . . A worker, a bricklayer, a soldier are the featureless fragments of one mass, the segments of the same circle, the same tool . . . work is to them like an enigma whose solution they [the workers] seek till they die.[28]

Work, that distinctively human activity, is that by which humans are demoted to the function of objects. It is because of excessive subjectivity, that is, the desire to impose an anthropomorphic imprint onto the world by means of work, that the subject falls to the level of instrument pure and simple. Indeed, the historical period in which Balzac lived is one that increasingly demanded that the human element of change, of improvisation and subjectivity, be sacrificed to rationalized production process: in making the factory worker a mere step in the conveyor belt, industrialism treats the autonomous subject as an impediment to efficient output. The less the subject is allowed to input its subjectivity into the making process, the better the making process as a whole will run. Thus the world where the abstract subject has taken control over the rational process of production and consumption is a world where the individual subject is no longer a subject but an objective quantity. Complete humanization of the world leads to the dehumanization of the particular subject. The dialectic sketched in Balzac's essay plays itself out in his novel, through the allegory of the Skin: the truth of technological reality ("to create something with your own hands [faire œuvre de ses dix doigts]") is that of a subject who so pervades the substance of phenomena that it winds up falling under the spell of objecthood. Having found the instrument of absolute domination over reality by the subject, Raphaël-the-subject soon becomes an appendage to that instrument, a piece of reification.

Evil and Esthetic Life

Absolute spirituality destroys itself in its complete domination over the objective world: it becomes entrapped in the very materiality it sought

to conquer. Balzac translates this process into a cautionary tale with Mephistophelian overtones. The Ass's Skin is associated with evil: "the devil is hidden in there," says the scientist who tries to break the Skin apart (249); "I believe in the devil," another scientist opines (251); and the Skin is later named "la diaboline": "'There is something definitely diabolical in all this,' Raphael cried out in despair" (249). Demonization of the Skin is tied up with the reversion of spirituality into materiality. It is the story of Satan's fall: Lucifer, the bearer of light whom Milton describes as the brightest, most celestial angel, lapses due to his excessive spirituality. The Angel Lucifer, who is pure mind, is cast into abysmal materiality after an unsuccessful bid at out-spiritualizing God. The diabolical nature of evil stems from Lucifer's fall from the ether of Spirit into the pit of Carnality: it is forever reversing spirit and matter, subject and object, Lucifer and Satan.

Evil is one of the names for the reversibility of absolute spirituality into absolute materiality. On the one hand, evil is always linked with abstraction and excess of intellect and knowledge (Goethe's Mephistopheles appearing as a scholar or the Hollywood villain mouthing his threats in Oxford diphthongs). On the other hand, evil is also linked with materiality, carnality, lust, bondage to matter (Satan the lecher, the goat, the dog, and so on). Trying to be more spiritual than God himself, Satan ends up in dire materiality. In the same manner, Raphaël lapses into a purely material existence (a notion that the Skin will cruelly impart to him time and again) for having attempted absolute dominion of mind over matter ("From now on, your desires will be scrupulously satisfied, but at the expense of your life. The circle of your days, represented by this skin, will shrink in accordance with the force and number of your desires," 88). Raphaël's mind is all-powerful but his life is, as a result, a mere patch of hide. His excessive idealism passes over into excessive materiality. Indeed Raphaël has this in common with Satan—they were both condemned to crushing materiality for their excessive idealism.

How does the Satanic reversal of absolute subjectivity into absolute materiality pertain to the esthetics of the gallery of art? How does Raphaël, the esthetic dilettante, become Raphaël, the wretched prisoner of the Skin? The esthetic belief embodied in Raphaël is, as shown, one of unfettered subjectivism. Raphaël's perception of the art object is self-

centered: its vision is aimed inwards, toward consciousness and away from the actual, concrete nature of the artworks on display (hence Balzac's description of the collections is actually a description of Raphaël's dreamy perception of them). Raphaël behaves like the museum visitor who takes artworks as an excuse for a prolonged reverie, an agreeable time spent in private conversation with oneself. The object is supplanted by the subject's idea of it. This, as observed above, causes Raphaël to lose his foothold in the objective world.

What does the repression of the objective world have to do with classical esthetics? Eighteenth-century esthetics, from Baumgarten to Kant, had hoped to reconcile, through esthetic experience, the subject with the object, knowledge with palpable reality, cognition with perception, the life of spirit with sensuous existence. But this reconciliation entails the rationalization of the sensate. Cognition does not reach out to materiality but instead tries to penetrate and subjugate it. Such was Kantian esthetics, which aimed at sanitizing the world of feelings and sensations by, first of all, transcending taste, that is, irrational sensuousness. Hence esthetics hopes that reason, the most immaterial of faculties, can somehow pacify the material by bringing it under control. Only in the sublime (which Kant never meant to be an art object) is reason exposed to something so vast and so aggressively material that it is forced to bow down. Generally in Kantian esthetics, however, the experience of esthetic beauty happens for the benefit of reason.

Inasmuch as Raphaël's attitude is unambiguously biased toward the subject, it represents an extreme caricature of the classical esthetic. Raphaël swings the esthetic pendulum so far toward the subject that he ends up losing the object altogether: "He made all the formulas of existence his own and so generously dispersed his life and feelings over images of that hollow, plastic nature" (73). The subject is absolute, the object empty, a mere shell waiting to be filled. Yet this absolute esthetic subject suddenly reveals itself to be a mere epiphenomenon of the material subject: "He continued to perceive things in strange colors or starting into slight movement, an effect no doubt of the irregular circulation of his blood" (68). The esthetic stance of the absolute subject turns out to be grounded in physiological conditions. The solipsist mind, in which objects exist only as faint echoes of themselves, is actually the product of

objective processes: physical stimulation of the retina, palpitations in the veins, the rushing of cerebral juices. Excessive spirituality (the artwork is nothing more than my thoughts and feelings about it) brings about materiality in excess (esthetic perception is a bodily response). The esthetic subject begins by trying to bring reason to the body, the physical, the concrete; but it ends by becoming one with the body due to its single-minded focus on the spiritual.

The bourgeois esthetic subject is already the stimuli-besieged homunculus of experimental psychology: it is a forerunner of the late capitalist consumer who has become malleable clay in the hands of marketing research. The moment esthetic experience is believed to be wholly made of the subject's sensations, the subject finds himself made into prime laboratory material. The reduction of artistic experience to a battery of psychological stimulation leads not to the enthronement of subject, but to its debasement as mere matter. The esthetic subject eventually falls victim to its own triumph. Esthetic discourse seeks to penetrate the concrete and the opaquely material with the light of reason but ends up falling victim to the very materiality it sought to dominate. Like Lucifer it sinks into materiality by excess of spirituality. This dialectic explains why estheticism is entangled with naturalism and why, historically, they tend to appear as a pair. The extremism of Raphaël's initial subjectivism already prepared the ground for his naturalization, that is, for his becoming a natural object, the Skin.

This dialectic also governs esthetic creation. Excess of subject in the work of art does not lead to spiritual art but to a petrified material kind of art. An artwork that is suffused with subjective intentions and expressiveness usually turns out to look lifeless and inexpressive (for instance, propagandistic art, edifying art, inspirational art, and so on). The wholly subjective work of art (the one overripe with unmediated messages and ready-made information) looks stunned by an excess of unprocessed subjective input. By repressing or silencing its objective dimension, the overly subjective work of art paradoxically ends up looking spiritless. Social realism, such as that favored by National Socialism or Stalinism, looks dull from being overwrought with expressiveness. This type of art clamors about the control of matter by a boundlessly powerful subject, or rests on the conviction that matter can be bent to man's will. Its message,

like its form, is the triumph of the will, triumph of the subject over the object. Yet the art that celebrates this triumph is lifelessly objective: the human figure itself looks spiritless and artifactual. It is the robot worker or mechanical peasant of Nazi art (Arno Breker's sculpture is a good instance). The subject is petrified or flattened by its own apotheosis.

This is the fate of overly beautiful art as well. Indeed, wherever the Kantian ideal of esthetic beauty is fulfilled—wherever the penetration of reason into the material is complete—the work of art has the stupefied look of a circus animal: it is dull for being tamed, flat for being overly legible, tasteless for being so agreeably tasteful. This is the fate of commercial art in which, from Bouguereau school landscape paintings to pop songs, the subject is given the license to pour out his inner self and, for precisely that reason, ends up as just another commodity. Sentimentalism is the expression of a subject who mistakenly takes his inner self to be a standing reserve of readily available emotions, as though they were objective elements waiting to be tapped: this makes the subject himself into a collection of discrete items objectively determined. Above all, sentimentalism is the belief that the subject has direct access to his subjective states and, correspondingly, has no trouble expressing them: it is a reified subject, one whose artistic output bears the blemish of having repressed its material moment. Such a work of art will look spiritless, contrived, dull—in a word, material. Taken to its extreme, Kant's idea of the esthetic beautiful, as one doctored by reason, ends up in unreason, in dumb materiality. (By contrast one would have to guess that the successful work of art is the one that initially holds its subjective element in check, the better to let it burst through in the end.)

The Skin is an oversubjectified work of art. It is thoroughly written over by subjective inscriptions; in fact, it *objectively sacrifices itself* to bear out the subject's message. Yet in the end it gets the upper hand, regaining its objecthood at the expense of the subject. Here again, the absolutely subjectified (reasoned-out) object winds up as the most objective object possible. This same dialectic of exchange is at work in conceptual art. Conceptual art aims to be an art of pure expression, an art that is entirely subsumed under the concept. It fulfills Hegel's prediction that art would some day be supplanted by philosophy: art is now the *idea* of art. It is the

product of a subject who has replaced objects with words. So-called word art seemingly aims at an expression having as little to do with matter as possible. Yet there is an aspect of this ideational art which is paradoxically objective, almost crudely so: mere objects assembled or just simply thrown together in an installation. Already in Magritte's *Ceci n'est pas une pipe*, the artistic work made over into a message draws attention to the very materiality of its support. Out of excessive spirituality, it looks flatly objective. Installation artist Joseph Beuys's *Coyote: I like America and America likes me* is a work that, although theoretical, has the appearance of unprocessed raw material (in fact it makes use of a live animal). Suffused with conceptual intent, it looks completely nonconceptual, even nonmade: objects that have not been created.

This reversal is not lost on conceptual artists themselves. Joseph Kosuth, the self-professed father of word art, creates works in which words, emissaries of the transcendental subject, nevertheless look crudely objective. He watches for the becoming-object of language, which is really the becoming-object of subject. This reversal is ironically expressed in a neon work of 1981, which reads "the object has taken the place of the ego ideal."[29] An Ass's Skin for postmodern days.

This digression into contemporary art is no digression: the onager's skin would be perfectly at home in today's museum of contemporary art. Like conceptual art, it is utterly meaningful, fraught with the subjectivity that built it. Yet, in appearance, it is brutish and unsubject-like, organic and bestial. As the ultimate object of the antique shop, the Skin stands as the end of Raphaël's tour: each object before has been a mere mirror, a blank slate for Raphaël to write over. The Skin too is a blank surface on which the subject has carved his wish for total world domination, for absolute control over objective matter. Yet, in the end, the Skin turns frighteningly indifferent to the subject; it becomes absolute matter, absolute realism. In fact, when Raphaël takes the Skin to a scientist for examination, the latter, after having plied, cut, slashed, exploded, and torched the hide without inflicting so much as a scratch, simply says: "We cannot deny the fact. . . . It's as dumb as a fact" (252). All attempts at making the object legible fail when they come up against an unreachable core of objecthood, a precipitate of sheer reality, the implacable revenge of object.

Realism and Objective Alienation

In this respect, the Skin provides philosophic comfort. In a sea of mass fungibility, it is a drop of rock-hard objecthood. With the Skin, the subject can be sure of being in the presence of an object, almost an In-Itself. This explains the scientists' laconic reverence before the Skin. Like the realist, the scientist finds vindication of his positivism in the Skin: fact enthroned as a credo.

Yet, *La Peau de chagrin* sounds the alarm about the dangers of objectivity. Its concern is that reality is not what it used to be. Behind the dictatorial materiality of the Skin-object stands the industrial revolution, which was a revolution in the nature of objecthood itself. The commodity's unknown provenance, its rational, mechanical production, conspire in making it inorganic, aloof, indifferent, dead even. The Skin is such an object: devised as an instrument, it nevertheless repudiates its own instrumentality and, rather than serving the subject, attacks him. Although Raphaël and the Skin are consubstantial and although the Skin grants him his every wish, it resists all negotiation and shrinks no matter what. Though a human-made thing, the Skin sticks to its program, irrespective of the subject's agony. In this way the Skin is like the industrial object, which discourages any human association with its hollow shell. What makes modern man's doting on his car pathetic is that, by its very mass-produced and alienated nature, the car can bear no such personal relation to him. It is not a particular object but a specimen. Unlike hand-crafted objects which invite anthropomorphic projections and sentimental bonding (Pinocchio and his maker, for example), mass-produced goods inspire nothing but dread and mistrust (see the literature of the uncanny object, from Gautier's *La Cafetière* to Ravel's *L'Enfant et les sortilèges*). The nineteenth-century individual experiences the novelty of being surrounded by objects that, too familiar to be called exotic, are nonetheless too ubiquitous and impersonal to be called familiar.

La Peau de chagrin tells the story of the transition from the familiar object to the mass-marketed item. As he steps into the shop, Raphaël still believes in the epic world where the subject is master of the surrounding objects. He imagines himself a figure of heroic legends and epics—a pirate, a knight, a soldier, and so forth.[30] These characters are all doers,

movers and shakers of the slightly archaic world where the subject kept the terrors of the objective world at bay. The horseman battling the dragon has no doubt about who shall slay whom. By contrast, Raphaël is powerless before the terror of the Skin; the outcome of his struggle is determined from the start. Raphaël becomes a prisoner of an object that acts of its own accord, something as harsh as it is brutal, something at once murdering and moribund. The dragon, in the guise of the Skin, has spread its evil empire over him. Raphaël goes from a world of objects appropriated by consciousness to a world in which an impenetrable, unbreachable object claims victory over an enslaved subject. His progress is the world of the epic capsizing before the world of the novel. Flaubert's *La Légende de Saint Julien l'Hospitalier* is a symptom of this decline of the epic world: the knight never attains complete victory over the forces of nature, over the object. Animals keep crowding around Julien. The more he slays them, the more they assemble around him, as though fresh out of the factory. Here the medieval knight becomes a modern-day butcher trying to keep up with his quotas. The battle of the subject against the objective world is endless: in the end it yields only resignation and stupefaction, the complex of the Flaubertian hero (whose epitome, it seems, is Frédéric Moreau of *L'Education sentimentale*). Characteristically, Flaubert's knight becomes a saint, the very figure of self-abnegation. Once upon a time, the subject managed to subdue the foreign and hostile object. Industrialization of the objective world accrues and multiplies the power of objectivity to such an extent that the subject is cowed into surrender. The Skin is a throwback to the world of chthonian myths (the dragon in the lake, the enchanted forest, the magic mountain), yet it is thoroughly modern, since it cannot be mastered or tamed and since it functions mechanically and affectlessly. Set on its course by human agency, the Skin will shrink, as relentlessly as the steam engine in Zola's *La Bête humaine* crushes human existence on its path. Once Raphaël is dead, we may imagine, the Skin will spring back to its original full size. In the world of the novel the dragon, like the factory, keeps going and going.

Though omnipresent, the object nevertheless remains strange and apart. *La Peau de chagrin* recognizes this strangeness: the object, no longer to be colonized, takes on the aloofness of a triumphant enemy. In this respect, the antique shop episode foreshadows the modern novel's experi-

ments in alienation, whereby all objective elements stray away from their human center and take on an objective impenetrability. Balzac's description of the shop may be seen as the predecessor of quite a number of realist works that contended with reality's claim to separation, each time with added alienation and the subject's impoverished experience—from Flaubert's *Bouvard et Pécuchet*, to Zola, Huysmans, Roussel, Robbe-Grillet, and Perec. The world of objects serves as a precipitate for the world of the novel at large, one in which the subject supposedly pervades the world (through a private, intimate vision of it) and yet finds the world scattering centrifugally away from him. Thus Balzac's legendary attention to objects reveals an alienation of objects from the human. It is as though objects began to appear in the novel when, objectively, they severed connections with the human, became unrecognizable, and started acting of their own accord, in a world of their own. Balzac's realism testifies to an estrangement from the object, not a deepened companionship with it. Raphaël's hybridization with the piece of hide does not yield an ecstatic situation of mutual recognition between subject and object; rather, it is an intensification of irreconcilability, an irreconcilability that ultimately brings about the subject's demise.

Triumphant materiality defeats spiritualization. In shrinking, the Skin condenses down to the core of its objecthood, where objectiveness hardens and becomes intractable. The Skin materially disappears but paradoxically makes its material existence painfully materially overbearing. The object's supremacy is illustrated in the episode at the forge, where Raphaël has the Skin hammered, pounded, cast into molten fire, stretched with hydraulic pliers, all without inflicting the slightest damage ("it does not even make a difference," 249). The Skin embodies the irreducibility of objecthood, one no longer amenable to human work and subjective experience. Through the Skin speaks the voice of the concrete, refusing to be denigrated any further. The Platonic supremacy of the idea over the thing is overturned by the absolute empiricism of the Skin. For in trapping the subject on its material surface, the object seizes hold of the universal. The Skin is therefore no mere instance of objecthood, rather it *is* objecthood, the concept of objecthood itself, a universal, the world contained by reification. "We cannot deny the fact. . . . It is as

dumb as a fact" (252). The Skin undeniably is: for Raphaël, it is in fact *all* there is, the totality of existence.

Broken

In shrinking, the Skin spreads its tyranny over Raphaël. The possibility that human-made objects, such as commodities or instruments, may turn against their human users hangs over modern consciousness like Damocles' sword. This fear finds expression in fantastic literature (Mary Shelley's *Frankenstein*) or in the detective novel, where a simple paperweight can inspire dread. Grandville's illustrations in *Les Petites misères de la vie humaine* (1843) depict the moments in daily life when instruments refuse to fulfill the role for which they have been designed. They suddenly become bothersome.[31] The otherwise innocuous annoyance of a boot stuck halfway round one's ankle spawns the realization that beneath the most compliant instrument lies some obscurely resistant piece of objecthood. The defective object calls attention to itself and thus comes to consciousness. It is by breaking down—when the shoe sticks, or the table collapses, or when the Skin shrinks—that objects acquire ostensible objecthood. By refusing to be useful, the commodity suddenly reverts into an obtrusive mass of objectivity that is potentially harmful to human beings.

Thus, when the object breaks down we realize that its instrumentality was synonymous with its silent deference to the subject. The pen I am holding in my hand complies with my wish for it to write. In fact it has been designed just for this use. There is not a part of the pen that is not suffused by its instrumentality, that is, with my expectation that it serve me well. The pen, as a tool, bears the imprint of the subject through and through. Hence the subject is what sustains the existence of the pen as pen. Should the pen break, however, it would turn into a block of senseless matter. The malfunctioning pen is now a useless piece of plastic that rejects my wishes. What gets suddenly thrown out in the instrument's failure is the subject itself. Upon breaking down, the commodity, once a spiritualized object, becomes something dreadfully material, something brutish and stubborn. It becomes a real object. The Skin too becomes an

FIGURE 7. J. J. Grandville, illustrations in *Les Petites misères de la vie humaine*, 1843.

absolute object as soon as it is no longer an instrument controlled by the subject. For it is an instrument so long as Raphaël uses it, but it becomes a mean *object* when Raphaël is no longer able to stem its shrinking. The subject is suddenly faced with the nightmarish realization that the object has gained the upper hand in their exchange. Because the Skin's shrinking cannot be stymied, it gains dominance over Raphaël. There is, in Grandville, a direct line from the sketches of *Les Petites misères*, in which defective objects stage comical coups against the subject, and those

FIGURE 8. Grandville, illustrations in *Un autre monde*, 1844.

of *Un autre monde*, in which animated objects move about freely in a world of their own.

The best frontispiece for *La Peau de chagrin* would be Grandville's sketch in which a hammer holds the chisel sculpting a human hand. As the Skin defines precisely the outline of Raphaël's life, so too the self-moving instrument now presides over the human form. Grandville depicts not so much the instrumentalization of things as the instrumentalization of humans. Behind the autonomous chisel one beholds the technological, instrumental world (the assembly line, the factory, the mine, and so on) which, reconfiguring humanity according to its functional necessity, becomes the authority in defining what a human being is or, as in Grandville's sketch, what shape the human has. The hand (symbol of human control over the objective world) is now controlled by the self-ruling instrument. As in the Skin's case, it is out of excessive anthropomorphization that the object (the humanlike chisel) acquires the authoritative objecthood capable of ruling over human destiny (the hand). Ex-

cessive subjectivization of the object (the Skin, the instrumentalization of objects) mutates into a surplus of objectivity which, in turn, acquires a subjectivity inherently detrimental to humans.[32]

The impulse to strike back at the table into which one has knocked is by no means superstitious or neurotic. It demonstrates how, in failing to fulfill quietly our desires—in failing to be wholly instrumental—objects stand out so much as objects that they seem like subjects. I hit the table to hurt it. We suspect the recalcitrant instrument of sentience and even cognitive intention. It is as though, in shedding use-value, the object claimed the right to dissent from human ends, a right proper to humans. In this way, the dialectic has come full circle: the skin is an object (hide) which, as a result of being thoroughly subjectivized by meaning (talisman), turns into an overbearing object (Skin) instilled with a second-order subjectivity (the malicious Skin). This soulful materiality nearly always registers on the side of the supernatural and the sacred, at the juncture of which is evil: Balzac's Skin, or the crepuscular world of Grandville, which Baudelaire found so terrifying;[33] or again Frankenstein's creature which, as the most subjectivized artifact, wreaks the most havoc on humans.

The description of the Pension Vauquer at the outset of *Le Père Goriot* illustrates quite well the second-order subjecthood which objects acquire by refusing their use-value, in decay: "how old, cracked, rotten, shaking, worm-eaten, one-handed, one-eyed, infirm, moribund the furniture is." As in Grandville's sketches, objects in the Vauquer boardinghouse acquire a human character defectively, that is, through their failure to remain instrumental: the furniture is broken and therefore described as one-armed, one-eyed, ailing, dying, all of which are human properties. Objects and humans meet in decay. The Skin too embodies decay: its essential program is to putrefy, to disintegrate into nothingness. Subject and object reconcile, not in a Hegelian fanfare of absolute Spirit, but rather in *decay*, that is, in horror. Thus the mutual permeation of subject and object elaborated in Balzac's description of the Vauquer pension ("her whole person explains the house, as the house implies her person") is mostly conceived through rot. Indeed it is by filth that humans join themselves to objects or leave their imprint on them: "a long table covered with oilcloth so greasy a playful diner can autograph it using his fin-

ger as a stiletto." Symmetrically, objects take over humans through filth as well: in the same way that the table is contaminated by the subject's name, the subject is contaminated by the objective world ("using his finger *as a stiletto*").

In *La Peau de chagrin*, it is by breaking down that the Skin becomes subject and includes the subject. And it is by breaking down the Skin, that is by carving a message on its physical body, that the subject mingles with it. Interpenetration between subject and object in the Skin takes place under the aegis of decay: the abject is an overly intimate contact with the object, as all contacts with the object originate in abjection.[34] Raphaël's abject subjugation to the Skin is also the Skin's abject subjugation to the subject's language. Abjection is the limit between subject and object. This is where the particular symbolic function of the Skin comes to light: the skin is the adhesive membrane that binds the subject with the objective world; it is by definition the place where abjection is played out, where the subject and object fail to separate and fail to meet, and therefore remain abjectly bound in their separation.

The image of the Skin wrapping itself around Raphaël's hand ("the wild ass's skin which, now as supple as a glove, rolled up around his frenzied fingers," 98) evokes the primitive terror of relapsing into animality. One of the earliest examples of this fear is perhaps the story of Circe, who turned men into swine, or that of the sorcerer who transforms the prince into a frog. Perrault's fairy tale, "Peau d'Ane" (Donkey skin), of course, comes to mind. Balzac's Ass's Skin harks back to the same threat of abjection, of human existence smothered by an animal's skin. To see this most archaic fear surface "on the Quai Voltaire, in the nineteenth century" (79) shows that technological reason has by no means outgrown this fear. On the contrary, industrialization of labor generalizes the abject concatenation of subject and object that myth sought to exorcise: "workers are nothing but pulleys and stay welded to their wheelbarrows, shovels and pickaxes, . . . like steam engines" ("Traité de la vie élégante" 212). This is why the Skin, although appearing to be the emanation of a necromantic past, actually describes an abjection that is part and parcel of technological reality. Indeed, to Balzac, the world of capital strikes the same terror as the prehuman world when human and animal were as yet undifferentiated. Technology conjures up the hellish image of prehistory, of

the oozy world where the subject has not yet sloughed off his animal skin, or constantly fears regressing to an earlier biological form (a tree, a frog, or a donkey). By pressing subject and object together, technological reality is indeed, *stricto sensu*, abject.

The Topsy-Turvy World

> Everything comes alive when contradictions abound.
>
> Bachelard, *Poetics of Space*

Like the archaic consciousness of older folk religion, capitalism is rife with animism. We just need to consider Grandville's riotous world or the animated objects in horror tales. It is difficult to explain the upward transfer of folk tale animism to high literature in the nineteenth century otherwise than by arguing that, somehow, reality itself became fantastic. There is no other explanation for why the realist novel, chronicler of the social totality, should have produced elements of the supernatural in its stories. It is a moot question whether *La Peau de chagrin* is a realist novel or a fantastic tale. Balzac's novel is fantastic insofar as capitalist reality is fantastic, or pre-historical. Marx intuited this idea when he compared the production of commodities to something as occult as table-turning. The antique shop episode in *La Peau de chagrin* reveals animism lurking behind technological reality.

As observed above, the shop's collection is initially no more for the subject than an occasion for solipsistic fun. Each object is treated by Raphaël like a costume, a skin basically "hollow and plastic" for him to don (Raphaël imagines himself as a pirate, a scholastic monk, a soldier, a Flemish burger, a Cherokee, a chivalrous inamorato, and more). Balzac's museum is eventually won over to this "moral galvanism" (76) and, in a manner reminiscent of Grandville's bacchanalias of objects come to life, turns into something of an animated cartoon:

The pictures lighted up, the faces of the Virgin smiled at him, the statues took on the deceptive colouring of life. . . . Each of the idols grinned at him, each face in every picture blinked its eyes as if to rest them. These works of art, under the favour of the half-light, set dancing by the feverish turmoil fermenting in his

stricken brain, stirred and whirled before his eyes. . . . Every one of these strange shapes shuddered, quivered, moved gravely. . . . It was a weird witches' sabbath worthy of the fantasies glimpsed by Dr. Faust on the Brocken. But these optical illusions, born of weariness, the strain resulting from ocular tension . . . had no power to frighten the stranger. . . . He even favoured with a sort of mocking complicity the bizarre elements of this moral galvanism. (76)

The appearance of Faust, while laying the ground for the Mephistophelian theme, also recalls solipsistic absolutism: the Faustian power to annex all external objects to the mind. This strange sabbath, in which object breathes with the life of the subject, is actually typical of Balzacian realism. Perpetually scrutinized by the eye of the paleontologist, the historian, or the archeologist, Balzacian reality is a subjective bacchanalia in its own right: it bespeaks the omnipresence of the subject who, interpreting everything, pulls the strings from behind the stage. The drawback, however, is that the world will at some point appropriate this subjectivization. The Skin is that parcel of the real which will enact that appropriation. Its evil spell recalls the magic that Marx, two decades later, discovered in the commodity:[35]

A commodity appears, at first sight, a very trivial thing, and easily understood. Its analysis shows that it is, in reality, a very queer thing, abounding in metaphysical subtleties and theological niceties. So far as it is a value in use, there is nothing mysterious about it. . . . The form of wood, for instance, is altered, by making a table out of it. Yet, for all that, the table continues to be that common, everyday thing, wood. But, so soon as it steps forth as a commodity, it changes into something transcendent. It not only stands with its feet on the ground, but, in relation to all other commodities, it stands on its head, and evolves out of its wooden brain grotesque ideas, far more wonderful than "table-turning" ever was. (*Selected Writings* 435)

The animistic image of table-turning is an apt metaphor for the process whereby, thoroughly subjectified by exchange-value, the table as a commodity seems to have a life of its own (as in Grandville's *Un autre monde*). The magical turn identified by Marx (which, in Balzac, takes on the dark hues of the malevolent) occurs when the subject becomes alienated from the subjectiveness it has injected into the commodity. I forget that commodities circulate in the world only because of the human labor con-

gealed in them and this creates an idea of them as self-ruling, animated objects. In the topsy-turvy world of commodities the subject forgets that objects move because of his "moral galvanism" and instead sees the object-world acting of its own will. The effect is the same as when one attributes the fluctuations of Wall Street to the stocks themselves (or even to that great abstraction "the economy") rather than the cumulative effect of numerous all-too-human investors deciding to buy or sell. Although the subject has constructed the process, the process seems to be moving according to its own laws and biological rhythms:

A commodity is therefore a mysterious thing, simply because in it the social character of men's labour appears to them as an objective character stamped upon the product of that labour; because the relation of the producers to the sum total of their own labour is presented to them as a social relation, existing not between themselves, but between the products of their labour. . . . In the same way the light from an object is perceived by us not as the subjective excitation of our optic nerve, but as the objective form of something outside the eye itself. . . . The existence of the things *qua* commodities . . . is a definite social relation between men, that assumes, in their eyes, the fantastic form of a relation between things. In order, therefore, to find an analogy, we must have recourse to the mist-enveloped regions of the religious world. In that world the productions of the human brain appear as independent beings endowed with life. (*Selected Writings* 436)

As Marx explains, the exchange-value, by which the object seems to have a life of its own, is the return of the repressed subjectivity that was put into the object by human labor. It is the repressed memory of the subject alienating itself as an objectifiable substance (much like Raphaël, in a step leading toward the antique shop episode, cast himself into his last coin). Like the eye that fails to recognize vision as product of cerebral processes or the religious mind that fails to recognize the deity as a projection of subjective dreads and aspirations, the commodity possesses a magical externality that conceals the mediated nature of its production. The commodity is an eerie object whose subjective process of mediation has congealed into a foreign substance once known and now forgotten. For Marx, the saturnalia of commodities begins "to turn on its head" not simply when use-value recedes under exchange-value, but when the subject is made to

forget its own subjective mediation of the object: namely, when exchange-value turns into an objective substance. This is when the human-made world turns into a second nature, when absolute subjectivity reverts to materiality: when the Skin-as-tool becomes the Skin-as-a-master.

Hence technological reality effaces the subject's imprint. Unlike pre-modern social reality, which centered around interpersonal, intersubjective hierarchies (the slave and the master, the serf and the lord, the lord and the king), rationalized modern society pits the impotent subject against the objective order of things. Market fluctuations and economic laws have taken the place of the feudal lord. The ruling order thereby stands as an immutable, all-encompassing state of *things*, not of human beings. In technologized reality the subject is no longer enslaved to other subjects but to an objective reality conceived as an impenetrable, and yet implacably actual, *primum mobile*. It estranges the subject from other subjects but also from itself: the subject forgets he makes reality and therefore submits himself to reality as if to an alien god or a self-ruling organism.

Capitalism is a return to the archaic world of demonic chthonian forces, before the advent of the subject who, in the person of the mythic hero, began asserting the individual right of human existence. It is almost a truism to say that the world of the novel has no room for heroes—or what heroes there may be do not have the strength to change their destiny. The novel therefore paints a primitive world, one still under the sway of shamanic forces and animistic apparitions. In capitalism, rationality itself extinguishes reason, as something unnecessary to the business of business as usual. Balzac's Skin, and the forest of galvanized objects where Raphaël loses himself, are symbols of such erasure of the subject.

Thoughtful Matter

The danger that thoroughly technologized reality may spring to life and have plans independent of its human creators is present throughout *La Peau de chagrin*. It is the main idea behind the Skin, but also surfaces in other materials, such as money and iron. In Balzac's mind, iron represents another one of those substances which, though the product of human labor, turn against humanity with a seeming will of their own: "The

iron had a life of its own, it was organized, it flowed into streams . . . , was capable of thinking, in taking on every shape, in complying with every fancy" (248). These are Balzac's thoughts upon the metalwork factory Raphaël visits. Pervaded with the life of the subject ("complying with every fancy"), iron seizes that subjectivity for itself ("iron . . . was capable of thinking"). Human-made reality becomes the one reality ("taking on every shape"), yet paradoxically it becomes less and less anthropomorphic. In fact iron takes over humans, washing over them: "the men were covered with iron, everything reeked of iron" (248), just as Raphaël is covered with the Skin. Iron, a product of human labor, begins to act with a mind of its own, spreading over human existence. It is a completely subjective (because thoroughly manufactured) object which reverts into absolute objectivity, a self-ruling phenomenon.

This perhaps explains the ominous organicness of the first iron structures built in the nineteenth century. The pliancy of the material, which allowed total control over the building, made iron uncannily like a natural thing. The organic efflorescences of iron structures in art deco and art nouveau buildings seem to have sprouted on their own, replicating the undesigned look of nature. Iron is far more human-made than wood or stone and yet it is the one that threatens most to develop a life quite independent from the subject. Unlike plastic, which submits itself without reserve to the subject's manipulation—and thus bespeaks a later age perfectly at ease with technological domination of nature—the restlessness of iron in its nineteenth-century form reveals uneasiness toward the object. On the one hand, iron is suffused with subject insofar as it is a human-made substance; on the other hand, it gives rise to forms that seem to evolve independently of human ends. Iron bulges and curls in mocking mimicry of biological forms. The technological future loops back to the horror of the primal ooze in which human existence is as yet undistinguished ("the men were covered with iron . . . , taking on every shape"). Like the Skin which shares the same protean suppleness, iron is matter out of the subject's control and therefore antithetical to the subject. Also like the Skin, iron is an instrument that promises world domination, the imprinting of subject over the face of the world. This instrument performs so well, however, that it takes over its human master ("covered with iron"). Grandville's theater of animated objects in fact

FIGURE 9. Grandville, illustration in *Un autre monde.*

marks a moment in the history of manufactured objects when iron definitively replaces wood and stone as the main raw material for buildings, transportation, and tools. Grandville sketches an image of a world torn between futurist utopia and mythic prehistory. Through iron, the subject forgets his own mediation of created reality with the result that reality acquires life, a life of its own and stands ready to replace the subject. It is the same fantasy or nightmare of the Skin which, from an object overrun with subjective inscriptions, evolves into a self-willed subject. Grandville's saturnalia, Balzac's Skin or even Shelley's monster stand for the nightmare of a world so technologized that it begins to think and act for itself. This world, however, is pre-historical, that is, it antedates the full dissociation of subject and object.

Grandville's Museum

Refusing to function as directed, that is, as an instrument, the Skin jettisons use-value and acquires an individuality of its own. This dialectic recalls the dynamic of the work of art (the Skin is, after all, found in an art gallery). To technological reason, ruled as it is by efficiency, the work of art is indeed like a broken-down instrument. It serves no practical purpose and obeys no particular function. It is objecthood reinstated to primitive thingness, one in which it is enough just to *be*. The contemplation it fosters is anathema to instrumental reason. Like a broken tool, the work of art is inefficient, impractical. The Dadaist and Surrealist avantgarde exploited this affinity between the artwork and the broken tool. Implicit in Duchamp's ready-mades, for instance, is the notion that redemption of the object from use-value is essential to the work of art. The Skin then is art insofar as it hardens into a nonfunctioning object, a selfpurposive monad freed from all uses except that of being itself. When the Skin ceases to be useful, that is, when any further exercise of its wishgranting powers would prove lethal, Raphaël is forced into a contemplative life. Not only the Skin but Raphaël himself becomes as useless—beyond use—as a work of art. The Skin lends life to esthetic sufficiency, disfunctionality as a way of being.

Raphaël encounters the Skin as the culmination of a series of artworks (after "a number of paintings by Poussin, a sublime statue by Michelangelo, several enchanting landscapes by Claude Lorrain, a Gerard Dow which resembled a page of Stern, Rembrandts and Murillo, some dark Velasquez canvases," 73–74). Perhaps, then, it represents a summation, as well as critique, of esthetic behavior. As argued before, Raphaël's attitude regarding those works is typical of the bourgeois esthetic reception: he uses the works as an extension of the self, a mirror. The essentially narcissistic underpinning of this attitude ties into Balzac's conception of external reality as an index code of clues pre-scripted for human consumption: because everything in the Balzacian real is legible, reality is essentially always a human reality. The subject transcends and levels out all phenomena by making them center around the subject as their meaningful core: "Here, in fact, the *ego* accounts for the truth of all phenomena," Balzac writes about his œuvre.[36] This system, however,

meets with its own critique at some crucial points in Balzac's work. *La Peau de chagrin* constitutes one of those moments. In the end, the Skin is as ruthlessly ignorant of Raphaël's subjective difference, which it annuls, as Raphaël is initially ignorant of the objective independence of the artworks. There where the subject had declared his unlimited dominion, the Skin inflicts on him the utmost subjugation. Submitted to a purely material existence, concatenated into the object, Raphaël finds out about esthetics the hard way. He is thrust into matter and is forced to lead a material life. I, Raphaël could say, am just a piece of hide.

A sketch by Grandville, titled *The Museum*, depicts a museum and a museum-goer and illuminates the object's retaliation against esthetic subjectivism. In it the visitor is caricatured as a mole, the blind animal *par excellence*. Grandville thus parodies the type of blind looking symptomatic of bourgeois esthetic reception: the subject never actually sees further than his nose. Rather like a mole, Raphaël cannot see beyond the circle of his subjectivistic self-involvement as he ambles through the antique shop: he visits the museum, blindfolded and pretending to see. Preoccupied with his own shortsightedness, the mole-like esthetic subject cannot see what lies before him. If the mole could see beyond the tip of his nose, the painting would presumably keep quiet in its material frame. But because the mole cannot see the painting properly, the painting comes alive, it uses the subject's self-enclosure to mock, or deceive, or even perhaps assault, the subject.

The morality, perhaps, is this: what I refuse to see comes back to harm me with the strength of repressed material. Solipsistic subjectivity (which the mole symbolizes) reverts into a second-order materiality: the painting, which for the bourgeois beholder is wholly an expression of subjectivity, has now become coarsely material, restive, prosaically empirical. To face the work of art solely and wholly as subject, as a self-involved mole, is to unleash against oneself a vengeful materiality: the very hostile materiality of the Skin. The painting attacks the mole for the same reason the Skin attacks Raphaël, in order to impose the proof of a concrete life which has been previously dismissed by subjective self-involvement. It is as though the object sought to remind the subject that only as partners in a healthy dialectic can the object stay in its place. Once ignored— that is, once the subject carries on as though only the subject existed—

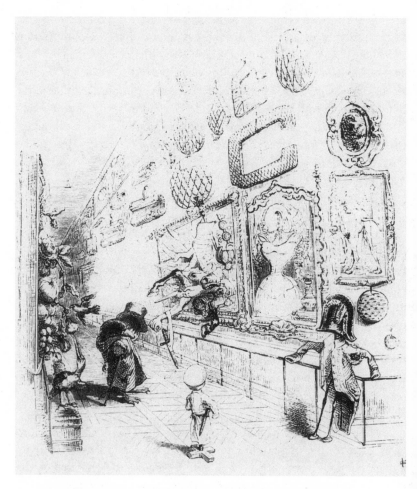

FIGURE 10. Grandville, "Le musée," illustration in *Un autre monde*.

the object overflows its bank: a wholly subjective world is a world that cancels the subject. It is a world where, literally, the subject does not take place.

The painting, or living tableau, behind the mole unmistakably indicates the kind of materiality to which the visitor falls prey in shutting himself inside his subjective self-enclosure. Behind the mole, birds peck

at the fruit of a painting. This is the story of Zeuxis, the ancient Greek painter who so perfected realism that birds flocked to eat his painted grapes. Animals are consummate empiricists; they cannot perceive an image as such. Theirs is a world of concreteness which makes no room for semblance. To animals, art is real; it does not stand out of the empirical continuum, which is why they do not notice images as such. The mole-like visitor exists on the same level of materiality as the birds: the painting facing the mole achieves the same empirical reality as the image of grapes in the birds' eyes. In other words, the inward-directed human eye falls prey to the same kind of brute materialism as the bird's empirically driven, outward-directed perception. Grandville's division of space between animal perception—that is, absolute empiricism—and human perception—that is, absolute subjectivity—in the end amounts to the same thing: a painting that is pure immediacy, that is a thing. In that sense, the mole is not so much an animal anthropomorphized by its top hat and overcoat; rather, it is an image of the bourgeois subject who is bestial even in clothes and who, by excess of subjectivism, lives in the same soulless materiality as Zeuxis's birds. Something of Wittgenstein's reversal of absolute solipsism into absolute realism is captured in Grandville's caricature of the bourgeois museum experience. The transcendental bourgeois subject who is blindly drunk with his own inner life exists in the world like an animal. The museum-goer is a mole. Lucifer the angel turns into Satan the goat. Raphaël is an Ass's Skin.

The Skin as Esthetic Modernity

> What is pure art in our modern conception? It is the creation of a suggestive magic holding both object and subject.
>
> Baudelaire, "L'Art philosophique"

An inkling of Raphaël's impending misery already lies in his weary renunciation of the riches laid before him: "The wonderful objects the sight of which had just revealed the whole of known creation to the young man plunged his soul in dejection . . . , more than ever he wished to die" (76). His is the weariness of a universal subject that has so com-

pletely fashioned the world after his own image that he never encounters anything but his own reflection: "He came to a Virgin by Raphael, but he was tired of Raphael" (74). It is as though, cloyed with his own universality, Raphaël shared the lassitude of the absolute demiurge for whom nothing can be new under the sun. Having seen everywhere and in everything only himself, Raphaël finally becomes sick of his own omnipresence. His world is the world of Balzacian realism: a world so suffused with subjective traces, so shaped after the meaning it is asked to embody, that it only sends back the image of the subject. This is what Lukács had in mind when he stated that, in Balzac's universe, "the outside world is a purely human one."[37] Balzacian reality is the kind of technologized, subjectivized reality whose debilitating poverty Fredric Jameson pointed out:

It is only in the most completely humanized environment, the one the most fully and obviously the end product of human labor, production, and transformation, that life becomes meaningless, and that existential despair first appears as such in direct proportion to the elimination of nature . . . , and the prospect of a well-nigh limitless control over the external universe.[38]

Much as the subject yearns to instill meaning into the objective world, a completely meaningful world reverts into meaninglessness. The subject's dominion over external phenomena is only viable so long as it is not fully successful. In other words, the subject needs the object to maintain dialectically the subject's subjectivity. In squelching objecthood, the transcendental ego does not necessarily triumph. A completely subjectified universe takes on the blank uniformity of matter itself.[39] When everything in the world becomes artifactual, everything becomes natural once again. Thus it is that, as the series of industrial revolutions remodeled the world after human designs and purposes, the subject experienced the human world as less and less human. The Skin is the inhuman core of the completely human-made world: although it is wholly the subject's doing, it is experienced by the subject as brutish matter, intractable inhumanity, an archaic grudge, a bestial revenge against the subject. In a sense the fate of dehumanization of the completely subjectivized work of art parallels that of the completely humanized world: it looks dumbly material, inexpressive, inhuman.

The work of art is the site of an extreme struggle between subjec-

tivity and objectivity. No other artifact is so thoroughly the product of an externalized subjectivity; and yet in no other artifact is the particular, concrete, objective form so tyrannical with the subject. The work of art is undoubtedly produced by subjective activity; yet it manifests the primacy of concrete, actual materiality. As such, the artistic object leaves the subjective-expressive behind and condenses into a second-order objectivity. This is the secret assumption of Kantian esthetics, which takes the success of a work of art to consist in its appearing like a natural object, that is, like an object that was never *made*. The second-order objectivity of art also lies behind the never disproven request that art must stand alone, that to "understand" a work of art does not entail interviewing artists about their intentions but rather proceeding to a phenomenological description of the work itself: if the artistry of *Madame Bovary* lay in Flaubert's intention, and not in the inner life of its language, it would presumably be a psychological document, never a work of art with rules and secrets of its own. It is only because the work of art sublimates the subjective ("aesthetica" describes initially a plunge in the concrete and the sensible) that it is a work of art at all.

As such, Raphaël's attitude is a resistance to esthetics. He perceives objects not in their immanent features but in their cultural, political, and personal references. Indeed, he sets his attention on everything that draws attention away from the object's physical existence. Through him, it seems, the subject reacts against the very esthetic experience of art in museums. The museum severs the object from its context and, simultaneously, takes the context out of the object. Raphaël counters this by submerging the object so deeply in context that it ends up drowning in a flood of circumstantial associations. Whereas the museum commands an esthetic response, Raphaël considers the objects only anecdotally and contextually; where the museum asks that the objects be viewed as indicators of themselves, Raphaël views them as indicators of everything but themselves.

As is well known, however, the museum fosters both the esthetic and unesthetic stances. That the modern museum came to existence in the thrall of revolutionary fervor with the mission of instructing the people shows clearly that its mission was not all that artistic to start with. The museum repaid the artworks for the loss of a direct contact between the

object and its historical, architectural, religious, or cultural provenance by increasing its historiographic, ideological contextualization. Whatever meaning was lost as a result of wrenching the statue out of the temple was compensated by framing it in historiographic discourse (lecturing about the chronology of forms, stylistic evolutions, cultural significance, and so on). As the museum encourages an esthetic apperception of objects, it represses it as well. This is the contradiction of bourgeois esthetics: it opens the door to concrete existence—the objective, the sensuous, the palpable, the esthetic—but refuses to let it in, since bourgeois estheticism is only interested in the concrete to the degree that transcendental reason may rationalize it. Unable to step out of his subjective circle, Raphaël only acts out the fact that, much as it seeks to touch the sensible and the concrete, esthetic experience always remains a *discourse*. As such it always views things from the side of the subject. Esthetics is an experience of the concrete but only insofar as it has been subsumed under the concept.

How does the Skin, ultimate object in the gallery of art, work within the subject-object dialectic of esthetic experience? As a hide bearing human language, the Skin may well be artifactual, that is, mediated by and through the subject. Inasmuch as the Skin's inscription entails the subject's destruction, however, it is an object hostile to its human origins. This makes the Skin more like a work of art and less like an instrument, insofar as it eludes, rather than serves, the subject's control in its very mode of existence. To be art, a work must evolve its own laws of formation and structure. The work of art builds itself on the principle that, while expressing the subject, it estranges itself from the subject (otherwise, a work of art would simply be a mouthpiece, absolutely transparent in its intentions and equal to the message dictated into it). No work of art limits itself to the intention of its maker: the "I" that speaks the poem is not the "I" of the poem. This recalls the situation between Raphaël and the Skin: both share the same "I" (they are consubstantial) and yet the Skin represents what in Raphaël's "I" is no longer subjugated to the subject: like the work of art, it is a piece of the subject over which the subject relinquishes power. It is never as a subject that the subject speaks in the work of art, but as a subject-object, a sublime hybrid or a liminal abjection.

But the work of art is not simply objective either. As the Skin, it turns demonstrably objective by overfulfilling the subject's demand: you

asked me to shrink and I am going to do just that, relentlessly, objectively, regardless of what you want. The work of art turns objective, impenetrable to the subject, by virtue of being completely subject: what is most enigmatic about the work of art, what resists a conclusive interpretation, is precisely the fact that, unlike nature, it *speaks* to us. The very expressivity of art acts as its shield. The Skin is impenetrable (both literally and figuratively) not because it is, like nature, an In-Itself; rather, it is impenetrable because its existence is directed at the subject. Its expressivity (the fact that it has been made for us and expresses our every desire) is what enslaves us to its relentless objectiveness. Its very expressiveness is what we cannot crack. Absolute subjectiveness makes art absolutely objective, and therefore beyond the grasp of the subject. Raphaël's trying to tear through the surface of the Skin with the help of rational science (zoology, history, engineering, chemistry) is an image of the subject trying to recoup, by means of rationality, that piece of subjecthood which has become alienated in a work of art. All interpretation of a work of art initially begins as a confrontation with this alienation. In this respect, Raphaël's violence against the Skin is a form of interpretation.

The subject-object dialectic of art reflects the subject-object dialectic of reality, that is, of technologized reality. Raphaël's difficulty in penetrating the Skin constitutes an interpretive failure. In a sense, the Skin concretizes the situation of modern epistemology, described by Raphaël: "Short of being capable of inventing things, Raphaël said, it seems you are now reduced to the business of inventing names" (249). His is a world materially bounded. The object is that which no longer lends itself to exploration. Like the Skin, the objective world is shrinking. Human existence is prisoner to this boundedness: faced with it, interpretation falls back into a purely ideational, nominal mode of investigation: *inventing names*. It is no longer a world of *praxis* but of *theoria*, that is to say, the subject has capitulated before the object. The Skin embodies this failure of the subject before the concrete. Though a product of human praxis, it defeats praxis: Raphaël cannot have desires if he wants to live, he must no longer want to penetrate the world. In this respect, the Skin brings about a distinctively modern inferno which, as Raphaël dimly perceives, is a quelling of the subject, or rather the subject falling to his own reification. The modernist work of art draws attention to this reification by

mimicking it. Never in history has the world been so fully shaped after human design as in modernity; never before has the individual been so surrounded by an entirely human-made environment. Yet at no other time has the work of art been so removed from subjective expression as in modernity (from the Mallarméan poem to the ready-made) and at no other time has art appeared to be less human-made.[40] In itself, this contradiction between an environment pervaded by human action and an inhuman work of art unveils the truth about technological progress: that the subject was never meant to profit by it. The modernist work of art shows this unsentimentally: for the bourgeois who rails against the *objet-trouvé* because it does not speak to him, the question necessarily arises: what in his environment does speak to him? It is ideological escapism to demand that art still behave subjectively in a world where the subject and its relations to other subjects are utterly objectified, devised by technicians for optimal efficiency.

Modern art thus enacts the decay of subject. It searches for an expression that does not bear any trace of human expressivity, one that appears to have made itself. For this reason, it privileges the purely material moment, searching for a form so raw that it eventually settles for mere matter (one thinks of the "brutalistic," unprocessed look of the modern work of art, sometimes simply made of raw materials, paint as in Pollock or Newman, unchiselled stone as in Morris or Judd, pure noise as in Boulez, or found, semi-organic objects as in Beuys and countless others). Modernist art emphasizes the objective element, perhaps as a corrective to romanticism whose bourgeois subject viewed and used the artwork purely subjectively and thus perpetuated the ideological deceit about the triumph of spirit. The modern work of art corrects this tendency by being mute, by wrapping itself in pure matter, pure form, a mere quantity of affects with no idealist rapture implied in it. In a world where political and commercial advertising clamors about the achieved happiness of the subject (well-fed, entertained, fawned upon, and constantly reminded that he lives in the best of worlds), the work of art has no recourse but to self-destruct as an emissary of the subject: it refuses to play along, striking dissonant and jarring chords in the choir of rationalization, making itself ugly, impossible, banal, or simply refusing to be.

Modern art introduces an element of indomitable objecthood into

the world of technologized reality. Through it, the subject is faced with an object that resists domination by reason. The modern work of art is evidently artifactual, human-made as well as made for human perception; yet it hangs on fiercely to its concrete element to the point where, as it is still heard, "it does not mean anything." In making it impossible for us to overlook its materiality, the modern work of art is esthetic in the strictest sense of the term: it is a language of matter, and like matter, it does not speak. When modern art was first greeted with the alarmed cries about loss of meaningfulness, it was in fact behaving purely esthetically, upholding the utopian hope that had been invested in esthetics by the Enlightenment: that art could give expression to that which does not speak, the bodily, the physical, the material. In this respect, the Skin anticipates the modern work of art. As the last object in the museum, the Skin behaves also in the most modernist manner: inasmuch as its concrete materiality becomes tyrannical, the Skin is an object that is intractably self-possessed. The toughness of the hide, its resistance to all attempts at breaking through its surface, present an artifact which, however human-made, rebukes human interference and interpretation.

Balzac prefigures the dialectic of the modern work of art (the anti-ideational, antisubjective dimension of modern art) in his *Le Chef d'œuvre inconnu*. Frenhofer's masterpiece (a Pollock-like "wall of painting") is intractably material and, as such, antisubjective. The spectator cannot see anything beyond the surface of the canvas: it is all a jigsaw puzzle of colors and lines, a mesh of paint and brushwork. The paint itself is the spectacle: a material limit. There is no image that would allow the subject's visual experience to transcend the materiality of the paint. Nothing can be said about Frenhofer's painting except that, in being intractably material, it takes on the impenetrability of a natural phenomenon. It, like the Skin, is *as dumb as a fact* (252) (at first, the two artists visiting Frenhofer's studio cannot distinguish it from the studio around it). The impenetrable Skin is another version of Frenhofer's unbreachable surface. Initially found among paintings and other works of art, the Skin starts out behaving in accordance with the subjective, ideatilist demands of bourgeois esthetics. Through it, Raphaël can make his dreams come true: he can mold the world after his idea. Just like the work of art in front of which Raphaël dreamt himself a king, a pirate, and a monk, the Skin would let him be a

king, a pirate, a monk, and a Flemish burgher if he wished to. Yet, just like Frenhofer's painting, this image of the subject suddenly turns into an image of resistance against the subject. No human-made expertise or device can break through the Skin. What bemuses Raphaël about the Skin is its combination of subject-made objectivity and subject-resistant objectivity. The Skin is cut to the measure of the subject, it is made by him and invites him; yet at the same time, it is intractably resistant to the subject: "The suppleness of the Skin when he handled it, and its hardness when means of destruction available to man were aimed against it, frightened him. This irrefutable fact made him dizzy" (252). The Skin is both easily handled, like an instrument made expressly for the subject ("suppleness of the Skin when he handled it"), and impossible to handle by the subject. As in the modern work of art, object and subject live in the Skin as irreconcilable halves. Abysmal materiality and utter spirituality coexist in the Skin to an uttermost degree: unlimited subjectivity triumphs in it (the subject can will anything through it) and subjectivity is miserably bound to the unsurpassable "fact" of an empirical horizon (the wretched patch of skin).

This confrontation characterizes a particular moment in the history of the subject-object dialectic: Balzac stands at the juncture between the solipsistic age of romanticism and the materialistic age of naturalism. In romanticism, the subject sublimates the object into the transcendental sphere of an all-encompassing subject. The external world, as well as the particularities of subjecthood, are sacrificed to an empyrean super-self (a case in point is Hugo's larger-than-life poetic alter egos, forever peeking behind the veil of Maya). In naturalism, on the other hand, the dialectic of subject and object is tipped toward the object, toward social reality and empirical data: the subject is a mere plaything of sociological, economic, physiological, and genetic forces. His life follows the course of objective parameters that social programming drilled into him. What romanticism and naturalism have in common, then, is the estrangement of subject and object, or at least the suspension of their dialectic: in either case, one side is allowed to win over the other. The subject triumphs in romanticism but at the cost of being removed from objective involvement (the well-established fact of romantic solipsism); the object triumphs in naturalism but at the cost of reducing the human being to an automaton. On the

contrary, Balzac's Skin represents a philosophical moment in esthetics where, as in the modernist work, subject and object come face to face without sacrificing their mutual stances. They communicate their mutual distinctiveness. To be sure, Balzac reveals a spirit of synthesis between materiality and subjectivity (which is the topic of a great many of his *Etudes philosophiques*). Yet it is a synthesis that remains unworked through and, for that reason, it is always actual and, most importantly, dynamic. The Skin encapsulates the esthetic principle itself: the unresolved equilibrium of subject and object.

But this equilibrium, as the novel proves, is fragile, illusory even. For it is but a brief interlude between Raphaël's subjectivism and his abject bondage to materialism. This interlude is the utopian space of the work of art, which is fleeting. One glimpses it in the portrait of Christ by Raphaël of Urbino, shown to our hero.

Christ's Exemplum

Just before he is presented with the Skin, the young man is shown the portrait of Jesus Christ by Raphaël the painter. Initially the painting has a sobering effect on Raphaël, who shakes off his subjectivistic daze:

At the hallowed names of Jesus Christ and Raphael, the young man gave a gesture of curiosity. . . . At the sight of this immortal creation he forgot the fantastic objects he had studied in the shop and the wayward visions he had seen in slumber. He became a man once more, saw that the old man was a creature of flesh and blood, fully alive and in no way phantasmagorical. He began to live again in the real world. (79)

On first contact with the divine portrait, Raphaël regains an empirical grasp of his surroundings: "he forgot the fantastic objects he had studied in the shop and . . . began to live again in the real world." The image of God reestablishes the distinction between object and subject that had hitherto been sapped. Raphaël knows what is what, that is, what is object and what is subject. Through the very image of the Incarnate Spirit, of the transcendental ego (God) made into flesh (Jesus Christ), Raphaël himself is reembodied in the empirical world. Christ is a reality check.

Given its obviously edifying and symbolic character, the portrait of

Christ must be regarded as a moral admonition given to Raphaël before he finally succumbs to the evil Skin. Christ is the very *exemplum* of the dialectic of matter and spirituality (appearing precisely at the moment when the former is about to quash the latter in Raphaël's life). A Spirit (God) who seeks to become Absolute Spirit (the God of the New Testament) must cast Itself into flesh and live as man (Christ). God's descent into the flesh really makes sense in light of the Ascension: after alienating Itself in matter, Spirituality returns to Itself as the triumphant God-head, the moment when Christ returns to God. Thus Christ's progress encapsulates the redemptive process of a subject who, having objectified itself in the flesh, emerges victorious in the end, as absolute spirituality. The subject comes back to Itself strengthened by the experience and the knowledge of its alienation in objectivity. The counterpoint to Christ's Ascension is, of course, Satan's fall: both aspire to supreme spirituality but the latter ends up in absolute materiality. Indeed whereas God goes to matter to make Himself more spiritual, Lucifer seeks to become more spiritual by means of spirituality (and winds up in absolute matter). Christ and Satan are inverted images of each other, not only as good and evil are, but also in the dialectic of subject and object.

Without taking into account the narrative function of this speculative tug-of-war between subject and object, the presence of Christ preceding the appearance of the evil Skin is little more than melodrama. While it is that also, the appearance of Christ sets up the philosophical dialectic which is about to condemn Raphaël-the-subject to becoming Raphaël-the-monstrous-automaton. It is a last warning: follow my example, it seems to say; the way toward true spirituality is not through the idea. The portrait of Christ urges Raphaël to come back down into the realm of material embodiment, Christ's trajectory. But the evil Skin urges him to believe in the boundless power of the transcendental ego (Lucifer's mistake). Following Christ's exemplum would have kept him safe from the Skin. But by succumbing to the Skin's promise of boundless subjective power, Raphaël will land in abject materiality. That Raphaël, right after viewing the portrait of Christ, exclaims, "So then, death is the only way" (80) seems to indicate that Christ and the Skin are indeed linked by a dialectic: the failure to heed Christ's word leads Raphaël directly to come back out with his "skin" (life) covered by the Skin.

No doubt, in putting Christ below the Skin in the hierarchy of the antique shop, Balzac points to a state of affairs in which the redemptive work of Spirit falls victim to absolute materiality. The subject has fallen prisoner to its own reification; Christ himself cannot redeem the world of technology.

The Death's Head

Like Satan, the subject, however, does not fall so deeply into objecthood that he falls also into oblivion and forgets the loss of spirituality. The materiality into which Raphaël falls is not soulless—that would imply a primal self-erasure which Raphaël certainly does not find in the Skin. Precisely because Raphaël does not become completely one with the Skin is his attachment to the Skin wretched agony: he knows he is stuck in the Skin, not a natural part of it. The death's head speaks about this dissociation between subject and object even while they are monstrously hybridized: "He looked up and saw the dim form of a skeleton skeptically wagging his skull from left to right as if to tell him: 'The dead are not yet ready to receive you'" (76). Evidently, the message refers to Raphaël's initial intention to commit suicide. It is an object, then, that tells Raphaël that death does not want him yet. Instead the story lays out a situation in which Raphaël has to play dead and act like object because of the Skin ("Everything seemed artificial in this puny, sickly body . . . , like an automaton, he abdicated life in order to live," 217). The death's head also says that Raphaël is not yet welcome among those who have become objects (the cadaver as object: one notes that, in addition to Balzac's comparison of the showrooms to an ossuary, there are objects there, like the stuffed animal or the waxed corpse of a child, that are actual corpses). In other words, Raphaël is told that he is not an object yet. This means that however close the subject draws to the object (in projecting and inscribing himself on it), the object is not ready to provide a haven for the subject. The Skin will crush Raphaël with its objectivity but will leave him enough subjecthood for him to realize he is being crushed, that is, for him to suffer.

Thus Raphaël's fall into objecthood yields not a cadaver but an un-

concluded dialectic, something like a living corpse, an automaton, a subject cross-bred with an object. In short, Raphaël is to live out the ailing lack of reconciliation between subject and object. This puts him below the worker on the scale of misery. For if workers are, in Balzac's words, brutally concatenated to their tools, they nonetheless disappear into them ("Workers are nothing but pulleys and stay welded to their wheelbarrows, shovels and pickaxes"; *La Traité de la vie élégante* 212). In that respect, workers are spared the misery of being subjects shackled to dictatorial objecthood for, in them, subjecthood has vanished: "Like steam engines men shackled by labor are produced in the same energy and have nothing singular about them" (213). Being an undifferentiated part of the labor apparatus, the worker-subject is not even there to recognize his or her own subjugation to instrumentality. Not so with Raphaël who, having fallen into the Skin, is prevented from dissolving himself in it: just as he is forbidden to die, he is forbidden to become completely reified. Thus he must pretend to be an object in order to survive (" . . . an automaton, he abdicated life in order to live"). Like the worker, he behaves like the machine (the image of the steam engine used to described the workers is applied to Raphaël in *La Peau de chagrin*, "he lived the life of a steam engine," 217); but unlike the worker he is not able to enjoy the unconsciousness which would make his residence in matter bearable. "The dead are not yet ready to receive you!" means that you may not yet forget yourself in the object. In Raphaël's case, technologization of the subject remains incomplete, and therefore ailing, painful, restless, much like that of the creature in *Frankenstein*. It is the desperate cry of a subject whose enchainment to a machine is still felt as a horrendous injury (unlike the blissfully stalwart robocops, terminators, and proudly half-human cyborgs of today).

Still Life

No doubt, the death's head also strikes an esthetic effect. It allows Balzac to tie his antique shop description to still life painting. In fact, it is immediately following the appearance of the death's head that Balzac designates his tableau as a still life: "then this whole *still life* [nature

morte] vanished in black hues" (77; emphasis added). The skull is of course a traditional subject of still life painting. It is traditional in still life representation to invest the skull with the significance of the *vanitas* theme concerning the transience of material things. Interestingly enough, this interpretation exists conjointly with the one that identifies in the skull a *memento mori,* the reminder of a transience which, in this case, concerns the mortal subject: human life will pass while objects last. There is still another way of interpreting the skull in still life, one which has to do with the desire for absolute objectiveness. The skull represents the subject's absence, an image of the day after Judgment Day when no living being is left to look at objects. In a sense, the still life only brings out the death wish present in all objectivity, the wish to be rid of the subject and its subjective viewpoint: the truly candid camera does not have an operator.

The still life is the object's fantasy of a subjectless world. The object reminds me that I will inevitably become an object (the skull) and that things will carry on exactly the same after my death. Both ways, the object's autonomy reminds me of my death. Indeed the object's existence is an *in*sistence, the being-there of the object's superiority over the transience of human existence. All objects, not solely the antique or the skull, are omens concerning human finitude. Their very existence harbors the script of human obsolescence—something that is emblematized in the Skin crushing down Raphaël's life.

The terror of human submission to objecthood is unmistakable not only in the Skin but also in the general landscape of the antique collection. It is described as an ossuary: "He was to see *in advance* the ossuary of a score of civilizations" (69; emphasis added). The sentence is slightly puzzling, in part because of the proleptic twist given to the relics: they are the bony remains of yesterday's civilizations, but also, *in advance,* the ossuary of civilization. Objects are culture's future remains *today.* Hence, objects not only represent the corpses of antique civilizations, they also prefigure the world's future death. In itself, the concept of object entails that which is no more. Philosopher Martin Buber suggests that the proper temporality of objects is always the past: "Objects subsist in a time that has been. . . . The object is not duration, but cessation, suspension, a break-

ing off and cutting clear and hardening, absence of relation and of present being."[41] The object is what *has been* thrown out (*ob-jecere*, past participle). Its relevance is past. In this sense, objects are always funereal objects.[42] Objects not only play dead and remain dead in the world; they are also the death of the world, the haunting image of its passing away, the skull beneath the skin of culture. Objects remind the living of their dead (*memento mori*), as well as of the death of culture; they are what will constitute the corpse of this civilization. Objects embalm culture while it is still alive. They (as the Skin to Raphaël) force culture to play dead.

The Skin is therefore right at home in the collection of objects: indeed, in keeping with the collection's funereal beginnings, the Skin literally contains the subject's death even when the latter is still living. The Skin embodies the being-toward-death of the subject. In the end, this dialectic perhaps boils down to a simple word, "skin," which French idiomatic speech uses to mean "life" in contexts concerning death, for example, "faire la peau à quelqu'un," "vouloir la peau de quelqu'un," "sauver sa peau," and so on. The skin is Raphaël's life insofar as it is given for dead, his death in life, his own skull *in advance*, the subject as an object: "*la peau qui lui a fait la peau* [the skin who gets his skin]." At once a dogged memento of death and the concrete limit at which Raphaël encounters his death, the Skin is the Skull of today, the skull *in advance*: the living death of the subject who is not yet dead ("he abdicated life in order to live").

The still life encapsulates the spell that the object exercises over the subject in realism: only as an object, that is, as a bone, is the subject allowed to enter still life. To show things as they are, realistically, one must stop being a subject and surrender oneself to the objecthood one is trying to capture. In this sense, the skull is a pictorial expression of the wish for an absolute representation, one that does away with the need for a subject. Objective realism uses the skull to represent the subject's fascination with its own annihilation and, correspondingly, the separation that is ultimately necessary to maintain the concepts of objectivity and subjectivity. Objective realism invites the subject's gaze by saying it must merge with the object (the skull in still life), and yet ultimately debars the subject from fully vanishing into the object (the skull rejecting Raphaël). Like Raphaël and the Skin, subject and object form a hellish, but ex-

pected, pair: they can live neither together nor apart. One would have to say that ordinary life is hellish, or untenable.

Dialectically, the Skin represents both the subject's submission to its objective materiality (Raphaël's existence as it is bounded by the Skin's outlines) and the object's submission to transcendental idealism (the hide shrinks by behaving scrupulously and *literally* within the bounds of the subject's wishes). The Skin is the locus of the tension tearing at the seams of realist representation: an object (the Skin) wishes the subject's destruction; the subject (Raphaël) casts himself into such a destruction; the subject wishes the object's destruction (Raphaël trying to destroy the Skin); the object destroys the subject by destroying itself (Raphaël dies when the Skin is destroyed): neither one can be without the other. The Skin is the liminal extreme between subject and object, a mere skin indeed between a subject turned object and an object turned subject, a disastrously unsuccessful mediation which ends in the death of both. The Skin is realism, and realism is deadly.

"The tradition of all the dead generations weighs like a nightmare"

The message of the death's head also calls for a historical examination of the subject-object dialectic: *the dead are not yet ready to receive you.* Those who have died, the dead generations preceding you, do not want you yet. Through a death's head, the dead declare they have no room for the subject and have nothing to say to the living except that the past is off-limits to them. The object is the effigy (the skull) of a totemic ancestor who rejects his descendants: the newcomer is not wanted. What lies behind the subject-object dialectic in the collection (and particularly in an *antique* shop where all objects are an appearance of the past) is a historical divide between the subject and the past.

Certainly the vision of "the entire known world" and of "the philosophical dunghill from which nothing was missing" is sure to induce a modicum of historical weariness in the subject. One does not stare at an overwhelmingly comprehensive "panorama of the past" (76) without feeling the dead collectively weighing down on one's puny presence at the

end of history: "He felt smothered under the debris of fifty vanished centuries, sick with this surfeit of human thought, crushed under the weight of luxury and art, oppressed by these constantly recurring shapes which, like monsters springing up under his feet, engendered by some wicked genie, engaged him in endless combat" (74). This is not the utopian vision of a place where the whole of history stands at attention, but rather the awesome image of riotous legions of historical objects trampling over the living. In the museum, history condenses into a crushing authority. There the historical subject suffers the epigone's fate. The historical stock is replete from the start ("nothing was missing"); I am left with no option but to wither away in the shadow of a fulfilled past.

Raphaël groans under the weight of history. Nothing is left of the amicable handing-over of the past to the present once carried out under the aegis of tradition. The past, as it crystallizes in the museum, is an edict passed against the rights of the living: its motto, for Balzac, is that of epigonic modernity: "All is already said and we have come too late, for the last two thousand years of mankind."[43] The museum is a treasure trove under the authority of the dead, not the living. The latter must fight dearly for whatever breathing space they can wrest from history. In fact, the past appears to be the actual place of the living ("constantly recurring forms") pushing aside an ailing present ("sick"). The story of the Ass's Skin squeezing life out of the hero is already implicit in the museum's overpowering historical authority. The object crushes the latecomer with the weight of history:

The visitor . . . came to a fourth gallery, where his tired eyes were greeted by, in turn, a number of paintings by Poussin, a sublime statue by Michelangelo, several enchanting landscapes by Claude Lorrain, a Gerard Dow canvas which resembled a page of Sterne, Rembrandts . . . ; then ancient bas-reliefs, goblets in agate, wonderful pieces of onyx! In short, works that would discourage anyone from working, so many masterpieces brought together as to wear down enthusiasm and make one hate the arts. (74)

Clearly the museified work of art is not the comforting gift of the past handed down by avuncular tradition. The past is no longer a fount of wisdom and a repository of *exempla*. It is a poisoned well: everything shrivels in its shadow. In the museum, the subject is scrutinized by the

evil eye of history and slowly wilts away. In that sense, Balzac's museum echoes the distant report of the historical clash of modern consciousness with the past—a clash that, to some extent, is handmaiden to modern consciousness. The Balzacian gallery is an image of how uprooted things must have been for Marx's verdict, terrible in its implications, to be true: "The tradition of all the dead generations weighs like a nightmare on the brain of the living."[44] Marx's sentiment shows how far modern consciousness has drifted from the tradition-based world where ancestors were an auspicious, benign presence. The past now hangs over the present like a censorial threat. For such a conflict to arise, a wedge must have driven itself between past and present. A walk through the museum does not bring one closer to the ancestors; instead it so estranges one from them that they appear hostile to one's existence. Here, Balzac's museum reads like the historically alienated consciousness of modernity itself.

In the museum, the subject encounters objects that serve as historical lessons. In being abstracted from its original background, the museified work of art in fact becomes more historical. On the one hand, the statue taken out of the temple may lose its symbiotic relation with its historical home. On the other, it acquires a mythical veneer of pastness once it is relocated to the historiographic sphere of the museum. It takes on an aura of absolute historicity. In the same way that one's nationality is highlighted when one is abroad, but is also reified into an abstraction, the object's historicity comes to the fore in the museum but only as a precipitate of abstract pastness. Once removed from its historical context, the work's historicity becomes a given. Indeed history becomes aura, something almost mythic which takes on an absolute, overbearing character. The past is no longer something that grows old among the living, handed down by tradition; rather it is something remote and aloof, untouchable and hostile: an angry father, Saturn devouring his children.

Balzac's museum lays out the place of conflict between the domineering dead and the beleaguered living. Conflict is conceivable only if the two parties stand in mutual alienation. In order for the past to be inimical to the present, as it is to Raphaël, it cannot appear to be integrated with the present. Historical consciousness must have gone from an integrated, homogenous sense of historical continuity to a splintered state of

separation. What used to flow into the present like a generative stream of age-tested wisdom (and likened historical knowledge to soothsaying) is now dammed up as something alien and threatening. The museum piece is a bit of historical consciousness that has cut itself off from its source in traditional time. It embodies the rootlessness of modern consciousness. Behind Raphaël's fight to the death with the collectibles—a fight that comes to a head in the Skin—stands alienated history. History is ready to become a science because it has become an object standing over against consciousness. The development of historiographic science in the nineteenth century can be conceived only in an age which, because it experiences itself in severance from tradition, can turn an objective eye on the past: to it the past is a thing, at once removed and alien. The museum's philosophical paradox is the alienation of history in its very preservation: indeed that history is nothing but the product of estrangement, that is, of our inability to penetrate time.

Dialectical History

The museum owes its existence to modern consciousness's sense of acute separation from the past. Antiques and historical objects cannot be fetishized by a primitive consciousness to which temporal distinctions (the fall from grace, separation from the elders, the forward flight of progress, decadence, and so on) have not yet brought a feeling of historical alienation. Alienation from the past means that the past comes back with the force of repressed material: repression empowers, because the repressed—the dead, alienated past—has nothing left to lose, having already suffered death. Having lost the life of its original historical context, the historical artifact possesses the power of a specter, that is, the power of no longer fearing for its life. The deadness of the past is what shines through the museum piece. Collecting can begin only when the past assumes a collectable form: this collectable form is given by the object's uprooted abstraction from the past as well as from the present. For the museum piece also stands aloof from the present. Removed from its context in the past, the object cannot settle comfortably into the present either, for if it did, there would be no use for the museum. The antique shop

would simply be a convenience store. The raison d'être of an antique shop or of the museum is history disconnecting itself from time: neither of the past nor of the present. As the museum piece shows, history is not a discourse about the past or the present, but rather a way of conceiving one's alienation from time, a way of suffering the disjointedness of consciousness in time.

It would be a mistake to assume that the past out of which the object is wrested precedes the act of wresting itself. Without the act of misplacing and uprooting, the concept of past means nothing. The historical past does not precede its transplantation in the present: history is precisely the recognition that the past does not exist outside of the reminiscing present. To criticize the museum for turning objects into dead images is to imply wrongly that the past may exist outside of the present discursive structure that designates it as past: the past belongs to the present. Accordingly, one does not seek the past where it seems to be, in the past, for it actually never took place there (only the then-present happened in the past—the past, like the future, never happens, for only the present is capable of happening). Whereas time happens as subject, it is recollected as object. History is the becoming-object of the subject in time: a becoming-object, however, without which the subject dissipates. The ironist who views matters detachedly, with an eye to their contradiction, is better suited to historiographic tasks than the chronicler who seeks immersion in an autonomously conceived past. For all the glittery fieldwork and erudite reconstruction in *Salammbô*, it is the museum-obsessed Flaubert of *Bouvard et Pécuchet* who has the real insight into the dialectical nature of history: "Antiques.—always modern fakes" (*The Dictionary of Received Ideas*). Indeed the past is always of modern stamp: it is the emergence of the past in the present. To overlook this fact is to fall victim to the outlandish vision of ancient people walking among ruins instead of houses, using antiques rather than tools, and paying with numismatic rarities rather than coins. In order to touch the past, one must embrace the present of its construction. Having no illusions about the uprooted existence of the past, the museum does away with the historicist view that the past exists somewhere before the time of our reminiscing. It shows uprootedness as, paradoxically, the ground of historical existence.

Ruins

Since the past does not belong to the past but to the present, the historian who searches for an authentic relation to the past searches in vain. For if the past only comes to be in the act of being handed down, the very act of receiving the past is nevertheless a betrayal of its actual nature: to treat the past as past is a perversion of the fact the past once took place as a present. Tradition is as destructive as preservation, and yet without this destruction nothing could possibly be handed over. Balzac adduces the destructive character of historical preservation with his notion of a "retrogressive Apocalypse": "Their imagination enflamed by this retrospective glance, these puny men, born only yesterday, are able to stride across chaos, intone an endless hymn and imagine the shape of the past history of the universe in a sort of retrogressive Apocalypse" (75). Intoxicated by his retrospective glance, the historian perceives the past as an apocalypse in reverse. This gives one pause. Why should Balzac have chosen to evoke the burgeoning of the past in consciousness as an inverted destruction? Why the apocalypse in the midst of the museum? Why all this destruction in the heart of preservation?

The act of resuscitation involves the annihilation of what is resuscitated. Indeed, insofar as the past only exists in the reminiscing present, the past's origin is betrayed as soon as it is remembered. "Retrogressive Apocalypse" captures history's constructive destruction or destructive construction. The past emerges in the present as a result of being lost in and by the present. My recollection of a past event—by which this event still survives in the present—is also a betrayal of the event as it took place. For one cannot remember an event without coloring this event with the knowledge that is now past. Thus the liveliness of the event (what once made it present) is betrayed in the process of being recollected. The past event is always recollected, not as it happened, but as it is seen happening from the alienated standpoint of the present. In this sense, the past is always bowdlerized, altered, disfigured, and destroyed by its very recollection. Destruction, or Apocalypse, is the way the past is created, hence a "retrogressive Apocalypse," an Apocalypse in reverse. Thus it is not simply that transmission of the past involves destruction

and loss; but that destruction is the only mode of transmitting the past. The past always appears as its own ruin.

The ruin carries the image of the destruction that the past necessarily suffers on its way to the present. Destruction ingrains itself so deeply in the physiognomy of the ruin that the latter embodies the necessary destruction by which it is remembered. Each ruin is its own Apocalypse in reverse, a destruction that builds a memorial. The ruin embodies the damage incurred by time's journey into the present, a damage without which the past does not exist. This is reflected in Goethe's insight that ruins "are monuments of themselves":[45] a ruin is both the historical thing and its historical transmission. Similarly, the past is always a ruin since it is inconceivable to think of the past as existing otherwise than in its damaged state in the present. The ruin is the actual physiognomy of the best preserved, or even the most recent, historical document. For any historical document first says this: that it has drifted away from the event, that it testifies to the event having once taken place in a time impossible to recoup. Inasmuch as it is involved in transmitting historical materials, the museum participates in the ruination of the past. In the gallery, the object first whispers about the distance cutting it off from its historical provenance.

For Balzac, this loss takes the form of monetary devaluation:

The most extravagant whims of spendthrifts who had died in garrets after owning millions were to be found in this vast museum of human folly. A little writing-desk that had cost a hundred thousand francs and had been bought back for a five-franc piece stood next to a secret lock whose price would formerly have sufficed for a king's ransom. . . . An ebony table, a gem of artistic creation . . . which had cost years of toil, had perhaps been picked up for the price of a load of firewood. (73)

The decline of history strikes the bourgeois where it hurts the most, in the pocketbook. This materialist slant is Balzac's saturnine conception of history as hopeless spiritual decline—a proposition that no doubt rings true to the beleaguered monarchist in Balzac. History is the place where values are constantly eroded and revised downwards (an idea permeating, *sotto voce*, the entire *Comédie humaine*). This process of deauthentification, however, *is* the very form of historical transmission: it takes place

even in the antique shop, the anointed place of commemoration and preservation of the past.

The decay of history—the decay that *is* history—reawakens a nightmare from which rational consciousness can never wake: the decomposition of culture. "It was a kind of philosophical dunghill from which nothing was missing" (69) smacks of putrefaction, of cultural artifacts rotting away into primitive nature: it is as compost, by returning to organic refuse, that culture transmits itself. The ebony table bought back at the price of firewood evokes the process by which a cultural object falls back to the level of raw material. As in the ruin where the distinction between the human-made and nature blurs, the philosophical compost of history evokes the threat of impending deculturization. Cultural decline ends with the return to primitive nature. The description of animals scurrying over the debris testifies to this threat: "Crocodiles, apes, and stuffed boas grinned at stained glass windows, seemed to be about to snap at carved busts, to be running after lacquer-ware or to be clambering up chandeliers" (69). Nature seems to be taking over the cultural remnants as though, in old age, culture might blur again with natural phenomena. The regression of culture to nature is synonymous with terror in *La Peau de chagrin*, where an animal's skin takes over a man's existence. Historical becoming is, in a sense, the becoming-nature of culture. History threatens culture with rot. There is, however, no culture without history, for (Western) culture is inherently historical. This means that, in the Balzacian perspective, culture is essentially rot. This explains perhaps why the process of civilization (Raphaël getting his transcendental ego through the Skin) is always fearful of relapse into pre-civilization (Raphaël existing as a skinlike thing): culture is a rotting, not only insofar as it is always becoming old, but also insofar as history privileges objects over subjects, cadavers over beings.

As rot, manure, or compost, culture is also clutter. The "chaos of antiques" (69) unfolding before Raphaël evokes the image of a cabinet of collections where, as in the ruin, the objects seem to have been stranded by the tide of history itself:

An ivory ship was sailing under full canvas on the back of an immovable tortoise. A pneumatic machine was poking out the eye of Emperor Augustus, who re-

mained majestic and unmoved. Several portraits of French aldermen and Dutch burgomasters, insensible now as during their life-time, rose above this chaos of antiques and cast a cold and disapproving glance at them. All the countries on earth seemed to have brought here some remnants of their sciences and a sample of their art. (69)

The objects answer to no preconceived order, a slipshod arrangement merely the result of chance: unruly time itself has washed the objects into the shop. Yet perhaps this jumble carries a comforting message after all: all is as it should be in the grand scheme of things. That no one is in charge of the tumbling-down of history is reassuring: it is the comfort that consoled the early romantic circumambulators of ruins, the notion that the great natural order has made it this way. The romantic ruin stresses the obsolescence of the past. In Chateaubriand, for example, the *vanitas* ingrained in the physiognomy of ruins mostly has the effect of confining the dead to their graves:

I went and sat among the ruins of Rome and Greece, those countries of virile and brilliant memory, where palaces are buried in the dust and royal mausoleums hidden beneath the brambles. O power of nature and weakness of man! A blade of grass will pierce through the hardest marble of these tombs, while their weight can never be lifted by all these mighty dead![46]

The ruin protects the living by giving an image of a past sealed off from the present: the obsolescence of the past is irrevocable, no matter how much the dead may be revered in memory. Chateaubriand's quintessential ruin is the tomb: there, the past is entrusted to the dead. Lying dead in ruins, the past signifies its deference to the living. In a word, the romantic ruin lets the dead be dead and puts the past in its place. By the same token, it lets the living live. This is why Goethe, in reference to a painting of ruins by Ruisdael, declares that "the past has nothing to bequeath but mortality" (*Collected Works* III 64). To bequeath mortality is to offer the gift of the past's obsolescence to the present time. Through the image of the ruin, the past shows itself as the place where the dead, keeping to themselves, bow out of the present. That explains why, in the romantic tomb, history proves itself to be one with the wisdom of natural cycles: the ruin reconciles human history with the cosmic forces that confine the dead to their tombs. There they are recycled back into nature.[47]

The ruin is almost always naturally adjusted to its scenery, as though nature blessed the historical by harboring it in her bosom. In the end, history is reconciled with the hidden wisdom of nature. The poetry of ruins is apologetic (hence its popular success: it presents bourgeois culture with the congratulating image of being reconciled with a nature otherwise badly abused by the industrial revolution).

Balzac, however, takes no comfort in the ruin. He experiences it all as a death threat against the living: "The wonderful objects the sight of which had just revealed the whole of known creation to the young man plunged his soul in dejection . . . , more than ever he wished to die" (76). History as a rag-bag of disconnected details is ruinous to the human spirit. It is all a tragedy, a disorder that attacks Raphaël, foils the taxonomist in Balzac, and defeats reason itself. Rather than calming the subject with soothing wisdom about the inevitability of transience, Balzac's ruin wages war against the hero. It squeezes all lust for life out of Raphaël: "We wonder, crushed as we are under so many worlds in ruin, what can our glories avail, our hatreds and our loves, and if it is worth living at all if we are to become, for future generations, an imperceptible speck in the past. Uprooted from the present, we are already dead" (75). With Balzac, the ruin no longer wears the benevolent complexion of cosmic reason. It ruins the present and spreads rot over the epigone. Although the gallery has the appearance of a field of ruins, it stands in sharp contrast to the ruin: it does not return the dead to the gentle bosom of nature. In picking over the debris, the museum awakens the ruin's evil spell. There every object becomes a ruin but, unlike the tomb, it does not keep the past asleep. In the process of gathering ruins, the museum wrenches them from their symbiotic ties to nature, to what made the ruin idyllic. In the romantic landscape, these ties insured that the cultural fragment would find a final resting place in the cradle of a nature at once destructive and kind. The museum, on the contrary, is a Pandora's box of cultural fragments. Overripeness and decay abound. Whereas the ruin merged with its setting, the fragments of a collection are not a testimony of how things stood but, conversely, of how things have been ruthlessly distanced from their natural setting. In the process of being translocated, the ruin loses its roots in nature. The collection displays the *membra disjecta* of history utterly unmoored from native settings, a process that wrests the narrative

principle out of historical presentation: "A Sèvres vase on which Madame Jacotot had painted Napoleon was standing next to a sphinx dedicated to Sesostris. The beginning of the world and the events of yesterday were paired off with grotesque good humour. A roasting-jack was posed on a monstrance, a Republican saber on a medieval arquebus" (69). The grotesque always crops up whenever cultural materials are no longer gathered according to organic or necessary configurations. The "grotesque good humour" stems from the removal of the narrative principle. In the collection, remote and recent, native and foreign events are thrown together in some "monstrous displays" of bacchanalian disorder: "A multitude of sorrowing figures, gracious or terrifying, dimly or clearly descried, remote or near at hand, rose up before him in masses, in myriad, in generations" (70). The old elegiac ruin made no secret about the damage incurred by the past on its way to the present because it conformed to the concept of homogeneous natural time. The collection, however, ruins even the continuity of time itself. What is ruined is not so much the object as the historical narrative of the past's handing-over.

The museum evidently marks an age of dislocations. Whereas the ruin kept track of its destruction in a manner consistent with the progress of time, the collection is incapable of tracing a historiographic coherence through the rubble. In the collection, history is pure destruction. Unlike Goethe's ruin, the museum cannot become a monument to itself because its mode of historical presentation is not consistent with historical appearance itself. Whereas the historical content and the historical transmission coincided in the look of ruins, the two are wrenched apart in the collection. That destruction is at work in the object's transmission is something clearly visible in the ruin; yet the ruin causes no distress because it offers the certainty, handed down by the dead to the living, that things stand as they should. Ruination in Balzac's museum, however, is anything but rational: it is an unjustified infliction. It lacks the tutelary support of cosmic order. This is because the dead, unremoved from the living, mingle freely with us. Rot begins to seep out of the tomb. Apocalypse, even in reverse, is a prelude to Judgment Day, when the graves open. On this day, history itself will collapse and the present and future will merge with the present (which therefore will not even be the present). This day has already occurred in Balzac's museum, where all his-

torical layers ooze into one. The Apocalypse is the truth of the museum. Unlike the ruin, which is always poised on the redemption of memory, the museum destroys memory: when everything is absolutely recalled, as on Judgment Day, nothing is remembered, because everything is inextricably present. The "retrogressive Apocalypse" is a perpetual cataclysm, the end of history, time, life itself: all immemorial, all forever scattering away. *Uprooted, we are already dead.*

Judgment Day

Judgment Day proves that one of the earliest conceptions of historical time is not chronological but dialectical. All events make sense and come into their own, not when they happened, but only from the standpoint of the end of time. Judgment Day is the one true historical day that proves all historical strata have ever existed only in and for that moment of recognition. It is the day when history reveals itself, not so much because all historical events, good and bad, will be exposed; but because history finally discovers that its nature is not chronico-narrative but dialectical. Inasmuch as the past only exists in being called up by the present, its existence is contained in the instant of remembrance. Each day in history contains the whole of history, up to that point: every day is Judgment Day.[48] In that respect, Balzac's collection (where all historical strata are simultaneously present, "the beginnings of the world and the events of yesterday were paired off") is a representation of dialectical history.

What makes the museum a distinctively modern phenomenon is that it recognizes the dialectical structure of history. Balzac's collection makes it difficult to go on nursing the image of the past as a homogeneous continuum rolling into the present. To the historical consciousness aware that the past does not exist diachronically but synchronically in the moment of its being remembered, the beginning of the world and the immediate past appear synchronously. History is not a road winding through the thicket of historical events; it is the flash of remembrance in which all historical layers exist simultaneously. The loss of narrative from historical consciousness, however, means that the present is no longer distinct from the past. The traditional chronicler believed that past and present are sep-

arated by a long stretch of historical journeying. The modern dialectical historian knows that past and present melt simultaneously on the same plane ("the beginnings of the world and the events of yesterday"). In Balzac, this melting away breaches the present's distinct identity. Raphaël's overwhelmed response stems from his inability to hold the past at bay because it is no longer tied to the past in a formally narrative sequence: "He felt smothered under the debris of fifty vanished centuries, he was sick" (74). The present, knowing itself to be the host of the whole of history, feels overcome and indeed ransacked by its guests. Forced to harbor the dead, the subject lives out the erosion of the barrier between the dead and the living: "He was like these objects, neither altogether dead, nor altogether living" (73).

Not only do the dead, as on Judgment Day (Apocalypse), become indistinguishable from the living; but the dead and the living now participate in a symbiotic, or rather vampiric, exchange. Each trades properties with the other. On the one hand, the historical object, being dead to the present, knows that its deadness is dependent on the reminiscing subject upon whose life it feeds (even the object's deadness is not immanent to it but a product of its dialectical involvement in the present). On the other hand, the subject who knows itself to be the only host of the past is killed by its parasitic guests: "Uprooted from the present, we are already dead" (75). Raphaël is crushed by the past, which no longer exists over the horizon of what has been, but presses up against him, as close to him as . . . a skin. For, in the end, it is clear that the vampiric relation of past and present in dialectical history is the same as that between the Skin and Raphaël, or between object and subject: in the same way that Raphaël possesses the Skin but finds himself possessed by it, the present subject which knows itself to be carrying the entirety of human history succumbs to the burden. Dialectical historical consciousness is a form of solipsism: it believes the historical event exists only in the consciousness of it. The proximity of the historical past to the remembering present blurs their distinction. *Neither altogether dead nor altogether living*, the historical solipsist ends up succumbing to the historical object: Raphaël has taken the Skin as his own skin and is now forced to play dead. Just as the past (the object, the dead) invades the subject which has invited it in, so Raphaël is taken over by the Skin he has taken up. The

dead and the living meet on the skin's surface, as they do in the dialectical nexus of history.

History in Balzac's antique shop anoints the victory of the dead over the living. Raphaël's living corpse provides the spoils of the war. The object he buys in order to have dominion over all objects turns him into just another object. Thus the historical battle between the dead and the living, or between the object and subject, is won by the former. In that respect, the Skin is a trophy of the dead's victory over the living. It ratifies the triumph of the antiques, triumph of the historical age. The dead win over the living, and the living must play dead: a fact which Nietzsche, in his *Untimely Meditations*, diagnosed as the disease of the overly historical nineteenth century.

Balzac's vision of historical development as historical decline signals the death of the subject who acknowledges this vision. Historical significance is purchased only at the price of death: this is the lesson that all phenomena are bound to learn, since they all give their lives to enter history. Meaning in history is meted out at the end, on the gravesite of what has been. Similarly, the Skin's significance, which is the meaning of the subject (as one says the meaning of life, the meaning of one's "skin"), is death. It is life in death (the idiomatic meaning of "peau" as life-under-the-sign-of-death). In that respect, the Skin is the mode of signifying proper to history: life toward death, people and events as seen from the standpoint of their being dead. The Skin (as "life"-for-death) *is historical significance* and the subject's significance as historical being, that is, as mortal, as being-toward-death. The Skin is life as subjected to death or, more exactly, life as it accedes to meaning only *historically*, through death. As soon as Raphaël takes on the Skin he lives historically, that is, in the shadow of death. His life is the Skin, and *the Skin is the submission of life to the meaning of history.* As such, the Skin truly belongs in the museum. And, equally, the museum belongs to the dialectic of the Skin.

REFERENCE MATTER

Notes

INTRODUCTION

1. T. W. Adorno, "Valéry Proust Museum," *Prisms*, p. 175.

2. M. Proust, *Le Temps retrouvé*, VIII: 148.

1. MUSEUM TIMES

1. On the Louvre Museum as a model for the role played by museums in political and cultural representations, see G. Bazin, pp. 169–91; A. McClellan, *Inventing the Louvre*; C. Duncan, "Art Museums and the Ritual of Citizenship," in I. Karp and S. Lavine, eds., *Exhibiting Cultures*, pp. 88–103.

2. Baudelaire, "Salon de 1846," *Ecrits sur l'art*, p. 73.

3. See in particular, P. Bourdieu and A. Darbel, *L'Amour de l'art: Les musées d'art européens et leur public*. Vera Zolberg shows how, taking in stride Bourdieu's critique, the modern museum can overturn the elitist, culturally exclusive, and socially petrifying effects of museum presentation; "'An Elite Experience for Everyone': Art Museums, the Public, and Cultural Literacy," in D. Sherman and I. Rogoff, eds., *Museum Culture*, pp. 49–65. In a similar vein, many of the articles written by museologists and curators and collected in *Museums and Communities* (ed. I. Karp, C. Kreamer, and S. Lavine) are interested in finding solutions to the stultifying consequences of museum exhibition on culture. They chronicle an experience of the museum working against itself, against its past of cultural petrifaction.

4. See F. Dagognet, pp. 31–35.

5. On Quatremère de Quincy and his influence, see in particular R. Schneider, *Quatremère de Quincy et son intervention dans les arts (1788–1830)*; S. Lavin, *Quatremère de Quincy and the Invention of a Modern Language of Architecture*.

6. Quatremère de Quincy, *Considérations morales sur la destination des ouvrages de l'art*, pp. 47–48.

7. Chateaubriand, "Génie du Christianisme," in *Œuvres complètes* 15, pp. 226–27 (Part III, Book 1, chap. 8, "Des églises gothiques").

8. P. J. Proudhon, p. 339.

9. J. Clifford, in *The Predicament of Culture*, emphasizes how, in the modern period, the concept of culture, as a product of management and rational planning, becomes a cultural object in its own right: "Culture [in recent history] strains towards aesthetic form and autonomy" (p. 232). D. Sherman shows the relevance of Quatremère in constructing an archeology of the concept of cultural critique. He lays emphasis on the far-reaching ideological critique implicit in Quatremère's animadversions against the museum: "Quatremère's analysis goes beyond the mediation to focus on the relationships themselves, which we may call ideological in that they provide the basic principle by which museums operate." In "Quatremère/Benjamin/Marx: Art Museums, Aura, and Commodity Fetishism," *Museum Culture*, pp. 123–43.

10. F. Nietzsche, "On the Uses and Disadvantages of History for Life," *Untimely Meditations*, p. 78.

11. M. Heidegger, "The Origin of the Work of Art," pp. 40–41.

12. J. Dewey, pp. 3–9.

13. M. Merleau-Ponty, "Indirect Language and the Voices of Silence," *The Merleau-Ponty Aesthetics Reader*, pp. 99–100.

14. T. W. Adorno, "Valéry Proust Museum," p. 175.

15. Most of the essays collected in Karp and Lavine's *Exhibiting Cultures* reflect Quatremère's concern to curate culture without stripping it of its liveliness and experiential content. See in particular these essays: Stephen Greenblatt, "Resonance and Wonder"; Spencer Crew and James Sims, "Locating Authenticity: Fragments of a Dialogue"; James Clifford, "Four Northwest Coast Museums: Travel Reflections"; James Boon, "Why Museums Make Me Sad." Two articles in *Museum Culture*, besides Sherman's piece on Quatremère, also illustrate the continuing relevance of authenticity in the contemporary discourse on museums: Boris Groys's "The Struggle Against the Museum; or, the Display of Art in Totalitarian Space"; and Brian Wallis, "Selling Nations: International Exhibitions and Cultural Diplomacy." Such volumes as *The Museum Time Machine*, ed. Robert Lumley, or Stephen Weil's *Rethinking the Museum* show the extent to which the Quatremèrian critique, in its distilled form, has become a concern of curators and museologists in designing and selecting exhibitions. The modern museum is self-conscious about its cultural dangers, its deauthentifying and uprooting effects.

16. J. Clifford is one of the foremost American voices, heirs to Lévi-Strauss, who speak the risk of inauthenticity in all study of culture: "Intervening in an interconnected world, one is always, to varying degrees, inauthentic." In *The Predicament of Culture*, p. 11.

17. D. Crimp, particularly pp. 44–65 and 282–318.

18. Crimp, p. 302.

19. Novalis, p. 65.

20. See M. Loreau, "La Philosophie comme construction nécessaire du mythe d'origine," in Pontalis, ed., *Le Temps de la réflexion*, vol. 1, pp. 315-42.

21. In Goldwater and Treves, eds., *Artists on Art*, p. 206.

22. G. W. F. Hegel, *Phenomenology of Spirit*, p. 455.

23. As Carol Duncan writes, "the new arrangement [of art in the museum] illuminated the universal spirit as it manifested itself in the various moments of high civilization" ("Art Museums and the Ritual of Citizenship," in Karp and Lavine, eds., *Exhibiting Cultures*, p. 95). Analyzing the foundation of the Louvre, Duncan shows how revolutionary and Napoleonic France imagined itself as the fourth and final episode in the history of art and culture.

24. See Crimp, pp. 282-318. The Altes Museum "was itself to constitute the Hegelian Aufhebung, or sublation" (p. 300).

25. See Quatremère's "Lettres écrites de Londres à Rome sur les marbres d'Elgin, ou les sculptures du temple de Minerve à Athènes" in *Considérations morales*.

26. Ortega y Gasset, *Dehumanization of Art*, p. 136.

27. This point roughly undergirds Adorno's testy critique of Heideggerian philosophy, in *The Jargon of Authenticity*.

28. Dewey, *Art as Experience*, p. 9.

29. Hegel, *Aesthetics*, vol. 1, p. 5.

30. B. Groys, "The Struggle Against the Museum," in Sherman, ed., *Museum Culture*, pp. 144-62. Groys shows how the erasure of the boundary between life and art in the Russian artistic and political avant-garde led to the co-optation of art by politics under Stalinism.

31. For a metacritique of Hegel's critique of natural beauty, and the relation between art and life, see Adorno, *Aesthetic Theory*, pp. 105-13.

32. Hugo, *Quatrevingt-Treize*, p. 483.

33. Here we must part company with Crimp who seems to treat Hegel mostly as the fall guy of philosophical idealism.

34. The concept is borrowed from Adorno's *Negative Dialectics* and describes the process that stalls the synthesis of the dialectic movement, that is, its tendency toward reconciliation rather than tension, assimilation rather than objection.

35. See Deleuze and Guattari, *Anti-Œdipus*, about the perpetual deterritorializing, schizophrenic drive inherent to modern capitalism, something like an enforced state of permanent homelessness which ends up sedimenting into a status quo. See also Lukács's famous analysis of the homelessness of the modern age in *Theory of the Novel*, pp. 40-42.

36. K. Walsh, *The Representation of the Past*. The author addresses the question of museums and postmodernity. Museums have recently struggled against their

inherent postmodernity in trying to reestablish a sense of belonging and place, most notably through the ecomuseum. The question raised by Walsh is whether ecomuseums can successfully escape the sterility of museum consciousness.

37. Dagognet, *Musée sans fin*, pp. 32–35.

38. Plato, "The Republic," in *The Collected Dialogues*, p. 830.

39. Plato, "Laws," in *The Collected Dialogues*, p. 1387.

40. M. Heidegger, *Nietzsche: The Will to Power as Art*, vol. 1, p. 142.

41. A. Artaud, *Le Théâtre et son double*, p. 13.

42. That is, Benjamin's well-known motto that there is no document, no historical appearance, that is free from barbarism. In "Theses on the Philosophy of History," *Illuminations*, p. 256.

43. Nietzsche, *Birth of Tragedy*, p. 56.

44. Nietzsche, *Human, All Too Human*, §215.

45. P. Bürger, *Theory of the Avant-Garde*.

46. See L. Negrin, "On the Museum's Ruins."

47. Bürger, pp. 17–20.

48. See Philip Fisher's very convincing *Making and Effacing Art*.

49. A. Danto, "The Artworld," in S. D. Ross, ed., *Art and Its Significance*, p. 479.

50. H. G. Gadamer, pp. 101–64.

51. M. Merleau-Ponty, *L'Œil et l'esprit*, p. 23.

52. See R. Krauss on minimalist objects and their positioning of the viewer, in "The Cultural Logic of the Late Capitalist Museum," pp. 8–9.

53. F. Ward, "The Haunted Museum." Ward expresses the need to go beyond Bürger's notion of the avant-garde as a reunification of art and praxis.

54. S. Stewart, *On Longing*.

55. Arthur Danto studies this phenomenon by which ordinary objects may be transmuted into art in *Transfiguration of the Commonplace*.

56. P. Nora, "Between Memory and History," p. 7.

57. S. Weil examines the problem of the proliferation of museums in the chapter "Enough Museums?" in *Rethinking the Museum*. To him the expansion of museum culture is the healthy sign that culture is progressing, i.e., that it keeps producing stuff. But isn't culture thereby made synonymous with the production of objects, that is, with an industrialist imperative of consumption?

58. In Goldwater and Treves, eds., *Artists on Art*, p. 210.

59. W. Benjamin, "On Some Motifs in Baudelaire," *Illuminations*, p. 188. In his piece on Proust from the same collection of essays, Benjamin insists that it is memory loss which lays the basis for the interruption of *mémoire involontaire*; what the latter ushers in, he writes, is the past in its lostness: "Is not the involuntary recollection, Proust's *mémoire involontaire*, much closer to forgetting than

what is usually called memory? And is not this work of spontaneous recollection, in which remembrance is the woof and forgetting the warp, a counterpart to Penelope's work rather than its likeness?" (p. 202).

60. Kant, *Critique of Judgment*, §43, p. 146.

61. This analysis concerning the seminal character of art belongs to a philosophical tradition particularly active in modernity. It is to preserve this exemplary, or history-forming, character that Benedetto Croce argues against the methodological choice of a historical investigation into the beginning of art on account of the idea that art stands at the beginning of history: "History is commonly divided into human history, natural history, and the mixture of both. . . . It is clear that artistic and literary history belongs . . . to the first, since it concerns a spiritual activity. . . . And since this activity is its subject, the absurdity of propounding the historical problem of the *origin* of *art* becomes at once evident. . . . If expression be the first form of consciousness, how can we look for the historical origin of what is not a product of nature and is presupposed by human history? How can we assign a historical genesis to a thing which is a category by means of which all historical processes and facts are understood?" (*Aesthetic*, p. 37). Croce sees in art the concrete substance wherein the activity of consciousness chronicles its own activity or, as it were, represents it. What is delineated in any art work, according to Croce and later to Heidegger, is the beginning of human history in the tracing of consciousness out of what merely exists. Art establishes something of an origin to the properly historical, the moment separating human history from natural history. So art is indeed historical, but only insofar as the notion of history originates in the moment of self-creating consciousness whose gesture the work of art captures. Thus human history, which starts when consciousness first gains the power of expressing itself, cannot possibly account for art since art is its possibility. The question of a historical origin is entirely presupposed by the a priori presence of a consciousness expressing its own self-relation—what Croce identifies as the artistic moment. So historical investigation belongs to art rather than the reverse (which leads to the illogic of putting the effect before the cause).

62. For the centrality of theories of catastrophic creation in the Western notion of createdness, see H. Bloom, *Agon*.

63. Levinas saw in this the tragic, impotent character of art. In "Reality and Its Shadow," *Collected Philosophical Papers*.

64. R. M. Rilke, *Rodin*, pp. 22–23.

65. W. Benjamin, *Reflections*, p. 155.

66. We refer the reader to Adorno's decisive analysis of the Proustian image of the museum in "Valéry Proust Museum," pp. 173–86. For the question of the work of art in Proust, see Michel Butor, pp. 129–98; and Gilles Deleuze, *Proust et les signes*.

67. P. Fisher, *Making and Effacing Art*, p. 51: "The hinges and joints that will later facilitate the work's capacity to slip into place within the institution of the museum are the conspicuous content of the modern work of art."

68. No doubt remembering Proust, Sartre made the same demonstration at the conclusion of *L'Imaginaire* on the subject of a Beethoven symphony, arguing that the perception of art is never simply a matter of surrendering to the senses, but just as much a resistance to sensuous involvement.

69. Proust, *Jean Santeuil*, p. 896.

70. See G. Agamben on the decay of experience in modernity, in *Infancy and History*.

71. Hegel had warned against the didactic doctrine of art which, in his words, led to "the uttermost extreme of insipidity" that makes the work of art "become a mere otiose accessory, a husk which is expressly pronounced to be mere husk . . . an external and superfluous adornment, and the work is a thing divided against itself" (*Aesthetics*, vol. 1, pp. 50–51).

72. See D. Preziosi, *Rethinking Art History*, chap. 4, section 7.

73. T. W. Adorno, *Notes to Literature*, vol. 2, p. 112.

74. J. Clifford, "Collecting Art and Culture," in D. Ross, ed., *Art and Its Significance*, p. 626.

75. Y. Cantarel-Besson, *La Naissance du musée du Louvre*, vol. 1, p. 29.

76. P. Zucker, *Fascination of Decay*, p. 149.

77. In Y. Cantarel-Besson, *La Naissance du musée du Louvre*, vol. 1, p. 15 (emphasis added).

78. D. Sherman, *Worthy Monuments*, p. 49.

79. P. Valéry, "Le problème des musées," *Œuvres*, vol. 2, p. 1293. This text is a frequent feature of anthologies devoted to the subject of museums and museography. Adorno conclusively analyzed its ideological underpinnings in "Valéry Proust Museum."

80. M. Donnay, *J'ai vécu 1900*, p. 177.

81. Baudelaire, "Le Cadre," *Les Fleurs du mal*, p. 63.

82. See Hans Haacke, *Framing and Being Framed*.

83. J.-C. Lebensztejn studies the dialogic principle of frameworks and framing in a discussion of Frank Stella's paintings in *Zigzag*. On the question of framing, see also J. Derrida, "Parergon," in *La Vérité en peinture*.

84. G. Bazin, *The Museum Age*, pp. 263–64. Bazin gives an arresting image of this shift in the museographic style of exhibition which occurred everywhere in Europe around the time of the First World War. He juxtaposes before-and-after-1914 pictures of the Rubens room at the Kunsthistorisches Museum in Vienna. The first picture shows canvases large and small piled up from floor to ceiling. The second picture shows the same room stripped of all but a few pictures,

hung at eye level and at a few paces from one another. The first picture is still that of a "cabinet d'amateur," the second is already that of the modern gallery.

85. W. Benjamin, "Unpacking My Library," *Illuminations*, p. 67.

86. S. Greenblatt, "Resonance and Wonder," *Exhibiting Cultures*, p. 53: "The modern museum paradoxically intensifies both access and exclusion. The treasured object exists not principally to be owned but to be viewed."

87. R. Schaer, *L'Invention des musées*, p. 75.

88. D. Sherman, *Worthy Monuments*, pp. 65–78.

89. C. Duncan, in "Art Museums and the Ritual of Citizenship," published in Karp and Lavine, *Exhibiting Cultures*, underscores the different production of individuality effected by the modern museum: "The new, more alienated kind of individualism celebrated [in the modern museum] is very different from the idealized citizen-state relationship implicit in older museums" (100).

90. Cited in R. Schaer, *L'Invention des musées*, p. 126.

91. Duncan, "Art Museums and the Ritual of Citizenship," in Karp and Lavine, *Exhibiting Cultures*, p. 101.

92. R. Lumley, *The Museum Time Machine*, p. 2.

93. G. Bazin, *The Museum Age*, p. 187.

94. I. Karp speaks the premise of most articles in *Museums and Communities* in writing that museums are "places for defining who people are and how they should act and as places for challenging those definitions" (4). It is on this challenge that these articles focus their analysis of modern anthropological and cultural museums.

95. Neil Harris, in "Polling for Opinion," notes that the museum now lives in an age of "existential scrutiny, one in which the institution stands in an unprecedented and often troublesome relationship to its previous sense of mission" (46).

96. E. Hooper-Greenhill, "A New Communication Model for Museums," pp. 47–62.

97. For a brief but comprehensive description of the "ecomuseum concept" see D. Poulot, "Identity as Self-Discovery: The Ecomuseum in France," in D. Sherman, ed., *Museum Culture*, pp. 66–84; N. Fuller, "The Museum and Community Empowerment: The Ak-Chin Indian Community Ecomuseum Project," in Karp, Kreamer, and Lavine, eds., *Museums and Communities*, pp. 327–365. On examples of ecomuseums, see also G. Kavanagh, ed., *Making Histories in Museums*.

98. See J. Clifford, "Four Northwest Coast Museums," in Karp and Lavine, eds., *Exhibiting Cultures*, pp. 243–49.

99. Ibid., p. 244.

100. Karp, in Karp, Kreamer, and Lavine, eds., *Museums and Communities*, p. 20 (emphasis added).

101. D. Poulot, "Identity as Self-Discovery: The Ecomuseum in France," in D. Sherman, ed., *Museum Culture*, p. 69.

102. Official museum brochure. Cited in Poulot's article.

103. Guillermo Gómez-Peña's article, "The Other Vanguard" (in Karp, Kreamer, and Lavine, eds., *Museums and Communities*, pp. 65–75) is quite inspiring in this respect. In the same volume, Constance Perin ("The Communicative Circle: Museums as Communities," pp. 182–220) demonstrates how, in practical ways, the museum can undo its own "authoritative paradigms" so as to allow disagreement, resistance, and reinterpretation from the audience. The museum would thereby become a labory of identity rather than its mausoleum.

2. BRINGING THE MUSEUM HOME

1. R. Saisselin, *The Bourgeois and the Bibelot*, p. 12.

2. C. McCorquodale, *History of the Interior*; J. Feray, *Architecture intérieure*; G. Janneau, *Le Mobilier français*. See also M. Perrot, "Manières d'habiter" and R.-H. Guerrand, "Espaces privés," in Ariès and Duby, eds., *Histoire de la vie privée*, vol. 4, pp. 305–412.

3. G. de Maupassant, "Etude sur Emile Zola," *Œuvres complètes*, vol. 24, p. 165.

4. T. Gautier, "Le Pied de momie," *Récits fantastiques*, p. 141.

5. C. Baudelaire, "Salon de 1846," *Ecrits sur l'art*, p. 149.

6. E. Zola, *Les Rougon-Macquart*, vol. 2, p. 1347.

7. In Feray, *Architecture intérieur*, p. 340.

8. This is the famous premise of Marx's "The Eighteenth Brumaire of Louis Bonaparte."

9. F. Nietzsche, "On the Uses and Disadvantages of History for Life," *Untimely Meditations*. See also Philippe Lacoue-Labarthe's work on the second meditation in "Histoire et mimésis," *L'Imitation des modernes*, pp. 87–112.

10. P. Bourget, *Œuvres complètes*, vol. 1, p. 379.

11. On the concept of philosophical homelessness in artistic forms and consciousness, see G. Lukàcs, *The Theory of the Novel*, pp. 29–41.

12. For the kitsch celebration of home in the bourgeois imaginary, see John Lukacs, "The Bourgeois Interior."

13. In *Non-Lieux*, Marc Augé studies the paradoxical space of postmodernity (airports, hotels, city walks) as anthropological places of solitude. Modernity, he argues, engineers the social production of desocialization.

14. In *Being and Time*, of course, but also more specifically in writings such as those collected in *The Question Concerning Technology and Other Essays*.

15. M. Heidegger, "Building, Dwelling, Thinking," in *Poetry, Language, Thought*, p. 148.

16. G. Bachelard, *The Poetics of Space*, p. 36.

17. M. Proust, *Contre Sainte-Beuve*, p. 193.

18. All this in Balzac, *Lettres à Madame Hanska*.

19. A. Nettement, *Histoire de la littérature française*, vol. 2, pp. 266–67.

20. T. Gautier, *Honoré de Balzac*, pp. 120–21.

21. V. Hugo, *Choses vues*, vol. 2, pp. 67–68. For a biographical account on the acquisition and decoration of the house, as well as a history of its subsequent owners, see P. Jarry, *Le Dernier Logis de Balzac*.

22. In writing *La Maison d'un artiste*, Goncourt thus fulfilled his life-long dream of combining literature with interior decoration. "If I had not been a man of letters, the profession I would have chosen would have been to be a creator of interiors" (26).

23. Balzac, *Inventaire de l'Hôtel de la rue Fortunée*, in *Lettres à Madame Hanska*, vol. 4, pp. 615–16.

24. Proust, *Contre Sainte-Beuve*, pp. 201–3.

25. Balzac, *La Peau de chagrin*, in *Œuvres Complètes*, vol. 10, p. 148.

26. C. Lévi-Strauss, *La Pensée sauvage*, p. 54.

27. For a discussion of the nineteenth-century taste for miniature objects and models, see Susan Stewart, *On Longing*.

28. See the superb study on the inherently accidental nature of experience by David Appelbaum, *The Stop*.

29. P. Ariès, *L'Enfant et la vie familiale sous l'Ancien Régime*, p. 65.

30. S. Stewart, *On Longing*, p. 61.

31. Baudelaire, "La morale du joujou," *Ecrits sur l'art*, p. 161.

32. Heidegger, "Building, Dwelling, Thinking," in *Poetry, Language, Thought*, p. 154.

33. Flaubert, *Bouvard et Pécuchet*, p. 142.

34. Goethe, "The Collector and His Circle," *The Collected Works*, vol. 3, p. 136.

35. In Norma Broude, ed., *Seurat in Perspective*, p. 43.

36. N. Bryson, "Chardin and the Text of Still Life," p. 234. See also Louis Marin, *Etudes sémiologiques*.

37. The realist, according to Baudelaire, is the one who says: "'I want to represent things as they are, or as they would be, while pretending that I do not exist.' The universe without man." In "Salon de 1859," *Ecrits sur l'art*, p. 265.

38. F. Nietzsche, *Human, All Too Human*, p. 29.

39. Baudelaire described Delacroix's *Femmes d'Alger* as a "a poem of an inte-

rior, restful and silent, cluttered with rich cloths and toiletries." "Salon de 1846," *Ecrits sur l'art*, p. 97.

40. For a materialist critique of bourgeois escapism, see E. Bloch, *The Principle of Hope*, in particular vol. 3.

41. Of course, the flight away from the world leads invariably back to it, as the story of *A Rebours* shows. The orgiastic indulgence of decoration in the bourgeois interior refers back to the world of mercantilist practicality, not only because it apes its senseless accumulation, but because also it ends up fueling its dynamo in the process of consuming its regular supply of knicknackery.

42. In *The Fold: Leibniz and the Baroque*, Gilles Deleuze defines baroque architecture as "a severing of the facade from the inside, of the interior from the exterior, and the autonomy of the interior from the independence of the exterior" (p. 28). Baroque architecture would have the effect of making the interior into a Leibnizian monad, that is, an inside without an outside.

43. M. Heidegger, "Building, Dwelling, Thinking," in *Poetry, Language, Thought*, p. 110.

44. Huysmans, *A Rebours*, p. 77.

45. D. Hollier, *Against Architecture*, p. 69.

46. Chateaubriand, *René*, p. 151.

47. E. Bloch, *The Utopian Function of Art and Literature*, pp. 207–8.

48. Novalis, *L'Encyclopédie*, p. 65.

49. M. Foucault, *Surveiller et punir*, p. 210.

50. In F. Ewald, "A Power Without an Exterior," in Armstrong, ed., *Michel Foucault Philosopher*.

51. Quoted in C. McCorquodale, *History of the Interior*, p. 176.

52. See T. Adorno, "Subject and Object," in Arato and Gebhardt, eds., *The Essential Frankfurt School Reader*, pp. 497–511.

53. C. Rosset, *L'Objet singulier*, p. 34.

54. C. Blanc, *Grammaire des arts décoratifs*, p. 128.

55. W. Benjamin, *Paris, Capitale du XIX siècle*, p. 239. Or again in *Das Passagen-Werk*, p. 68: "It is as though the bourgeois made it a point of honor not to lose the trace of his things and accessories. Untiringly, he makes a mould for a myriad of objects; for his slippers and watches, his kitchenware and his umbrellas, he invents sheathes and covers. He has a distinctive preference for velveteen and plush since they keep the imprint of touch."

56. For loss of aura, see W. Benjamin, "The Work of Art in the Age of Mechanical Reproduction," *Illuminations*, pp. 217–52.

57. W. Benjamin, "Unpacking My Library," *Illuminations*, p. 67: "The phenomenon of collecting loses its meaning as it loses its personal owner."

58. W. Benjamin cited in Alexander Garcia-Düttman, *La Parole donnée*, p. 117.

59. A. Rimbaud, "Enfance III," *Illuminations*, in *Œuvres poétiques*.

60. J. Goody, *The Domestication of the Savage Mind*, and again W. Ong, *Orality and Literacy*.

61. W. Benjamin, *Das Passagen-Werk*, p. 582: " . . . in the nineteenth century the number of 'hollowed-out objects' increases in a mass and tempo previously unknown."

62. Flaubert, "Lettre à Louise Colet," Aug. 26, 1853, in *Correspondance*.

63. S. Stewart, *On Longing*, p. 151: "In the collection, time is not to be restored to an origin; rather all time is made simultaneous and synchronous within the collection's world."

64. W. Benjamin, "Louis-Philippe or the Interior," *Reflections*, p. 155.

65. P. Nord, "Republican Politics and Bourgeois Interior," in Nash, *Home and Its Dislocations*, p. 208.

66. T. Gautier, "La Cafetière," "Le Pied de momie," in *Récits fantastiques*.

67. In Mallarmé's famous "Sonnet en X."

68. G. W. F. Hegel, *Aesthetics*, vol. 1, p. 597.

69. T. Adorno, "Reading Balzac," *Notes to Literature*, vol. 1, p. 129.

70. K. Marx, *Capital*, in *Selected Writings*, p. 429.

71. One may quote here the analysis of Maurice Blanchot who, drawing from the Heidegger of "The Origin of the Work of Art," insists on the imagistic status of an instrument put out of use: "Analogously, a broken utensil becomes its own IMAGE (and sometimes an aesthetic object: 'these old-fashioned, fragmented, unusable, incomprehensible, almost perverted objects' which André Breton loved so much). In this case, the utensil, no longer vanishing behind its use-value, APPEARS." In M. Blanchot, *L'Espace littéraire*, p. 271.

72. Balzac, "Traité de la vie élégante," *Œuvres complètes*, vol. 12, p. 245.

73. Balzac, *La Recherche de l'Absolu*, *Œuvres complètes*, vol. 10, p. 657.

74. Balzac, *Gobseck*, p. 81.

75. Balzac, *Eugénie Grandet*, p. 189.

76. In the Foreword to the 1837 edition of this novel, Balzac spells out the insight that the notion of individual is superseded by that of species even if, in order to prove it, literature still has to stage individual figures, thus replicating the social situation which, entirely hostile to the individual, nonetheless elevates it to a mythic image in order to better enforce conformity: "the social state adjusts men to its needs and reshapes them in such a way that in no place men are really quite themselves" "Préface de la première édition (1837) de 'Illusions perdues' ," *La Comèdie humaine*, vol. 5, p. 109.

77. Balzac, "Préface de la première édition (1837) de 'Illusions perdues' ,"
vol. 5, p. 111.

78. G. Lukács, *The Historical Novel*, p. 83.

3. BALZACANA

1. G. W. F. Hegel, *Aesthetics*, vol. 1, p. 604.

2. Balzac, *La Peau de chagrin, Œuvres complètes*, vol. 10, p. 67. I draw most of
the translation from Herbert Hunt's own translation of *La Peau de chagrin* for
Penguin Books, 1977. We refer the reader to the series of decisive essays on this
novel collected by Claude Duchet in *Balzac et "La Peau de chagrin."*

3. W. Benjamin, *The Origin of German Tragic Drama*, p. 179.

4. M. Proust, *Contre Sainte-Beuve*, p. 203. See section II for a discussion of
Proust's idea of Balzacian prose.

5. Balzac, "Avant-Propos," *La Comédie humaine*, vol. 1, p. 11.

6. Balzac, "Traité de la démarche," *La Comédie humaine*, vol. 12, p. 275.

7. Balzac, *Le Père Goriot*, p. 28.

8. On the reading of this painting we take our cue from Philip Fisher's ele-
gant analysis of Manet, which already lays stress on the discontinuous space be-
tween the human figure and the still life. In *Making and Effacing Art*, pp. 204–5.

9. More advanced in the century than Balzac, Manet went on to synthesize
subject and object: he began painting people as though they were things. In this
he proves himself the contemporary of Zola's automatons, those pseudo-subjects
who behave like objective cells in the laboratory of hereditary experiments.

10. One of the very first objects glimpsed in the galleries is a stuffed croco-
dile, an almost obligatory fixture in the Renaissance iconography of the *Kunst-
und Wunderkammer.*

11. Jean-Claude Lebensztejn insisted on the monetary value the museum as-
signs to the reportedly "priceless" value of art, demonstrating that, while the mu-
seum claims to enshrine objects in an eternal, untouchable category of value, it
sets the market for art going: "In giving the work of art a phantasmatically high
monetary value, the Museum makes itself into the annex and the guarantee (the
Stock Exchange) of galleries and art sales and the art world, amateurs, connois-
seurs, appraisers (and a shady world, in negative, of thieves, hoarders and coun-
terfeiters) who live from the circulation of artworks (which eventually wash up
in the Museum) with the highest price tag possible." In "L'espace de l'art,"
pp. 324–25.

12. "Our doctrine here is therefore that all reality . . . is brought forth solely
by the imagination." In J. G. Fichte, *Science of Knowledge*, p. 202.

13. Apocryphal though it may be, the following anecdote recounted by
Baudelaire exemplifies the Balzacian brand of aesthetic response evidenced by

Raphaël: "There is a story about Balzac . . . , once he was standing in front of a beautiful painting . . . , and having looked at a little cottage with a slender plume of smoke rising above, he cried out: 'How beautiful this is! But what do the people do in this shack? what are they thinking of, what sorrows do they have? has the harvest been good? they probably have some bills to pay?'." The actual aesthetic display recedes behind the subjective psychological projections that the viewer, in this case Balzac himself, directs at the representational contents of the painting. In this case also, the aesthetic display is not considered in itself, as a work of form, but as a vessel of subjective projections. In Baudelaire, "Exposition universelle," *Ecrits sur l'art*, p. 169.

14. J. W. Goethe, *Collected Works*, p. 20: "We must be careful not to confuse the effect the work of art has on us with the work itself."

15. I. Kant, p. 149.

16. Ibid.

17. Particularly in *Louis Lambert*, p. 165: "There is a ruling, primitive phenomenon which suffers no explanation. . . . This X is language."

18. Pascal, *Pensées*, p. 35.

19. L. Wittgenstein, "Proposition 5.64," in *Tractatus Logico-Philosophicus*, p. 58.

20. P. Barbéris, *Mythes balzaciens*, p. 132: "Economics weave through the individual's life. There is hardly a book by Balzac where man's destiny is not explained by work and money, rather than by the mystery of sentiments."

21. T. W. Adorno, "Subject and Object," in Arato and Gebhardt, eds., *Frankfurt School Reader*, p. 501.

22. T. Eagleton, *The Ideology of the Aesthetic*, pp. 97–98.

23. Destutt de Tracy, *A Treatise on Political Economy*, p. 5.

24. K. Marx, "The Capital," *Selected Writings*, p. 441.

25. Balzac, *Eugénie Grandet*, p. 167.

26. H. Marcuse, "A Note on Dialectic," in Arato and Gebhardt, eds., *Frankfurt School Reader*, p. 451.

27. M. Heidegger, *The Question Concerning Technology*, p. 17.

28. Balzac, "Traité de la vie élégante," *La Comédie humaine*, vol. 12, pp. 212–13.

29. On Kosuth's writings and art, see J. Kosuth, *Art after Philosophy and After*.

30. On the subject of the objective world in the epic versus the one in the novel, see G. Lukács, *Theory of the Novel*, and F. Jameson, *Marxism and Form*.

31. Agamben devotes a paragraph to this dynamic in Grandville, in *Stanze*, p. 85. Before him, W. Benjamin discusses the historical relevance of Grandville in "Paris, Capital of the Nineteenth Century," in *Reflections*, pp. 151–53.

32. That the life of the object takes place at the expense of the subject is almost illustrated in Grandville's self-authored epitaph. There too the life the subject has lent to the object seems to turn against the former: "There lies Grandville, he breathed life into everything and, after God, made everything talk or walk. Only he could not walk his way alone." In Laure Garcin, *Grandville, révolutionnaire et précurseur de l'art du mouvement*, p. 7. Evoking the onslaught waged by the inorganic world on the organic, Walter Benjamin's analysis of Grandville further underscores the affinity of Grandville's imagination with the Balzac of *La Peau de chagrin*: "Grandville's fantasies extend the character of a commodity to the universe. . . . Grandville extends fashion's claims both to the objects of everyday use and to the cosmos. By pursuing it to its extremes he discloses its nature. This resides in its conflict with the organic. It couples the living body to the inorganic world. Against the living it asserts the rights of the corpse." *Reflections*, p. 153.

33. Baudelaire, "Quelques caricaturistes français," *Ecrits sur l'art*, p. 224.

34. See J. Kristeva, *Pouvoirs de l'horreur*.

35. Samuel Weber runs Balzac's *La Peau de chagrin* through a Marxian critique in *Unwrapping Balzac*.

36. Balzac, "Notice biographique," *Comédie humaine*, vol. 1, p. 1502.

37. G. Lukács, *The Theory of the Novel*, p. 108.

38. F. Jameson, *The Political Unconscious*, p. 251.

39. P. Hamon in *Expositions* eloquently traces the debilitating presence of flatness in the imagination of the late nineteenth century: a world of uncommunicative matter, unreflecting planes, and impenetrable, dumb surfaces.

40. See Ortega y Gasset, *The Dehumanization of Art*; J.-F. Lyotard, *The Inhuman*; and T. Adorno, *Aesthetic Theory*, particularly chap. 7.

41. M. Buber, *I and Thou*, p. 13.

42. K. Pomian, in *Collectors and Curiosities*, shows that the cult of objects appears first in the guise of funeral offerings entombed with the dead in ancient civilizations, particularly Mesopotamian and Egyptian.

43. La Bruyère, *Les Caractères*, p. 67. La Bruyère's epigram is famous for encapsulating the mood of all artistic modernity, i.e., of this time which, cut off from the past, is annihilated by its precursors.

44. K. Marx, "The Eighteenth Brumaire of Louis Bonaparte," in *Selected Writings*, p. 300.

45. J. W. Goethe, *Collected Works*, vol. 3, p. 64.

46. Chateaubriand, *René*, p. 152.

47. This reconciliation between nature and culture in the ruin is perhaps the main philosophical idea of the poetry of ruins. In his analysis of a painting by Ruisdael, Goethe writes: "Yet the most important idea in this picture also makes

the greatest artistic impression. The collapse of immense walls seems to have filled up or obstructed a gently flowing brook, diverting it from the original course, and now it is rushing past the graves in search of a way in this wilderness" (*Collected Works*, vol. 3, p. 64). While nature has nibbled away at the structure, the structure has responded by working on the landscape, shaping it with culture; or rather the very destruction of culture at the hands of nature modifies the natural landscape. This dichotomous process eventually heads towards a comingling where, nature and culture trading properties with each other, the erasure of their distinction is envisioned.

48. See in particular thesis III in W. Benjamin, "Theses on the Philosophy of History," in *Illuminations*.

Bibliography

Adorno, Theodor. *Aesthetic Theory.* Trans. C. Lenhardt. London: Routledge & Kegan Paul, 1984.

———. *The Jargon of Authenticity.* Trans. Knut Tarnowski and Frederic Will. Evanston, Ill.: Northwestern University Press, 1973.

———. *Negative Dialectics.* Trans. E. B. Ashton. New York: Continuum, 1973.

———. *Notes to Literature.* Ed. Rolf Tiedemann. Trans. Shierry Weber Nicholsen. 2 vols. New York: Columbia University Press, 1992.

———. *Prisms.* Trans. Samuel and Shierry Weber. Cambridge, Mass.: MIT Press, 1981.

———. "Valéry Proust Museum." In *Prisms,* pp. 173–86.

Agamben, Georgio. *Infancy and History: Essays on the Destruction of Experience.* Trans. Liz Heron. New York: Verso, 1993.

———. *Stanze.* Trans. Yves Hersant. Paris: Christian Bourgois Editeur, 1981.

Appelbaum, David. *The Stop.* Albany: SUNY Press, 1995.

Arato, Andrew, and Eike Gebhardt, eds. *The Essential Frankfurt School Reader.* New York: Continuum, 1982.

Ariès, Philippe. *L'Enfant et la vie familiale sous l'Ancien Régime.* Paris: Seuil, 1973.

Ariès, Philippe, and Georges Duby, eds. *Histoire de la vie privée.* 5 vols. Paris: Seuil, 1987.

Armstrong, Timothy, ed. *Michel Foucault Philosopher.* New York: Routledge, 1992.

Artaud, Antonin. *Le Théâtre et son double.* Paris: Gallimard, 1964.

Atget, Eugène. *Intérieurs parisiens, photographies.* Paris: Musées de la ville de Paris, 1982.

Augé, Marc. *Non-Lieux: Introduction à une anthropologie de la surmodernité.* Paris: Seuil, 1992.

Bachelard, Gaston. *The Poetics of Space.* Trans. Maria Jolas. Boston: Beacon Press, 1969.

Balzac, Honoré de. *La Comédie humaine*. Ed. Pierre-Georges Castex. 12 vols. Paris: Gallimard, 1976–81.

———. *Eugénie Grandet*. Ed. Pierre Citron. Paris: Flammarion, 1964.

———. *Gobseck*. Ed. P. Berthier. Paris: Flammarion, 1985.

———. *Lettres à Madame Hanska*. Ed. Roget Pierrot. 4 vols. Paris: Editions du Delta, 1971.

———. *Louis Lambert*. Paris: Gallimard, 1980.

———. *Le Père Goriot*. Paris: Gallimard, 1971.

Barbéris, Pierre. *Mythes balzaciens*. Paris: Armand Colin, 1972.

Baudelaire, Charles. *Ecrits sur l'art*. Paris: Librairie générale française, 1992.

———. *Les Fleurs du mal*. Paris: Presses Pocket, 1989.

Bazin, Germain. *The Museum Age*. Trans. Jane van Nuis Cahill. New York: Universe Books, 1967.

Benjamin, Walter. *Illuminations*. Trans. Harry Zohn. New York: Schocken Books, 1968.

———. *The Origin of the German Tragic Drama*. Trans. John Osborne. New York: Verso, 1977.

———. *Paris, capitale du XIXe siècle*. Paris: Editions du Cerf, 1990.

———. *Das Passagen-Werk*. Frankfurt am Main: Suhrkamp Verlag, 1972.

———. *Reflections: Essays, Aphorisms, Autobiographical Writings*. Trans. Edmund Jephcott. New York: Schocken Books, 1978.

Blanc, Charles. *Grammaire des arts décoratifs*. Paris: Renouard, 1882.

Blanchot, Maurice. *L'Espace littéraire*. Paris: Gallimard, 1955.

Bloch, Ernst. *The Principle of Hope*. Trans. Neville Plaice, Stephen Plaice, and Paul Knight. 3 vols. Cambridge, Mass.: MIT Press, 1986.

———. *The Utopian Function of Art and Literature*. Trans. Jack Zipes and Frank Mecklenburg. Cambridge, Mass.: MIT Press, 1988.

Bloom, Harold. *Agon: Towards a Theory of Revisionism*. New York: Oxford University Press, 1982.

———. *The Anxiety of Influence*. New York: Oxford University Press, 1973.

Bourdieu, Pierre, and Alain Darbel. *L'Amour de l'art: Les musées d'art européens et leur public*. Paris: Minuit, 1966.

Bourget, Pierre. *Œuvres complètes*. Paris: Plon, 1899.

Broude, Norma, ed. *Seurat in Perspective*. Englewood Cliffs, N.J.: Prentice Hall, 1978.

La Bruyère. *Les Caractères*. Ed. Robert Garapon. Paris: Garnier, 1962.

Bryson, Norman. "Chardin and the Text of Still Life." *Critical Inquiry* (1989) 2: 234.

———. *Looking at the Overlooked: Four Essays on Still Life Painting.* Cambridge, Mass.: Harvard University Press, 1990.

Buber, Martin. *I and Thou.* Trans. Ronald Gregor Smith. New York: Macmillan, 1958.

Bürger, Peter. *Theory of the Avant-Garde.* Trans. Michael Shaw. Minneapolis: University of Minnesota Press, 1984.

Butor, Michel. *Essais sur les modernes.* Paris: Gallimard, 1964.

Cantarel-Besson, Yveline. *La Naissance du musée du Louvre: La politique muséologique sous la Révolution d'après les archives des musées nationaux.* 2 vols. Paris: Editions de la Réunion des musées nationaux, 1981.

Chateaubriand, François-René de. *Œuvres complètes.* Paris, 1836.

———. *René.* Paris: Garnier-Flammarion, 1964.

Clifford, James. *The Predicament of Culture: Twentieth-Century Ethnography, Literature and Art.* Cambridge, Mass.: Harvard University Press, 1988.

Crimp, Douglas. *On the Museum's Ruins.* Cambridge, Mass.: MIT Press, 1993.

Croce, Benedetto. *Aesthetic.* Trans. Douglas Ainslie. New York: Noonday Press, 1958 [1905].

Dagognet, François. *Musée sans fin.* Paris: Champ Vallon, 1986.

Danto, Arthur. *Transfiguration of the Commonplace.* Cambridge, Mass.: Harvard University Press, 1981.

Deleuze, Gilles. *The Fold: Leibniz and the Baroque.* Trans. Tom Conley. Minneapolis: Minnesota University Press, 1993.

———. *Proust et les signes.* Paris: Presses Universitaires de France, 1964.

Deleuze, Gilles, and Félix Guattari. *Anti-Œdipe.* Paris: Editions de Minuit, 1972.

Derrida, Jacques. *La Vérité en peinture.* Paris: Flammarion, 1978.

Destutt de Tracy. *A Treatise on Political Economy.* Trans. Thomas Jefferson, 1817. Reprints of Economic Classics. New York: Augustus Kelley, 1970.

Dewey, John. *Art as Experience.* New York: Putnam, 1934.

Donnay, Maurice. *J'ai vécu 1900.* Paris: Fayard, 1950.

Duchet, Claude, ed. *Balzac et "La Peau de chagrin."* Paris: Société d'enseignement supérieur, 1979.

Eagleton, Terry. *The Ideology of the Aesthetic.* Oxford: Blackwell, 1990.

Feray, Jean. *Architecture intérieure et décoration en France des origines à 1875.* Paris: Berget-Levrault, 1988.

Fichte, J. G. *Science of Knowledge.* Trans. P. Heath and J. Lachs. Cambridge: Cambridge University Press, 1969.

Fisher, Philip. *Making and Effacing Art: Modern American Art in a Culture of Museums.* Oxford: Oxford University Press, 1991.

Flaubert, Gustave. *Bouvard et Pécuchet.* Ed. Jacques Suffel. Paris: Garnier-Flammarion, 1966.

———. *Correspondance.* Ed. Jean Bruneau. Paris: Gallimard, 1973–91.

Foucault, Michel. *Surveiller et punir.* Paris: Gallimard, 1975.

Gadamer, Hans-Georg. *Truth and Method.* Trans. Joel Weinsheimer and Donald G. Marshall. New York: Continuum, 1994.

Garcia-Düttman, Alexander. *La Parole donnée.* Paris: Galilée, 1989.

Garcin, Laure. *Granville, révolutionnaire et précurseur de l'art du mouvement.* Paris: Losfeld, 1970.

Gautier, Théophile. *Honoré de Balzac.* Paris: L'Arche du Livre, 1973.

———. *Récits fantastiques.* Paris: Bookking International, 1993.

Goethe, Johan W. *The Collected Works.* Ed. John Geary. 12 vols. Princeton, N.J.: Princeton University Press, 1994.

Goldwater, Robert, and Marco Treves, eds. *Artists on Art.* New York: Pantheon, 1945.

Goncourt, Edmond de. *La Maison d'un artiste.* Paris: Charpentier, 1881.

Goody, Jack. *The Domestication of the Savage Mind.* New York: Cambridge University Press, 1977.

Haacke, Hans. *Framing and Being Framed.* New York: New York University Press, 1975.

Hamon, Philippe. *Expositions: Littérature et architecture au XIXe siècle.* Paris: José Corti, 1991.

Harris, Neil. "Polling for Opinion." *Museum News* (Sept.–Oct. 1990).

Havard, Henri. *L'Art dans la maison: Grammaire de l'ameublement.* Paris, 1884.

Hegel, Georg Wilhelm Friedrich. *Aesthetics: Lectures on Fine Art.* Trans. T. M. Knox. 2 vols. Oxford: Clarendon Press, 1975.

———. *Phenomenology of Spirit.* Trans. A. V. Miller. Oxford: Oxford University Press, 1977.

Heidegger, Martin. *Nietzsche: The Will to Power as Art.* Trans. David Farrell Krell. 3 vols. London: Routledge & Kegan Paul, 1981.

———. *Poetry, Language, Thought.* Trans. Albert Hofstadter. New York: Harper & Row, 1975.

————. *The Question Concerning Technology and Other Essays*. Trans. William Lovitt. New York: Harper & Row, 1977.

Hollier, Denis. *Against Architecture: The Writings of George Bataille*. Trans. Betsy Wing. Cambridge, Mass.: MIT Press, 1989.

Hooper-Greenhill, E. "A New Communication Model for Museums." In Gaynor Kavanagh, ed., *Museum Language: Objects and Texts*. London: Leicester University Press, 1991.

Hugo, Victor. *Choses vues*. Paris: Ollendorff, 1913.

————. *Quatrevingt-Treize*. Paris: Garnier, 1963.

Huysmans, J. K. *A Rebours*. Paris: Garnier-Flammarion, 1978.

Jameson, Fredric. *Marxism and Form*. Princeton, N.J.: Princeton University Press, 1971.

————. *The Political Unconscious: Narrative as a Socially Symbolic Act*. Ithaca, N.Y.: Cornell University Press, 1981.

Janneau, Guillaume. *Le Mobilier français*. Paris: P.U.F., 1966.

Jarry, Pierre. *Le Dernier Logis de Balzac*. Paris: Editions du Sagittaire, 1924.

Johnson, Galen A., ed. *The Merleau-Ponty Aesthetics Reader*. Evanston, Ill.: Northwestern University Press, 1993.

Kant, Immanuel. *Critique of Judgment*. Trans. J. H. Bernard. New York: Hafner Press, 1951.

Karp, Ivan, and Steven D. Lavine, eds. *Exhibiting Cultures: The Poetics and Politics of Museum Display*. Washington, D.C.: Smithsonian Institute Press, 1991.

Karp, Ivan, Christine Mullen Kreamer, and Steven D. Lavine, eds. *Museums and Communities*. Washington, D.C.: Smithsonian Institute Press, 1992.

Kavanagh, Gaynor, ed. *Making Histories in Museums*. London: Leicester University Press, 1996.

————, ed. *Museum Language: Objects and Texts*. London: Leicester University Press, 1991.

Kosuth, Joseph. *Art After Philosophy and After*. Ed. Gabriele Guercio. Cambridge, Mass.: MIT Press, 1991.

Krauss, Rosalind. "The Cultural Logic of the Late Capitalist Museum." *October* 54 (Fall 1990): 3–17.

Kristeva, Julia. *Pouvoirs de l'horreur*. Paris: Editions du Seuil, 1980.

Lacoue-Labarthe, Philippe. *L'Imitation des modernes*. Paris: Galilée, 1986.

Lavin, Sylvia. *Quatremère de Quincy and the Invention of a Modern Language of Architecture*. Cambridge, Mass.: MIT Press, 1991.

Lebensztejn, Jean-Claude. "L'espace de l'art." *Critique* (April 1970).

———. *Zigzag*. Paris: Flammarion, 1981.

Levinas, Emmanuel. *Collected Philosophical Papers*. Trans. Alphonso Lingis. Boston: Martinus Nijhoff Publishers, 1987.

Lévi-Strauss, Claude. *La Pensée sauvage*. Paris: Plon, 1962.

Lukács, Georg. *The Historical Novel*. Trans. Hannah and Stanley Mitchell. London: Merlin Press, 1962.

———. *The Theory of the Novel*. Trans. Anna Bostock. Cambridge, Mass.: MIT Press, 1971.

Lukacs, John. "The Bourgeois Interior." *The American Scholar* 39 (1970): pp. 616–30.

Lumley, Robert, ed. *The Museum Time Machine*. New York: Routledge, 1988.

Lyotard, Jean-François. *The Inhuman*. Trans. Geoffrey Bennington and Rachel Bowlby. Stanford: Stanford University Press, 1991.

Marin, Louis. *Etudes sémiologiques*. Paris: Editions Klincksieck, 1971.

Marx, Karl. See MacLellan, ed.

Maupassant, Guy de. *Œuvres complètes*. 29 vols. Paris: Conard, 1924.

MacLellan, David, ed. *Karl Marx: Selected Writings*. New York: Oxford University Press, 1977.

McClellan, Andrew. *Inventing the Louvre*. New York: Cambridge University Press, 1994.

McCorquodale, Charles. *History of the Interior*. New York: Vendome Press, 1983.

Merleau-Ponty, Maurice. *L'Œil et l'esprit*. Paris: Gallimard, 1964.

Nancy, Jean-Luc. *The Birth to Presence*. Eds. Werner Hamacher and David E. Wellbery. Stanford: Stanford University Press, 1993.

Nash, Suzanne, ed. *Home and Its Dislocations in Nineteenth-Century France*. Albany: SUNY Press, 1993.

Negrin, Llewellya. "On the Museum's Ruins: A Critical Appraisal." *Theory, Culture and Society* 10 (1993): 97–125.

Nettement, A. *Histoire de la littérature française sous le gouvernement de Juillet*. Paris, 1859.

Nietzsche, Friedrich. *Birth of Tragedy*. Trans. Francis Golffing. New York: Doubleday, 1956.

———. *Human, All Too Human*. Trans. Marion Faber. Lincoln: Nebraska University Press, 1984.

———. *Untimely Meditations*. Trans. R. J. Hollingdale. New York: Cambridge University Press, 1983.

Nora, Pierre. "Between Memory and History: Les Lieux de Mémoire." *Representations* 26 (1989): 7–25.

Novalis. *L'Encyclopédie.* Paris: Editions de Minuit, 1966.

Ong, Walter. *Orality and Literacy: The Technologizing of the Word.* New York: Methuen, 1982.

Ortega y Gasset, José. *The Dehumanization of Art.* Princeton, N.J.: Princeton University Press, 1968.

Pascal. *Pensées.* Ed. Philippe Selliers. Paris: Mercure de France, 1967.

Plato. *The Collected Dialogues.* Ed. Edith Hamilton and Huntington Cairns. Princeton, N.J.: Princeton University Press, 1961.

Pomian, Krzysztof. *Collectors and Curiosities.* Cambridge, Mass.: Polity Press, 1990.

Pontalis, J.-B., ed. *Le Temps de la réflexion.* Vol. I. Paris: Gallimard, 1980.

Preziosi, Donald. *Rethinking Art History: Meditations of a Coy Science.* New Haven: Yale University Press, 1989.

Proudhon, Pierre Jean. *Du principe de l'art et sa destination sociale.* Paris: Garnier, 1865.

Proust, Marcel. *A la recherche du temps perdu.* 3 vols. Eds. Pierre Clarac and André Ferré. Paris: Gallimard, 1954.

———. *Contre Sainte-Beuve.* Paris: Gallimard, 1954.

———. *Jean Santeuil.* Paris: Gallimard, 1971.

Quatremère de Quincy. *Considérations morales sur la destination des ouvrages de l'art.* Paris: Fayard, 1989 [1815].

Rilke, Rainer Maria. *Rodin.* Trans. Jessie Lemont and Hans Trausil. London: The Grey Walls Press, 1946.

Rimbaud, Arthur. *Œuvres poétiques.* Paris: Garnier-Flammarion, 1964.

Ross, Steven David, ed. *Art and Its Significance.* Albany: SUNY Press, 1994.

Rosset, Clément. *L'Objet singulier.* Paris: Editions de Minuit, 1979.

Saisselin, Remy G. *The Bourgeois and the Bibelot.* New Brunswick, N.J.: Rutgers University Press, 1984.

Schaer, Roland. *L'Invention des musées.* Paris: Gallimard, 1993.

Schneider, René. *Quatremere de Quincy et son intervention dans les arts (1788–1830).* Paris: Hachette, 1910.

Sherman, Daniel, and Irit Rogoff, eds. *Museum Culture: Histories, Discourses, Spectacles.* Minneapolis: University of Minnesota Press, 1994.

———. *Worthy Monuments: Art Museums and the Politics of Culture in Nineteenth Century France.* Cambridge, Mass.: Harvard University Press, 1989.

Stewart, Susan. *On Longing: Narratives of the Miniature, the Gigantic, the Souvenir, the Collection.* Baltimore, Md.: Johns Hopkins University Press, 1984.

Valéry, Paul. *Œuvres.* Ed. Jean Hytier. 2 vols. Paris: Gallimard, 1960.

Walsh, Kevin. *The Representation of the Past: Museums and Heritage in the Postmodern World.* New York: Routledge, 1992.

Ward, Frazer. "The Haunted Museum: Institutional Critique and Publicity." *October* 73 (Summer 1995): 71–89.

Weber, Samuel. *Unwrapping Balzac.* Toronto: Toronto University Press, 1979.

Weil, Stephen. *Rethinking the Museum and Other Mediations.* Washington, D.C.: The Smithsonian Institute Press, 1990.

Wittgenstein, Ludwig. *Tractatus Logico-Philosophicus.* Trans. D. F. Pears and B. F. McGuinness. Atlantic Highlands, N.J.: Humanities Press International, 1992.

Zola, Emile. *Les Rougon-Macquart: Histoire naturelle et sociale d'une famille sous le Second Empire.* Eds. Armand Lanous and Henri Mitterand. Paris: Gallimard, 1960–67.

Zucker, Paul. *Fascination of Decay: Ruins, Relic-Symbol-Ornament.* Ridgewood, N.J.: Gregg Press, 1968.

Index